STUDIES IN BRITISH ART

GERMAN ROMANTICISM AND ENGLISH ART

WILLIAM VAUGHAN

PUBLISHED FOR THE PAUL MELLON CENTRE
FOR STUDIES IN BRITISH ART BY
YALE UNIVERSITY PRESS
NEW HAVEN AND LONDON
1979

FOR MY MOTHER

Designed by Faith Brabenec Hart and set in Monophoto Bembo.
Printed in Great Britain by BAS Printers Limited, Over Wallop, Hampshire.

Published in Great Britain, Europe, Africa, and Asia (except Japan) by Yale University Press Limited, London. Distributed in Australia and New Zealand by Book & Film Services, Artarmon, N.S.W., Australia; and in Japan by Harper & Row, Publishers, Tokyo Office.

Library of Congress Cataloging in Publication Data

Vaughan, William, 1943–
 German Romanticism and English art.

 (Studies in British art)
 Expanded and rev. version of the author's thesis,
The German manner in English art, 1815–55, London University, 1977.
 Bibliography: p. Includes index.
 1. Art, Victorian—England. 2. Art, English—German influences. 3. Painting, German—Influence.
4. Romanticism in art—England. 5. Romanticism in art—Germany. 6. Germany in art.
I. Title. II. Series.
N6767.V38 1979 709'.42 79–10621
ISBN 0–300–02194–1

PREFACE

THIS BOOK is an expanded and revised version of my Ph.D. thesis, 'The German Manner in English Art, 1815–55' (University of London, 1977). I would like to thank first my two supervisors for that work, Professors L. D. Ettlinger and Michael Kitson. The former stimulated my enthusiasm and gave me the courage to undertake a project which was, in the beginning, quite bewildering. The latter saw the finished product through with great sympathy and patience, and was directly responsible for it being considered for publication.

There have been many who have offered invaluable help and advice. Keith Andrews has been throughout most encouraging and most generous in his suggestions. Peter Howell and Clive Wainwright have given me most valuable information about Pugin, De L'Isle and Hauser. Martin Harrison very generously shared information about borrowings from Nazarene pictures by Victorian stained-glass designers. The late Celia Phillips very kindly followed up references for me in a number of archives in the United States. I would like to thank Dr George Katkov and Professor Michael Podro for having read through Chapter II and for making invaluable suggestions. John Peppin most kindly read through the whole text and made innumerable improvements.

I have received help from numerous archives, libraries and museums and would like to mention in particular that given by the staffs of Aberdeen Art Gallery; Kupferstichkabinett, Staatliche Museen, Berlin; Staatsarchiv, Berlin; Landesbibliothek and Gemäldegalerie, Dresden; National Gallery of Scotland, Edinburgh; Kunsthalle, Hamburg; British Museum, Tate Gallery and Victoria and Albert Museum, London; Centralbibliothek and Staatsarchiv, Munich; and Ashmolean Museum, Oxford.

Amongst the many who have discussed topics relating to this thesis with me I would like to thank especially the following; Dr David Bindman, Professor Alan Bowness, Dr Helmut and Dr Eva Börsch-Supan, Dr Anita Brookner, Dr Hans Ebert, Stephen Calloway, Dr John Gage, Timothy Hilton, Dr Jens Christian Jensen, Dr Stefan Muthesius, Dr Hans Joachim Neidhardt, Richard and Leonée Ormond, Dr Alexander Potts, Dr Gottfried Riemann, Dr Reihe, Professor Allen Staley, Dr John Turpin and Professor Siegfried Wichmann. Professor John White has given great support during the period in which this book was written.

Finally I should like to thank the Paul Mellon Centre for Studies in British Art and Yale University Press who have made possible the publication of this book. At the Yale University Press John Nicoll has been a most understanding editor and Faith Hart invaluable in bringing the text up to a printable standard.

William Vaughan
London, 1978

CONTENTS

LIST OF PLATES

All measurements are in centimetres. ★ Indicates engraving after artist named.

Leipzig, 1834.

84. J. E. Millais: *The Death of Romeo and Juliet*. 1848. Pen (21.6 × 36.8). By courtesy of Birmingham Museum and Art Gallery.

85. F. A. M. Retzsch: Act V, Scene 3. Plate 13 of *Romeo and Juliet*, Leipzig, 1836.

86. ★T. Johannot: Vignette to *Oeuvres de Molière*, Paris, 1835, I, p. 715. Wood-engraving.

87. J. N. Strixner: Page 43 of *Albrecht Dürers Christlich-Mythologische Handzeichnungen*, Munich, 1808. Lithograph.

88. P. von Cornelius: Title page to *Goethes Faust*, c. 1815. Pen (48 × 34.1). Städelsches Kunstinstitut, Frankfurt-am-Main.

89. ★E. Neureuther: *Heidenröslein*. From *Randzeichnungen zu Goethes Balladen*, Munich, 1828. Lithograph.

90. ★J. Hasenclever: Page 11 of Reinick, *Lieder und Bilder*, Düsseldorf, 1843. Etching by T. Janssen.

91. ★A. Rethel: Page 9 of Reinick, *Lieder und Bilder*, Düsseldorf, 1843. Etching.

92. ★E. Neureuther: Stanza 41 of *Der Cid*, Munich, 1839. Wood engraving.

93. ★A. Rethel: *Wie Iring erschlagen wird* (How Iring was Slain). Page from *Das Nibelungenlied*, Leipzig, 1840. Wood engraving by F. Unzelmann.

94. ★A. Rethel: *Wie die Königin den Sall Verbrennen Liess* (How the Queen had the Hall burnt down). Page from *Das Nibelungenlied*, Leipzig, 1840. Wood engraving by W. Nicholl.

95. ★A. Rethel: Plate 4 of *Auch ein Totentanz* (Another Dance of Death), Dresden, 1849. Wood engraving.

96. ★A. Rethel: *Der Tod als Freund* (Death the Friend). Dresden, 1851. Wood engraving by J. Jungtow.

97. ★J. Schnorr von Carolsfeld: *Abraham's Servant and Rebecca*. From the *Bible in Pictures*, 1860. Wood engraving.

98. ★H. Warren: Illustration to *Lockhart's Spanish Ballads*, 1840. Wood engraving.

99. ★J. Franklin: *Genevieve*. Page from *The Book of British Ballads*, 1842. Wood engraving by T. Williams.

100. ★J. Franklin: *Chevy Chase*. Page from *The Book of British Ballads*, 1842. Wood engraving by Armstrong.

101. ★D. Maclise: *But why stands Leonora there?* Page from *Leonora*, 1847. Wood engraving by J. Thompson.

102. J. E. Millais: *Garden Scene*. 1849. Pen (28 × 20.3). J. A. Gere.

103. ★A. Crowquill: *The Student of Jena*. Page from Bon Gaultier, *Book of Ballads*, 1848. Wood engraving.

104. ★F. R. Pickersgill: *The Woman taken in Adultery*. Page from *Six Compositions from the Life of Christ*, 1850. Wood engraving by Dalziel Bros.

105. ★D. G. Rossetti: *The Maids of Elfin Mere*. From *The Music Master*, 1855. Wood engraving by Dalziel Bros.

106. ★D. G. Rossetti: *Sir Galahad*. From Tennyson, *Poems*, 1856 (Moxon edn.). Wood engraving by W. J. Linton.

107. *The German School*. From *Punch*, 1846. Wood engraving.

108. ★J. Severn: *Queen Eleanore*. From Linnell, *The Prize Cartoons*, 1845. Lithograph.

109. C. L. Eastlake: *The Spartan Isodas*. 1827. Oil (188 × 254). The Trustees of the Chatsworth Settlement.

110. C. L. Eastlake: *Pilgrims in sight of Rome*. 1841. Oil (81.5 × 104). Private collection.

111. C. L. Eastlake: *Hagar and Ishmael*. 1830. Oil (50.7 × 58.4). Royal Academy, London.

112. C. L. Eastlake: *Christ Lamenting over Jerusalem*. 1841. Oil (96 × 148). Tate Gallery, London.

113. E. Bendemann: *Die trauernden Juden im Exil* (Jews in Exile). 1832. Oil (183 × 280). Wallraf-Richartz Museum, Cologne.

114. C. L. Eastlake: *Hagar and Ishmael*. 1843. Oil (75 × 94). Sold Christie's, 9 October 1964 (lot 102).

115. ★C. L. Eastlake: Scene from *Comus*. From *The Decoration of the Garden Pavillion in the Grounds of Buckingham Palace*, 1846. Lithograph by L. Gruner.

116. W. Dyce: *The Judgement of Solomon*. 1836. Tempera (150 × 246). National Gallery of Scotland, Edinburgh.

117. W. Dyce: *Paolo and Francesca*. 1837. Oil (132 × 160). National Gallery of Scotland, Edinburgh.

118. W. Dyce: *The Holy Trinity and Saints*. 1849. Oil (135 × 88). Design for fresco in All Saints', Margaret Street. Victoria and Albert Museum, London.

119. W. Dyce: *Jacob and Rachel*. 1853. Oil (58 × 58). Kunsthalle, Hamburg.

120. J. Schnorr von Carolsfeld: *Jacob and Rachel*. 1826. Pen (27.9 × 25.8). Kupferstich-Kabinett, Dresden.

121. W. Dyce: *Religion—The Vision of Sir Galahad*. 1851. Fresco (341 × 427). Queen's Robing Room, Palace of Westminster.

122. W. Dyce: *The Departure of the Knights of the Round Table on the Quest for the Holy Grail*. 1851. Watercolour (23.2 × 44). Rejected design for Queen's Robing Room. National Gallery of Scotland, Edinburgh.

123. J. Schnorr von Carolsfeld: *The Battle of Lipadusa*. 1816. Oil (102 × 170). Kunsthalle, Bremen.

124. W. Dyce: *Joash shooting the Arrow of Deliverance*. 1844. Oil (76 × 89). Kunsthalle, Hamburg.

125. W. Dyce: *Madonna and Child*. 1838? Oil (103 × 80.5). Tate Gallery, London.

126. W. Dyce: *Madonna and Child*. 1845. Oil (80 × 58.5). By gracious permission of Her Majesty the Queen.

127. W. Dyce: *Madonna and Child*, c. 1845? Oil on slate (78.7 × 60.2). Castle Museum, Nottingham.

128. ★W. Dyce: *The Bridgewater Family reunited*. From *Decoration of the Garden Pavilion*, 1846. Lithograph by

L. Gruner.

129. W. Dyce: *Courtesy—Sir Tristram Harping*. 1851. Fresco (341 × 170). Queen's Robing Room, Palace of Westminster.

130. T. Sibson: *A Saxon Town*. *c*. 1843. Pencil (13.3 × 18). Yale University Art Gallery.

131. *E. Armitage: *Caesar's first Invasion of Britain*. 1843. From Linnell, *The Prize Cartoons*, 1845. Lithograph.

132. *C. W. Cope: *The first Trial by Jury*. 1843. From Linnell, *The Prize Cartoons*, 1845. Lithograph.

133. *H. J. Townsend: *The Fight for the Beacon*. 1843. From Linnell, *The Prize Cartoons*, 1845. Lithograph.

134. *W. C. Thomas: *St Augustine Preaching*. 1843. From Hunt, *Book of Art* 1846. Wood engraving.

135. *J. C. Horsley: *St Augustine Preaching*. 1843. From Linnell, *The Prize Cartoons*, 1845. Lithograph.

136. *W. C. Thomas: *Philosophy*. 1844. From Hunt, *Book of Art*, 1846. Wood engraving.

137. *J. C. Horsley: *Peace*. 1844. From Hunt, *Book of Art*, 1846. Wood engraving.

138. *R. Redgrave: *Loyalty*. 1844. From Hunt, *Book of Art*, 1846. Wood engraving.

139. *C. W. Cope: *Jacob and Rachel*. 1844. From Hunt, *Book of Art*, 1846. Wood engraving.

140. *D. Maclise: *The Knight*. 1844. From Hunt, *Book of Art*, 1846. Wood engraving.

141. *W. Dyce: *Consecration of Archbishop Parker*. Chalk study for fresco formerly in Lambeth Palace Chapel. Victoria & Albert Museum, London.

142. F. Madox Brown: Study for the *Spirit of Justice*. 1845. Watercolour (75.7 × 51.7). City Art Galleries, Manchester.

143. W. Dyce: *The Baptism of Ethelbert*. 1846. Fresco (551 × 291). House of Lords, Palace of Westminster.

144. J. C. Horsley: *Spirit of Religion*. 1847. Fresco (551 × 291). House of Lords, Palace of Westminster.

145. D. Maclise: *Spirit of Chivalry*. 1847. Fresco (551 × 291). House of Lords, Palace of Westminster.

146. D. Maclise: *Sacrifice of Noah*. 1847. Oil (205 × 254). City Art Gallery, Leeds.

147. *G. Jäger: *Dankopfer Noahs*. From Cotta, *Bibel mit Bildern*, Stuttgart, 1844. Wood engraving.

148. *J. N. Paton: *Spirit of Religion*. 1845. From Hunt, *Book of Art*, 1846. Wood engraving.

149. F. Madox Brown: *The Body of Harold brought before William the Conqueror*. 1844–61. Oil (105 × 123.1). Sketch for cartoon exhibited in Westminster Hall, 1844. Subsequently reworked. City Art Galleries, Manchester.

150. P. Cornelius: *Four Riders of the Apocalypse*. 1845. Chalk (472 × 588). Destroyed. Formerly National-Galerie, Berlin.

151. F. Madox Brown: *The Seeds and Fruits of English Poetry*. 1845–53. Oil (86 × 117). Ashmolean Museum, Oxford.

152. F. Madox Brown: *Work*. 1852–6. Oil

(135 × 196). Cith Art Galleries, Manchester.

153. J. E. Millais: *Christ in the House of his Parents*. 1849. Oil (86 × 140). Tate Gallery, London.

154. J. R. Herbert: *Our Saviour subject to his Parents at Nazareth*. 1856. Oil (81 × 130). Replica of picture exhibited at Royal Academy in 1847. Guildhall Art Gallery, City of London.

155. *F. Overbeck: *Puer Jesus in Fabrica Josephi*. Plate 9 of *Die Vierzig Evangelischen Darstellungen*, Düsseldorf, 1847. Engraving by X. Steifensand.

156. W. Holman Hunt: *The Hireling Shepherd*. 1851. Oil (76.4 × 109.5). City Art Galleries, Manchester.

157. W. Holman Hunt: *The Light of the World*. 1853. Oil (125.5 × 59.8). By permission of the Warden and Fellows of Keble College, Oxford.

158. *P. Veit: *Christus an die Seelentüre klopfend* (Christ knocking on the Door of the Soul). 1824. Städelsches Kunstinstitut, Frankfurt-am-Main. Engraving by G. Rist.

159. *W. Dyce: *Ladye Mary*. Page from *Poems and Pictures*, 1846. Wood engraving.

160. W. Dyce: *Christ and the Woman of Samaria*. 1865. Oil (34.3 × 50). By courtesy of Birmingham Museum and Art Gallery.

161. W. Dyce: Design for 'Choristers' Window, Ely Cathedral. *c*. 1850. Charcoal and wash (120 × 40). Art Gallery, Aberdeen.

162. W. Dyce: Cartoon for *St Paul Preaching at Antioch*. Laing Art Gallery, Newcastle-upon-Tyne.

163. F. Overbeck: *Der Tod des Heiligen Joseph* (Death of St Joseph). 1857. Oil (100 × 75). Georg Schäfer Collection, Schweinfurt.

164. F. Preedy: Memorial window to Elizabeth Tovery. 1858. Stained glass. Church Lench, Worcestershire. Photograph by Martin Harrison.

165. E. Burne-Jones: *The Good Shepherd*. 1857. Wash and watercolour (129 × 47.5). Design for stained-glass window. Victoria and Albert Museum, London.

166. *J. Schnorr von Carolsfeld: *The Two Spies escape from the House of Rahab*. From the *Bible in Pictures*, 1860. Wood engraving.

167. *A. L. Richter: *Hansel und Gretel*. Wood engraving.

168. K. T. Piloty: *Nero among the Ruins of Rome*. 1860. Oil. National Gallery, Budapest.

169. A. Menzel: *Frederick the Great and his Troops at the Battle of Hochkirch*. 1856. Oil (295 × 378). National-galerie, Berlin.

170. A. Rethel: *Otto III in the Crypt of Charlemagne*. 1847. Oil (52.5 × 82.7). Colour sketch for fresco in the town hall at Aachen. Kunstmuseum, Düsseldorf.

171. *W. Busch: Page from *A Bushel of Merry Thoughts*, 1868. Wood engraving.

172. A. Menzel: Illustration from *History of Frederick the Great*, 1840. Wood engraving.

173. A. Menzel: *The Market Place at Verona*. 1884. Oil (74 × 102). Staatliche Gemäldegalerie, Dresden.

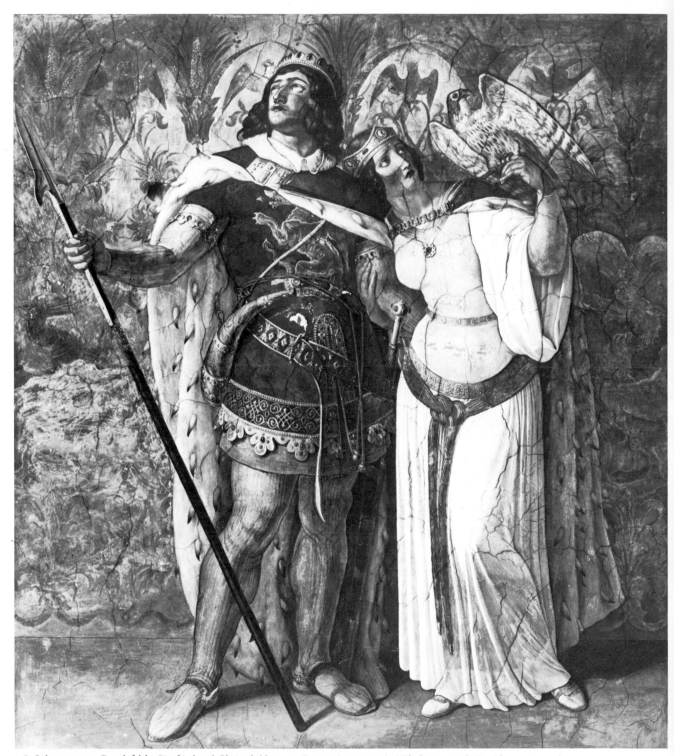

1. J. Schnorr von Carolsfeld: *Siegfried and Chriemhild*. 1831. Fresco (475 × 291). Nibelungensaal, Residenz, Munich.

INTRODUCTION

The Crisis in English History Painting

THE INTEREST taken by English painters and designers during the early Victorian era in certain aspects of German Romantic art is undoubtedly the most spectacular event in the history of English responses to the pictorial production of that country. While many artists of German origin have, since the time of Dürer and Holbein, been both influential and successful in England as individuals, there has never been a period either before or since the mid nineteenth century when German art was the source of so much emulation and controversy.

Although it might seem strange at first, in view of the variable quality of German art of the period, that the English should have developed such an inclination, there can be no doubt about the strength of the reactions that were aroused. Both the extravagant praise and condemnation that occurred in such contemporary periodicals as the *Art Union*, the *Athenaeum*, and the *Ecclesiologist*, as well as the subsequent memoirs of the Pre-Raphaelites and the generation of historical painters preceding them, make it clear that German art was held by an influential section of the London art world to be a fitting model for the English.

This situation reflected not only the prestige of German art, but also the lack of confidence that was felt in English painting at this time. Recent studies, especially those of the late Professor Boase and of Professor Bell,[1] have elucidated the circumstances which surrounded the German influence — in particular the re-emergence of a concern for monumental and didactic art which was epitomized in the foundation of the Government Schools of Design and the decoration of the New Palace of Westminster. Furthermore Keith Andrews, in his account of the Nazarenes and their followers,[2] has not only provided an overall survey of those artists who were the principal object of English emulation, but has also drawn attention to the international scope of their reputation. For it was not only in England but throughout Europe that the work of Overbeck, Cornelius and their associates was admired. Their fame spread as far as Russia, where the Munich painter J. G. Hiltensperger provided designs for the new Hermitage art gallery,[3] and to the United States, where by 1841 Düsseldorf was already becoming the European city to which young artists were advised to go to complete their training.[4] At the same time that Dyce, Maclise and other English painters were working on the decorations of the Palace of Westminster, the Belgian artists Godfried Guffens and Jan Swerts were decorating St George, Antwerp, and other churches in Flanders in a manner openly indebted to Overbeck.[5] Even in France, the country least likely to feel the need for Teutonic enlightenment in the fine arts, the Germans found their supporters—notably in Ingres's pupil Hippolyte Flandrin and in the Dutch-born

I

Ary Scheffer, whose Germanic tendencies earned him Baudelaire's censure in the poet's review of the Salon of 1846.[6]

The scope of this subject is already sufficiently clear, therefore, to make it possible to concentrate on problems relating more to the nature of the influence itself. Yet it is here that contradictions and uncertainties begin to arise. For, although the existence of a German influence is indisputably documented, it is less easy to determine what precisely it implied, and what the English gained from their encounter with it.

It is these two problems which form the basis of this book. Superficially, one might provide an answer to the first by saying that the type of German art emulated was that of the Nazarenes and their followers, those artists who developed out of the general interest in primitivism around 1800 which is evident in the works of Blake, Carstens, Flaxman, 'Les Primitifs' and Ingres—a literal attempt to revive the spirit and art forms of the late Middle Ages. Yet this would not encompass the full extent of the term. In the first place, while these artists were the contemporary German painters best known abroad, they were not the only ones. Many German illustrators—notably Retzsch, Otto Speckter and Ludwig Richter—also enjoyed international renown at this time; and, while the painters Friedrich and Runge (whose mystic primitivism present so many interesting parallels with Blake and Samuel Palmer) appear to have been virtually unknown in England,[7] a great variety of artists of German origin were working there throughout the period.

Despite strong regional and stylistic differences, however, English commentators of the period tended to view German artists as representatives of a homogenous manner. In Chapter I, therefore, an attempt is made to isolate the German artists whose work was best known in England during this period and to indicate which were of most significance for English artists.

Secondly, the interest in the 'German Manner'—as it was often called—was as much an interest in an attitude as in a pictorial achievement. Even the Germanophile *Art Union* considered the Germans to be the 'first in Eruope' on the basis that 'they alone can give a reason for the treatment of every work of art'.[8] Behind the grandiose schemes of Munich and the uncompromising piety of Overbeck lay a systematic approach that appeared to have solved problems relating to the identity as well as the social and moral functions of the fine arts with seductive definiteness. This development was inseparable in the minds of most contemporaries from the emphasis placed on aesthetics by the German critics and philosophers after Kant. Many of the revivalist artists of the period—in particular Dyce and Eastlake—took a direct interest in the subject, and the popular enthusiasm for the theories of writers like Schiller, the Schegels, Novalis and Schelling is evidenced by the number of cheap edition translations of their work which appeared during the 1840s.[9] This theoretical background to the German Manner and its effects upon art theories and organization will be indicated in Chapter II.

At first sight the gain to English artists provided by their interest in German art might seem to be minimal. This has certainly been assumed by most English commentators from Ruskin to Bell. Even at the time, while many painters were

2

accused of German tendencies, few admitted the charge. Even Dyce and Maclise—commonly considered to be the principal figures in the movement—vigorously denied the association, and their defenders went to great pains to point out how independent their religious and historical paintings were of those produced in Munich and Düsseldorf.[10]

Certainly the impact of German art produced a spirit more of emulation amongst English artists than of imitation. There was little of the wholesale admiration that a later generation of painters was to feel for the French Impressionists in the 1880s. That kind of enthusiasm was reserved in this case for those less directly involved; for connoisseurs like Thomas Wyse and Henry Bellenden Ker or architects like Pugin and Street. Most painters were too concerned for the painterly tradition of English art to accept wholeheartedly the asceticism of the German revivalists. Dyce himself feared that the admiration for the German method expressed by members of the royal commission appointed to supervise the decoration of the Houses of Parliament[11] would lead them to overlook the true nature of the alternatives.[12]

In both the condemnations and defences of German art there was a recognition that this new manner ran against many of the standards that were felt to have become the basis of English art since the late eighteenth century. The *Discourses* of Reynolds, if no longer followed in detail and much attacked by later critics such as Hazlitt, had nevertheless exercised a determining influence on English historical painting. The Grand Manner (where the ideal was approached through generalization, and the rhetoric of Raphael's cartoons, the colouring of the Venetians, and the compositions of the Carracci appeared the most imitable features of the art of preceding centuries) remained a paradigm in England long after it had fallen from favour elsewhere. More generally, English artists had tended to emphasize the immediate aspects of visual appeal—in particular the effects of colour—at a time when artists on the continent were reducing these in deference to other values. As Eastlake said, when presenting his view of the state of English art in the first report of the Commission about which Dyce had expressed concern,

> Its rise in the last century was remarkable for sudden excellence in colouring and chiaroscuro, an excellence so great as to eclipse contemporary efforts in a severer style, while it gave a bias to the school. The peculiar union of what we called the ornamental parts of the art, with those essential to history, which has prevailed in England, not unattended with some sacrifice of more solid qualities, has been generally attributed to this influence.[13]

Eastlake tactfully avoided any mention of Reynolds in this passage, but other commentators, who saw nothing at fault with the sensory qualities of English art, often evoked the name of the first president of the Royal Academy against the ascetic spirit of the Germans. Cut off from continental developments at a crucial period by the Napoleonic Wars, most English painters—with the striking exception of Blake and his followers—had remained inherently suspicious of the more extreme primitivistic tendencies of that time. Indeed these had often been associated in their

minds with the despotic nature of contemporary French government, and many traditionalists felt that Germanism was no more than another attempt to insinuate these false principles into the healthy democracy of English art. This was certainly the opinion of the most vociferous survivor from this period, Benjamin Robert Haydon. Musing on how the blockade had saved English art, he complained in his Journal on 11 August 1841,

> We escaped the contagion of David's brick dust which infected the continent, and the frescoes at Munich are but a branch of the same Upas root grafted upon Albert Dürer's hardness, Spranger's exaggeration, Cimabue's Gothicism, and the gilt ground inanity of the middle ages.[14]

Haydon, superseded by a new generation of historical artists, had cause for bitterness, but even pro-German critics like Wornum warned against the decay of the naturalistic tradition.[15] By the 1840s, whatever the current reputation of German art, the English could look back on a distinguished history of contributions to the European *avant-garde*. As early as 1802 Benjamin West had been hailed in Paris on account of his modern history paintings, a genre that was admired by David and was soon to be developed by Gros, Géricault and Delacroix. English landscape painting had, since the time when Washington Allston demonstrated his method of obtaining atmospheric distances to Schick in Rome in 1805, achieved widespread admiration. If Turner's paintings sometimes created bemusement and con-fusion—as in Rome in 1829 and in Munich in 1845[16]—such artists as Constable, Bonington, Eastlake and Callcott were proverbially successful in Paris; and the last two also in Rome. Portraiture, too, had retained its high reputation since the days of Reynolds and Gainsborough. Lawrence, when he toured the continent in 1819, was acclaimed the finest portrait painter in Europe—a reputation that subsequently enabled many third-rate English portraitists, such as George Dawe, to make their fortunes in the courts of Europe. Before the 1830s, English confidence in their art had run high. It was commonly held to be the best in Europe, a true flowering of the democratic spirit that had brought so much prosperity to the English way of life. Some observers even went so far as to believe that the lack of organized patronage— the bane of such aspirants to the Grand Manner as Barry and Haydon—was a positive advantage. Henry Sass, later to become well known for his drawing academy, wrote on returning from his continental tour of 1817,

> I have observed that the improved state of the arts in England is owing to the exertion of the artists themselves; and when contrasted with their state in France and Italy, where immense sums have been expended to forward and support them, it only shows the futility of a particular patronage. The public at large are the only real patrons.[17]

While such associations between art and political systems might now seem naïve, they were common amongst nineteenth-century observers. The associations were for them meaningful ones, as was the fear that with the introduction of German methods and styles into English art the excellencies born of a democratic

community were being sacrificed to the stereotyped values of a hierarchic society. One pamphleteer who concerned himself with the decoration of the New Palace of Westminster, H. G. Clarke, considered not only the 'hard manner' but also the eclecticism of German art to derive from their political system:

> In most countries court influence or individual patronage, and not the spirit of free municipal institutions directed, controlled, the new kindled aspirings of taste, and their favour, as usual, promoted imitation and not original, independent genius. Hence the artists of Munich imitate and copy the works of Italian masters and the English are instructed to follow the steps of German imitators without sufficient attention to circumstances.[18]

Yet such political analogies could work in more than one direction. The principle of a self-determining school of art might fit in well with the *laissez-faire* opinions of the Manchester school, but the events of the 1840s were rapidly bringing such principles into question. The acute poverty and social injustice suffered by a large section of the community were leading to a growing call for the re-establishment of traditional social and spiritual bonds between rich and poor that were epitomized in the Oxford movement and the new conservatism of Disraeli and the 'Young England' faction.[19] At the same time the paternalistic socialism that was to be adopted by Ruskin and Morris found its precursor in the visual arts in Pugin, whose *Contrasts* (1836) made such damaging comparisons between life in nineteenth-century and fourteenth-century England, and gave the English a definite statement on the social duty of the fine arts.

Certainly the spirit of free enterprise did not seem to have been favouring the development of high-minded painting in recent years. Indeed historical painters seemed to seek attention mainly through light-hearted and amusing themes. Complaints about the 'exhibition of fireworks' at the Royal Academy and at other public exhibitions increased during the 1830s,[20] while travellers marvelled at the opportunities given to artists abroad to develop a different type of art. Already in 1833 Mrs Anna Jameson was moved by the sight of Schnorr's *Nibelungen* frescoes (Plate 1) in Munich to speculate upon the benefits of such opportunities for English artists:

> What would some of our English painters—Etty or Hilton, or Briggs or Martin, O what would they give to have two or three hundred feet of space before them, to cover at will with grand and glorious creations,—scenes from Chaucer, or Spenser, of Shakespeare, or Milton, proudly anxious that they were painting for their country and posterity, spurred on by the spirit of their art and national enthusiasm, and generously emulating each other! Alas, how different! With us such men as Hilton and Etty illustrate annuals, and the genius of Turner shrinks into a vignette.[21]

Although such schemes had been the anxious dream of English historical painters since the days of Barry, it was only in the 1830s that they became seen as a matter for government intervention. Already in the first report of the Select Committee

2. (below) *D. Monten: *Bavarians taking a Turkish Entrenchment before Belgrade by Storm, 1717*. From *Fresco Gemälde aus der Geschichte der Bayern . . . in den Arcaden des Hofgartens zu München*, Munich, 1829. Lithograph by W. Gail.

3. (right) D. Maclise: *Spirit of Justice*. 1849. Fresco (551 × 291). House of Lords, Palace of Westminster.

4. (lower left) C. W. Cope: *Charles I erecting his Standard at Nottingham*. Peers' Corridor, Palace of Westminster.

5. (lower right) *A. L. Richter: Illustration to *The Vicar of Wakefield*, 1857 edn.

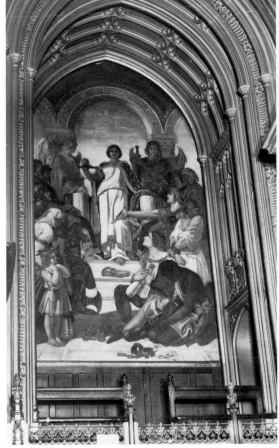

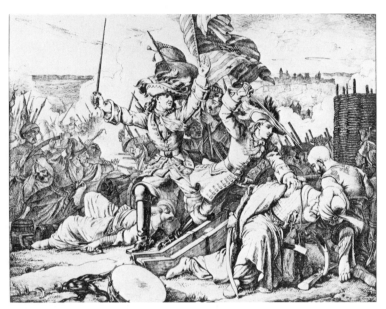

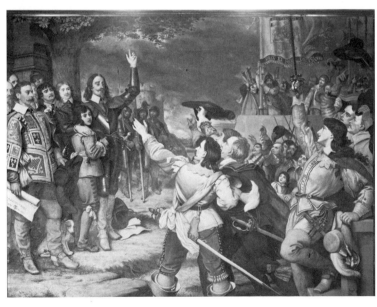

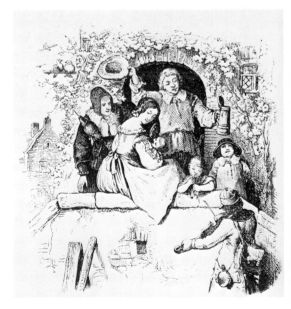

on Arts and Manufactures of 1836,[22] the didactic potential of art had ranked with commercial incentive in the deliberations of the committee. The evidence of the Berlin expert Gustav Waagen on the educational value of museums and public monuments was closely studied. Even style began to take on political implications when it was insisted in the competition rules for the design for the New Palace of Westminster that it should be built in the 'national' styles of either Gothic or Elizabethan. Painting was valued by the Fine Arts Commission for its capacity to demonstrate the history and character of the Parliamentary institutions—the House of Lords having its constituents expounded in terms of Justice, Religion and Chivalry.[23] Here again, Munich could provide a specific prototype in the Hofgarten frescoes (Plate 2) which expounded the history of Bavaria.[24] In one of the most frequently reprinted sections of the first report of the Select Committee, Thomas Wyse, recently returned from Munich, gave an eyewitness account of these murals at work:

> The effect upon the public at large is . . . diversified; the higher class has an opportunity of judging of the propriety of the classic illustrations, while I have seen the peasants of the mountains of Tyrol holding up their children and explaining to them the scenes of Bavarian history every Sunday.[25]

The final layout of the decorations of the Palace of Westminster did, in fact, follow similar divisions, with the more esoteric allegories adorning the House of Lords (Plate 3) and Queen's Robing Room, while the more public galleries were filled with scenes from British history (Plate 4).

At the same time that interest was being expressed in the arrangement of the fine arts in Munich, English artists were experiencing even more urgent reasons for emulation of the Germans. In 1841 Prince Albert, recently arrived in England, was given as his first public duty the presidency of the Fine Arts Commission. With his appointment the problems surrounding didactic art became more vexed; for this prince considered that German artists, with their greater experience in this field, should be employed on the scheme. This view was also entertained seriously by Eastlake, the secretary of the Commission who, during his long stay in Rome, had developed an intimate knowledge of the Nazarenes and their ideals and methods.[26] The employment of German artists and architects on public commissions abroad was by no means uncommon at this time.[27] Cornelius, who was visiting England in the autmn of 1841 and who freely offered his advice, did not even think that there was a serious national issue at stake, for he argued that the English and Germans had similar racial and cultural origins.[28]

In view of the unfavourable reactions to such suggestions[29] the Commission rapidly altered their position on the subject. Yet the selection of English artists to work on the Palace of Westminster decorations was made with great caution, and only after a series of three competitions.[30] During the years of these competitions, from 1843 to 1846, ambitious historical painters made a close study of the style and methods of the artists of Munich—a study that was assisted by the pro-German policy adopted by the *Art Union*, the large number of German prints and illustrated

books that flooded the London print-sellers, and the information provided by the reports of the Fine Arts Commission. At the same time, in the eyes of official art circles at least, steps were being taken to acquaint the English public at large with the virtues of didactic art. The establishment of Art Unions in England on the model of German *Kunstvereine* was directed, in these early days at least, towards the improvement of public taste, and the *Art Union* was able to report smugly in 1842 in its review of these institutions that 'A taste for the production of the schools of Germany is growing up amongst us, in proportion as our progressive education in art prepares the many to understand its higher purpose.'[31]

However, while these factors certainly brought about a Teutonic complexion to much English historical art in the 1840s, this craze hardly survived the competitions. The successful contestants set to work on their murals, and were soon forgotten by the public, while the main developments in English art took place elsewhere—in the exhibitions of the Royal Academy or the private worlds of such leaders of the unofficial *avant-garde* as Rossetti and Whistler. Monumental didacticism was perhaps, after all, the prerogative of an authoritarian society. Certainly the history of the struggles of monumental painters like Watts, Leighton, and Stevens in the latter part of the century is as dispiriting as that of Barry and Haydon had been previously.

Yet, if the reasons for the emulation of German painters around 1840 can be found in the history of these events, the pictorial influence of German Romantic art is not limited to the Westminster competitions. The didactic approach touched deeper issues, and led to a reassessment of narrative and design which was to have far-reaching effects on the methods of Victorian artists. The full scope of the pictorial influence extended, in fact, like the influence of revivalist theories, both before and after the hastily assumed Germanism of the 1840s. It reached from the years immediately after the Napoleonic Wars, when artists like Eastlake, Seymour Kirkup and Joseph Severn first came into contact with the Nazarenes and the illustrations of Retzsch first arrived in England, to the 1880s, when Burne-Jones could still express excitement at the designs of the 'veritable angel' Ludwig Richter[32] (Plate 5), and Madox Brown still be moved by the 'vivid sentiment' of an engraving after Overbeck when he saw it in a print shop window.[33] Such influences were essentially personal, yet there were few major historical artists and designers who did not feel the need to come to terms with the art of their German contemporaries. Indeed the history of these encounters outlines the history of the spirit of revivalism as it affected English painting. It provided a catalyst at a time when the primitivism of a previous generation of British artists was largely forgotten. Unlike this former generation, too, the didacticism of the revivalism of the Victorians led to its adoption in new fields—not only in monumental decorative schemes, but also in the refurbishing of churches and in the illustration of books for mass production. If, as will be seen in the second part of this book, the major English artists of the period emerged from their encounter with the German Manner with a type of art far different from that of the Teutonic revivalists, it is perhaps a demonstration that the originality of the English artist was not dulled by the influence of German art as so many of the commentators of the 1840s had feared, but was enriched and stimulated.

CHAPTER I

German Art in England, 1800–50

THE MEANS by which the English became aware of contemporary German art are of interest, not simply because they demonstrate the degree to which certain aspects of this art were by the 1840s common knowledge, but also because they show a process of selectivity at work which suggests a directed concern. Indeed one might say that the significant feature was not so much that the English became aware of the work of German artists in the early nineteenth century, as that they recognized the existence of a modern German style.

This point becomes clearer when this position is contrasted with that previously held by German artists in England. Since the time of the Reformation many German painters had formed part of the continuous immigration of continental artists to this coutry. Some indeed, like Holbein and Kneller, had strongly affected the course of English art. Yet, unlike Van Dyck, Van Loo or Canaletto, these artists had never been associated with a national style. In Reynolds's *Discourses*, furthermore, there is discussion of Italian, French, Dutch and Netherlandish 'schools' but not of German. Such German artists as are mentioned are considered for other reasons. Dürer is commented on for his 'gothic' manner[1] and is given no national designation. Mengs is cited as an example of the modern Roman school.

Such a situation was not peculiar to England, but reflected the hierarchy of schools that had evolved since the Renaissance. The sense of a cultural identity in Germany after the sixteenth century had been weak, and most of the major artists in the German states looked to France, Holland or Italy for their inspiration. Consequently one finds that when such terms as 'German art' or 'German Manner' occur they are used in a pejorative sense to indicate the art of Northern Europe up to the time of Dürer and certain wilful aberrations that had been perpetrated since. As with Vasari's comments on Dürer or 'The Rhyme of Veit the Sculptor',[2] 'German' was mentioned primarily as a contrast to the Southern classicizing style of Italy. Even the development of interest in collecting Northern primitives in England in the late eighteenth century did not alter matters; for this taste was antiquarian rather than aesthetic.[3] In 1805 Fuseli still used 'German' to describe a faulty, mannered style when he wrote in *Pilkington's Dictionary*: 'Albert Dürer is called the father of the German school and, if numerous copyists of his faults can confer that honour, he was.'[4] For Ruskin the term remained sufficiently general for him to refer in the first volume of *Modern Painters* (1843) to the 'germanism' of Salvator Rosa's exaggerations.[5]

In fact, even after the emergence of a nationally orientated school in the German states around 1800, these older meanings of the term retained currency, and merged with the appreciation of modern art.

Certainly little attention was paid to such German art as did not tend towards archaism. Thus in 1839, when Caspar David Friedrich was still alive and such major naturalists as Dahl, Rottmann, Blechen and Menzel were in mid-career, the *Art Union* could write—in the same article that hailed German painters as the 'first in Europe'—of the inferiority of the Germans' observation of nature and their inability to paint even the principal features of their own countryside: 'the traveller finds no views of these much frequented spots that give any satisfactory idea of them unless an English or French artist has passed that way'.[6] Not until the 1850s, indeed, did a number of these naturalists, in particular Menzel, Waldmüller and the Düsseldorf landscape painters, begin to find recognition in England.[7]

This assessment of contemporary German art also bore little relationship to the work produced by artists of German origin then active in England. The most successful of these, such as Eduard Ströhling[8] and Franz Xavier Winterhalter[9] (Plate 6), continued in the tradition of international court portraiture, albeit with a 'germanic' flavour. Nazarene artists, on the other hand, tended to make no more than fleeting visits—although the events of the 1840s encouraged them to take a greater interest in English patronage.

6. F. X. Winterhalter: *Queen Victoria, Prince Albert and Their Family*. 1846. Oil (248 × 315). Her Majesty the Queen.

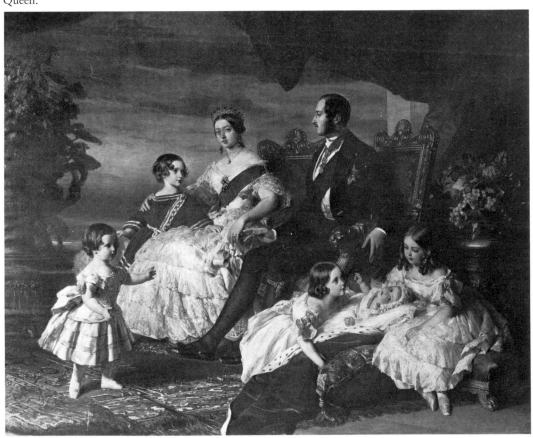

This discrepancy between the work of Germans practising in England, and the art that was recognized as 'German' emphasizes the degree to which the interest grew out of the concerns of highly motivated groups of artists and connoisseurs. It was through their activities that German painting became such a crucial issue in the 1840s. and it was principally through their agency that the work of the revivalist artists first became publicized in England. In discussing the presence of German art in England in the period preceding the craze for the 'German Manner', therefore, it is the activities of these groups which will mainly be considered.

However, the division between the old and the new is never total, and in order to gain a broader picture one must outline first the traditional channels through which German artists became known in England, since these often brought unexpected developments to the situation.[10]

CONTACTS IN ENGLAND
POLITICAL AND COMMERCIAL CONNECTIONS

English relations with German states have traditionally been strongest in the North. The commercial links which were manifested in the Middle Ages in the formation of the Hanseatic League were strengthened after the Reformation by religious sympathies, while the growth in Atlantic trade made the Germans increasingly dependent upon England for their imports.[11] Finally in the eighteenth century these associations became focused through the establishment on the English throne of the descendants of James I's daughter Elizabeth—the rulers of the northern German state of Hanover.

While of small and ever-decreasing political importance, the German bias of the English court exerted a degree of influence in the field of Royal and State patronage. Even after the Hanoverian monarchs had with the accession of George III in 1760 begun to see themselves as English, family associations remained, and Germans of talent were likely to be favoured at court. It was such considerations that affected the arrival in England of the musicians Handel and J. C. Bach, as well as such celebrated scientists as the astronomer Herschel. Hanoverians, as might be expected, were in a particularly favourable position. Amongst painters from this state to profit from this connection were Friedrich Rehberg, perhaps best remembered for his outline drawing *Lady Hamilton's Attitudes*,[12] J. H. Ramberg[13] and the Riepenhausen brothers.[14]

Similarly, during a period when English portraiture was internationally regarded as the best in Europe, one finds a continuous stream of Germans working at the Royal Court. Zoffany, Angelica Kauffmann and Hoppner were all employed by George III. Even during the reign of George IV, when this monarch's favourite portraitist Lawrence was enjoying an international reputation, employment was also found for such minor figures as Eduard Ströhling[15] and August Grahl.[16]

The termination of the Napoleonic Wars in the Anglo-Prussian victory at Waterloo and the redivision of Europe following the Congress of Vienna in 1815 set the scene for closer political connections between England and the German states.

By this time, however, the Hanoverian connection had become virtually meaningless. It was formally dissolved in 1837 when Queen Victoria was excluded from the Hanoverian succession by the Salic law and the State passed to her uncle, the Duke of Cumberland. Meanwhile Prussia, a member with England of the Quadruple Alliance (1817), was gradually emerging as the dominant German state. During the early years of the reign of Frederick William IV (1840–61) this growing power was coupled with a degree of liberalism, and it was this apparent progressiveness that made Prussia seem all the more valuable as an ally to the English monarchy. It was, for example, through his cordial relations with Frederick William IV that Albert had hoped to discover a 'handle with which to grip and manipulate the mighty cauldron of that Triple Alliance of Prussia, Russia and Austria'.[17] In itself this wooing of the Prussian monarchy led to an interchange of gifts which included many contemporary German paintings, including works by the Berlin painters Wilhelm Hensel and Eduard Magnus as well as such Nazarene works as Ferdinand Oliver's cycle *Journey to Emmaus*[18] (Plate 7) and Cornelius's *Glaubenschild*—a christening gift for the Prince of Wales.[19]

However, even these contacts were peripheral to the main royal patronage of German art. If the Hanoverian connection had been replaced politically by alliance with Prussia, it had been superseded dynastically by that of Saxe-Coburg. This ambitious family of German princes had first forged a link with the English throne in 1817 when Leopold of Saxe-Coburg married Charlotte, daughter and heir to the Prince Regent. Separated by his wife's death a year later from the English throne, he succeeded in 1830 in becoming King of the newly established monarchy of Belgium. At the same time he retained the confidence of the English royal family and was ultimately successful in arranging a match between Victoria and his nephew Albert in 1840.

Albert's involvement in public art patronage in England during the 1840s is so fundamental that its effects belong to the latter part of this book. However, it is worth noting here that his marriage to Victoria in 1840 brought into England, in his own person, an influential figure educated in the full German Romantic tradition. His remark to Frederick William IV in 1847, 'though I am, incidentally, the Queen of England's husband, I am also one German Prince speaking to another',[20] was perhaps not intended as more than diplomatic flattery. Yet it is certainly true that at the hands of his uncle Leopold and Baron Stockmar he had received a careful and thorough education that had impressed on him, together with the virtues of public duty and constitutional monarchy, a sense of Teutonic tradition. Fortunately he also had sufficient political acumen to moderate his views according to the pressures of his position in England.

Thus, while remaining an enthusiast for German music, art and literature, he never attempted to impose these upon an unwilling public. His suggestion in 1841 that German artists should be employed to decorate the new Palace of Westminster was quickly withdrawn when he sensed the unpopularity of the proposal.[21] As president of the Fine Arts Commission he subsequently gave every encouragement to English history painters, although he also assisted many of these artists to gain a

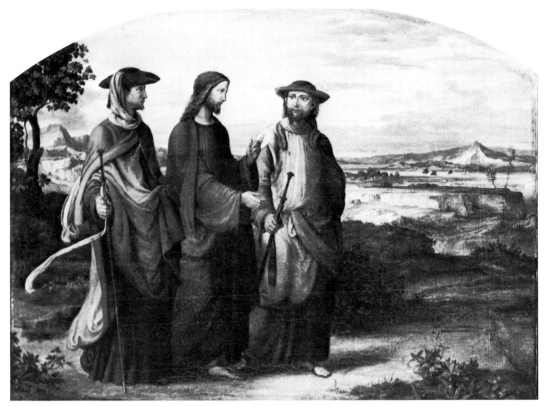

7. F. Olivier: *Der Gang nach Emaus* (The Journey to Emaus). 1827? Oil (24 × 28). Her Majesty the Queen.

closer knowledge of German monumental painting and made use of the experience of the Dresden decorator and engraver Ludwig Gruner, whom he had met in Rome in 1839.

Yet Albert's concern here was primarily to ensure the success of a didactic scheme; despite the *Kunstreise* in 1838–9 to Munich and Rome,[22] his personal enthusiasm for German revivalist art seems to have been limited. An examination of his collection reveals a surprisingly restrained number of works of this nature.[23] The only major Nazarene work that he acquired, Overbeck's cartoon for *The Triumph of Religion in the Arts* (Plate 8), appears to have been purchased on the initiative of Ludwig Gruner,[24] while the works by Cornelius and Olivier that he owned were gifts from the King of Prussia. Similarly, the handful of Nazarene pictures that he did himself buy were by Overbeck's more sentimental followers, like Führich, Steinle, Jäger and Marie Ellenrieder. In history painting, his collection reveals a preference for the French and Belgian schools. Indeed his own painting style shows the impact of the school of Brussels—where he spent part of his student days—and, encouraged by 'Uncle Leopold', he subsequently bought many works by Wappers and his followers.[25]

The only Munich painters he patronized were the genre painters Riegel and Pfoltz—the latter being a protégé of his relative the Princess Leiningen.[26] Even the

13

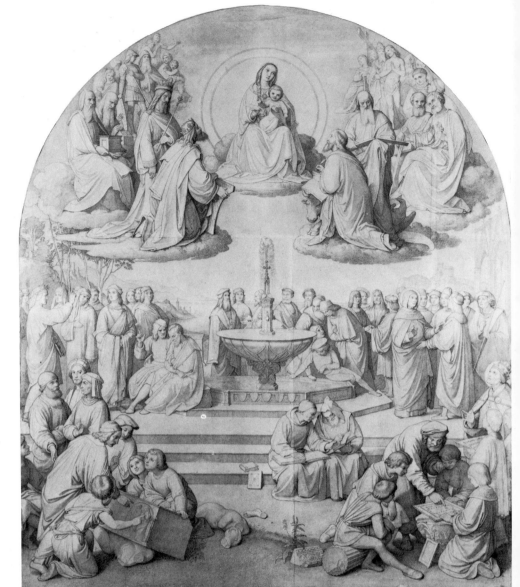

8. F. Overbeck: *Der Triumph
der Religion in den Künsten*
(The Triumph of Religion in
the Arts). *c.* 1830–40. Pencil
and chalk on reddish paper
(150 × 125). Her Majesty the
Queen.

9. (below) F. Leighton:
*Cimabue's celebrated Madonna
being carried in Procession
through the streets of Florence.*
1855. Oil (222.7 × 520.3).
Her Majesty the Queen.

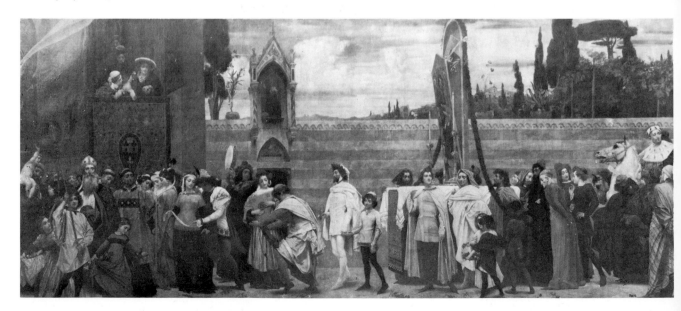

lyrical adaption of the Munich manner in the work of Schwind failed to interest him, and when this artist attempted to sell him his *Symphonie*, Albert was unresponsive.[27]

Albert was scrupulous, moreover, in his acquisition of modern English paintings. Most of the successful contestants of the Westminster competitions received private commissions from the Royal Family; and, even if neither Queen nor Consort could bring themselves to purchase the work of a Pre-Raphaelite, a blow was struck for English revivalist art in 1855 with the acquisition of Leighton's *Cimabue*[28] (Plate 9). The works from the Royal Collection that appeared as a series in the *Art Journal* between 1855 and Albert's death in 1861—and which were apparently selected by Albert himself for the benefit of the public—show an overwhelming emphasis on English art. Forty-eight of the seventy-eight works reproduced, furthermore, were landscape and genre subjects. Only nine historical paintings were included, of which six were English, two Belgian, one French, and none German. Of the six with religious themes, four were English, and two German.[29]

These continuing dynastic links also maintained an atmosphere that was sympathetic to the German immigrant. During the unsettled period following the French Revolution many northern German families came to settle in England, and many of these were to produce artists active in England yet aware of their German origins. Notable amongst these were Henry Richter, son of the Saxon engraver J. A. Richter and one of the earliest English Kantians;[30] Theodore Von Holst;[31] George Scharf junior, first director of the National Portrait Gallery;[32] William Behnes, the first teacher of Watts and the son of a Hanoverian piano tuner;[33] and George and John Fredrick Lewis, descendants of the Hanoverian family of Ludwig.[34]

Whatever the sympathies of the reigning monarch, however, such immigrations would have been less frequent without the existence of strong commercial links between England and northern Germany. Although these links had been firmly established since the Middle Ages (one must remember that it was the Hansa merchants who supported Holbein at the beginning of his second visit to England),[35] they became reinforced during the latter part of the eighteenth century. For England's expansion as an industrial and colonial power provided a radical boost for the sea trade and brought renewed prosperity to the ports of northern Germany. The dependence of these towns on the English trade was made cruelly obvious by the continental blockade which Napoleon imposed after his invasion of Germany in 1806, as this brought ruin to the merchants of the Baltic seaports. It was at this time that Runge's brother Daniel, a Hamburg merchant, faced bankruptcy, and the artist was forced to return to his home town of Wolgast where his father, a shipbuilder, was also in straitened circumstances.[36] Overbeck's family, too, were impoverished by these events, and his brother Hans was obliged to give up his position with the London merchants George and Morris Oppenheimer to return to his native Lübeck.[37] After the Napoleonic Wars, however, this trade not only revived, but also encouraged uncompromising independence. Indeed the relationship with England was so important to the northern states that they refused for decades to join the Prussian-dominated *Zollverein* established in the 1830s. Even after the

unification of Germany in 1870 the ports of Hamburg and Bremen remained independent, only finally being incorporated in 1888.[38]

Hamburg, the largest and most international port, was so dependent on the English trade that it was commonly referred to as 'the commission agent of England'.[39] English ships accounted for more than half of their oceanic traffic during the 1830s and completely regulated the fluctuations of their Bourse.[40] Anglophilia ran high in the city, and their admiration for the free-trade liberal merchant state expressed itself not only in the adoption of English customs and building styles that Waagen noted,[41] but also in a penchant for English literature and art. Runge might speak disparagingly of the 'effektsuchende Manier' of English artists,[42] but the merchant collectors of his acquaintance were hardly of the same opinion. Indeed the collections of engravings that provided his first introduction to the major schools of European art—that belonging to the partner of his brother, Michael Speckter—contained a large number of prints after Copley, West, Reynolds and other contemporary English history painters.[43] In view of the interest in English art, it is perhaps not surprising to find amongst Hamburg painters of the nineteenth century a strong naturalist bias, or that the Hamburg Kunsthalle today possesses the largest collection of English nineteenth-century painting on the continent.[44]

One could hardly argue the case for any corresponding influence of Hamburg on England. Nevertheless the standing of Hamburg merchants in the City of London was of sufficient importance to afford many Hamburg artists an entrée amongst English connoisseurs and patrons.[45] Sometimes, as was the case with Rudolph Lehmann,[46] these introductions were far from successful. The failure in Lehmann's case was to lead to a further seventeen years of wandering through Europe until he was able to return to England by force of an established reputation in 1867. Other artists remained despite discouraging beginnings and sought to adapt their methods to English expectations. The 'John Crome' of Hamburg, the landscape painter Siegfried Bendixen who came to settle in England in 1832,[47] appears to have suffered from the common prejudice against German practitioners of this genre. A decade later, inspired by the current vogue for the German Manner, he attempted history painting and became one of the unsuccessful contestants in the first and second Westminster Hall competitions.[48] He later tried his hand as a designer[49] and finally resorted to picture dealing.[50] A more fortunate artist was Otto Speckter who, with the help of the merchant Eduard Sieveking and the scholar Christian Wurm, was able to find a profitable outlet for his children's illustrations in England.[51]

Amongst the settlers, William C. T. Dobson, John W. Bottomley and Rudolph Lehmann all became well-known figures in late-nineteenth-century England. Yet none of them was known primarily as an exponent of German art. Dobson and Bottomley, both from English merchant families settled in Hamburg, exhibited pictures with themes from German literature and history during the 1840s. Later, however, they went their separate ways: Dobson becoming a painter of sentimental religious scenes (Plate 10), and Bottomley emulating Landseer as an animal

16

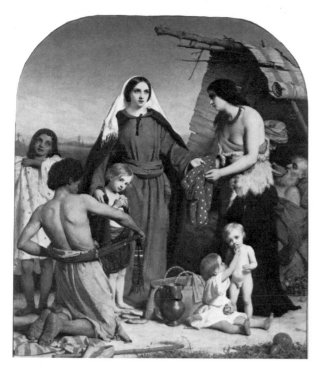

10. W. C. T. Dobson: *The Almsdeeds of Dorcas*. 1855. Oil (101 × 82). Her Majesty the Queen.

painter.[52] Lehmann, too, was not an artist who showed any sympathy for revivalist art, despite having spent a year in Munich in 1838. 'Lucky would it be for Cornelius and Kaulbach if they were only forgotten', he later wrote in his reminiscences.[53]

These links between Hamburg and England, however tenuous in themselves, do at least show how the German-born artists who continued to come to England to settle in the nineteenth century did so for reasons that had only the most distant connection with the current vogue for the German Manner. It would serve no useful purpose to extend the list, yet the very mention of such names as Hubert von Herkomer and Walter Richard Sickert are sufficient to demonstrate that this immigration did not cease in the latter part of the century.

If it is not possible to create any coherent pattern out of the cultural interrelations that sprang up around such contacts, their irregular nature did lead to some of the most unusual and intriguing associations between English and German art. As has already been mentioned, the recognition of a contemporary German style in Victorian England related most strongly to the international success of German revivalist art and art theories. Yet this essentially public art, which flourished in Rome and post-Napoleonic Germany, was the outcome of a decade of intense and highly personal activity which had resulted in the achievements of Friedrich, Runge, and the first and most intimate works of the Nazarenes themselves. This earlier and greater achievement of German Romanticism remained virtually unknown to the rest of Europe, yet it is these works that seem to present the closest analogies with the English primitivist movement that centred around Blake and the Shoreham group.

These similarities, which have been frequently commented upon in recent literature,[54] seem more to indicate the international extent of the interest in primitivism than to suggest any direct links between the individual artists. Nevertheless, in view of the nature of the present chapter, it should be pointed out that the closest associations between the circles of Blake and Palmer and their German counterparts are to be found in the personal links between the German and English trading communities.

In the case of Runge, whose designs suggest such striking visual and ideological comparisons with those of Blake,[55] the close contacts between Hamburg and England become particularly intriguing. Runge's friend and patron, the publisher and bookseller Friedrich Perthes, had close contacts with England from the 1790s. It had been the intention of Runge in 1798 to set up a bookselling business in England under Perthes' direction.[56] Of more specific interest are the activities of Henry Crabb Robinson, the Germanophile and friend of Flaxman's, who met Perthes during his stay near Hamburg in Altona between January and September 1807 when he was acting as a war correspondent for *The Times*.[57] In 1810 Robinson, who had been greatly intrigued by Blake's exhibition of 1809, wrote an article on the English artist for Perthes' periodical *Vaterlandisches Museum*.[58] Runge designed the cover for the magazine,[59] but the idea that the work of the two artists is actually brought together by this volume is a deceptive one, for the article was not published until 1811, shortly after Runge's death on 2 December 1810; and Robinson did not in fact meet Blake until 1823.[60] Furthermore, while it might seem hard to imagine that Robinson could have moved amongst such friends of Runge as Perthes and the Sievekings while he was in Altona without either having met the artist or having seen some of his works, he did not find his name memorable enough to mention it either in his diaries or in his extensive correspondence.[61]

Other connections are feasible but equally difficult to establish. One could postulate that Runge might have come across some of Blake's engraving through Perthes or his brother Daniel in the same way that he came across such English publications as Flaxman's *Odyssey* and Bewick's wood engravings.[62] Blake's engravings for Edward Young's *Night Thoughts* (1797) were circulated in Germany around 1800 and were commented upon by Goethe and Jean Paul Richter. Runge's *Return of the Sons* (Plate 11) bears a resemblance to one of Blake's designs for Stanley's translation of Bürger's *Lenore*[63] (Plate 12). Similarly, it might have been possible for Blake to have learned of Runge through Miss Flaxman and the Hare Naylors, who may have visited Perthes in Hamburg during the years 1804–6.[64] Yet if either of these artists ever did come across the other's works, he does not seem to have made a record of the occasion. Berefeld, who considers Blake's art to be 'unkonventionellen, subjektiv expressiven und grotesken Phantastereien', feels that Blake's art would have been of little interest to Runge if he had seen it.[65]

Even if Blake's imagery is more exuberant than Runge's, there remains their shared interest in nature, mysticism and the expression of their ideas through symbolical and schematic compositions and border designs. In these respects Blake was far from the 'effektsuchende Manier' that Runge found to be so objectionable in

11. P. O. Runge: *Die Heimkehr der Söhne* (The Return of the Sons). 1800. Pen and ink (44.5 × 63). Kunsthalle, Hamburg.

12. ★W. Blake: Illustration to *Leonora*, 1796.

English art, and it is perhaps appropriate that one of the reasons cited by Crabb Robinson for writing about Blake in a German periodical was that the artist's ideas and methods seemed more Germanic than English.[66]

If Robinson was no doubt referring here principally to the transcendental aspects of German Romanticism, he was also to be an agent in forging contacts between Flaxman, Blake and Palmer and certain German artists and connoisseurs interested in mediaevalism. Robinson's most important acquaintance in this respect was the Elberfeld-born merchant Charles Aders (1780–1846), who was the leading partner in the London import-export firm of Aders and Jameson from 1806 to 1833.

Robinson also first came across Aders during his stay in Altona of 1807.[67] Aders, however, was principally active at this time in Frankfurt, and his cultural connections were with those Rhineland artists, writers and collectors, such as Brentano, the Schlegels and the Boisserée brothers, who pioneered a revival of interest in Northern mediaeval art. Even after he had settled in England permanently in 1811 Aders kept close contacts with his Rhineland acquaintances. He travelled extensively on business and maintained a summer residence at Bad Godesburg near Bonn. It was here that Wordsworth and Coleridge met August Wilhelm Schlegel,[68] and, indeed, Aders's interest in German art and literature made him a crucial figure to all who shared his concern. At the same time his German connections encouraged him to provide an open house for all visiting Germans of literary or artistic importance. Robinson, who shared his interests so completely, kept in close contact with him from 1811 to 1838 (the year in which the final failure of his business caused Aders to retire to Florence), and it is largely through Robinson's diaries that Aders's activities can now be traced.

While Aders's inclinations appear to have been primarily literary, he began in the years following the Napoleonic Wars to collect pictures. His collection showed a taste for Northern mediaeval art similar to that which had sprung up in Germany. His interest in this direction appears to have been stimulated not only by his contacts in Germany, but also by his liaison—and eventual marriage in 1820—with Eliza Smith, an amateur painter and daughter of John Raphael Smith. Having previously lived in Frankfurt, where she had been married to a German musician, Mrs Aders shared the German enthusiasm and once astounded Robinson by openly preferring the art of the Netherlands to that of France and Italy.[69]

Aders appears to have acquired much of his collection during his visits to the Rhineland. He was in contact with the Boisserée brothers in Cologne,[70] and by 1818 was sufficiently informed about the collections there to provide Robinson with a comprehensive list for his tour of the Rhineland in that year.[71] Like these collectors, Aders profited from the large number of ancient paintings that became available as a result of the upheavals of this time, in particular the temporary closure of religious institutions after the French occupations of the Rhineland in 1806. He seems to have assembled his collection with remarkable rapidity, since the first record of his activities in this direction occurs as late as January 1817, when Robinson took his friend Collier to Aders's house in Euston Square to admire a reputed Dürer.

13. J. Götzenberger: *The Ballad of Chevy Chase*, 1862. Watercolour design for a fresco (26.8 × 35.6). National-Galerie, Sammlung der Zeichnungen, Berlin.

Despite his interest, Aders does not appear to have extended his collection to include works by contemporary German revivalists. Certainly none appear in the sales of his collection in the 1830s.[72]

Nevertheless, if Aders's collection was more important for spreading the appreciation of Northern primitives in England than for bringing an acquaintance with contemporary German art, he was certainly responsible for introducing a number of German artists to their English counterparts. From 1821 he held open house every Wednesday for the viewing of his collection, and was visited by many Germans interested in the arts who came to London: notably the critic Ludwig Schorn, editor of the influential *Kunstblatt*, the art critic J. V. Adrian, the architect Schinkel,[73] and the painter J. D. Passavant.[74] It was at Aders's house, too, that the celebrated meeting between Blake and the young pupil of Cornelius, Jacob Götzenberger, took place in 1827.[75]

Götzenberger, who had worked with Cornelius on the Glypthothek frescoes in Munich and who was soon to be undertaking murals of his own in the Aula of Bonn University,[76] was far from being an artist of major importance. Nevertheless his visit is of interest since he was the first painter from Nazarene circles to meet contemporary artists working in England.[77] His visit, moreover, appears to have aroused considerable interest. Lawrence, who had admired contemporary German art on his continental tour of 1819 and possessed Overbeck's cartoon for the *Seven Lean Years* in the Casa Bartholdi,[78] described him in a letter to John Frederick Lewis as a 'young man of considerable genius'.[79] A bust of him by the fashionable portrait sculptor C. Moore was even exhibited at the Academy in the year of his visit to England, and he was described in the catalogue as a 'Distinguished young German painter'.[80] There is no record of Blake or Palmer, whom he also met,[81] having seen any works by Götzenberger. However, he certainly had examples of his art with him, for Lawrence mentions drawings by him 'In the purest taste, yet with equal

21

originality and power'.[82] If these resembled those of his master Cornelius, they would certainly have aroused the admiration of Flaxman.[83] However, the examples that survive from Mrs Aders's album[84] and the later designs for *Chevy Chase*[85] (Plate 13) reveal a more flaccid manner.

The reasons for Götzenberger's visit to England are not clear. If he was in search of commissions he appears to have met with little success. Two years later, however, when working in Rome, he was commissioned by Crabb Robinson to design an illustration to Faust. The delivery of this work was delayed by his activities in Bonn,[86] for Götzenberger was soon fully employed as a mural painter in his own right. It was in this role that he eventually returned to England. Accompanying Cornelius to this country in 1841, he was active in the 1850s and 1860s working for the second Earl of Ellesmere at Bridgewater House and for the Duke of Northumberland at Alnwick.[87] While the Bridgewater murals are in a Raphaelesque mode, the Alnwick paintings have a Biedermeier prettiness reminiscent of Schwind. There fairy-tale interpretations of Northumberland ballads may well have affected William Bell Scott, particularly in his *King's Quair* murals at Penkill.[88]

The differing outcomes of Götzenberger's first and later visits epitomize the change in appreciation of German art. Meanwhile Aders, whose collection had never impressed more than a small if highly significant band of devotees, began to run into financial difficulties. After 1830 he began to sell off his collection. Already when the Frankfurt artist J. D. Passavant visited it in 1832 it was in decline,[89] and when Waagen came in 1837 he was just in time to witness it before its dispersal.[90] Taste had not caught up with Aders, and when he held auctions of his works they fetched absurdly low prices.

Previously an offer of the whole collection to the National Gallery had been turned down. Since that time sixteen of his pictures have arrived in that collection, mainly through J. H. Green, the friend of Coleridge and patron of Dyce, who seems to have been one of the few English purchasers of Aders's pictures.[91] Meanwhile it was not until Prince Albert purchased the Oettingen-Wallerstein collection in 1848 that the country again possessed an extensive collection of Northern primitives.

While Aders certainly had the largest collection of Northern primitives in England, there were others who took a more modest interest in the art. There was a reappraisal of the graphic work of Dürer, the 'gothic' antipode of eighteenth-century criticism whose 'wonderful use of line' became an object of praise in Blake's *Descriptive Catalogue* of 1809. William Young Ottley devoted a whole chapter to Dürer in his *Inquiry into the History of Engraving*,[92] and J. T. James published a book on Flemish, Dutch and German art in 1822.[93] Of more general interest was Ackermann's version of Strixner's lithographs after the *Gebetbuch* of Dürer which was published in 1817.[94] Furthermore, there was also the antiquarian interest in collecting Northern primitives, which has been pointed out by Reitlinger and Cooper and which is epitomized by the activities of Francis Douce.[95]

Despite this it still seems rather strange to read Sulpiz Boisserée complaining in 1818 of the English collectors who were despoiling Germany of its early treasures.[96]

Possibly he had particularly in mind Edward Solly, the English timber merchant living in Berlin who was then building up his remarkable collection of over 3000 items which included a large number of early German works. Boisserée need not have been so anxious, however, for in 1821 Solly sold his entire collection to the Prussian Government, who used it to form the nucleus of the Berlin Museum. Indeed it has been suggested that Solly may have acquired his German paintings in order to make his whole collection more attractive to the Prussian Government. In later life, when he returned to England, he certainly built up no collection of Northern primitives, and professed to be interested only in the Raphaelesque. He did, however, make an appearance at the 1835 Aders sale to buy one of the finest works in the collection, Dieric Bouts's *Portrait of a Man*.[97] But despite this it would appear that the Englishman who had owned the most Northern primitives exercised no influence towards an appreciation of this art on his fellow countrymen.

LITERATURE AND THE BOOK TRADE

The activities of connoisseurs and collectors, whether regal or mercantile, may have forged many interesting contacts with Germany, but they did not lead to a general interest in or awareness of a contemporary German style. To a large extent the first sense of a national art was preceded by an interest in the dramatic revival of German literature during the late eighteenth century.[98] This phenomenon in itself focused attention upon a self-consciously German culture, and many of the most popular German works—in particular Bürger's *Lenore*, La Motte Fouqué's *Undine* and Goethe's *Faust*—provided a rich fund of illustrative material for English artists, ranging from Blake and Fuseli to Maclise and Rossetti.[99] At the same time the enthusiasm for German literature also provided one of the earliest occasions for German revivalist art to become known in this country, through the illustrations and engravings that accompanied the works that were sold by London's foreign booksellers.

These booksellers themselves ranged from entrepreneurs to devoted enthusiasts of German culture; the former tending to meet with greater commercial success than the latter. Paramount amongst these was the indefatigable bookseller, publisher and inventor Rudolph Ackermann. Ackermann, born at Stolberg, Saxony, in 1764, came to England in 1785 and set up shop in the Strand ten years later. His major publishing ventures, directed towards the lucrative fields of topography and fashion,[100] had little to do with his native country. However, he remained a firm patriot, and distinguished himself after the battle of Leipzig in 1814 by organizing relief funds for the victims and a banquet in London to fête its heroes—who included the artist Friedrich Olivier.[101]

After the Napoleonic Wars, Ackermann re-established contacts with his native country. But now his main motives were commercial. Recognizing the value of the new printing technique of lithography, which its inventor, Senefelder, had unsuccessfully attempted to establish in England in 1798,[102] he made a visit to Munich in 1817 to study the method in its place of origin.[103] On his return he began to use it successfully in his own publications, demonstrating its commercial viability

14. Page from *Albert Dürer's Prayer Book*. Lithograph, published by R. Ackerman, 1817.

in a way that soon made it attractive to others.[104] While the pioneering of lithography did not directly affect the fortunes of German art in England, it did have one incidental consequence; for it was the need to have a technical *tour de force* as a demonstration piece that induced Ackermann to produce a version of Dürer's calligraphic *Gebetbuch*[105] (Plate 14). This work, which was rather more assiduously produced than Strixner's version, attracted appreciation as a connoisseur's item.[106] And, if it did not lead to the outburst of *Randzeichnungen* that followed Strixner's production in Germany, [107] it did enter the collections of a number of English artists, in particular Sir Thomas Lawrence[108] and Richard Cosway.[109]

Ackermann also maintained connections with his native Saxony. He was a regular exhibitor at the important Leipzig book fair and maintained a frequent correspondence with the antiquarian, publisher and librarian to the Saxon royal family, C. A. Boettiger. Boettiger, like Ackermann, ran an art periodical, in his case the *Artistisches Notizenblatt*,[110] and by mutual agreement they advertised each other's wares. Thus, while Boettiger ran features recommending Ackermann's aquatints, topographical views and watercolour paints, Ackermann gave a good press to such protégés of Boettiger as F. A. M. Retzsch in his *Repository of the Fine*

Arts.[111] But despite these activities Ackermann was too sound a businessman to take risks on German art, and he never attempted to pioneer any of the more advanced works of his countrymen. Characteristically, his main innovation from Germany was the fashion for producing small ladies' annuals, such as the *Keepsake* and *Forget-Me-Not*, which were based on the German *Taschenbücher*.[112]

Meanwhile other dealers handled the main part of the trade of importing German books. By 1800 the craze for German literature had already spread sufficiently for a 'monthly repository of the literature of Germany', the *German Museum*, to be published in London.[113] Even Boosey's, a firm traditionally associated with dealing in French books,[114] were soon to be offering German books as more than half of their stock,[115] while some booksellers, such as Henry Escher, appear to have specialized in German books almost exclusively.[116]

During the next few years this trade appears to have declined, owing partly to political reasons and partly to a change in taste. The English public had begun to tire of the German pre-Romantic and *Sturm und Drang* authors like Wieland, Klopstock and Kotzebue, and were not yet fully aware of the generation of Goethe and Schiller, or of the Romantic poets and writers.[117] After 1812, however, the situation revived. Escher by this time seems to have gone out of business, while Boosey had been overtaken in the German trade by Black, Young and Young, and J. H. Bohte. By 1819 both of these firms had offices at Leipzig during the fair, and Bohte, the more enterprising of the two, had a permanent contact there throughout the year.[118] By 1814 Bohte had already set up a German reading room in London, where German literary periodicals could be found.[119] In the same year he was offering a stock comprising 1400 German titles. By 1819, when he had been appointed foreign bookseller to the King, his whole stock had risen to 6358 titles, of which the German books accounted for 2458.[120] From this time until his death in 1824 he was the leading German bookseller in London, and his services were widely appreciated. After his death the Germanophile John Hawkins wrote to Boettiger,

> He was intelligent and indefatigable in his profession. His shop is the first in that line . . . there is no other German bookseller here who enjoys much credit. The dealers in German books being mostly German bookbinders; low-minded and imposing.[121]

Public tribute was paid by no less a personage than A. W. Schlegel, who wrote in the introduction of the 1825 catalogue that Bohte's death was 'a real loss to literary Germany as well as to England'.[122] Despite such distinguished support, however, the firm could not survive its founder's death, and on 29 June 1826 it went into liquidation. Outstanding orders and the position of foreign bookseller to the King were granted to the old Strasbourg firm of Treuttel and Wurz, who had previously specialized in French books.[123]

Bohte's principal business had been in German literature and philosophy. However, he also took an interest in the fine arts, particularly in the illustrated books that had become so popular amongst the German Romantics. By 1819 his list included the Riepenhausens' defence of early Italian art, *Geschichte der Malerei in*

15. *P. von Cornelius: *Valentins Tod* (Death of Valentin). Plate from *Bilder zu Goethes Faust*, Frankfurt-am-Main, 1816. Engraving by F. Ruscheweyh.

16. P. von Cornelius: *Chriemhild discovering the Body of Siegfried*. Pencil. Städelsches Kunstinstitut, Frankfurt-am-Main.

Italien (1810), as well as Cornelius's two major book productions, the illustrations to *Faust* (Plate 15) and the *Nibelungenlied* (Plate 16). He appears to have had little success with these, although Cornelius's *Faust* became sufficiently well known to be attacked in the *London Magazine* of 1820[124] and to receive the praise of Flaxman.[125] However, if the English public was as yet not prepared to accept works that reminded them too much of the 'dry, Gothic, matter-of-fact work of old Dürer',[126] they proved more amenable to those German illustrators who combined Germanic themes with an imitation of Flaxman's use of outline. Of these Bohte stocked Schulze's *Undine* (1817), Ludwig Schnorr's *Undine* (1817) and, most successfully of all, Retzsch's *Faust*. Indeed it was due to Bohte's propaganda that this artist was to become the best-selling German artist in England.[127]

Black, Bohte, and Boosey also all offered a miscellany of German prints; as indeed did other non-specialist firms. Sometimes the names that occur are highly intriguing. One would give much to know precisely which of C. W. Kolbe's prints were on sale at Colnaghi's in 1821.[128] If they were any of his more fantastic renderings of trees and foliage they might well have been of interest to the young Samuel Palmer; for these works of Kolbe's show a magnification of vegetable forms

17. *E. Neureuther: *Der Fischer*. From *Randzeichnungen zu Goethes Balladen*, Munich, 1828. Lithograph.

18. *A. Rethel: *Die Sage vom Bürgermeister von Köln* (The Tale of the Burgermaster of Cologne). From *Rheinischen Sagenkreis*, Frankfurt-am-Main, 1835. Lithograph.

that bears a certain resemblance to the English artist's treatment of such features in his Shoreham pictures. However, one rarely encounters the name of a major German artist in these lists, and the main trade here seems to have been topographical views and portraits of notable Germans. The real success in German prints began a number of years later, when the work of the Nazarenes was already attracting international interest, and their illustration style had tempered Düreresque calligraphy with a more flowing Italianate manner.

Neureuther's charming *tour de force, Randzeichnungen zu Goethe's Balladen* (Plate 17), was probably the first of these second-generation works to win approval in this country; for it was apparently well known before Mrs Jameson's visit to Munich in 1833.[129] By 1836 the Frankfurt publisher Charles Jügel, who had ventured to bring out a London edition of Rethel's *Rhenischen Sagenkreis*[130] (Plate 18), felt there was a large enough market to open a special London department for German prints and engravings—although his stock was still largely topography and portraiture.[131] In 1839 he was followed by George Nott[132] and Black and Armstrong—a development of Black, Young and Young.[133] Two more sellers of German prints, Williams and Norgate, and Hering and Remington, started to advertise their businesses in the *Art Union* in 1842,[134] the latter proudly announcing the

establishment of their 'German Repository' at 9 Newman Street with the claim that, 'If our own publishers will not, the Germans *will* supply us with works of loftier aim than portraits of dogs, birds and monkeys.'

Hering and Remington appear indeed to have been the firm most committed to German art. Nor did they confine their activities to selling prints. They also attempted to attract English subscribers to a number of German *Kunstvereine*. Despite the enthusiasm of the *Athenaeum* and the *Art Union*, however, this attempt does not appear to have been very successful.[135]

To judge by the later accounts of Holman Hunt and Madox Brown, these print shops were the most important single means by which German art reached young English artists and the general public during the 1840s.[136] However, unlike Bohte and Ackermann, they were responding to a demand that had already begun to emerge. The people who had engendered this market were those travellers and connoisseurs who had been encountering German art and theories during the previous two decades, and it is their activities and response which must now be considered.

CONTACTS ABROAD
ROME

Rome was undoubtedly the centre where an international awareness of the contemporary German revivalist style first occurred. This is hardly surprising, since the international assemblage of artists and connoisseurs allowed a more rapid spread of ideas and styles between different nationalities there than elsewhere. Just as Flaxman owed his immediate success to publication of his outlines in Rome, so the Nazarenes were to owe their European reputation to their presence in Rome during the years following the Napoleonic Wars. Although the Nazarenes' reasons for settling in Rome were essentially historical, propaganda also played a large part in their objectives, especially after 1812, when they were joined by Cornelius. Even before their art was widely known, their mediaevalizing dress and appearance were attracting attention, and indeed it was these that first gained them the name 'Nazareni' around 1813.[137]

Their presence and work were to strike the English with peculiar force; for between the years 1806 and 1815 the English had been totally absent from the city on account of the French occupation. Thus when they returned they found Rome in the grips of a new vogue which had previously been unknown to them.

If the art and appearance of the Nazarenes were unfamiliar to the English, they were more familiar with the interest in mediaeval art and primitivism which had inspired it. During the 1790s English artists and connoisseurs had played an equal role with those of other countries in the rediscovery of the art of mediaeval Italy. The English enthusiast William Young Ottley had begun his studies in collaboration with the Netherlander Humbert de Superville, and it was in this milieu that Flaxman had studied such mediaeval works as the reliefs of Orvieto Cathedral.[138]

Many English patrons had also been sympathetic to German artists whose interests

19. J. A. Koch:
*Landschaft mit
Regenbogen* (Landscape
with a Rainbow).
1815. Oil (190 × 171).
Neue Pinakothek,
Munich.

20. (far right) J. A.
Koch: *Dante and the
Three Women; Dante
and Virgil at the Gate of
Hell. c.* 1801/2.
Designs for Dante's
Divine Comedy. Pen
and pencil (25.4 × 37).
Hessisches
Landesmuseum,
Darmstadt.

leant towards the archaic. The exhibition held by Carstens of his works in Rome in 1795 is reputed to have attracted particular attention from the English.[139] Carstens's follower, Joseph Anton Koch, later to be an acquaintance of the Nazarenes, attracted the patronage of the English maecenas, the Earl Bishop Lord Bristol.[140] Through the admiration of another Englishman, the clergyman George Nott, he subsequently received a number of commissions for landscapes, including a version of his *Landscape with a Rainbow*[141] (Plate 19). Indeed the enthusiasm from English patrons was so great that in 1812, when he decided to leave Rome as a consequence of the French occupation, he boasted that he knew enough patrons to set up practice in England.[142] He was to remain patronized by the English for the rest of his life.[143] For Nott, Koch produced versions of his 1801–2 designs to the *Divine Comedy* (Plate 20), which were intended to be more genuinely mediaeval in character than those of Flaxman.[144] These were actually brought to England by Nott, and were eventually auctioned after his death in Winchester.[145] Although Koch's plan to issue a volume of Dante illustrations failed, a number of the designs were engraved. It has been suggested that these may have been an influence on Blake's Dante series, although such a suggestion must remain hypothetical.[146]

The almost total disappearance of the English from Rome after the French invasion of 1798 left the Germans the most prominent Northern community in Rome. The followers of Carstens were centred on the Villa Malta, residence of the

distinguished Prussian consul, Wilhelm von Humboldt,[147] though a more informal meeting place was provided by the Café Greco, 'the resort of the northern barbarians for so many decades'.[148] The successful exhibition of Schick's *Sacrifice of Noah* (Plate 21) in the Pantheon in 1805[149] assured the reputation of this group, as well as gained the Germans renown as the revivers of Christian art over a decade before the Bartholdi frescoes.[150] Two artists, the Englishman George Augustus Wallis, and the American Washington Allston, provided the English with some intimations of this earlier archaizing movement. Wallis, who arrived in Rome in 1794 and had been a friend of Carstens, maintained his association with the Germans through Schick, who shared lodgings with him and who later married his daughter.[151] His artistic interests were nearer to those of Koch, however, and like the Tyrolean artist he concentrated on the revival of the 'heroic landscape'. Following his return to England in 1806, he exhibited a series of Alpine scenes and religious landscapes at the Royal Academy, works which sound from the titles thematically similar to the subjects favoured by Koch.[152] The construction of Wallis's surviving work from this period, such as the *Ave Maria* (Plate 22) in the Thorwaldsen Museum, Copenhagen,[153] also shows the influence of the rigorous landscape composition that Koch derived from Poussin; but Wallis's technique remained closer to the English use of bravura and glazing, which he apparently learned from Allston.[154]

31

In England Wallis appears to have met with little success, and he returned to the continent as soon as he could. In 1808 he was in Spain, and by 1813 he was back in Italy. His real impact was in Germany. Passing through Heidelberg in 1812, he painted a number of scenes, including a view of Heidelberg Castle[155] which entered the local collection of B. Fries. Both the 'heroic' design and the fluid technique of these works were to have a formative effect upon the younger Heidelberg landscape painters Ernst Fries and Carl Rottmann.[156]

Although he occasionally sent works to England for exhibition,[157] Wallis stayed in Italy. To the last he remained devoted to the Carstens circle, and his association of art and religion made him pessimistic about the state of art in England. In 1842, when like the Aders he had taken refuge in Florence, he wrote to Schick's son giving a summary of his views:

German artists are distinguished by their profundity. Our dear, deep, lamented Schick had a fineness of feeling quite unlike that of the Italian masters. Carstens and Wächter were two apostles of art. Their religion prohibits English artists from decorating churches—that area which has always been open to the Italians. In England, therefore, only the painting of portraits and small domestic scenes is fully at home.[158]

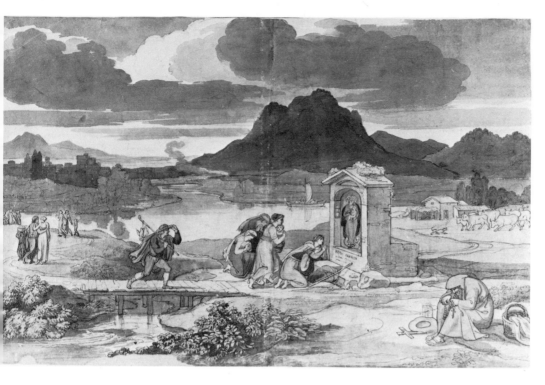

21. (below left)
C. G. Schick: *Das Opfer Noahs* (Noah's Sacrifice). 1804–5. Oil (250 × 327). Staatsgalerie, Stuttgart.
22. (left) G. A. Wallis: *Ave Maria*. Pen, pencil, sepia and watercolour (53 × 80). Thorwaldsens Museum, Copenhagen.
23. (below) F. Overbeck: *Der Verkauf Josephs* (Joseph being sold by his Brethren). 1816–17. Fresco (243 × 304). Formerly in Casa Bartholdi, Rome. National-Galerie, Berlin.

As it happens, Wallis wrote these words at a time when a concerted effort was being made to revive both religious and monumental art in England; but his attitude no doubt reflects a long-standing bitterness at the lack of enthusiasm for his work on the part of his countrymen.

This was hardly a complaint that could have been raised by Washington Allston. Both before and after his sojourn in Rome he was well received in London.[159] Arriving in Rome in 1805, he soon entered the circle of the Villa Malta. While the fame of the 'American Titian'[160] was largely based on the glazing technique that he had learned from studying the works of Reynolds, he in his turn benefited, as Wallis had done, from the comprehensive and rigorous designs of Koch. While his much admired *Diana in the Chase*[161] shows him responding most closely to the revival of interest in Poussin, such historical subjects as *The Dead Man Revived*[162] and *Christ Healing the Sick*[163] are more primitivistic in their style. This was indeed recognized at the time. When *The Dead Man Revived* was exhibited in London at the British Institution in 1813 (where it won a premium of 200 guineas), West exclaimed: 'Why sir, this reminds me of the fifteenth century; you have been studying in the highest schools of art.'[164]

During this second stay in London, which lasted from 1811 to 1818, Allston also got to know the works of the Northern primitives after being introduced to Aders by his old Roman companion Coleridge.[165] In later years he was to retain his enthusiasm for the primitive style, and when Raczynski sent him a copy of his *Histoire de l'art modern en Allemagne* in 1842, he was full of praise for the 'purity of taste' of Cornelius, Kaulbach, Schnorr and Bendemann.[166]

Although there had therefore been some knowledge and sympathy in England for those German artists who were developing towards an archaizing style, the position of the Nazarenes presented a far more radical phenomenon. While Koch, Schick, and even the Riepenhausen brothers (who were active in Rome from 1805) showed mediaevalizing tendencies in their art, they had like Allston never fully abandoned the conventions of neoclassical history painting. They did not contribute to an aesthetic in which the idea expressed in a painting actually determines its technique, nor had they taken their archaisms to the extent of trying to recreate the life-style of the Middle Ages. Finally, they did not possess that single-mindedness that enabled the Nazarenes to work so effectively as a group, and which was so essential for their success. This communal aim not only made them conspicuous through their life-style and clothes, but also enabled them to revive the concept of the artist–craftsman, and to work in harmonious co-operation on their first major commission—the frescoes (Plate 23) for the Prussian consul general, Salomon Bartholdi.

It was these frescoes, created in a room that Bartholdi used for social functions, that made their work acceptable to the fashionable world, and which led to commissions both from the Vatican and from the Italian nobleman the Marchese Massimo. From the start, their success seemed to rest on their image and their intentions. In the context of the religious restoration that was then sweeping Europe, their pietism found ready approval. Even their visual archaism could be condoned

when it veered towards the gentler of the early masters, the masters whose work could be seen in one way or another to prefigure Raphael. For even their most ardent defender, Friedrich Schlegel, judged them as much on potential as on achievement.

English accounts of the works of the Nazarenes revolved around the question of their intentions and their achievements. The very first English account to be published, sent to the *Annals of the Fine Arts* in January 1817 when the Bartholdi frescoes had barely been completed, represented the sympathetic but slightly hesitant viewpoint that was to characterize so much subsequent English criticism.[167] The reviewer, the painter Seymour Kirkup, begins by approving the Italianate tendencies in their archaism, but deploring the Germanic: 'At best they imitate Masaccio, at worst Albert Dürer.' Similarly, their noble intentions and sense of design are appreciated, while their bright local colours and lack of chiaroscuro are deplored. Above all it is their conception that wins them praise. The Germans, says the review, 'are determined to restore the *mind* of art', even if they are deficient in 'colour and effect'. Finally he sums up his dilemma with a paradox that was to become familiar amongst English artists: 'When I first saw some of their works I thought them without merit; I now think they have the highest, but still not what one would follow.'[168]

The notoriety that the Bartholdi frescoes achieved must have made them known to all visitors to Rome who took an interest in contemporary art. There certainly appears to have been little difficulty in gaining admission to them, since Bartholdi

24. J. Schnorr von Carolsfeld: *Die Hochzeit zu Kana* (The Marriage at Cana). 1819. Oil (140 × 210). Kunsthalle, Hamburg.

25. F. Overbeck: *Die sieben mageren Jahren* (The Seven Lean Years). 1816–17. Fresco (150 × 480). Formerly in Casa Bartholdi, Rome. National-Galerie, Berlin.

was always anxious to show off the work of his protégés. Indeed in his letters to his sister Henrietta Bartholdi he makes frequent reference to visitors, many of whom in the post-Napoleonic climate of Anglo-Prussian achievement were English. Mostly, as might be expected, these came from diplomatic circles, and included Lord Aberdeen, Lord Westmorland and the Duke of Sutherland,[169] but there were also influential connoisseurs like Thomas Hope.[170] On 21 January 1817 Bartholdi recorded with pride what may have been the first English acquisition of a Nazarene painting, the purchase of a *Flight into Egypt* by Cornelius for forty Napoleons.[171] Two years later, in May 1819, he discovered a particularly enthusiastic visitor, Sir Thomas Lawrence, who not only was greatly pleased with the frescoes himself, but also returned with a number of other Englishmen to see them again.[172]

By this time, however, the Nazarenes had reached an even wider public through the exhibition of works by German artists held in the Hanoverian Embassy, the Palazzo Caffarelli, in the spring of 1819. While failing to arouse the enthusiasm of the visiting Austrian Emperor, in whose honour it had been organized, it was this exhibition that attracted the attention of the Crown Prince Ludwig of Bavaria, thus leading to momentous opportunities for Cornelius and his followers in Munich. English interest was of minimal importance in comparison to such events, yet there were a number of interesting purchases. The *Marriage at Cana* (Plate 24) by Julius Schnorr von Carolsfeld, an artist who always seems to have had a special appeal for English collectors,[173] was acquired by the Scottish collector and diplomat William Cathcart.[174] Overbeck's *Seven Lean Years*, a cartoon for a lunette in the Casa Bartholdi (Plate 25), was bought by John Scott, then in Rome collecting material for the *London Magazine* which he was about to edit.[175] Schnorr's painting disappeared to Scotland almost immediately,[176] but Overbeck's cartoon presumably returned with Scott to London in 1820. In any case, Scott's appreciation of the Nazarenes is highly significant, for it does much to explain the coverage that was given to German art in the *London Magazine* during his brief editorship. While in Rome, Scott also enlisted Eastlake as a contributor. Eastlake who had by this time a detailed knowledge of the activities and aims of the Nazarenes might well have first introduced Scott to their art. Nevertheless his article on contemporary art in Rome that appeared in the *London Magazine* in 1820[177] is far less sympathetic to the

Nazarenes than a detailed description of the Bartholdi frescoes that appeared in the following issue. Possibly the latter was written by Scott himself.[178]

In 1821 Scott died tragically in a duel, the result of his defending the poetry of Keats against the vicious attacks of Lockhart.[179] After his death the Overbeck cartoon was acquired by Lawrence. Since his viewing of the Bartholdi frescoes, Lawrence's admiration for contemporary German art remained undiminished: 'Germany ought to abound in patrons, since I know it is rich in talent of the highest order',[180] he wrote to John Frederick Lewis in the same letter in which he had expressed such admiration for Götzenberger's genius. In his last address to the Academy, too, he apparently found space to refer to Overbeck.[181]

In view of his position and influence in the London art world, Lawrence's enthusiasm for Nazarene art takes on a peculiar interest. Possibly there lay behind it some regret that he had himself not followed the career of a history painter. At the same time, there can hardly be any question of stylistic influence in his case, and his appreciation of an art so different from his own bears witness most to his proverbial fair-mindedness and catholicism of taste. Whatever the reasons, however, his collection is notable for containing the largest quantity of contemporary German art to be found in London in the 1820s. Apart from the Overbeck cartoon and some topographical works by Catel, he also possessed a number of German illustrated books, including two copies of Retzsch's *Faust*, the same artist's *Fridolin* and *Hamlet*, Schultze's *Undine* and Cornelius's *Faust*.[182]

Apart from such illustrious visitors, the Nazarenes also found patrons amongst the large contingent of tourists who flooded to Rome in increasing numbers after 1815. While there were few places where contemporary art was on display in Rome in the 1820s, most artists kept an open studio to which visitors could come and inspect works. Such a process required potential patrons to have some means of contacting artists, and this would usually be through personal acquaintances or occasionally through obliging galleries.[183] By this time, however, an even more anonymous kind of traveller was beginning to appear, and for these the main cicerone was the guidebook. Such works as Mariana Stark's *Travels on the Continent* list and occasionally give addresses of artists then in fashion.[184] For the most part the art that was sold by these means was a superior form of souvenir trade— such as pretty Italian views by Kaisermann, Dessoulavi and Catel,[185] and the genre scenes of peasants and banditti that occupied Penry Williams and Eastlake. The English, whose philistinism was often the occasion of satire,[186] appear to have been amongst the principal clients in this trade, and it is quite within the pattern of English patronage in Rome that the most extensive undertaking should have been the series of landscape views commissioned by the Duchess of Devonshire from such artists as Gmelin, Catel, Voogd and Eastlake for an illustrated edition of the *Aeniad*.[187]

Despite the vogue of the Nazarenes during the 1820s, English patronage of their work appears to have been on a modest scale. From the account of Schnorr, English patrons appear to have taken most interest in Nazarene drawings[188]—a preference that certainly fitted in with English critical attitudes. Occasionally a more personal involvement emerged, as when Lady Crafford had herself portrayed by Carl Vogel

von Vogelstein as St Cecilia[189]—an event that has parallels with the fictitious Casaubon, whom George Eliot describes in *Middlemarch* as portrayed by a German artist as St Thomas Aquinas.[190]

One striking exception to this tendency is the large number of commissions that the Riepenhausen brothers received from English sources around 1820. Possibly the less extreme archaism of these forerunners of the Nazarenes made their work more acceptable to the English. If this was the case, however, it does not seem to have been reflected in the opinions of English critics, for the Riepenhausens are rarely mentioned by English commentators. Furthermore the Riepenhausens were hardly ever, with the exception of the Earl of Shrewsbury,[191] purchased by patrons with pretensions to an advanced taste. In view of this, a more practical reason for this unusual English patronage seems likely, one that again reflects the highly personal nature of art patronage in Rome during this period. In this case it was the Hanoverian link that appears to have been paramount. Since the Reformation there had been no diplomatic representation in the Holy See from Britain—a deficiency that was only remedied in 1848 with the appointment of Lord Minto as ambassador to Rome.[192] Consequently, in the early nineteenth century all representation for Englishmen took place through the ambassador from Hanover. From 1817 to 1842 August Kestner, the scholar, amateur artist and close supporter of the revival of 'Christian' art, was a diplomat in the Hanoverian embassy.[193] From his student days in Göttingen he had been a firm admirer of his fellow Hanoverians, Franz and Johann Riepenhausen. Indeed it was he who showed the young Overbeck outline drawings after early masters by these artists in 1805, an incident that he later claimed first stimulated Overbeck to take an interest in revivalist art.[194] Although a friend of Overbeck's, Kestner was less intimate with him after Overbeck's conversion to Catholicism in 1813,[195] and this situation appears to have been compounded by a certain sense of rivalry when the success of the Bartholdi frescoes led Bartholdi to boast of his 'Prussian' artists.[196] In any case Kestner seems to have been assiduous in drawing the attention of English visitors to the existence of the Riepenhausen brothers, and his notebooks contain many references to the English visitors whom he led to their studio. On 17 September 1817 he was triumphantly reporting to his sister that the Riepenhausens had even more commissions than Cornelius and Overbeck.[197] It was in this year, in fact, that they painted *Suffer Little Children to Come unto Me* for the Duchess of Devonshire.[198] In 1819 a 'Miss Mellish' acquired a version of their illustration (Plate 26) of Schiller's poem 'Das Mädchen aus der Fremde',[199] and in 1822 the scholar Sir William Drummond bought a scene from the life of Socrates.[200] They also worked for Lord Bristol.[201]

Besides this, Kestner managed to obtain royal patronage for them. In 1822 the Duke of Cambridge, son of George III and at that time Regent of Hanover, commissioned *St Elizabeth of Hungary*[202] (Plate 27), and in 1826 the Riepenhausens were commissioned by George IV to paint a scene from the life of Barbarossa for the Guelph Hall in Hanover.[203]

Despite Kestner's efforts, however, there was no doubt that the Nazarenes rather than the Riepenhausen brothers were the centre of revivalist art in Rome. Whatever

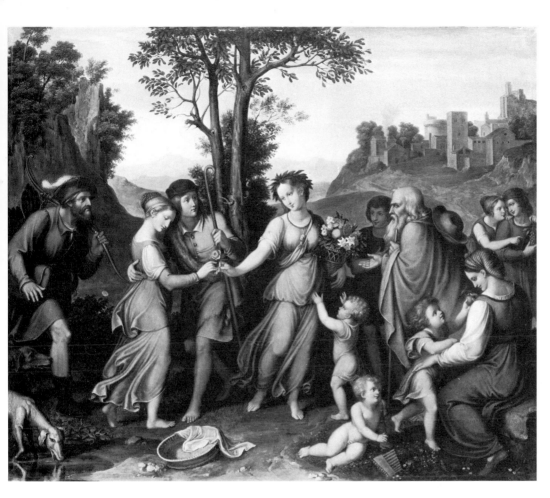

26. F. & J.
Riepenhausen: *Das
Mädchen aus der Fremde*
(The Maiden from the
Distant Land).
c. 1816–17. Oil
(66.5 × 73). Kunsthalle,
Karlsruhe.

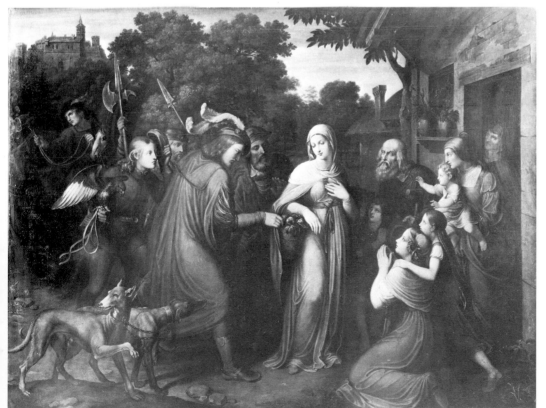

27. F. & J.
Riepenhausen: *Das
Rosenwunder der
Heiligen Elisabeth* (The
Rose Miracle of St
Elizabeth of
Hungary). 1822. Oil
(199.5 × 260.5). Georg
Schäfer Collection,
Schweinfurt.

the pattern of English patronage, it was the Nazarenes who were to have the most profound repercussions upon the style of generations of English painters visiting Rome from Eastlake to Madox Brown, and whose attitudes were to be so critical for English history painting during the 1840s. The history of these artists' reactions belongs to Chapter IV, yet it must be remembered here how important the position of those English artists living in Rome was for introducing Nazarene art to their fellow countrymen. The most influential figures were undoubtedly Eastlake, who was centred in Rome from 1816 to 1830, and Joseph Severn, who lived in Rome from 1820 to 1841 and again from 1850 when he returned to occupy the position of British Consul to the Holy See.[204] Even artists who had no particular affinities with the Nazarenes were brought into close contact with the Germans' work through such agencies. It was no doubt through his friendship with Eastlake that Turner learned of the circle of artists listed in his Roman notebook of 1819.[205]

Similarly, Wilkie, when making his European tour in 1826, inspected both the Casa Bartholdi and the Casino Massimo. Wilkie was himself leaning towards history painting at this point in his career and therefore investigated these modern murals with great care. However, while admitting their 'great cleverness and research', he felt their style was too archaic ever to attract widespread popularity.

> Their style, wanting so much modern embellishment, cannot now be popular, and can neither be admired nor followed, as Pietro Perugino and Ghirlandaio were in that early day. This has given occasion to the wags to say, that Overbeck has overreached himself, that Fight is shy and timid, that Schadow has neither depth nor softness, and that Schnorr is without repose.[206]

Nevertheless he admired their ambition and felt that fresco, which 'can exist only with the higher qualities of painting and cannot, like oil, with its beauty of execution, supply their place . . . might be used with advantage by our artists in England'.[207]

Paradoxically, it was only after he had witnessed Schnorr working on the Ariosto frescoes (Plate 28) in the Casino Massimo and seen him using the technique in a highly fluid and painterly manner that he felt encouraged to attempt the technique himself.

> He was painting the naked back and arm of a foreground figure; used a palette; colours moist and liquid; with brushes of very long hogs hair, so as not to rub up the wet plaster. The process was like oil painting much more than distemper: the colour sinks in, but remaining wet all day admits of repetition, softening and even glazing. I longed to have a touch at it. I would have tried more solidity in the lights and more grey in the half tints, than this enterprising though methodical German seems disposed to do. I was, however, pleased to find that the material served him in everything he wished; and his work, besides great talent, bears evidence of great dexterity of imitation.[208]

Wilkie was soon afterwards to become thoroughly disillusioned with modern German painting when he visited Munich.[209] Nevertheless he retained his

admiration for fresco, and was later to be lampooned for his enthusiasm by Haydon at the time of the controversy over the decoration of the Palace of Westminster.[210]

A more regretful observer of the Massimo frescoes was Thomas Uwins. Then resident in Rome, Uwins accompanied Wilkie on some of his visits; unlike Wilkie, Uwins was more concerned with the ideals of ancient Italian art than with the question of technique, and with remarkable perceptiveness related the primitivism of the Nazarenes to that of Flaxman. Writing to Raimbach the engraver, he said,

> Were I a young man instead of an old man, I would seriously set about making careful outlines of the selected works of this age [of Giotto and Cimabue] as the foundation on which my future exertions might wisely be based. It was in this school even more than in the antique that Flaxman studied, and it is following soundings left by Flaxman, that the Germans are now making such discoveries and such progress, as will lead to the regeneration of taste throughout Europe.[211]

Yet with the completion of the Massimo frescoes in 1829 the fashionableness of the Nazarenes in Rome began to decline. Schnorr had already left for Munich in 1827, joining Cornelius, who had been there since 1819. Of the major Nazarene painters, only Overbeck was left working in Rome. Yet Overbeck had by now retreated into a dogmatic pietism. Eager to devote his life to religious art, he had in 1829 abandoned his Tasso frescoes to his pupil Führich, in order to paint the *Miracle of the Rose* for the Franciscans at S. Maria degli Angeli in Assisi, free of charge.[212] In the following year he was to begin his major confession of faith, *The Triumph of Religion in the Arts*.

This growing pietism also affected the Nazarenes' adherents. From 1829 one finds their patrons and admirers belonging increasingly to those revivalist circles intent upon a resurrection of Christian art. Overbeck himself, with his devotion and modesty, impressed people immediately by his sincerity. Crabb Robinson, visiting him in 1829, compared him to a Methodist preacher.[213] For divines like Lamennais and Montalembert in France and Döllinger in Munich who were intent on reviving the spiritual authority of the Catholic Church, such enthusiasm was most welcome.

Amongst the English, too, the move towards piety was most opportune. In 1829 the Bill of Emancipation had been passed, restoring to English Catholics civil rights and public worship.[214] The decades following this event witnessed the renewed Catholic offensive which culminated in the re-establishment of the Catholic hierarchy in 1850 and the emergence of the Anglo-Catholics in the Anglican church. Many visitors to Rome from both these factions were deeply sympathetic to Overbeck's aims. Apart from such painters as William Dyce, there came many influential churchmen and patrons. The most significant was Lord Shrewsbury, the senior English Catholic lord, who was widely regarded as the secular figurehead of the Catholic revival in England.[215] From 1829 Shrewsbury spent a considerable amount of time in Rome each year. A member of the exhibiting body *Società degli Amatori e de' Cultori delle Belle Arti*,[216] he was deeply involved in the artistic life of Rome, and a supporter of Overbeck and his followers. He was inviting German artists to his English residence, Alton Towers, as early as 1832.[217] Later, after he had

become a patron of Pugin, he prevailed upon the architect to allow the Swiss follower of Overbeck, Eduard Hauser, to paint a Last Judgement to go over the chancel arch of St Giles, Cheadle.[218] In 1847, when Overbeck's pupil Enrico Casolani came to England with letters of recommendation from his master to Lord Shrewsbury he, too, was introduced to Pugin. The artist subsequently remained in England for four years, during which time he worked for Pugin in St Mary's, Greenwich, and St Mary's, Oscott, besides executing a number of private commissions.[219] Shrewsbury also entertained the idea of employing Steinle, although this plan came to nothing.[220]

If Lord Shrewsbury was one of the most influential patrons of Nazarene art in England, another member of the English community in Rome, Nicholas Wiseman, proved to be Overbeck's most eloquent English apologist. Wiseman, the able and cultured priest who was later to head the restored Catholic hierarchy in England, was from 1828 to 1840 rector of the English College in Rome. He took a deep interest in archaizing religious art and was a vigorous supporter of the revival. He befriended a number of English artists in Rome and appears to have gone to some lengths to interest them in Overbeck and his objectives. Indeed it seems likely that he was active in encouraging a friendship between Dyce and Overbeck. He certainly acted as an ambassador between them in later years.[221]

Wiseman's promotion of Overbeck did not remain on a personal level. In 1839 he

28. J. Schnoor von Carolsfeld: *Melissa Zeigt Bradamante ihre Nachkommen; Die Taufe Rüdiger*. (Mellissa shows Bradamente her Successors; The Baptism of Roger). 1822–5. Fresco (c. 300 × 400). Ariosto Room, Casino Massimo, Rome.

29. (far right) J. Settegast: *Christ and the Apostles*. 1854. Fresco. St Mary's Church, Clapham.

had published in London a series of lectures on the Eastern services of the Catholic Church, which, apart from having an Overbeck *Pieta* which he owned engraved as their frontispiece, argued the case for a return to mediaeval pictorial principles for modern religious art.[222] Wiseman's influence, however, was only of importance in the early 1840s, since in 1847 he rejected the revivalist creed.[223] Despite this, Catholic patronage of German painters continued. A notable later example of this is the commissioning of Josef Settegast to paint a mural (Plate 29) over the chancel arch of the Redemptionist church, Our Lady of Victories, in Clapham in the early 1850s.[224]

Overbeckian art also found favour amongst the Anglo-Catholics. In 1829 Pusey had visited Overbeck in Rome,[225] and in the following years German artists were often praised by the Tractarians. Enthusiastic German publishers appear to have recognized a market here; for according to T. Mozley German agents were filling Oxford with lithographs of mediaeval and mediaevalizing paintings in the 1830s. Equally deliberate was the Anglo-Catholic patronage. Beresford Hope turned as a matter of course to German artists for designs for the stained-glass windows for his parish church of Kilndown in 1841,[226] and German artists were to remain serious competitors in this field in England up to the 1860s, when Schnorr was designing a window for St Paul's Cathedral, Hess for the cathedral in Glasgow, and Kaulbach for the law schools in Edinburgh.[227]

43

While Overbeck remained an important figure in the Roman art world and a seminal focus for the revivalists of Christian art throughout Europe, the main centres of German revivalist painting had by the mid-1820s become firmly established in Munich and Düsseldorf. Consequently the movement of English travellers in Germany itself became crucially important for the spread of the reputation of the revivalist artists after 1830.

Before this time, cultural visitors to Germany had had no more than a limited interest in the contemporary pictorial art of the country. In the eighteenth century it was common for travellers to make a detour on their return from Italy to visit Vienna and the magnificent collection of paintings in Dresden which had largely been acquired from the Duke of Modena by August III in 1746.[228] With the closure of France to British travellers this habit increased around 1800, but there was little interest shown in the growing circle of Dresden artists. Indeed virtually the only case of English patronage of a Dresden artist to be recorded before 1815 is that of the portraits of Nelson and Lady Hamilton that were commissioned from Heinrich Schmidt when they were in Dresden in 1801.[229]

With the growth of interest in 'Picturesque' travel, certain parts of Germany, in particular the Rhineland, began to be visited on account of their scenic beauty. In the wake of these visitors there came in the early nineteenth century topographical draughtsmen who produced series of Rhenish, Alpine and Tyrolese views, at the same time as views of other picturesque parts of Europe, such as Normandy and the Pyrenees, were being produced.[230] While English artists ranging from Turner and David Roberts to Brockedon and Captain Batty[231] were highly active in this trade, it was by no means their exclusive prerogative. The engravings of local artists like C. L. Frommel, who had travelled to England specially to learn the technique of steel engraving and who had subsequently set up in business with Henry Winkles,[232] sold in England in the same way as Hackert's views of Naples and Catel's paintings of Rome were bought by English travellers in Italy. Despite Frommel's associations, however, there was little contact between these English and German topographers, and what influence there was seems to have gone from England to Germany rather than vice versa.[233]

As with traditional commercial and dynastic links between England and northern Germany, these topographical connections appear to have had little direct impact upon the appreciation of German revivalist art, beyond arousing an interest in German antiquities and legends, and the first visitor to give any account of the new movement in German art was, appropriately enough, a traveller in search of the literary and philosophical Germany—Madame de Stael.

Madame de Stael's famous acccount of her tour of Germany in 1804, *De l'Allemagne*, was to remain the most influential foreign account of modern Germany for more than two decades. Banned by Napoleon on account of its implicit censure of contemporary France, it was published in London in 1813 in both English and French editions, and subsequently exerted as much influence upon the English understanding of Germany as it did upon the French.[234]

As Heine was later to complain,[235] Madame de Stael's view of contemporary Germany was in fact largely an account of the opinions of her German mentor, A. W. Schlegel. This is nowhere more evident than in the single chapter that she devoted, towards the end of the third volume, to the fine arts in Germany. In this, Madame de Stael begins with one of the earliest examples of the proverbial characterization of German artists as being primarily intellectual: 'The Germans in general understand the arts better than they practise them; no sooner is an impression made in their minds than they draw from it a number of ideas.'[236]

She then proceeds to associate the new tendencies in German art with modern literature which, following Schlegel, she believed had saved German painters from the pernicious classicizing influence of Winckelmann. The saving grace of this new literary school had, of course, been to make contemporary painters aware of the essentially Christian spirit of modern Europe: 'The new school maintains the same system in the fine arts as in literature, and affirms that Christianity is the source of all modern genius.'

Nevertheless she is careful to emphasize that the return to the recognition of a Christian spirit and the concomitant reappraisal of Gothic art should in no way lead to mere imitation of the ancient masters:

> It is only of consequence to us, in the present silence of genius, to lay aside the contempt which has been thrown on all the conceptions of the middle ages. It certainly does not suit us to adopt them, but nothing is more injurious to the development of genius than to consider as barbarous everything that is original.[237]

Despite this appraisal of modern German art, there is a surprising dearth of examples or names of artists cited. The only centre of the arts that she mentions is Dresden. Although this is the centre that Schlegel himself knew particularly well, the details here are also of the sketchiest, amounting to no more than a *Head of Dante* by an artist whose name she had forgotten, and a *Three Marys at the Sepulchre* by Ferdinand Hartmann. No doubt Hartmann attracted Madame de Stael's attention because he was one of the painters who, like the Riepenhausen brothers, had started painting Christian and mediaeval subjects under the influence of the Schlegel circle.[238] It was under the influence of Schlegel that she chose as the supreme example of modern German art the *Sacrifice of Noah* by Gottfried Schick (Plate 21); for it was this work that had so impressed Schlegel when he came to Rome with Madame de Stael in 1805 that he wrote an eulogy on 'Einige Künstler in Rom' for the *Jenaer Literaturzeitung*.[239] Like Schlegel, Madame de Stael praises the 'lively and natural colours' of the grass, flowers and sky, and acknowledges the exciting primitivism of the work. Yet, despite this, her enthusiasm is decidedly cooler, and she ends by repeating that the copying of the ancients is no replacement for 'original genius' which 'has not yet decidedly displayed itself'.[240]

Madame de Stael's treatment of modern German art perhaps displays above all a lack of any interest in considering it as more than an illustrated appendage to the literary movement. In the succeeding years few visitors took even this much interest in contemporary painting. Even J. T. James, who was later to write the first English

book dealing with early German art, had little to say on modern works when touring Germany in 1818.[241] The Reverend Dibdin, too, despite being accompanied on his 'bibliographical tour' by the artist George Robert Lewis, whose family were Hanoverian in origin,[242] mentioned no modern German artist apart from Retzsch in his subsequent account.[243]

It was not until 1834 with the appearance of Mrs Jameson's *Visits and Sketches at Home and Abroad* that a work was published in English that gave an extensive account of modern German art. Mrs Jameson's interest is perhaps not so much evidence of a greater perceptiveness than her predecessors' as of a change in the situation in Germany. For by 1833, the year of Mrs Jameson's visit, revivalist art was not only still in the ascendant, but it was also exceedingly public. Since Cornelius's arrival in Munich in 1819, Crown Prince Ludwig—who succeeded to the throne in 1826— had fully integrated revivalist art into his scheme for creating an 'art city' out of his Bavarian capital. The impulse towards providing an aesthetic education for his subjects had led to widescale activities in all forms of art patronage. He had amassed extensive collections of Antique and modern art—including the famous Aegina marbles and the Boisserée collection of Northern primitives.[244] Meanwhile he had been employing the architects Fischer, Klenze and Gärtner in the creation of a range of public and royal buildings in which Cornelius and his followers were to paint their historical, allegorical and religious subjects. At the same time Ludwig also incorporated the applied arts into his scheme. One royal manufactory was devoted to Senefelder's new discovery of lithography, while another revived the production of stained glass.[245] Public involvement was not lacking in the 'art city' either; for it was in Munich that one of the first *Kunstverein* was established in 1822—needless to say, under the partonage of Ludwig.

The King's attitude towards his subjects, if well-wishing, was decidely paternalistic. By surrounding his people with works of art dealing with religious subjects, poetic themes from the classics, Nordic mythology and German literature, as well as scenes from Bavarian history, he hoped to raise a generation of loyal and patriotic subjects.[246] At the same time this vast and costly undertaking was often at the expense of more material advantages for his subjects. Yet, if this contrast aroused the hostile criticism which greatly contributed to his downfall in 1848,[247] the defenders of monumental art felt the new splendour to be ample compensation for other omissions. Even William Howitt, a distinguished journalist who was deeply involved in social reform in England,[248] was bowled over by Ludwig's achievement. In his account of his visit to Munich in 1842 he wrote,

> I will not pretend to say whether it be envy, or whether it be the most profound and philosophical taste, which has directed so many critiques on the king of Bavaria. But this I will say, that there is no king of modern times, not excepting Napoleon, who has conferred so substantial glory on his capital, or such decisive benefits on modern art and taste . . . Let him be an indifferent king; a neglecter of the solid interests of the people, if you will; but with all this he has, from earliest youth, displayed a taste of the most honourable and refined kind . . . The inhabitants of Munich do not now complain, but far the contrary. They see with

46

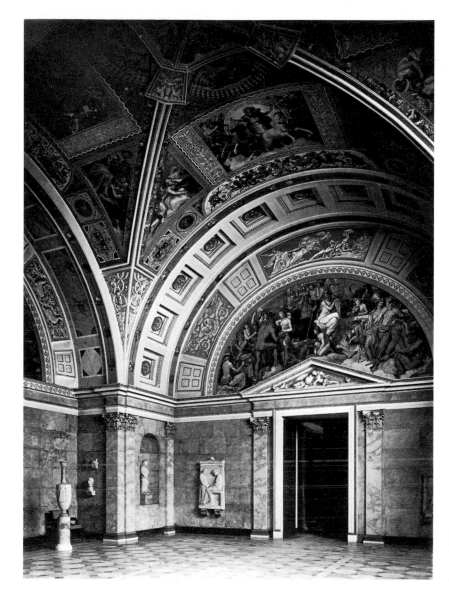

30. P. von Cornelius: *Göttersaal* (Hall of the Gods). 1825–6. Destroyed. Formerly Glyptothek, Munich.

pride the yearly growing influx of strangers from all parts of Europe and feel that what they there expend is a substantial advantage to them.[249]

Only after the scandal of Ludwig's liaison with Lola Montez broke in 1847 did his English supporters begin to express misgivings.[250] Yet by this time the emulation of his style of patronage had already passed its apex.

Reports of Ludwig's patronage had begun to reach England soon after Cornelius's arrival in Munich. In 1820 Wainewright gave a garbled account of the situation when he described Cornelius's Faust engravings as designs for wall paintings that Cornelius had already produced for Ludwig.[251] The first opinions had to wait for the completion of Cornelius's first cycle, the Glyptothek frescoes

47

(Plate 30), in 1826. On the whole they were unenthusiastic. Wilkie, during his visit to Munich on his way back from Italy, censured their 'flat and heraldic' style.

Even Eastlake, who visited Munich on his journey to Italy in 1829, considered the new works by Cornelius a disappointment:

> Cornelius' works have a grand conception and a sort of condensation of the spirit of his subject, but still, something which tells better in words than in painting . . . the colour in these frescoes is absolutely below criticism, the expression vulgar and exaggerated and the forms by no means pure.[252]

Perhaps the classical subjects of these frescoes prevented them from receiving the critical immunity that Eastlake had previously afforded the Bartholdi frescoes.[253] Yet the rigour of Cornelius's later works made him more respected than appreciated even amongst his fellow countrymen.[254] It certainly appealed little to Ludwig, who

31. J. Schnorr von Carolsfeld: *Siegfrieds Tod* (The Death of Siegfried). 1845. Fresco (475 × 529). Residenz, Munich.

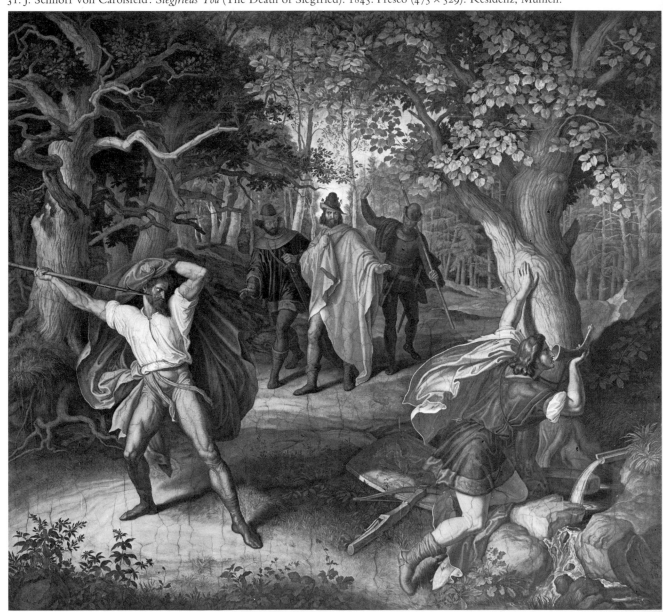

soon began to prefer the work of the pupils that Cornelius was training in Munich and Düsseldorf during the 1820s.

It was only when the work of some of these more approachable pupils and the *Nibelungen* frescoes (Plate 31) that Schnorr was painting in the Residenz (1827–63) began to become visible that a wave of enthusiasm for the actual painting in Munich began to emerge amongst English visitors.

It was fortunate for the reputation of Munich art, therefore, that Mrs Jameson did not reach Munich until 1833, for by that time Cornelius's work at the Glyptothek had been supplemented by a number of major schemes, most notably the scenes of Bavarian history by Kaulbach and others in the Hofgarten, the work by Neureuther and Schwind in the Queen's Chambers and by Hess in the Royal Chapel, and the first of Schnorr's Nibelungen halls in the Residenz.

The success with which Mrs Jameson's work was received—it was published in three editions between 1834 and 1839, and the review of it in the *Athenaeum* extended over three issues[255]—gives some indication of the interest that her subject was already arousing. It also merits the consideration of the contents of her book in some detail.

The work bore a conscious and confessed debt to its influential predecessor, *De L'Allemagne*.[256] While realizing the degree to which Madame de Stael's account was now outdated, she intended to supplement rather than replace that book. Instead of Madame de Stael's four-part division of her subject into the customs, literature and art, philosophy, and religion of the Germans, Mrs Jameson adopted the freer form of a travelogue. The first part, which takes us down the Rhine, to Heidelberg and thence to Frankfurt, consists of a dialogue, in which Mrs Jameson takes the opportunity to touch fleetingly upon a miscellany of topics relating to Germany— its morals, the position of German women in society, German romance, the picturesque aspects of the Rhine, and the relationship of Schlegel and Madame de Stael. This clears the way for the second part of the book, 'Memoranda at Munich, Nuremberg and Dresden', in which she treats the one subject that Madame de Stael had glossed over—the fine arts—in a more systematic and descriptive manner.

As it happens, Mrs Jameson's principal interest here is in painting. During the dialogue in part one she had noticed Dannecker, Rauch, Tieck and Schwanthaler as the leading sculptors of Germany, and she subsequently refers to contemporary works as she comes across them in the course of her travels. But the sculpture was too similar to the international neoclassicism of other countries to merit her particular consideration, and she ends this section musing upon the apparent fate of the modern sculpture in general—the continuous repetition of the forms of the Antique.[257] German architecture, too, seems to have brought her no surprises, and Klenze alone is mentioned, largely on account of his part in the redesigning of Munich.[258] Since she did not visit Berlin, however, she was unaware of both the greatest architect and the greatest sculptor of German neoclassicism—Schinkel and Schadow.

Mrs Jameson's interest in German painting, on the other hand, was stimulated by the contrasts that it provided to painting in England. She wrote not from the point of view of dogmatic commitment, but in an attempt to assess what the modern

German school had achieved, and what lessons this achievement might have had for artists in England. Ideally, she sought a synthesis, for she could see shortcomings in the art of both countries. Her strictures on the Germans are, for the most part, familiar. In the first place, they are over-theoretical and academic: '"You English have no school" was often said to me. I could have said "You Germans have *too much* school".'[259] For this reason it is landscape, so dependent upon naturalistic observation, that suffers the most:

> Not only have they no landscape painters who can compare with Callcott and Turner, but they do not appear to have *imagined* the kind of excellence achieved by these wonderful artists. I should say, generally, that their most beautiful landscapes want atmosphere. I used to feel while looking at them as if I were in the exhausted receiver of an air-pump.[260]

In view of her own preference for Callcott, it is hardly surprising to find her rating the Dutch-inspired Düsseldorf painters Andreas Achenbach and Wilhelm Schirmer high on the small list of landscape painters whom she felt worthy of mention.[261] Amongst the Dresden landscape painters, only Dahl is given approval. Friedrich, of whom she comments 'His genius revels in gloom, as that of Turner revels in light',[262] appears in the appendix of the first two editions, but is dropped from the third.

Portraiture, too, comes off badly when compared to the English, and is censured for lacking the breadth of Lawrence's style. Once again, it is the meticulous detail that is most objectionable: 'If I look into the face of a person I love, do I see *first* the embroidery of the comezon, or the pattern on the waistcoat?'[263] Altogether, in fact, Mrs Jameson is opposed to the obsession with minutiae which came from the interest in primitivism, a taste 'which I will not call natural, but national;—the remains of the old gothic school which, as the study of Italian art becomes more diffused, will be modified or pass away'.[264]

Such a rejection of the more extreme primitivism of the early Nazarenes admirably suited her for the modifications of the later Munich painters. It is in these painters that she can appreciate the value of theory, as it is applied to the most intellectual branch of art, the Historical. It is these German historical painters who 'through the merit of great earnestness of feeling and that characteristic integrity of purpose which they throw into everything they undertake or perform'[265] have shown the way back to achieving an art of the spiritual and physical dimensions of the High Renaissance. Once again it is, significantly, the High Renaissance rather than any earlier art that is the object of Mrs Jameson's admiration. But in one sense at least, Mrs Jameson shows herself on the side of the Romantics, in her appreciation of the value of content in a work of art; already possessing the concern for the meaning of images which was to lead to her major work, *Sacred and Legendary Art*,[266] she notes with approval the iconographical emphasis of the German painters and the way in which this attempts to fulfil a didactic purpose. Of the Hofgarten frescoes (Plate 32) she reports, in words that seem to foreshadow those of Thomas Wyse before the Parliamentary Committee of 1836:[267] 'I see every day groups of soldiers

32. *II. Stilke. *Ludwigs des Bayern Kaiser-Krönung zu Rom* (Coronation of Ludwig of Bavaria as Emperor at Rome). 1828. From *Fresco Gemälde aus der Geschichte der Bayern . . . in den Arcaden des Hofgartens zu München*, Munich, 1829. Lithograph by W. Roeckel.

and of common people, with their children, standing before these paintings, spelling the titles and discussing the various subjects represented.'[268]

It is in Munich, naturally, that Mrs Jameson finds this art most clearly developed, and it is there that the question of modern art is most fully discussed. Of the other two art cities that she describes in her 'memoranda', Nuremberg is mentioned purely as the home of Dürer and the old German art that she now hopes will be firmly left in the past,[269] and Dresden for its collection of old masters and for her interviews with Tieck and the 'extraordinary genius' Moritz Retzsch.[270] In Munich, on the other hand, 'art city' is a more integrated concept. She sets out by describing all the decorative schemes that are in progress, the organization of the arts and such schemes as the *Kunstverein*, in which the public was actively engaged in art patronage and appreciation. Like William Howitt, she has nothing but praise for the city's creator: 'Methinks this magnificent Prince deserves to be styled the Lorenzo de' Medici of Bavaria.'[271] After citing Nero's Golden House and George IV's 'Pimlico Palace' as examples of what happens 'when a selfish despot designs a palace',

she gives a grandiloquent report of Ludwig's command to Klenze for the building of the Residenz:

> Build me a palace in which nothing within or without shall be of transient fashion or interest; a palace for my posterity and my people, as well as myself; of which the decorations shall be durable as well as splendid, and shall appear one or two centuries hence as pleasing to the eye and taste as they do now.[272]

When discussing the works of individual artists, Mrs Jameson follows Eastlake in deliberating the question of the ideal and its expression. Cornelius's Glyptothek designs appeal to her for their iconography, although she, too, finds the execution in places crude.[273] The Hofgarten frescoes, despite their historical accuracy and effect on the populace, she feels to be 'generally better in the composition than the painting',[274] while the frescoes of the Royal Chapel baffle her by their archaism.[275] On the other hand she finds more to admire in the poetic illustrations in the Residenz, and it is here that she discovers in Schnorr the one painter who seems to her to have fulfilled the difficult synthesis necessary for the success of historical painting. It is a design by Schnorr—the portraits of Siegfried and Kriemhilde from the first room of the Nibelungensaale—that is used as a frontispiece to her work, and Schnorr whom she considers to be 'one of the greatest living artists of Europe'. For once she can wholeheartedly approve of a German artist for his technique and manner, although it is his approach to his subject that gains her greatest admiration:

> It is not alone the invention displayed in the composition, not the largeness, boldness, and freedom of drawing, nor the vigour and splendour of the colouring; it is the enthusiastic sympathy of the painter with his subject; the genuine spirit of the old heroic, or rather teutonic ages of Germany.[276]

This appreciation of Schnorr together with her championship of the works of Retzsch suggest that whatever her admiration for the didactic achievement of Munich, it is the luxuriance of imagination in German art which arouses her greatest sympathy. Indeed it is her opinion that Schnorr's *Nibelungen* cycle will form, when completed, 'the very triumph of the romantic school of painting'. Similarly, when comparing English and German art, she is put in mind of the then little-known Theodore von Holst who 'uniting the exuberant enthusiasm and rich imagination of his country, with a just appreciation of the style of English art, is likely to achieve great things'.[277]

Yet, despite this interest, it was Mrs Jameson's emphasis on the opportunities given to historical painters in Germany that made the most lasting impression. Similar opinions were soon to appear in the accounts published by other travellers to Germany in the 1830s. The excellent organization of the fine arts in Munich formed the basis of John Strang's account of the city—based on a visit in 1831, but not published until 1836[278]—and it was certainly this aspect that caused Bavaria to be hailed by the Select Committee on Arts and Manufactures as 'now the classic country of the arts'.[279]

In 1837 the fame of Munich finally came to the attention of the tourist. In this year

Murray's first guidebook to southern Germany was published, in which he advised the traveller: 'There are few capitals in Europe north of the Alps which will better repay the traveller for a visit or hold out greater inducements for a prolonged stay than Munich at the present time',[280] mentioning a little later its 'predominant position as the seat of the fine arts'.

In the spate of travelogues, guides, and reminiscences that appeared with growing frequency during this period Munich continued to dominate the accounts of contemporary German art. Gradually, however, more attention began to be paid to Berlin. The reasons for this were similar to those that had brought Munich its fame. For when Frederick Wilhelm IV ascended the Prussian throne in 1840 he attempted to put into operation a scheme of monumental didactic art based upon the same revivalist notions as Ludwig's in Bavaria. William Howitt, who visited Berlin in 1841, noted: 'As Prussia, moreover, has now acquired a solid and powerful expanse of empire, he has adopted the true course of political sagacity, and determined to elevate his people by intelligence and render his reign illustrious through science and art'.[281]

Yet, as Howitt also noticed, Frederick Wilhelm's cultural offensive was to some degree at the expense of Munich, for the new King was attracting those luminaries who had already made their name in the Bavarian capital. Already by 1841 Schelling had left Munich for Berlin and Cornelius had been commissioned to make designs for the Treppenhaus of the Altes Museum and for the Campo Santo. The former were eventually completed with the help of his old Munich pupil, Kaulbach.

Howitt did, however, mention the work of two principal Berlin artists of the preceding generation, the architect Schinkel and the sculptor Rauch; yet neither receives the praise that is reserved for Von Klenze and Schwanthaler in Munich.[282] Of the most significant artist of the younger generation then working in Berlin, Adolf Menzel, there is no mention.

If the appearance of monumental painting in Berlin led to a growing number of visits by those interested in contemporary art, the absence of it in Düsseldorf seems to explain the lack of comment from travellers on the art in that city. For despite the growing reputation of the Düsseldorf painters abroad their concentration on easel paintings left their work less in evidence in their native city. Indeed J. B. Atkinson, who visited Düsseldorf explicitly to study their works, complained of the difficulties that he had gaining an impression of his subject.[283]

The reputation of the art of other German cities also stood or fell by the standards of Munich in the 1840s. In the Rhineland, Cologne was known for the paintings by Overbeck and Steinle in the cathedral,[284] Bonn by the frescoes of Götzenberger and other pupils of Cornelius in the Aula of the university,[285] and Frankfurt for the frescoes in the town hall, as well as the cartoons for the Bartholdi frescoes and Overbeck's *Triumph of Religion* which was on show in the Städelsches Institut after 1840.[286] Even Dresden began to attract attention for the frescoes painted by Vogel in Schloss Pillnitz and Eduard Bendemann's frieze in the Throne Room of the Royal Palace;[287] while, similarly, the most famous work of modern art in Hamburg was the Abendroth-Zimmer, a frescoed room designed by Erwin

Speckter.[288] Vienna, on the other hand, where there were no such projects, hardly ever received a mention for its art.

GERMAN ART AND THE PUBLIC IN ENGLAND

By the late 1830s, however, the English public were no longer dependent upon the accounts of travellers for a survey of the modern German schools. While there was no fuller account by an English author than that provided by Mrs Jameson, two works on the subject were published around this time in France.

The first of these, *Histoire de l'art modern en Allemagne*, appeared in three volumes between 1836 and 1841. Its author, the Prussian diplomat Count Raczynski, was himself a collector and dedicated admirer of the revivalists. He also shared the proselytizing spirit of his heroes and specifically directed his publication towards a foreign market. In the introduction he declared, 'En publiant cet ouvrage je n'ai d'autre but que d'attirer sur les artistes allemands l'attention des étrangers.'[289] It was no doubt for this reason that he wrote his work in French, and had it published in Paris.[290] In 1838 he was in England, where he canvassed his book with Eastlake.[291] Nor did he forget the United States, for in 1841 he sent a copy of the completed work to Washington Allston, the old associate of Schick and Koch.[292]

Out of consideration for his international audience, Raczynski begins his work by placing the modern Germans in a historical perspective that shows them to be the true successors to the two great ages of European art: classical Greece and the Renaissance. Amongst German artists he considers only the Nazarenes and their immediate forerunners in Rome. In this scheme the Bartholdi frescoes become 'le premier essai pour faire revivre le style élevé de la peinture';[293] while the present art of Germany consists of three 'foyers'—Munich, Düsseldorf, and Berlin.[294]

As might be expected, it is the academic artists in these centres who form the main part of his narrative. Even the artists that he considers to be the principal luminaries of other towns—such as Götzenberger at Mannheim, Veit at Frankfurt or Erwin Speckter at Hamburg— had studied at one of these three places, and usually in Rome as well. At the same time, however, Raczynski is painstaking in the extent of his coverage. The bulk of the three volumes is in the form of a biographical inventory in which few names of any consequence are missed. Such artists as Friedrich and Retzsch may receive no more than brief notices in the list of Dresden artists, but they are nevertheless included.

However, the most influential aspect of these bulky volumes—which were, as the *Art Union* noticed, beyond the pocket of the general reader—was their illustrations. Apart from the innumerable woodcuts and line engravings in the text, Raczynski also issued in 1842 a supplement of forty folio-size lithographs which provided a high-quality pictorial résumé of his favourite artists.

A more popular if less comprehensive text appears to have been Hippolyte Fortoul's *De l'art en Allemagne*. First published in 1841 in Paris, it was twice reprinted within the decade. This two volume work—expanded to three in the 1844 edition— is unfortunately unillustrated. It gives, however, a lively account of the fruits of the

author's recent tour of Germany in which, like Mrs Jameson, he sought 'de combler cette lacune' left by Madame de Stael through her failure to give adequate coverage of the fine arts.[295]

As with Raczynski, it is monumental painting that preoccupies Fortoul: 'L'histoire de la peinture monumentale est à proprement parler, l'histoire de la peinture elle-même.'[296] His knowledge of German art is less extensive than Raczynski's, however; Munich remains the focus and he only briefly makes excursions to consider the art in Düsseldorf, Frankfurt, Weimar, Dresden and Berlin.

If Fortoul's scope and convictions follow a familiar pattern, he does afford a unique consideration of the nature of historicism. The 'formes transfigurées des époques antérieures' that he finds in Munich[297] lead him to muse upon a new form of criticism in which it is historical development rather than originality that becomes the criterion.[298]

Consequently, besides discussing modern German painters, he spends much of the book considering the nature and development of the main epochs of European art as these can be understood from the revivals and collections in Germany.

Curiously, the appearance of a full-scale English account of German art had to wait almost a generation, until William Bell Scott's *Gems of Modern German Art* of 1873 and Joseph Beavington Atkinson's *The Schools of Modern Art in Germany* of 1880. The gap was filled to some extent, however, by the close coverage of events in Germany provided by the English periodicals of the period. By far the most judicious account of modern German art was that provided by Lady Eastlake in her extensive review of Raczynski's *Histoire de l'art modern en Allemagne*, which appeared in the *Quarterly Review* in 1846.[299] While fully appreciating the earnestness of the German idealist endeavour she did not allow herself to be overwhelmed by mere intentions. Munich, she observes, 'has all the external signs which characterized the zenith of art . . . But, we regrettingly hold by our opinion, the signs are *got up*. There is a pedantic consciousness as to the parts they are all playing in the great epoch.'[300] She also felt that the school had gone too far in its emulation of the severity of the early masters. Her own preference was for the more fulsome ecclesiastical decorators of the Rhineland, and she concludes her review with a panegyric for the work of Deger, the Müller brothers and Ittenbach at the Apollinariskirche, Remagen. These artists, she also notes, worked independently of each other rather than under an autocratic leadership as was the custom in Munich. The success of such liberalness augured well, she felt, for the British endeavours at Westminster—something that her husband doubtless took to heart.

A more constant voice—up to his untimely death in 1846—was the principal reviewer of the *Athenaeum*, George Darley. He provided informed accounts of German art books and paintings as they appeared in London. His views gained authority from the first hand knowledge of German art he had acquired during his stay in Munich in 1834.[301] A more committed viewpoint appeared briefly in the *People's Journal*, with which Howitt became connected after his return from Germany in 1846. Its volumes contained copious wood engravings of pictures, including such works by principal German history painters as Cornelius's

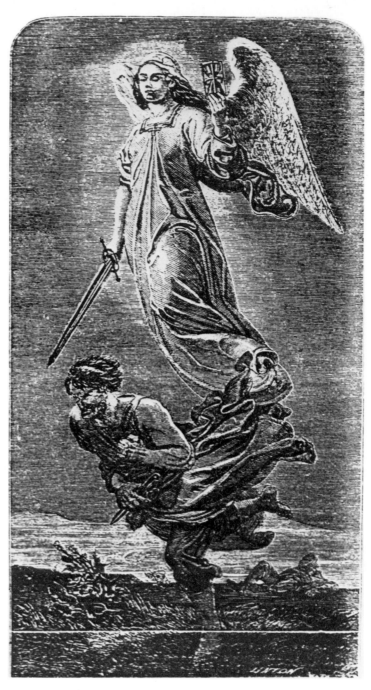

33. ★A. Rethel: *The Avenging Angel*. From *People's Journal*, II, 1846. p. 295. Wood engraving.

Nibelungen, Mücke's *St Catherine*, Kaulbach's *Robbers* and Rethel's *Avenging Angel*[302] (Plate 33).

The most fervent and comprehensive defender of German art, however, was the *Art Union*. In the first year of its publication its editor, S. C. Hall, was proclaiming German art to be the 'first in Europe', and as late as 1866 it was still describing Kaulbach as 'the greatest German painter—the greatest painter of Europe'.[303] Apart from the coverage of German art in the extensive continental reportage that was a

feature of the magazine, German artists were prominent in such series as the 'Living Artists of Europe',[304] and engravings after their paintings and examples of German graphic art were frequently reproduced.

Hall's interest in German art seems to have developed rapidly in the 1830s. An indefatigable publicist, he was attracted towards the field of art journalism at a time when the public debate on the fine arts was gathering force in England.[305] While his claim to have produced the first successful art periodical in Europe may have been an exaggeration—he himself was well aware of the existence of the *Kunstblatt*, 'the great organ of the arts in Germany',[306] which had been in operation since 1817—he was certainly successful in making his magazine an indispensable mouthpiece of the art establishment of the 1840s. From the start his opinions coincided with those of the leading members of the Fine Arts Commission, and each annual edition of the magazine—which was renamed the *Art Journal* in 1849—was dedicated to Prince Albert up to the Consort's death in 1861. During the period of the Westminster Hall competitions, Hall published illustrated articles to provide the contestants with information concerning fresco techniques, historical costume, and the methods of history painting. Hall also sought to aid English artists in their development by more direct means. His *Book of British Ballads*, illustrated by the 'rising talent' of British art,[307] was designed in open emulation of the illustrated German jubilee edition of the *Nibelungenlied* of 1840, and was actually dedicated to Ludwig of Bavaria.[308]

Like Eastlake and Prince Albert, Hall belonged to those of the English who admired the systematized nature of German revivalist art. While he himself expressed doubts that the artists of Düsseldorf and Munich were influenced by the theories of Schlegel, Tieck, Novalis and Wackenroder,[309] he saw the organization of the fine arts as having a definitive effect upon the German Manner. When describing in his picture book *Gems of European Art*[310] the nobility of intention to be found even in genre paintings in Germany, which 'aspire only to elevate everyday subject matter into sentiment', he concludes:

> but there is an essential difference in the constitution of artist society in England and Germany, which will prevent our seeing at home the same uniformity of style which prevails elsewhere. One great source of the German Artists in the new movement is the unanimity and harmony prevailing among members of the same school.[311]

Yet despite this difference it was still possible to make the English aware of this quality, and by 1842 he was convinced that 'A taste for the production of the schools of Germany is growing up among us, in proportion as our progressive education in Art prepares the many to understand its higher purpose.'[312]

Hall's efforts to provide a 'progressive education' mirrored the efforts not only of the select committee, but also of the organizations after which his magazine was first named, the 'Art Unions', which sprang up throughout Britain during the 1830s. Based upon similar organizations already existing in Germany, these societies received an annual subscription from their members, for which they provided engravings of contemporary works and, in effect, ran a lottery for premiums with

which members could purchase original paintings.[313] The London Art Union founded in 1837 was particularly active. Not only was its membership by 1842 sufficiently large to enable it to distribute annual premiums up to the value of £10,000, but it also offered annual prizes for historical paintings, sculpture and outline engravings. This made the London Art Union in itself one of the substantial patrons of the 1840s, and there is more than a grain of truth in the claim made by *Punch* in 1846 that

> The alarming spread of the German School in Art has created considerable astonishment. But the phenomenon has at length been accounted for, by it having been discovered that the Committee of the Art Union cannot understand, or will not patronize any other class of drawing.[314]

Yet even here 'progressive education' was not on the scale of the German *Kunstvereine*. For while the latter organizations selected works for their members by means of a committee, the London Art Union left the choice to those who had won a premium in the lottery. The resulting choices, which were published annually[315] by the Art Union, show little predilection for historical painting, and even an undistinguished taste in landscape painting and anecdotal genre. The *Athenaeum*, opposing the English system of free choice, went as far as to suggest that the majority of the premium winners 'have no higher object than to do a good turn to a poor artist, and rid themselves of the perplexity of choosing one picture out of five exhibitions, to fit the amount of their prize'.[316]

Some were even less altruistic than this, and cases were reported of prizewinners attempting to split their premium with an artist without any purchase of a work of art actually taking place.[317] Nevertheless the London Art Union was not altogether ineffective in encouraging the arts, and it should be remembered that it was a somewhat bewildered beneficiary of one of their lotteries who handed over his £60 premium to Holman Hunt for the latter's *Eve of St Agnes* in 1847.[318] Both the *Athenaeum* and the *Art Union*, in fact, took a dim view of the random nature of the activities of the London Art Union and found, by contrast, that the German *Kunstvereine*, where 'The prizes . . . are pictures selected by a competent committee appointed for the purpose',[319] were exemplary institutions, and heartily commended the attempts of Hering and Remington to open up English subscription lists for the *Kunstvereine* of Berlin, Düsseldorf, Dresden and Leipzig: 'Should the English subscription list realize expectation, it is intended to exhibit in London the next year's prizes—an experiment that we hope will be made.'[320]

The *Athenaeum*'s hope was not realized, however, and what records there are suggest that the public response to Hering and Remington's invitation was not large. The Leipziger Kunstverein appears to have received no English subscription before 1845, when they obtained seven. In the following year this had sunk to four— one of the three faithful adherents from the previous list being Prince Albert.[321]

Nevertheless, if the public were less enthusiastic about the German Manner than some authorities would have liked, there was sufficient interest expressed in official circles to attract the attention of artists and connoisseurs in Germany. The value of

34. W. von Kaulbach: *Das Narrenhaus* (The Mad House). *c.* 1834. Pencil (45.9 × 60.8). Staatliche Museen, Kupferstichkabinett, Berlin.

the patronage of an English Maecenas like the Earl Bishop Lord Bristol or Lord Shrewsbury was well known to those who had lived and worked in Rome, and such events as the announcement of the scheme for decorating the new Palace of Westminster, and the arrival of Prince Albert in England were followed with great interest. The events that caused such consternation amongst English artists had produced a different effect in Germany. The Munich-based *Kunstblatt*, which had reported such significant English commissions for German artists as the stained glass for Kilndown,[322] raised the hopes of Munich artists in 1841 by announcing that Eastlake was on his way to Munich to see if the employment of Munich artists in London would be feasible:

> The famous English painter Eastlake is expected here. He is to decide on behalf of his government whether it would be expedient to engage fresco painters in Munich for the pictures relating to English history which are to decorate the Houses of Parliament that are now being built.[323]

Only as late as 1843, with the exhibition of the results of the first Westminster Hall competition, did it admit that 'The original idea of decorating the Houses of Parliament with frescoes by Cornelius has been abandoned.'[324]

Meanwhile many German artists had taken an initiative in seeking English recognition. The hopes that Schwind and Genelli had expressed about Prince Albert may have proved unfounded,[325] but artists with more personal connections had greater success. Schnorr, who had been in correspondence with Eastlake since 1829 and who gave the English artist such generous and invaluable advice concerning fresco painting for the Fine Arts Commission,[326] used this contact to further his art in England. Already in 1836 he was writing to Eastlake to enquire about the possibility of his cartoons for the Nibelungensaale being exhibited in England.[327] Eastlake's reply is not preserved, but it appears to have been negative. Eight years later in 1842 he returned to the question, as the issue of the decoration of the Palace of Westminster had now altered the situation:

A few years ago you expressed the wish to exhibit some of your cartoons of the Nibelungenlied here. It seems to me that the coming spring would offer a very favourable opportunity for this. I do not know how convenient it would be for you to send them then; but I think that the English public would be ready to contemplate them with interest for several reasons. You know perhaps that a Royal Commission has been set up here to investigate the best procedures to take in connexion with the rebuilding of the Houses of Parliament.[328]

Such an exhibition never took place; for Schnorr, who in his reply to this letter expressed the opinion that the Westminster frescoes should decidedly be executed by English artists,[329] had no wish to make a gesture which would, under the circumstances, aggravate a national issue.

Even though Eastlake had not felt that Schnorr's cartoons would have found an eager public in the 1830s, Schnorr nevertheless had his admirers amongst English patrons at that time. Amongst these were two future members of the Fine Arts Commission, the connoisseur George Vivian (who went to Munich in 1840 to study German monumental art)[330] and Henry Bellenden Ker. Ker, a close friend and patron of Eastlake,[331] had urged Schnorr already in 1838 to show his *Nibelungen* cartoons in London, 'in order to show us that we are not the only artists of modern times'.[332]

He himself had done his best to convince his fellow countrymen of this by acquiring two paintings by Schnorr, a predella in 1835[333] and a panel painting in 1838.[334]

Schnorr was no doubt gratified to learn that his paintings were, as far as Ker was concerned, 'ganz was ich gewunscht'.[335] It is more difficult to imagine what he felt, however, when Ker then informed him that he had mounted one of them with one by Eastlake: 'It will also perhaps not be displeasing for you to note that it is enclosed in the same border with a picture by your friend Eastlake.'[336]

The remarkable admiration for Schnorr amongst Eastlake's patrons no doubt reflects Eastlake's influence as much as it does that of Schnorr. But the charm of

35. W. von Kaulbach: *Zerstörung Jerusalems* (The Destruction of Jerusalem). 1842–54. Oil (589 × 703). Neue Pinakothek, Munich.

Schnorr's art also reached a less committed public. His biblical designs, which had always been a favourite amongst the English[337] and which were published as a German pictorial Bible in 1851,[338] appeared in an English edition in 1860. Intended as a popular work, this book, which was so influential for English biblical illustration, has survived into present times.[339]

Yet, though Schnorr's art was to have an appeal that outlasted that of any of the other Nazarenes, his reticence and consideration made him less known during the 1840s. Cornelius was also less influential during this period because of his rigorous style. Instead, it was the pupils of Cornelius who received most of the admiration. When Haydon had been complaining about the adverse influence of Cornelius and Schnorr on Eastlake in 1842,[340] he had been looking at a copy of a fresco by Cornelius's pupil Heinrich Hess, which was then in Eastlake's house.

Possibly this was the same work as the *Christ Blessing Little Children* in the collection of Eastlake's patron Lord Lansdowne, which was exhibited, most unorthodoxly, together with a *Head of a Monk* by Kaulbach from the collection of Phillip Henry Howard, in the British Institution's Exhibition of Ancient Masters in 1843 'in compliance', as the catalogue said, 'with a wish that has been expressed to see some specimens of the Modern German School'.[341] It was a wish less eagerly shared

by George Darley in the *Athenaeum*, who when reviewing the works considered that

> We should propound no paradox by the assertion that German painters ought never to paint their pictures; for their colouring is rather discolouring and they blot out the beauty of their design with ugliness of their pigments or render it almost imperceptible.[342]

Despite this view, the pupils of Cornelius generally appealed more because of the greater concessions that they made towards the sensuous than their master did. Amongst these, Kaulbach was the most successful in combining the revivalist manner with elaborate design and feats of illusionism. It was no doubt for this reason that he seemed to both S. C. Hall and the Howitts to be the supreme German artist, and the greatest of European painters.[343] These populists had a more secular interest in the German Manner than did the Eastlake faction. Kaulbach had already attracted attention in England with the publication of his *Mad House* (Plate 34) in 1838, a highly schematic and stereotyped interpretation of insanity. Haydon's judgement of the work as being 'too individually human' seems the reverse of the censure that one might raise today.[344] A more telling proof of Kaulbach's reputation was the number of English pupils that he received as a result of the concern with monumental art. These included Henry O'Neil (1840), Harold John Stanley (1842), Thomas Sibson (1842), William Cave Thomas (1842) and the Howitts' daughter Anna Maria in 1850.[345] Besides displaying a more facile manner than his master, Kaulbach also favoured a more malleable mural technique than fresco – waterglass.[346] When Maclise found difficulties in handling fresco it was, appropriately enough, to Kaulbach that he was sent to learn the simpler method.[347] Yet even Kaulbach had relatively few patrons amongst the English. The attempt of Raczynski, via Eastlake, to sell the cartoon of Kaulbach's 'masterpiece' *Destruction of Jerusalem* (Plate 35) in 1838 to the Academy or to Lord Egerton or the Duke of Sutherland (both, incidentally, future patrons of Götzenberger) met with no success,[348] and the only paintings by him that are recorded as having crossed the channel are the *Head of a Monk* for Howard, and the *Happy Mother* for Anna Maria Howitt in 1855.[349] His popular reputation rested, as that of Schnorr did, upon his graphic work—on his book illustrations to *Siegfried* and to *Reinecke Fuchs*.[350] Nor is it perhaps accidental that the major monumental commissions that Schnorr, Hess and Kaulbach were engaged upon in Britain were the simplified designs for stained-glass windows in Glasgow Cathedral,[351] Edinburgh Law Schools[352] and St Paul's Cathedral, London.[353] For it was as designers and narrators that German artists remained most highly admired. If this is true of the Nazarenes and their followers, it is even more so of Ludwig Richter and Alfred Rethel whose graphic work was appreciated by the second generation of Pre-Raphaelites.[354]

To conclude that the major influence of the Nazarenes was through the medium of reproductions, might seem to be self-evident. Yet at the same time the emphasis on content and composition that this medium encouraged was coextensive with the elements of revivalist art that had preoccupied English observers since they had first encountered it.

CHAPTER II

The Mind of Art

NOTHING is more consistent in the attitude towards German art in the nineteenth century than the ascription to it of an overwhelming intellectual bias. Eastlake's aphoristic statement, 'The English have the matter and the Germans have the mind of art',[1] made as early as 1820, was to epitomize the attitude of commentators throughout the century. Even as late as 1902 William Sharp found it necessary to preface his remarks on the subject with: 'The Germans are primarily an intellectual nation, German artists a congregation of thinkers on life rather than spectators of life.'[2]

Although it is hardly difficult to see how the sparse manner and high-mindedness of the Nazarenes and their followers encouraged such assessments, these are not in themselves sufficient to account for the unique position ascribed to these artists by their contemporaries. Both England and France had, after all, produced internationally famed and equally high-minded schools of history painting in the late eighteenth century; and the Neo-Platonic cause of the idealist artists had been revived as a living issue ever since Winckelmann had advised artists to 'dip their brush in intellect', and extolled the virtues of outline. Such phrases as 'thinkers on life' and 'mind of art' did not, however, refer essentially to the artist's style; they referred rather to problems of interpretation, to the function of the fine arts and the nature of aesthetic experience.

Once again the art of the Nazarenes might not seem to be uniquely suited to the discussion of such problems. That it was seen as being such by so many contemporaries seems to have been due principally to two factors. First, the difficulty of coming to terms with the Nazarene style encouraged the search for an explanation of their approach in essentially non-pictorial terms. Second, by a process of cultural association, this was equated with the contemporary development by German post-Kantian philosophers of the study of aesthetics.

'They have dignified their style', wrote Eastlake, 'by depriving the spectator of the power of criticizing the execution.'[3] Such a position would in traditional academic art theory have been untenable. Neither Bellori nor Mengs would have denied that beauty, however ideal its origin, was made manifest through the mimetic skill of the artist. Against the proverbial passage from Raphael's letter to Castiglione concerning the painting of Galatea,[4] both had set the equally well-known story of the selection of models by Zeuxis for his painting of Helen of Troy;[5] thus emphasizing that ideal beauty was realizable by the artist only through a judicious attention to nature. For Eastlake, the Nazarenes' style seemed so far removed from the observation of nature that it was assumed that this was not a

prime factor in the creation of their imagery. While Eastlake was, as has already been seen, prepared to waive traditional standards of connoisseurship in deference to such 'dignity' and assume that the philosophical background of the Nazarenes adequately replaced any mimetic requirements, most English critics took the opposite view. Even Dyce expressed concern over the lack of executive finesse and observation of nature in German revivalist art during the 1840s,[6] while Ruskin railed against the 'headless serpent of Teutonic art (ending in German Philosophy constrictor powers—with no eyes)'.[7]

The elision of German art and philosophy that one finds implicit in such statements not only affected the appreciation of Nazarene painting but also the interpretation of its achievement. In the atmosphere of the 1840s, the vast didactic schemes of monumental art being erected in Munich and elsewhere were seen as the fruit of a deep understanding of the purpose of art as a moral and educational force and the ways in which this role could be realized.

It is hardly necessary to point to the restrictions that such an approach placed on the understanding of German art in Victorian England, or to emphasize how different such an interpretation was from that of the Nazarenes themselves. It had been the search for a visual no less than for a moral truth that had first led Overbeck and Pforr to turn to early German and Italian painting when they were students in Vienna,[8] and, as Friedrich Schlegel made clear in his defence of revivalist art in his review of the Palazzo Cafferelli Exhibition,[9] there was no question of these artists abandoning technical proficiency and imitating the 'faults' to be found in pre-Renaissance art. Moreover, though their intentions were certainly didactic, they sought to be effective on a contemplative and spiritual level as well as an intellectual one. Cornelius himself wished to create works that would fill the spectator 'with the uplifting consciousness of the eternal',[10] and his failure to comply with the more explicit intentions of Ludwig eventually led to his departure from Munich.

Yet despite this the revaluation of the nature of aesthetic experience and the function of art that German aesthetic writings implied must be considered a fundamental part of the response to German art in early Victorian England. It is no coincidence that the very word 'aesthetic' first began to find currency in England at this time and was popularly considered to be a 'science' of German origin.[11]

Although aesthetic considerations can hardly be said to have been born with transcendentalism, this movement did at least bring a new awareness to the subject, creating an autonomous basis for the nature of art, whose claims, for those contemporaries who became involved in them, were stimulating both for their scope and for the insight that they offered. Such enthusiasm can be felt in the early reviews of Carlyle:

Criticism has assumed a new form in Germany; it proceeds on other principles and proposes to itself a higher aim . . . it is no study of an hour; for it springs from the depth of thought, and remotely or immediately connects itself with the subtlest problems of all philosophy. One characteristic of it we may state, the obvious parent of many others. Poetic beauty, in its pure essence, is not, by

theory, as by all theories from Hume's to Alison's, derived from anything external or of merely intellectual origin . . . on the contrary; it is assumed as underived; not borrowing its existence from such sources, but as lending to most of these their significance and principal charm of mind. It dwells and is born in the inmost spirit of man.[12]

Quite as important as the effect that this synopsis of the autonomous aspects of German aesthetic theory made on Carlyle's contemporaries, is the fact that, in a review of contemporary German literature, Carlyle should have felt it necessary to devote the larger part of his article to the discussion of aesthetics. For in Carlyle's mind there was no doubt that these theories lay at the base of the achievements of contemporary German literature. It was the ability to consider literature as central to moral and spiritual awareness, to give it a status so undeniable that 'to inquire after its *utility* would be like inquiring after the *utility* of God', that had, Carlyle felt, provided the basis for a revival of the primal qualities of the great art of former and more fortunate epochs: 'Glances we do seem to find of that ethereal glory which looks at us in its full brightness from the "Transfiguration" of Raffaelle, from the *Tempest* of Shakespeare.'[13]

For Carlyle, German aesthetics provided the key to spiritual regeneration in the arts, both because of its emphasis on the primal position of the artist, and because it was able, through introspection and speculation, to return the artist to a spiritual state long since obscured in the contemporary world.

This demand for spiritual regeneration as well as the concept of the prophetic role of the artist was, of course, a commonplace of the late eighteenth century. It is every bit as applicable to Blake, Barry, Goya and David as it is to Carstens and Runge. The significance of the German contribution is not that it was in the forefront of a new awareness, but that it was able to ally this awareness with the speculative structure of transcendental philosophy, and thus place its claims on a more authoritative and communicable basis. Thus, while Blake's prophetic world could remain for his contemporaries essentially private, the claims and predictions of such critics as the Schlegels could achieve international importance. By the 1840s, when the heyday of German Romantic art had already passed, these ideas had become officially accepted throughout Germany and had, ironically, led to the most highly organized system of art education, production, and patronage to be found in Europe. It was this final legacy that was to have the strongest influence on English art theorists, organizers and educationalists.

This development of aesthetics was peculiar, not only for the autonomy and moral authority with which it vested the artist, but also for the unique position that it ascribed to the art of painting. Such a position was the reverse of that which had previously existed in Germany, and only emerged gradually as the study of aesthetics grew in importance for philosophers.

During the eighteenth century, philosophical enquiries into the nature of beauty were rarely concerned in any direct way with the visual arts. Despite the critical appreciation of Winckelmann, Lessing, Heinse and the young Goethe, philosophers

like Baumgarten and Kant were not greatly interested in pictorial phenomena. They discussed aesthetics primarily in relation to natural beauty and, to a lesser degree, to works of music and of poetry—traditionally the most supreme and fundamental of all the arts.

Nevertheless the investigations of these philosophers were crucial to future developments, since they determined the nature of the problem. Baumgarten is perhaps best remembered today for being the first to turn the Greek-derived word 'Aesthetica' from its original meaning of 'sensory perception' to the specific designation of the awareness of beauty.[14] Apart from the semantic objections to this usage that were raised from time to time by, amongst others, Kant, A. W. Schlegel and Ruskin, Baumgarten was to be seriously criticized for the cognitive bias of his interpretation. While establishing the independence of the origin of the sense of beauty from any considerations of utility—an achievement which separates him from the English empiricists—he saw it as being a branch of intellectual understanding. The judgement of beauty was to him 'confused thought', a branch of cognition mediated by the senses which was supplementary to the 'clear and distinct' cognition mediated by the intellect.[15] In considering the judgement of beauty to be essentially a cognitive process he betrayed his own rationalist origins as a disciple of Wolff.

This concept effectively suppressed any consideration of the subjective response to beauty, and it is not surprising to find that Baumgarten's work seems to have had little impact on those writers and theorists whose consideration of the phenomena of aesthetic experience so radically extended critical awareness in the late eighteenth century. Reynolds, Burke, Diderot and Winckelmann were less concerned with exploring the concept of the sense of beauty than in investigating phenomenological problems of taste and sensibility; for which they were most indebted to the opinions of Shaftesbury.

As in so many branches of philosophical thought, it was Kant who united these differing directions of ontological enquiry and phenomenological investigation. His achievement was all the more remarkable since he was at first far from sympathetic to the study of aesthetics. As he was to confess in his *Critique of Judgement*,[16] he had not originally considered aesthetic judgement to be a faculty by which laws are prescribed *a priori*, and had not at first intended to treat it as a separate critique. In his *Critique of Pure Reason*,[17] therefore, he used the term 'transcendental aesthetic' in the 'elements of transcendentalism' to describe not the awareness of beauty but 'the science of all the principles of sensibility *a priori*'. In a footnote,[18] furthermore, he rejects the 'false hope, first conceived by the excellent analytical philosopher, Baumgarten, of bringing the critical judgement of the beautiful under rational principle, and to raise its rules to the rank of a science'. When he finally turned to treatment of 'aesthetic judgement' as the awareness of beauty in his *Critique of Judgement*, this was due not so much to a rejection of his earlier reasoning as to a different understanding of the problem. In the opening passages of the critique, when considering the 'judgement of taste' he rejects all idea of such judgement being cognitive and asserts that

its determining ground *cannot be other than subjective* . . . To apprehend a regular and appropriate building with one's cognitive faculties, be the mode of representation clear or confused, is quite a different thing from being conscious of this representation with an accompanying sensation of delight. Here the representation is referred wholly to the Subject, and what is more to its feeling of life—under the name of the feeling of pleasure or displeasure—and this forms the basis of a quite separate faculty of discriminating and estimating, that contributes nothing to knowledge.[19]

In Kant's *Critique of Judgement*, then, he is recognizing that, despite the fact that the judgement of taste cannot be brought under rational principles, it still nevertheless has an *a priori* basis. It may well be that his knowledge of the works of the British empiricists Shaftesbury, Hume and Burke now encouraged him to consider a phenomenological approach to the problem of the judgement of beauty. Nevertheless he follows Baumgarten in asserting, unlike the English writers, the independence of this judgement from other considerations; that is, that it is an essentially disinterested contemplation of an object.

Kant's main achievement in this field was that, having accepted both the subjective and the disinterested nature of aesthetic judgements, he was then able to demonstrate that they do nevertheless share a common basis. The recognition of beauty in an object is manifested through the powers of perception being activated and stimulated to an unusually intense and harmonious degree. Although it would be impossible to determine laws or suggest arguments to govern these responses, the unique nature of this kind of relationship between the perceiver and the object is recognizable, and has a general validity. To quote Osborne's paraphrase:

since our faculties of apprehending or perceiving objects do not in principle vary from person to person (although of course empirically we are all differently endowed), our judgements about the stimuli which satisfy and allow full play to these faculties (i.e. about things of beauty) are judgements about the adaptedness of objects to human cognition as such and therefore do not depend on individual variations and differences but claim to be generally valid for all men as such.[20]

More than this Kant does not claim. His concern was with the nature of aesthetic judgement rather than its application. In the preface to the *Critique of Judgement* he describes his enquiry explicitly as 'not being undertaken with a view to the formation of culture of taste (which will pursue its course in the future, as in the past, independently of such inquiries) but being merely directed to its transcendental aspects'.[21] Even in the consideration of these transcendental aspects he is concerned chiefly with the contemplation of beauty in the natural world. The responses aroused by works of art he felt to be of an inferior nature since they were less immediate.

However, even if Kant was in no way setting himself up as an arbiter of taste, his views on aesthetic judgement did reflect the moral and religious background that can be found throughout his critiques. While he remained consistent in denying a moral causality to the judgement of beauty, he had in the last section of the *Critique*

of *Aesthetic Judgement* alluded to a symbolic relationship between beauty and morality. While an object in no way stimulates a sense of beauty *because* it suggests utility or adumbrates a moral principle, the appreciation of beauty contains points of analogy to moral awareness. Colours for example, Kant says, 'excite sensations containing something analogous to the consciousness of the state of mind produced by moral judgements'.[22] He then develops this theme further in an appendix, 'The Methodology of Taste', by suggesting that a 'definite unchangeable taste (as a universal phenomenon)', can only be achieved when 'sensibility is brought into harmony with moral feeling'.[23]

In these last remarks Kant was probably allowing himself an indulgent ride on a hobby-horse, and it was no doubt for this reason that he confined such sentiments to an appendix. For the generation of the 1790s, however, they appeared as a timely discovery. These people were in search of a new intellectual hero. The course of events followed the French Revolution (which broke out a few months before the publication of Kant's *Critique*) seemed to have destroyed for ever the Rousseauian belief that the affirmation of reason and the appeal to natural sentiments were sufficient for the establishment of Utopia. In this context the association of taste and moral feeling with universality threw the whole of Kant's achievement into a new light. To his dismay, Kant saw his views being given precisely that topicality that he had proscribed to them. The assertion of the general validity of aesthetic judgement together with its subjective and disinterested nature made it not merely independent and relevant, but also endowed with authority. Within the Kantian dualism of the observer and the inherent character of that which is being observed, aesthetic judgement was seen as providing a bridge, exalting our faculties to the point where an intimation of universal harmony and the ultimate nature of existence are deduced by means of a sensuous form.

It was such speculation that led the German Romantics to take a strong interest in 'transcendental' aesthetic theories. In the place of Kant's carefully qualified investigations came dramatic speculations often expressed in highly generalized language. It is symptomatic of the situation that the roles played in the formulation of these ideas by novelists, poets, critics and philosophers are difficult to separate.

All these writers were indebted deeply to the playwright and poet Friedrich Schiller, who first brought transcendental aesthetics into the critical arena with the greatest conviction and eloquence. Schiller, whose early plays—in particular *Die Räuber* (1781)—had expressed political sentiments that had gained him honorary membership of the French revolutionary assembly,[24] now adopted a more qualified approach towards the liberation of mankind. Yet it would, as Wilkinson has pointed out,[25] be a misinterpretation to see the outcome of this attitude, Schiller's *Letters on the Aesthetic Education of Man* (originally published in the magazine *Die Horen* in 1793–4), as a retreat from the political events of the period into an aesthetic ivory tower. It was rather an attempt to analyse the cultural predicament of modern man, a predicament that had been brought to a crisis point, though hardly instigated, by the epoch of revolution in which he found himself. Approaching the problem from the point of view of the supreme artist that he was, Schiller was concerned with the

relationship of aesthetic awareness to human destiny and with the function of the artist in society. It was his opinion that both problems were in fact of seminal importance for the ultimate goal of society—the achievement of true freedom. Already in the second of the twenty-seven letters he informs their imaginary recipient of his topical aim:

> I hope to convince you that the theme I have chosen is far less alien to the needs of our age than to its taste. More than this: if man is ever to solve that problem of politics in practice he will have to approach it through the problem of the aesthetic, because it is only through Beauty that man makes his way to freedom.[26]

Clearly Schiller's concept of 'Aesthetics' is of a far more extensive kind than that of his predecessors, and in the course of the letters he points to what he finds inadequate in the previous theories. The position of Baumgarten is confined by its intellectualism— it is one of Schiller's observations that the clue to the whole history of human freedom is that we are creatures of sense before we are creatures of reason—while Kant is found wanting for the limited scope of his inquiry. It is true that Kant established the 'disinterestedness' of the aesthetic response; furthermore, in his insistence on the *a priori* nature of aesthetic judgements, Kant's demand that in aesthetic experience the psyche should delight in the free play of all its faculties was crucially important for Schiller's own concept of the *Spieltrieb* (play-impulse) in aesthetic awareness. Yet at the same time this very 'freedom' for Schiller does not imply lack of involvement or the exclusion of vital or disturbing interests. As he himself remarked in the twentieth letter: 'The scales of the balance stand level when they are empty; but they also stand level when they contain equal weights.'[27]

Through this added weight Schiller endowed aesthetic judgement with the import that Kant reserved for moral judgement. Significantly, while Kant's examples were taken largely from the sphere of nature—such as the smell of a rose— or such uncharged artifices as the arabesque, Schiller's concern was essentially with bringing aesthetic judgement to bear upon spiritual expression and the formulation of experience. The median position ascribed to aesthetic judgement in Kant's dualistic system was now seen as providing the key to man's inmost and most essential state. As Schiller remarked in his review of Matthison's poems, it was this 'musical' aspect of poetry (musical in the sense that music contained this aspect most exclusively) that enabled it to 'symbolize through analogous movements the inner movements of the psyche'.[28]

It was this emphasis on the psychological aspect of the awareness of beauty— already implicit in Kant—that led Schiller to formulate the ultimate significance of the aesthetic response. Viewed in these terms, the awareness of beauty became at the same time self-awareness; and self-awareness the key to the internal harmony that is essential for the achievement of true liberty. Thus the work of art became the communication of an experience that was capable of arousing in man the aesthetic response, giving it free play and achieving a sense of harmonious balance.

In considering the role of the artist, Schiller touches even more deeply on the modern predicament. This problem was considered most fully in a separate essay,

'Die Naive und Sentimentalische Dichtung' (On Naïve and Sentimental Poetry), in many ways his most significant work for the Romantics, since it made an irrevocable distinction between the classical and modern world. In this essay the 'naïve' Greek is seen as possessing a sense of harmony that has become lost in the modern world.

In the 'Aesthetic Letters', Schiller arrives at the conclusion that, just as knowledge has driven man from the Garden of Eden, it is also through this knowledge that he must return, with full consciousness, to the harmonious state. There is no possibility of creeping back to the simple life and primitive society of classical Greece. Man must achieve harmony and awareness in the midst of the destructiveness of modern life; and to achieve this the aesthetic response is essential. The artist in such a society takes on the role of seer, who can re-awaken in his contemporaries a vision of the primal harmony and bring it into the midst of their existence. In the ninth letter he writes:

> The artist is indeed the child of his age; but woe to him if he is at the same time its ward or, worse still, its minion! Let some beneficent deity snatch the suckling betimes from his mother's breast, nourish him with the milk of a better age, and suffer him to come to maturity under a distant Grecian sky. Then, when he has become a man, let him return, a stranger, to his own century; not, however, to gladden it by his appearance, but rather, terrible like Agamemnon's son, to cleanse and to purify it. His theme he will, indeed, take from the present; but his form he will borrow from a nobler time, nay, from beyond time altogether, from the absolute, unchanging, unity of his being.[29]

Thus created beauty, and consequently the role of the artist, becomes of the utmost significance to man through its content. Not by the content of subject, which provides no more than information—and which in propagandist art attempts to instruct and convince rather than enlighten—but by the content of form, which comes from the 'absolute unchanging unity' of the artist's being, and which touches the recipient's inmost self and arouses it to active, creative and free participation.

Through establishing the primal and essentially free nature of aesthetic experience, Schiller had resolved the paradox whereby aesthetic judgement, apparently the most extraneous of man's activities, becomes the most fundamental to the achievement of true liberty.

Both of the twin themes that became illuminated during the course of Schiller's argument—the relationship of insight to action, and the relationship of art to political activity—were to remain central to aesthetic thought for the Romantics in Germany. However, it was the former that was in the first place to predominate. Amongst the circles of the self-styled Romantics towards the turn of the century— in particular the Schlegel circle in Dresden—attention was directed primarily towards the identity of the artist, and the nature of his revelation, rather than towards his social role. Just as Fichte was to isolate the subjective side of Kant's transcendental system, so these writers were essentially interested in art as the embodiment of a supernatural ideal. Like Schiller they emphasized the aspect of the

artist as prophet/genius whose insight was unique and communicated a sense of the infinite that was beyond common experience. However this glimpse of the infinite was more valued for itself than for its ennobling effect upon man and the course of his actions. By extension it was seen as being more real, and therefore more valid, than the visible and immediate world. For the writer Novalis, poetry became 'a genuine and absolute reality. This is the gist of my philosophy. The more poetical, the more true.'[30]

The ideas of the Schlegel circle received their most philosophical formulation in the writings of Schelling. For him, the revelatory nature of art was of such importance that 'aesthetic intuition' (the substitution of 'intuition' for Kant's 'judgement' is significant) occupied the central position in his *System des Transcendentalen Idealismus* (System of Transcendental Idealism) of 1800.

Schelling's preoccupation with the artist as the creative agent that brings into being 'reflected images' of the infinite was such that it became essential to him to underline the distinction between the awareness of beauty in nature and of beauty in a work of art. In *Über das Verhältnis der bildenden Künste zu der Natur* (Concerning the Relationship of the Visual Arts to Nature), a lecture delivered to the Royal Academy of Sciences at Munich in 1807 and published a year later, he demonstrated this by taking as an example the pictorial arts, in which mimetic qualities had traditionally been considered to be the supreme criterion. Creativity is for him the key to the distinction. It was a critical part of his 'nature philosophy' (*Naturphilosophie*) that one generative spirit permeated the whole of creation—a pantheistic view that owes as much to the mystic Boehme as it does to the metaphysics of Kant. What distinguishes this creativity in man from its existence in the rest of nature is that in man it achieves a conscious expression. While this consciousness is for all men brought into being through reflectiveness, the artist takes this awareness of the spirit one stage further and makes it productive. It is through this productivity that the two aspects of the spirit—the conscious awareness of man, and the unconscious energy which he shares with nature— become united. While conscious awareness gives him critical power and knowledge, it is the unconscious urge that provides the drive to create. Since both the artist and nature are urged to creativity by the same force, then the relationship of art to nature should not be one of imitation, but of parallel activity. The artist should above all be intuitive, should emulate 'the spirit of nature working at the core of things . . . and only so far as he seizes this with vital imitation has he himself produced anything genuine'.[31]

This statement has since been taken as a rationale for non-figurative art; and indeed the idea of parallel creation was made use of by Paul Klee in his essay *On Modern Art*.[32] However, while this essay (and indeed much of the idealism of German Romantic theorists) has subsequently proved stimulating to twentieth-century artists, it must be remembered that these theorists' conceptions remained imagistic. Perhaps because of their own literary background, the visual arts were seen by them essentially as a language. Such words as 'symbol' and 'hieroglyph' frequently occur in their discussions as indications of the cabbalistic quality that visual imagery held for them. They were seeking more rather than less content in the

forms created by the artist; and above all they were seeking intimations of the eternal and universal. Beauty, for Schelling, was 'the finite representation of the infinite'.[33]

Such an idealistic concept of beauty comes close to the traditions of neo-Platonism. Yet while Schelling and the Schlegels evidently drew much from the views that they encountered in Bellori and Winckelmann, their mystical leanings led them to take a greater interest in the actual relationship of the visible to the non-visible, than in the manifestation of an ideal. Visualization was for them only a partial achievement. The emotion that beauty aroused gave an intimation of the infinite, but it was not in itself an embodiment of perfection.

Schelling's essay was significant for applying his *Naturphilosophie* to a problem that related directly to the visual arts. Yet despite its importance in the history of aesthetics, its immediate impact on fine art theory was not large. Although much of the content of *Über das Verhältnis der bildenden Künste zu der Natur* seems highly sympathetic to the ideas of Friedrich and Runge, there is no evidence that either of these artists had read it. In his one active participation in the creation of a work of pictorial art—the assistance to Cornelius and Klenze in the preparation of a programme for the murals in the Glyptothek in Munich[34]—Schelling seems to have been mainly occupied with providing an account of classical mythology that would harmonize with a Christian interpretation of historical development. It would probably be true to say that Friedrich, Runge and the Nazarenes, like Schelling, synthesized many of their views from the more voluminous and excitable writings of those authors and critics in the Schlegel circle that were known to all of them. For while Schelling may have been more important as an aesthetician, it was the Schlegels and their associates who were the major propagandists of Romantic art in Germany, and who were in later years to become known abroad as the principal representatives of German Romanticism.

Although the writings of this circle on the visual arts were not their main production, it was far from being an inessential one. Even more than for Schelling, the visual arts occupied an important position in their aesthetic and cultural theories. In many ways they were consciously continuing in their art criticism the tradition of the eighteenth-century essayist;[35] a tradition quite distinct from the concerns of the aestheticians of the period. Yet the Schlegels were doing more than applying the novel and highly fashionable 'transcendentalism' to established literary genres. The pictorial arts also attracted them for the qualities that seemed to adumbrate Romantic attitudes. That sense of continuation, striving, and incompletion embodied in Friedrich Schlegel's famous 'Fragment'[36] seemed to find a peculiar resonance in the visual arts. Since their interest was more in evocation than embodiment, their emphases were more on the sensuous than the intellectual. Painting and Gothic architecture seemed to contain these to the greatest degree, and even before any Romantic theory was attempted, they were attracting a new kind of attention. It is a change of approach that made Wackenroder's *Herzensergiessungen eines Kunstliebenden Klosterbrüders* (Heartfelt Effusions of an Art-loving Monk) of 1797 of such significance for his generation.

While it is true that this book constituted no 'discovery' of pre-Raphaelite art—his information was largely based on such well-known accounts as Vasari and Sandrart—it does suggest a new attitude towards the appreciation of painters and their work. For Wackenroder, devoutness, deep emotion and aspiration become as important in the artist as achievement itself. This approach is made clear not only in the simplified and highly charged language with which his narrator monk writes, but also in his interest in the biographies and personalities of the painters whose work he describes. Even Raphael is valued as an aspirant of the divine more than he is valued as the creator of supreme grace; while Dürer, his inferior in achievement, is depicted joining hands with him in a celestial vision, by virtue of his devoutness and industry. The final essay, which actually deals with the life of a fictitious musician, Joseph Berglinger, completes this approach; for the artist here is one whose aesthetic sensibility is so intense that he is unable to express it in his art at all.[37]

Indeed this last essay of Wackenroder's pinpoints the major problem in the consideration of art as a spiritual emanation. If the work of art is to be seen in terms of intention, it is, as Eastlake found when looking at the work of the Nazarenes, impossible to criticize the manifestation. Even if one rejects, as Wackenroder did, the apparatus of academic criticism (the assessment of a work according to the degree that it achieves certain set qualities), there is still the question of how the work itself can be approached. Wackenroder's own method of enthusiastic evocation may have been stimulating, yet it appealed essentially by being itself a work of art, one that translated the experience of a picture into literature. Therefore, while many found Wackenroder's example inspiring, they were left by him to make their own way towards a new understanding. Amongst those who came forward as their guides, none were more widely appreciated than the brothers Friedrich and August Wilhelm Schlegel.

While being fully aware of the personal nature of aesthetic experience, the Schlegels did not accept intention as a substitute for achievement, or believe that relativism implied the suspension of judgement. Nevertheless they realized that judgement depends first upon the position of the critic himself, and that he must be aware of this if he is to enter into a balanced relationship with the object he is contemplating. 'Almost all judgements on art are either too general or too specific', declared Friedrich Schlegel. 'The critic should look for the golden mean here in his own productions, not in the works of the poets.'[38]

Of the two, A. W. Schlegel was the less original. Yet he was the more influential since he was able to formulate the criteria of Romantic criticism in a clear, concise form. Thus in his highly popular *Vorlesungen über dramatische Kunst und Literatur* (Lectures on Dramatic Art) of 1808 he is able to chart in the opening paragraphs the provinces of aesthetics and criticism, and to show the key position of the latter for relating theory to practice:

Aesthetics, or the philosophical theory of beauty and art, is of the utmost importance in its connexion with other enquiries into the human mind; but, considered by itself it is not of sufficient practical instruction; and it can only

become so by its union with the history of the arts. We give the appellation of criticism to the intermediate province between general theory and experience or history. The comparing together and judging of the existing productions of the human mind must supply us with a knowledge of the means which are requisite for the conception and execution of masterly works of art.[39]

In establishing the position of criticism, Schlegel clearly separated it from connoisseurship; for he held that everything should be judged relatively rather than absolutely. Such relativism also involves another vital change. This is the emphasis on the historical process. However, this latter point only emerges gradually in his work.

In his essay 'Die Gemälde' which appeared in the Schlegels' periodical *Athenaeum* in 1798 August Wilhelm had already demonstrated the principle of relativity in criticism brilliantly. The work, which is a discussion on art based on pictures in the Dresden Gallery, takes the form of a conversation between three individuals, in which their differing approaches, each dependent, as the text makes clear, on their differing characters and preoccupations, are expressed and become mutually enlightening. The emphasis here is on free expression rather than dialectics. Ideas and feelings are explored, but it is the exploration itself that is important, rather than the achievement of any conclusion. In the end the three figures—Reinhold, the artist, Louise, the *femme du sensibilité*, and Waller, the scholar and critic (probably a portrait of Schlegel himself)—contribute three totally different accounts of the *Sistine Madonna*, the crown of the Dresden collection.

In this relatively early work, August Wilhelm was exploring new forms of describing and discussing pictures and, as with Wackenroder, it is the attitudes that emerge, rather than any innovations in taste, that are significant. His future writings on the visual arts retained this character. Works interested him when they suggested new associations or illuminations—as, for example, when Flaxman's *Outlines* suggested to him a genre whose synoptic method was ideally suited for the illustration of poetry.[40] Yet Schlegel's relativism, when applied to a more general consideration of the problems of aesthetic awareness and the nature of the work of art, led to a much greater achievement, to the understanding of works of art in terms of change and development, terms that still underline the nature of art historical enquiry.

It was in his Berlin lectures of 1801-2 that he gave this approach its fullest exposition.[41] Like Schelling and the other romantic theorists he began by emphasizing the full autonomy of aesthetic awareness, stating 'Beauty is from the standpoint of necessity purposeless, because it has an absolute necessity.'[42] Furthermore, he borrowed Schelling's definition to locate this 'absolute necessity' as the intimation of the infinite through sensuous experience: 'Beauty is the symbolical representation of the infinite.' The change of 'finite' to 'symbolical' emphasizes Schlegel's own greater interest in contracted meaning and intuitive association. He thought of beauty as a sign or revelation.

But Schlegel was no less sympathetic to the idea that this sign was also the witness of an individual attempt to fuse matter with the spiritual. Behind each work of art

was an artist who had sought an individual solution. This was an aspect that had not been of primary importance to Schiller or Schelling. While these theorists acknowledged the spiritual struggle of the artist, they were less concerned with the question of whether each manifestation was in fact a description of a similar struggle or was a solution that was essentially unique.

It was this question that led Schlegel to explore the different characters of different types of art, and to consider these in a historical and geographical context. Schlegel was, of course, no pioneer in this approach. It had been one of the major arguments in Winckelmann's work that the unique achievement of Greek art was dependent upon climate and social conditions. While Winckelmann had used these arguments to urge special attention to the supremacy of Greek art, other were able to follow his association through to quite different conclusions. Since Greek art was the product and expression of the unique characteristics of a certain time and place, then their art could not be repeated elsewhere. Rather, the lesson of the Greeks was that each age and nation must discover its own unique expression. It was this consideration, too, that had led Herder to postulate in *Ideen zur Philosophie der Geschichte der Menschheit* (1784–91) that each nation has its own unique culture dependent upon its own character and experience. Yet the relativism of Herder had not been absolute. For he also expressed sympathy for a general progress towards the achievement of an enlightened humanity; a vision that he shared with Schiller. For Schlegel, progress, too, was present. For him, however, the goal was a mystical rather than humanitarian one; the increasing manifestation of the infinite. It is this that leads him to establish that the modern world is not only qualitatively different from the ancient, but is actually in its fragmentation a further step towards the spiritual. By these means he is able to retain both the idea of the separate characteristics of each art and the concept of a general progression.

Such an approach is not, strictly speaking, an individual one. While the artist before was measured by a universal norm, he is now seen as the spiritual expression of his age. In this one finds the embryo of the concept of *Kulturgeschichte* that was to be definitively stated by Hegel. Indeed Schlegel himself became so concerned with the artist as symptomatic of his age (symptomatic in form of expression, rather than the quality of that expression) that he went as far as to suggest the writing of a 'history of art without names'[43]. Fascinated as ever by associations, he also attempted to arrange the different forms of art in the light of this spiritual progression. Taking the polarities of space and time he created a hierarchy from the material to the ethereal which ascended from sculpture to poetry. These associations are more ingenious than enlightening, and are perhaps most notable as an early example of the dangerous kind of exegesis that the study of history in terms of cultures can lead to. Yet one more of these associations must be mentioned since it was to become widely quoted by the apologists of mediaeval art. Taking up a remark of Hemsterhuis[44] in which this critic remarked in reference to Bernini and Pigalle that sculpture seemed more suited to the world of the ancients and painting to that of the modern, Schlegel developed the idea of each being uniquely characteristic of its respective age. In the development towards the awareness of the

75

spiritual, the Antique world had achieved a level of perfection which expressed beauty as a physical embodiment. They thus achieved a harmony that was perfect in its own terms but incapable of extension to a higher degree of spiritual awareness. Sculpture, which is three-dimensional, material, and limited in its extension, was therefore the perfect medium for expressing a purely physical beauty. The modern world, on the other hand, having achieved through Christianity a direct revelation of the eternal tends always towards a more aspiring and immaterial expression. It is this that explains the difference between the Greek temple and the Gothic cathedral, and which also makes painting uniquely suited to the modern world. For it is the ambiguities caused by creating a two-dimensional account of a three-dimensional experience, the evocative effects of colour and indeterminate space that makes painting capable of the suggestiveness necessary to adumbrate the spiritual in terms of the material.

In this account Schlegel has taken the positive side of Schiller's analysis of the modern spirit and seen it as dynamic, aspiring and progressive. Although he quoted Gothic architecture as one example of such aspiration, he did not limit his interest to the Middle Ages. In painting, this spirit was associated with the artist of the High Renaissance and the seventeenth century, in poetry, with Shakespeare and Calderon. The essential quality of all such art was that its evocativeness and individualism made it anti-classical. His arguments support a more exclusive taste for pre-Renaissance painting; for in the years following his sojourn in Dresden, Friedrich Schlegel was increasingly won over to the developing vogue for mediaevalism.

For Friedrich Schlegel, a more emotional man than his brother, this enthusiasm was no passing fashion. Inspired by Wackenroder and Novalis, he came to associate the 'universal striving' of Romanticism with the character of mediaeval Europe. The progressive modern spirit of European society now appeared to him to have become spiritually stunted by the Reformation—an opinion that eventually led him to convert to Catholicism.

This new conviction stimulated Friedrich Schlegel to develop a critical interest in the visual arts. Equating the Protestant 'decline' with the secular mood of the Renaissance, he felt the true course of modern art to have been obstructed by this sudden lapse into paganism. A visit to Paris—where he studied the vast collection of treasures plundered during Napoleon's campaigns that had been assembled in the Louvre—provided him with the opportunity of extending his art historical studies, and confirmed him in his convictions. His impressions, together with those formed on a subsequent tour of the Netherlands, were published immediately in a series of letters in his magazine *Europa*.[45] In these, Schlegel consistently praises the Italian and Northern primitives at the expense of later schools. In the first letter he gives explicit reasons for his preferences, in which he shows himself true to the principles of Romantic criticism. It is not the 'universal form' of Schiller that Schlegel is seeking, but the expression of content. The earliest artists, inhabitants of an age of faith, used a simple manner to express subjects of devotion without artifice and guile. Thus one finds in their work

No confused heaps of men, but a few, isolated figures, executed with a diligence worthy of the dignity and holiness of that greatest of hieroglyphics, the human body; severe forms, contained in sharp and clearly defined contours; no chiaroscuro of dirt, murk and shadow, but pure relationships and masses of colour, like clear accords; garments and clothes which really belong to the figures, and are as simple and naïve as they are; and in the faces, where the light of the divine spirit of painting shines most radiantly . . . that childlike, kindly simplicity which I am inclined to regard as the original character of mankind.[46]

Such an account seems far from the assessment of painterly qualities that August Wilhelm Schlegel had seen as epitomizing the modern spirit. Yet if Friedrich Schlegel rejected the enigmatic properties of 'contrasts of effect, produced by blending chiaruscuro and dark shadows' he extends his brother's interest in the enigma of interpretation. Just as August Wilhelm saw beauty as being symbolical, so Friedrich talked of the human form as a hieroglyph. While the classicists were concerned with the beauty of the whole body, Friedrich Schlegel was more interested in the evocative expressions of the face, a preference that he was to share with the Nazarenes.

Yet even this interest in the associative and symbolical quality of art shows Friedrich Schlegel to be more dogmatic than his brother. It is not enough for him that pictorial imagery should be evocative; it had to be evocative within an accepted body of belief. Otherwise, instead of being spiritually uplifting, it would merely be confusing. Friedrich Schlegel makes this clear in the closing paragraphs of his letter, in which he turns the discussion to a consideration of how the modern artist should work in the light of the example of the ancient masters he had been discussing. Describing the path 'by which this high spiritual beauty will become possible and attainable for art', he warned against the creation of

works of a completely new kind . . . hieroglyphs, symbolic images, drawn from feelings, insights or intuitions about nature arbitrarily put together, rather than composed according to the methods of antiquity.

This method, he continues,

is surely the more dangerous. Its consequences are fairly predictable, especially if it were to be tried by various artists of unequal aptitude; the results would resemble what has lately been happening in poetry. It is safer to follow the old masters completely, particularly the oldest, assiduously imitating the truths and beauties in their works, until these become second nature to the eye and mind.[47]

Whatever its intentions, such a doctrine appears now as the epitome of aridness; especially when one discovers that Schlegel used it when revising this essay in 1823 to castigate Runge's 'Tageszeiten' outlines. To his contemporaries, too, there was no doubt that the path that Schlegel advocated was indeed that of the painstaking revivalism later followed by the Nazarenes; and it was completely appropriate that Schlegel should in later life have become one of their strongest defenders, publishing

77

in 1820 a review of the Cafarelli exhibition of 1819 that opposed the allegations made by Meyer in the article 'Neu-Deutsch Patriotische-relïgiös Kunst' in *Kunst und Alterthum* in 1817. When contrasted with Friedrich Schlegel's *Athenaeum* 'Fragment', which hailed Romantic poetry as 'universal progressive poetry', it would seem that these later writings comprise a complete reversal of his original position. Certainly they signify a retreat. He had lost confidence in his own age to the extent of doubting whether a truly spiritual path could be pursued in it through individual initiative alone. However, in doing so, he was also pointing to a genuine problem of communication which has since become a commonplace in modern art—the separation of the artist who pursues an 'individual path' from the understanding of his contemporaries. In calling for artists to revive a language of universal currency, Schlegel may have been asking the impossible, yet his demand at least deserves sympathy. Furthermore, Schlegel did not envisage this revival of a traditional language as the copying of a dead tongue, but rather as the continuation of a tradition. Thus he sought to separate the technical naïveties of the 'primitives' from their spiritual purity, rejecting the idea that the nineteenth-century artist should imitate the former as well as the latter. In his review of the Cafarelli exhibition he wrote,

> Still any student who attempts to take as models of design, perspective, the structure of the human face, or whatever belongs to the scientific elements of painting, those first stars of dawning light in Western Art, and servilely imitates or rather counterfeits their finished productions, must be abandoned to the consequences of his own folly.

In fact, Schlegel believed that the re-introduction of old themes through the greater technical resources of the nineteenth century would lead rather to a progression towards an art suitable for the modern age:

> if a model be well and judiciously chosen, the true path should lie not back upon itself, but progressively onwards to a new perfection of art, reproduced from the bosom of antiquity, yet nevertheless fresh, living and blooming; a new art meet for the new time.[48]

This view, too, he shared with the Nazarenes. It was their intention to re-establish a tradition rather than to retire. Yet even if Schlegel's theories had not in fact lost their progressive intention, his road to the future now seems less in evidence than the mediaeval crossroads at which it was supposed to have diverged from the course of recent centuries.

Important though both Schlegel brothers were for drawing attention to the interrelationship between the specific manifestation of an art and the society that produced it, it was a philosopher, Hegel, who was finally to produce from these observations the coherent scheme that even today, as Gombrich has recently pointed out,[49] underlies the assumptions of the cultural historian. Through the medium of dialectics, the concept of *Zeitgeist* assumed the dimensions of historical necessity. Hegel's lectures on aesthetics[50] view art in a perspective borrowed from the

Schlegels, and common to all advocates of 'Christian Art'. It is a development that sees the arts in European society evolving from the purely material, the limited expression of the Egyptians; to the physically perfect, the art of the Greeks; and finally to spiritual expression in the art of modern Europe. Even Hegel's terminology for these three phases—the symbolical, the classical and the romantic—bear close affinities to those used by August Wilhelm Schlegel in his Berlin lectures.[51]

Unlike the Schlegels, however, there are no false paths for Hegel. The system of thesis, antithesis and synthesis provides for the assimilation of apparent contradiction into a continuous progress towards the self-realization of the spiritual in which art, just as much as other emanations of the *Zeitgeist*, plays its inevitable part;

> And therefore, what the particular arts realise in individual works of art, are according to their abstract conception simply the universal types which constitute the self-unfolding Idea of beauty. It is as the external realization of this Idea that the wide Pantheon of art is being erected, whose architect and builder is the spirit of beauty as it awakens to self-knowledge, and to complete which the history of the world will need its evolution of ages.[52]

Despite the influential nature of this view of art as spiritual history, its complacent optimism could not be shared by the Schlegels or the Nazarenes. Regeneration remained for them a conscious and deliberate gesture rather than the next inevitable stage in self-realization. Thus the art historian Rumohr, whose *Italienische Forschungen*[53] represent the first significant gain to scholarship of the theory of cultural interrelation, could use the principle of development and modulation to establish a comparative classification of early Italian art, while at the same time lamenting even the limited humanism in Giotto's art as a deviation from 'die Ideen des Christlichen Alterthums'.[54] Important though Rumohr's study was for the development of an approach to early Italian art within a historical context, his ideology remained absolutist. It was still of relevance to him to contrast a spiritual past with a barren present.

It was the Schlegelian thesis rather than that of Hegel that made it seem possible to observers in the early nineteenth century to accept both that an art form was uniquely expressive of its age, and that it was possible to regenerate society by the re-absorption of the principles of a more fortunate epoch.

By 1830 it seemed to some observers that a living proof of this thesis could be found in the recent developments that had taken place in Munich. For in Ludwig's 'art city', 'aesthetic education' was conceived not so much in terms of Schiller's spiritual liberation as in terms of a return to a state of harmonious docility that was supposed to have existed in the idyllic Middle Ages. Indeed Ludwig's belief in the power of art was so strong that, according to Rudolph Lehmann, he even revived a mediaeval statute that required political offenders to beg forgiveness before his painted portrait.[55] Under these circumstances the monumental murals commissioned from Cornelius and his followers not only fulfilled a time-honoured tradition as propagandist paintings; they also demonstrated the culmination of European

civilization. Through the reproduction of architectural masterpieces—such as the Feldherrnhalle, a copy of the Florentine Loggia dei Lanzi—and styles from ancient Greece up to the Renaissance, the city became a living history of architecture. Furthermore, museums and art galleries were arranged on a didactic basis. The organization of works of art in chronological sequence and according to schools had already been established in the Musée Napoléon.[56] In Munich, however, such an arrangement was accompanied by a pictorial and architectural exegesis. Each form of art was allotted a separate museum in keeping with its particular characteristics— the Glyptothek naturally being in the Greek style and the Pinakothek in that of the High Renaissance. Furthermore, each building was adorned with sculptures and frescoes which expounded the significance of the works it was housing. In the Glyptothek, for example, the chronological development of Greek was interrrupted by a central *Göttersaal*, in which Cornelius's frescoes arranged classical legends describing the interaction of man and the Gods in such a way that not only suggested the divine nature of artistic inspiration, but also portrayed antiquity as the forerunner of Christianity.

It was completely in keeping with this evolutionary approach that a room should have been preserved in this building to receive the sculpture of the future, and that the King should have constructed a Neue Pinakothek to perform a similar function for painting.

The phenomenon of Munich is perhaps a sorry conclusion to an initiative that had attempted so much to reach a deeper understanding of the nature of the visual arts. When considering the art of such painters as Wilhelm Kaulbach, one would seem to have no more than a particularly tedious example of the artist working as part of the propaganda machinery of the state. Yet while this aspect was certainly present in the art of Munich—and as such makes it in no way different functionally from the art of Napoleonic France—there remained in the thoroughness of the exposition some vestiges of a more unique aim emphasizing art as a contemplative process with an educational and liberating aim. In this at least, the term 'Mind of Art' can be taken to mean more than simply an absence of sensuous qualities.

<p style="text-align:center">★ ★ ★</p>

For English commentators at least, the art of Munich was the visual manifestation of the new philosophical interest in the art of painting. As the spate of publications show,[57] many of these aesthetic writings were available to the non-German specialist by the late 1840s, and there is much evidence to suggest that they were widely read. However, these translations were the response to an interest, rather than its initiation. To trace the sources of this interest it is necessary to consider the development of the knowledge of contemporary aesthetic ideas prior to 1840 and the use that had been made of them by English critics and theorists.

The influence of German post-Kantian aesthetics in English critical writing of the early nineteenth century came at a time when little original art theory was being propounded in England. For there had been little to follow the enormous impact of

such eighteenth-century philosophers, critics and artists as Shaftesbury, Burke, Reynolds and Alison.

To some extent this situation reflects the direction that British philosophy took at this period. The development of empiricism and utilitarianism towards the end of the eighteenth century left English and Scottish philosophers as unsympathetic to speculation on the transcendental nature of aesthetic experience as they were to all other aspects of Kantian metaphysics. Indeed English philosophers remained uninterested in the independent consideration of aesthetic problems until the generation of T. H. Green (1836–82) and Bernard Bosanquet (1848–1923).

In the sphere of criticism there was, similarly, a lack of interest in the development of relativism or the notion of cultural history. As late as 1840 Horne contrasted the 'analytic' approach of the English to the 'synthetic' method of A. W. Schlegel in his introduction to the German's *Lectures on Dramatic Art*.[58] Two decades later, when the influence of German theorists had become commonplace, G. S. Layard paid tribute to the changes that they had brought about in an article in the *Quarterly Review*:

> They were, however, the first to point out the importance of art to the philosophical study of the history of the human mind and, consequently, of human civilization. They first treated the fine arts as outward manifestations of the various phases of man's development and of the condition of society at any given period, showing how they followed the course of this development and did not in any way promote it.[59]

If the absence of independent English philosophical and critical comment on aesthetic and relativistic problems makes ideas derived from German sources all the more discernible, it also makes the course of their development more sporadic. Each of the English writers who did take an interest in the ideas of the Germans before the mid-century tended to do so for differing and highly personal reasons.

It is perhaps appropriate therefore that the first association of Kantian ideas with the fine arts in this country was so idiosyncratic that it seems to have little bearing upon future developments. The English-born Henry Richter, son of the Saxon engraver John Augustus Richter, became an enthusiast for Kant even before the philosopher's *Critique of Judgement* was known in England, and appears to have made his own associations between transcendentalism and the fine arts. His introduction had been through Dr Wirgmann, who delivered a series of lectures on Kantian philosophy in London in 1795, after which 'the abstruse study of transcendental philosophy was his chief passion, and engaged his attention for more than fifty years'[60] up to his death in 1848. This interest would seem at first to be at variance with Richter's career as a moderately successful painter of humorous genre subjects such as *The Village School in Uproar*.[61] However, Richter was evidently a man who enjoyed discrepancy, for he chose to publish his views on Kant as an appendix to his book *Daylight: A Recent Discovery in the Art of Painting*, (1816) a treatise demonstrating the effect of the diffused light of the sky upon objects seen in the open air. In this appendix he argues the Kantian case on the basis that, since art is no longer

81

of use to 'state or church', it must assume a new value as the servant of reason and truth. If these sentiments seem to correspond to those expressed by Schiller, Richter's exposition, though spirited, is less convincing:

> Painting seems indeed to speak to the SENSE, while she appeals to the IMAGINATION: rousing, at the same time, the UNDERSTANDING, the nurse and early preceptor of the FANCY, who flies to protect her pupil. In vain the harsh censure of the rigid JUDGEMENT thunders in her ears; REASON, awaking at the well-known sound, casts down the lightening of HIS glance from the eminence on which he stands still by the aspect of the MAN–GOD, the wrangling logician is silent, and art ventures to make her last humble but successful appeal to REASON itself—that JANUS who standing upon the isthmus of two worlds, with one mortal and one immortal hand seizes the bright sceptre of a CELESTIAL FREEDOM, to extend the glory of its rule over dark NECESSITY OF NATURE.[62]

It is difficult to decide whether Richter intended this account to be as comic and chaotic as it sounds. However, he certainly saw the art of the future as one in which humour would predominate. His understanding of art as the union of the sensual and the intellectual led to a rejection of such neoclassical painters as David for their apparent rejection of the former. The union must take place, he argued, through the study of nature. Similarly, the subject matter of the artist should be contemporary rather than historical, for it was the inventiveness of art within the commonplace that was to become the ennobling force. For this reason he placed Hogarth at the head of a new tendency in art and strove to be his successor. Even when dealing with a philosophical subject, as in the obscure *Logician's Effigy*, the work has the appearance of a genre painting.[63]

It would be easy to dismiss Richter for his eccentricities; certainly he was regarded with amusement by his contemporaries. Yet, if he may well have done more damage than good to the reputation of his mentor, one must remember that he was also an associate of Varley and Linnell and was known to Blake and Palmer. Indeed he is recorded as having helped Blake, whom he met around 1813, to a 'greater fullness and depth of colour'.[64] Although this is difficult to credit, Blake may well have been sympathetic to the ideas of Richter's mentor. Certainly the 'transcendental' element in Blake, which makes the opening lines of 'Auguries of Innocence', for example, so close in sentiment to Novalis's 'transcendentalization of the everyday object',[65] was noted by his earliest commentator, Henry Crabb Robinson, in his essay in the Vaterlandisches Museum of 1810.[66]

It seems curious that Fuseli should have taken so little interest in Kantian aesthetics; for he evidently had the background and intelligence to come to grips with the new German ideas. However, Fuseli, despite his expressionistic proclivities, was very much an eighteenth-century pragmatist in his thinking. He had a deep distrust of metaphysical speculation which he expressed in 1801 in his *Lecture on Painting*: 'Of beauty I do not mean to perplex you or myself with abstract ideas, and the romantic reveries of platonic philosophy, or to inquire whether it be the result of simple or complex principle.'[67]

Although this is presumably directed against neo-Platonic theorists, it does also help to account for his lack of interest in recent aesthetic and critical developments in Germany. He does, it is true, make a reference to Herder's *Philosophy of History*. But this was of the most fleeting kind, and was no doubt a tribute to the writer as one of the mentors of *Sturm and Drang* rather than for his more recent ideas.[68]

The emphasis on artistic automony and the unique nature of the man-created work of art were factors that were developed in England more strongly at first by writers and critics than by artists. Robinson himself may have been the first Englishman to have used the word 'aesthetics',[69] yet it was Coleridge who, having been gripped by Kant 'as with a giant's hand' and being equally impressed by the works of Schelling,[70] first attempted to bring his aesthetics to an English audience in his apologia, *Biographia Literaria*.[71]

It can certainly be demonstrated that many of Coleridge's key notions are developed from the ideas of German theorists. The differentiation between 'Fancy' and 'Imagination' derives from the Kantian distinction between productive and reproductive imagination, the belief in the necessity of conflict in the process of artistic creation from Schelling, and the view of artistic development as an organic process from Schelling and A. W. Schlegel.[72] He can also be shown to have borrowed extensively from A. W. Schlegel's *Lectures on Dramatic Art* for his own Shakespearian criticism.[73] However, the ideas that he developed from these sources were very much his own and cannot be seen as an exposition of German aesthetics. His brilliant and allusive thoughts, while deeply stimulating, did not in any case lead to any systematic development of a new school of criticism.

During the 1820s a more strenuous and explicit defence of German aesthetics and criticism emerged in the essays written by Carlyle in the *Edinburgh Review*.[74] Carlyle's opinions on the value of the new German criticism have already been quoted, and his claims were soon to become a common debating point. The very word 'aesthetics', which Carlyle supposed English writers 'might also well adopt, at least if any such *science* should ever arise among us',[75] already appeared in a popular English work of reference, the *Penny Cyclopaedia*, in 1832; although it was noted that the term was used principally by German writers.[76]

Meanwhile opposition to the concept was to harden into two objections: one concerned with connoisseurship and one with morality. It was considerations of the former that led Mrs Callcott when reviewing German art scholarship to express indignation over the 'absurd notion, that those who know nothing practically of a subject, are the best judges and instructors of it'.[77] Moral opposition centred on the concept of artistic autonomy. It received its strangest exposition from Ruskin, who confused autonomy with the amoral 'art for art's sake' of the aesthetes.[78]

In view of such objections, it is perhaps not surprising to find that it was the revivalist element in German aesthetics that first began to make lasting impression in this country. British artists and connoisseurs had indeed played an active part in the development of a taste for the primitive that spread across Europe from Rome in the late eighteenth century,[79] but, despite the researches of Ottley and the enthusiasm of Blake and his circle, there had been no coherent defence of the reappraisal of

mediaeval art of the kind that one finds in the writings of Friedrich Schlegel.

There is perhaps one exception to this situation, in the sculpture lectures of Flaxman, first delivered at the Royal Academy in 1812, and posthumously published in 1829.[80] In these, Flaxman's enthusiasm for mediaeval sculpture, his deep religious sense and undeviating nationalism led him to an equation for English sculpture similar to the one that the Schlegels had made for German painting. In his first lecture he went to great lengths to show that there was a flourishing indigenous school of English sculpture in the Middle Ages, and then continued to ascribe the decline of the art in this country to the detrimental effects on church art of the Reformation. Furthermore, he was in no doubt as to the superiority of Christianity as an inspiration for the visual arts over classical antiquity. The editor of the *Kunsblatt*, Ludwig Schorn, who visited the sculptor in the last year of his life in 1826, published an account of their conversation in which Flaxman is quoted as having said that the purpose of his lectures had been precisely to emphasize this value of Christianity for the arts:

> It was the purpose of my academy lectures to show that art under Christianity was superior to that of paganism, since Christian ideas are more sublime than heathen ones; and the best that the Greeks and the Romans produced is also available to the mind in Christian presentations—as the Apocalypse demonstrates so magnificently.[81]

One is reminded in this preference for Christian themes and the suggestion that the best themes of antiquity foreshadow those of Christianity: of the approach of Cornelius to the decorations of the Glyptothek or of the upper regions of Overbeck's *Triumph of Religion*, in which vistas of half-realized compositions are depicted to suggest 'the pictorially rich character of Religion'.[82] It is perhaps not so surprising therefore that Flaxman should have been one of the earliest English admirers of the work of Cornelius.[83]

Flaxman's exclusive championship of Christian art might seem contradictory in view of the more ambiguous nature of his actual sculpture. Yet there can be no doubt of the sincerity of his opinions or of his attempts in later years to devote himself increasingly to Christian and national subjects.[84] His position was one that was shared by the sculptor Thorwaldsen, a close friend of the Nazarene Wilhelm Schadow, who also felt the contradictory attraction of classical form and Christian subject. It was a contradiction implicit in revivalist theory, and specifically referred to in the evaluations of sculpture and painting that had been made by A. W. Schlegel in his Berlin lectures.[85] Whatever Flaxman may have said in his lectures concerning the value of Christianity as an inspiration to sculpture, one finds him in agreement with Schlegel's opinion when it was put to him by Crabb Robinson in 1812.[86]

Flaxman's contacts with the ideas of A. W. Schlegel through the agency of Robinson suggest, in fact, that his Christian interpretation of art might not have been as independent as it might seem to be. Flaxman's discussions with Robinson began as early as 1810, when the latter, recently returned from Germany, was full of the new philosophy.[87] Their first conversation seemed portentous, for when

Robinson told Flaxman that in Germany the Kantians were contending with 'the revivers of Plato'—a term used at that time for the Schlegel circle—the sculptor replied, 'then the Platonists have the best of it'.[88] Despite this, Flaxman was irritated by Schlegel's assessment of his own work. Always embarrassed by the success that his *Outlines* had achieved he 'wished the Germans had something better to exercise their critical talents upon'.[89] Similarly, he was annoyed by Schlegel's suggestion that he preferred Dante to Milton. The only reason why he had chosen the former to illustrate, Flaxman said, was because Dante was more suitable for pictorial representation than the English poet. But, as with Schlegel's remark concerning sculpture, Flaxman is here perhaps admitting more than he intended.

Schlegel and Flaxman did not actually meet until 1823 when they were introduced at Aders's house. Once again Robinson was present at the occasion, but unfortunately did not record more than a few observations about Schlegel's character.[90] However, this meeting, which took place so late in the sculptor's life, would hardly have been an influential factor in the formation of his art or opinions. It is probably more likely that Schlegel's views, as transmitted to him via Robinson, did not so much form his as provide them with corroboration; for in his lectures on sculpture one finds a basic sympathy, without any of Schlegel's argumentation.[91]

Schlegel's views on the fine arts were not available in detail at that time in any English publication. However, his *Lectures on Dramatic Art* had been published in English in 1815, and these provided a general notion of his views of historical development as well as many asides about the visual arts. This work enjoyed a measure of popularity, and was to be brought out in two subsequent editions in the 1840s.[92] It is interesting to note Schlegel's opinions reaching people who did not have any committed interest in German ideas. Thus Constable's friend and patron John Fisher wrote to the artist in 1828: 'I met, in Schlegel, a happy criticism on what is called gothic architecture. We do not estimate it aright unless we judge of it by the spirit of the age which produced it, and compare it with contemporary productions.'[93]

In the same year in which this remark was written, the first English essay was produced which made a systematic use of German revivalist theories of the fine arts. Called 'On the Philosophy of the Fine Arts', it was written by Eastlake for the *Quarterly Review*. However, it was not published by that magazine and only became known in 1848, when it appeared in his *Contributions to the Literature of the Fine Arts*.[94] In 1829 Eastlake was little known in England. Living in Rome, his close acquaintance with German scholars and artists during his years abroad had given him a knowledge of German theories of the fine arts which was unrivalled amongst English artists and critics. His growing friendship with the Prussian diplomat Bunsen had encouraged him to learn German as early as 1818, and by 1820 he knew the language sufficiently well to make a translation of Kestner's *Über die Nachahmung in der Malerei*.[95] As was seen in the quotation at the beginning of this chapter, Eastlake had acquired by this time a sophisticated appreciation of the aims of the Nazarenes and the problems that they posed. As a practising artist this caused for him a dilemma which he was never able fully to resolve.[96] But as a theorist his contact

with revivalist ideas was to provide the basis of a distinguished career as an art theorist and scholar. Through his contacts with Bunsen and Kestner he encountered a circle of German scholarship which, in such figures as Rumohr, combined an admiration of the ideals of the Nazarenes with a systematic comparative study of early Italian art. Although Eastlake's attempt to bring Kestner's treatise to the attention of the English public proved unsuccessful, he was later to translate the first volume of Goethe's influential *Farbenlehre* (Theory of Colours)—which has become renowned for the response that it stimulated in Turner[97]—and to edit the first part of Mrs Hutton's translation of Kugler's *Handbuch der Malerei*, which when published in 1842 was the first history of Italian art giving a favourable account of the pre-Raphaelite schools to appear in English.[98]

In the years between his translation of Kestner and these later publications, Eastlake had worked principally as a painter. Nevertheless his knowledge of art history and theory had been continuously developing, and his experience had been extended by visits to Greece, France and Germany.[99] During the 1830s, after his return to England, his obvious inclinations gradually drew him into the growing debate concerning art education and patronage, until he was 'unwillingly' appointed secretary to the Commission on the Fine Arts in 1841.[100]

Despite these interests and his later championship of early Italian art when director of the National Gallery,[101] Eastlake's theoretical writings are essentially fragmentary. Indeed the very titles of his two major works, *Materials for a History of Oil Painting* (1847) and *Contributions to the Literature of the Fine Arts* (1st series, 1848; 2nd series, 1870), hardly claim them to be otherwise. Nevertheless much of the material within them is far from superficially investigated. The fragmentary nature comes more from the circumstances of their origin, for in most cases the writings were an outcome of his official duties and relate to specific problems that faced the Commission. The two volume *Materials*, as Eastlake says in the preface, was an investigation into the 'authentic traditions' of oil painting in order to discover 'some of the causes of durability for which the earlier examples of the art are remarkable', an investigation considered particularly desirable by the Commissioners 'at a time when the best efforts of our artists are required for the permanent decoration of a national edifice'.[102] Similarly, the *Contributions* consisted principally of reports originally written as memoranda for the Commission.

However, despite their technical objective, these essays have a more general historical interest. In confronting the problem of art education and public patronage, the Fine Arts Commission found itself facing decisions for which it was ill prepared. There was no precedent in the experience of most of the amateurs who formed the membership of the Commission to help them formulate opinions on such questions as whether the decorations of the House of Lords should be organized by one man or by a group of independently elected artists; in which technique the decorations should be executed; whether the subjects should be allegorical or historical; or whether figure drawing should be an essential part of the basic course in the Government Schools of Design.[103] Evidence provided by experts was confusing and conflicting and Eastlake often found himself in the position of making

the decisive recommendation. His experience of a culture in which a consistent attitude towards public art had been formulated on the basis of theoretical enquiry, together with his understanding of the viewpoint of the English connoisseur, enabled him to apply revivalist principles to the situation with great tact and moderation. Only he, perhaps, could have convinced the commissioners that Reynolds's statement that physical beauty should be placed above content was incorrect.[104]

The essays in the *Contributions* therefore should be seen not simply as a series of solutions to technical problems, but also as a subtle means of re-education. It was no doubt for this reason that he included amongst the Government Reports two earlier essays, in which he discussed aesthetic problems directly, 'How to Observe' (originally published in the *Penny Cyclopaedia* in 1835) and the above-mentioned 'On the Philosophy of the Fine Arts'.

In these essays Eastlake shows the same pragmatism that marks his reports to the Commissioners—a pragmatism that led him to translate Goethe's *Farbenlehre*, not for its speculation on the associative nature of colour, but for the value of his experiments as applied the laws of chromatic harmony.[105] It is not surprising therefore to find him basing his investigation on the philosophy of the fine arts upon an observation of the nature of the art object itself, before considering the question of aesthetic awareness. His intention is to demonstrate that the principle of comparison is the basis for the recognition of beauty. Great art, he suggests, has always been motivated by the principle of showing off beauty through effective contrast. In the Parthenon frieze, he claims, it was chosen to depict man together with horse, since there were sufficient associations between the two for both to be harmoniously regarded together, and at the same time enough contrast to prevent one from being seen as a caricature of the other. This would not have been the case, he argues reasonably enough, if man had been shown together with an orang-utang. One finds it harder to follow him, however, when he then proceeds to explain away the presence of the centaur in Greek art as 'temporary substitution'.[106]

If these examples are unhappily chosen, they are nevertheless the preamble to an important point; important because it shows a departure in his thinking from the classical viewpoint in which the human figure is the normative standard of beauty. Using a quotation from Schiller,[107] he suggests the existence of individual or 'characteristic' beauty. Like Schelling, he saw each form as approaching the ideal through being most true to its own characteristics and thus expressing itself most intensely. Furthermore, he censures Reynolds for considering the characteristic to be the 'average' of any given type. His concept of the characteristic has a more positive aspect than this, one that is animated by the 'vivifying spirit', an echo of Schelling's 'spirit working at the core of things'.[108]

After having demonstrated the existence of characteristic beauty, Eastlake than makes his peace with the doctrine of Christian art. The Greeks, although concerned with characteristic beauty, did not pursue the 'vivifying spirit' to its ultimate manifestation: 'It is here that Greek Art is found wanting; it is, indeed peculiarly expressive of mind, but not of mind in its truest and holiest relation.'[109] Eastlake was

later to elaborate this point in a more appropriate place, in his preface to Kugler's *Handbook*:

However imposing were the ideas of beauty and of power which the pagan arrived at, by looking around but not above him, by reviving his religion as well as his taste from the perfect attributes of life throughout nature, the Christian definition of the human being, at least, must be admitted to rest on more just and comprehensive relations. It is true the general character of the art itself is unchangeable, and the character was never more accurately defined than in the sculpture of the ancient Greeks but new human feelings demand corresponding means of expression, and it was chiefly reserved for painting to embody them.[110]

Yet, while admitting the supremacy of Christian art and painting, Eastlake does not completely capitulate to the spirit of Friedrich Schlegel. The Greeks may have achieved no more than physical beauty, whereas the mediaevalists have proceeded to crown this with the spiritual; but this does not mean that the example of the latter should be exclusively followed, or the example of the former totally ignored. While Schlegel had referred simply to the technical innovations following on the Renaissance, Eastlake is less reticent about allying the rebirth of the arts with the classicizing influence. Using Raphael as an example of the union of both, he suggests a solution in the spiritualization of classical form. Expressed in these terms, his position would not seem to have been a particularly novel one. But if Eastlake was hardly a leader in revivalist taste he was at least ahead of English taste of the 1820s in his preference for early to late Raphael, and his exclusion of the Bolognese from the artistic pantheon.

His editorial comments on Kugler's text, for example, show a continuing desire to modify the German's position. He cannot accept the symbolical approach to religious art which Kugler shared with Friedrich Schlegel. Nor is he particularly happy with Kugler's dialectical interpretation of the development of Italian art—in which feeling predominated in the fourteenth century, mind in the fifteenth, and the two principles fused to produce masterworks 'in the noblest *form* with a depth of feeling never since equalled' in the sixteenth.[111] It is in protest against such a determinist view that he objects to Kugler's contention that Giotto stands 'at the head of the didactic or allegorical style'. He remarks: 'The allegorical tendency on which the author lays so much stress, remarkable as it is, is far from being an essential characteristic of Giotto, but might rather be traced to the accidental influence of his friendship with Dante, and to the spirit of the age.'[112] His own approach to Giotto remains that of one who continues to see the development of Italian painting in terms of a gradual mastery of skill in representation:

To come to those qualities which appear to have been essentially original in Giotto, we observe that his invention is mainly distinguished from the earlier productions by the introduction of natural incidents and expressions, by an almost modern richness and depth of composition, by the dramatic interest of his groups, and by a general contempt for the formal and servile style of his predecessors.[113]

Similarly, despite his own predilections for earlier art, he could not let Kugler's remark that 'among the productions of the Bolognese painters, we rarely find works which bear the stamp of a spontaneous and really satisfactory feeling' go without comment. After explaining the current critical taste for 'spontaneous feeling and singleness of aim', he adds: 'this is one of the reasons why the Germans dwell so much on the unaffected efforts of the early painters, and is indeed a key to many apparently partial judgements of the author.'[114]

Eastlake's suspicion of partiality made him wary of the more extreme manifestations of primitivism. He was always more reticent about Northern primitivism than that of Italy, and did not consider it appropriate that the second volume of Kugler, which dealt with Flanders and Germany, should be issued with the first.[115] Mrs Hutton's translation of this had to wait for publication until 1846, when it was edited and introduced not by Eastlake but by E. Head. Perhaps it was his dislike of a too expressive and detailed primitivism that turned Eastlake against the Pre-Raphaelites.[116]

Nevertheless the defence of the characteristic remained an important part of Eastlake's outlook. For it is a principle to be applied, as A. W. Schlegel had done, not only to aesthetic sensibility, but also to the functions of the differing forms of art. This led not only to a reaffirmation of the distinction between painting and sculpture, but also to a distinction between the differing functions of the applied arts. Eventually it became a moral maxim for the artist who must, too, be true unto himself:

> The principle of distinctive character, as I have endeavoured to explain it, is not without a personal, and in some sense, a moral application. If the perfection of the Fine Arts depends on their developing, each for itself, the capabilities which belong to it—if nothing is gained, and if much may be lost by any one of them assuming the attributes of another; so the advanced student, in aiming at distinction, should learn to be true to himself.[117]

Although such a dictum might seem, when applied to the artist, to be an invocation to liberty, it does, when applied to types of art, become a form of restriction. For, historically seen, being true to type is hard to distinguish from conforming to the type that seems to have embodied that art form most perfectly in the past. In his advice to his patron Bellenden Ker upon the decoration of an ideal villa, Eastlake demonstrates this tendency to an extreme degree. The idea of each type of decoration and spatial arrangement being true to itself is rigorously pursued. The floor, for example, should avoid any attempt at illusionism, the dining room should avoid becoming an art gallery, frescoes may appear in the hall, but would be quite out of place in the sitting room, stucco *may* be combined with painting 'if in very low relief'.[118]

Such applications suggest that Eastlake's view, despite its apparent emphasis on individualism, was in fact creating simply an extended version of the normative. One finds a similar process taking place in his treatment of the other major tenet of Romantic theory, the relationship of content to form. As has already been

mentioned, Eastlake ostensibly challenged the classical concept of the supremacy of form over content in a passage in which he censures the position taken by Reynolds. Reynolds accepts the concept of beauty as relating solely to appearance, whereas Eastlake wishes to replace this with the more metaphysical understanding of the beauty of the idea. It is what is expressed that contains the true beauty of the picture; 'The power of expression has often triumphed over unpleasing forms', he comments.[119] Yet once again this leaning towards content no longer has the visionary enthusiasm that it had with the Romantics. Instead it has become interpreted in terms of the arid didacticism that had characterized so much of the work in Munich.

Since Eastlake's work remained unpublished until 1848, the proclamation of the doctrine of Christian art was left instead to Pugin's *Contrasts* published, eight years after Eastlake's essay was written, in 1836. In her article on the sources of Pugin's *Contrasts*, Phoebe Stanton has pointed out the similarity of Pugin's method to the techniques of Saint-Simon and Carlyle.[120] Indeed to a large extent the effectiveness of the book was due to Pugin's skill in uniting mediaeval nostalgia with modern propagandist forms of presentation. Like Flaxman, Pugin blames the Reformation for the decline of art in England. But the comparison is for Pugin a direct one, and shows little sign of a more complex understanding of historical development.

If this is true of the first edition of *Contrasts*, however, the second edition, published in 1841, shows a different understanding of the situation. For here Pugin extends his interest from Gothic architecture to the whole of Christian art and discusses its character in revivalist terms. In the preface to this edition he criticizes his earlier account for failing to see that the iconoclasm of the Protestants was, in fact, an effect rather than a cause of the decline of the religious spirit. Before this time society had already become sick through the neo-paganism of the Renaissance.[121] This realization led Pugin not only to change his preference for Gothic architecture from Perpendicular to Decorated, but also to adopt a position in which art was the expression of the spiritual nature of the age. This becomes clear in a new chapter that Pugin wrote for the second edition, 'On the Revived Pagan Principle', in which the damaging effects of Renaissance art are described. The argument is a familiar one, based like Eastlake's on the concept of the characteristic. It is the introduction of pagan art into a Christian society that leads to the expression of Christian ideas in an inappropriate form—such as the use of putti for angels. It is this which results in the bastardized art of later centuries, which has the virtues of neither the ancient nor the modern world.

Pugin also emerges in this chapter as an unquestioning defender of the Nazarenes. In a footnote he describes how

> the great Overbeck, that prince of Christian painters, has raised up a school of mystical and religious artists who are fast putting to utter shame the natural and sensual school of art, in which the modern followers of paganism have so largely degraded the representations of sacred personages and events.[122]

At the same time Pugin was anxious to make clear that this school of Christian art

was involved in a spiritual rather than a stylistic revival. In *An Apology for the Revival of Christian Architecture in England*, published in the same year as the second edition of *Contrasts*, he stated: 'We do not want to revive a facsimile of the works or style of any particular individual or even period; *but it is the devotion, majesty, and repose of Christian art for which we are contending*: it is not a *style*, but a *principle*.'[123]

Once again this is an argument already familiar from the defences of Nazarene art by Friedrich Schlegel and Kestner. Like these writers, Pugin also shows that, despite his spiritual approach, technical considerations lie at the bottom of this unwillingness to copy mediaeval art exactly. He even goes as far as to suggest that the forms of Christian art are uniquely suited for a naturalistic representation. It was only the lack of technical skill, in fact, he argues, that prevented the mediaeval artist from achieving this naturalism: 'The finest productions of Christian Art are the closest approximations to nature, and when they failed in proportion and anatomy, it was not a defect of principle but of execution.'[124]

The emergence of these opinions in Pugin's writings in 1841 reveal an acquaintance with revivalist opinions. No doubt he had responded to the views of his new patron the Earl of Shrewsbury, and Nicholas Wiseman, then on leave in London, whose *Four Lectures on the Offices and Ceremonies of Holy Week* of 1839 contained passages expressing similar views on modern art and Christian decorum.[125] Yet Pugin also drew upon more extensive sources; for by this time the views of the revivalists had become available to the English through the publication of a number of works by French writers. Indeed in the second edition of *Contrasts* he makes reference to the writings of A. F. Rio and Count Montalembert. No doubt he had in mind Rio's highly topical *De la poésie Chrétienne* (1836), which emphasized religious and moral criteria for judging the worth of artists and saw a struggle between spiritual and naturalistic forces in the history of Italian art. Montalembert, the author of *Du vandalisme et du Catholicisme dans l'art* (1839), is quoted at length on the recent desecration of ancient monuments in France.

Like the work of Wiseman, the activities of these French revivalists formed part of the renewed offensive that spread throughout Europe during the 1830s, replacing the largely spent force of the original German impetus. Both Rio and Montalembert had studied philosophy under Schelling, Goerres and Döllinger in Munich, and had been associated with the advocates of Christian art in Rome.[126] Rio's *De la poésie chrétienne* was strongly indebted to Rumohr's *Italienische Forschungen*: the author actually considered himself to be a 'disciple' of the German.[127]

The appearance of the works of these two French writers in England at this time was not entirely accidental. Montalembert, a liberal Catholic, had felt himself thwarted in his defence of an independent Catholic Church in France by the events following the July Revolution. In the rapid expansion of Catholicism in England (the country in which, as the son of a French exile, he had received his early education) he saw a new field of influence. A friend of Lord Shrewsbury and of Wiseman, his interest was eagerly accepted by the Catholic party in England and in 1839, the first volume of his propagandist *Histoire de saint Elizabeth de Hongrie* (1836) was translated by Ambrose Phillipps de L'Isle.[128] His authority as a defender of

Catholic ritual was such, in fact, that he was also courted by the Anglo-Catholics and elected a member of the Camden Society in 1844.[129] No doubt his reputation as an advocate of an independent Catholic Church in France also appealed to this group.

Rio's involvement in the English Catholic movement was even more personal. While *De la poésie Chrétienne* was hailed by Montalembert as having 'posé la première pierre d'une esthétique nouvelle, de cette science du beau aussi inconnue de nom que de fait dans la France moderne',[130] it was ignored in France by public and critics alike. Indeed no more than twelve copies were sold in five months.[131] In disappointment Rio, who had married the daughter of an English Catholic family, Apollonia Jones, left Paris to settle in London, where he spent the years between 1836 and 1841. Here he enjoyed considerable social success. Building on English contacts he had formerly made in Rome he met influential politicians like Gladstone, connoisseurs like Samuel Rogers and Crabb Robbinson (who tried to interest him in the Aders' copy of van Eyck's *Mystic Lamb*)[132] and propagandists like Mrs Jameson. He also persuaded two Roman acquaintances, Wiseman and George Darley, to review his book. Soon his reputation as the 'author of a well-known book on Christian art'[133] stimulated a genuine interest in the work. Indeed he seems in many minds to have become *the* apologist of early Christian art. Mary Shelley, for example, wrote in her *Rambles in Germany and Italy in 1840, 1842, and 1843* (1844): 'M. Rio satisfactorily proves that the modern art of painting resulted from the piety of the age in which it had birth.'[134]

It was the works of these French publicists that also provided a significant body of information for the painter most associated with religious revivalism in England, William Dyce. While Dyce, who had become a personal friend of Overbeck during his stay in Rome of 1828, was ambivalent in his attitude to Nazarene art, his response to the concept of Christian art was wholehearted.

Coming from an Episcopalian family in Scotland he adapted himself readily to the viewpoint of the Anglo-Catholics, and took a leading part in the offensive towards pictorial orthodoxy in the church. In this he was supported by the Anglo-Catholics' most prominent political advocate, William Gladstone.[135] The Anglican aspect of Dyce's Catholicism is an emphatic factor in his artistic outlook. Perhaps this was all the more pronounced in him because he had in his youth toyed with the idea of converting to Catholicism, at a time when the Anglo-Catholic movement in the Church of England had not become established.[136] In later years, however, he was outspoken against any confusion of the two, and joined in a heated exchange of pamphlets with Ruskin over the subject during the critical year of 1851, when the re-establishment of the Roman Catholic hierarchy in England had caused so much consternation amongst English Protestants.[137]

Like Pugin, who in contradistinction to him was an unstinting admirer of the Nazarene style, Dyce was fully aware of the social duties of the Christian painter. While having relatively little outlet for expressing these views as an artist during the years he spent in Scotland immediately following his visits to Rome, he was at least able to begin to operate as an educator. During the 1830s the concern over the organization of art education, which had led to the establishment of a Select

Committee to discuss the matter by Parliament, had repercussions throughout the country. In Edinburgh, where Dyce was working as a portrait painter, it led to questions concerning the organization and function of the Scottish Academy of Art. It was this circumstance that led Dyce, with the assistance of one of the teachers at the academy, Charles Wilson, to publish the pamphlet *On the Amelioration of the Fine Arts in Point of Taste* in Edinburgh in 1837.[138] In this work, Dyce displayed a detailed knowledge of the developments that had taken place recently in art education on the continent, drawing especial attention to those aspects that emphasized traditions of craftsmanship and which respected the need for individual training for the differing types of painting and design.

Dyce was soon to have a chance to put his ideas into practice. Eastlake had been made a member of the Committee of the Government Schools of Design after having refused the position of director. Having read Dyce's paper, he realized that his extensive knowledge and liberated attitude towards design students—for the revivalist position essentially liberated them from the position of second-class fine artists—ideally suited him for the position, and he was duly appointed.

Dyce's directorship lasted until 1843. It was not a successful period of his life, since he was prevented from putting his ideas fully into practice. Criticism reached a head over the question of whether life-drawing should be an essential part of the course—Dyce maintained that for those designers not employed in figurative work it should not—and eventually Dyce's powers were so restricted that he resigned. Ironically his position was taken by Wilson, who had claimed more credit for the 1837 pamphlet than was probably his due, and who was later to dog Dyce's footsteps and cause hindrances to many of his plans.[139]

Yet by this time Dyce was firmly established in London. Besides making his reputation as a painter he had also been active as a theorist, accepting in 1840 the position of professor of fine arts at Kings College London—again a position that had first been offered to Eastlake.[140] The position itself was a unique one in England, and it is significant that it should have been established in a college whose origins were so strongly rooted in the religious revival. The college was no doubt aware of Dyce's religious views when making the appointment, and, while it would seem that no actual teaching resulted from the engagement, his inaugural lecture can have been no disappointment to them. His *Theory of the Fine Arts* (published 1844) expressed, even more strongly than Eastlake's 'On the Philosophy of the Fine Arts', the revivalist view of art history. Dyce begins, indeed, where Eastlake ends, with a defence of the term 'aesthetics'. Like Carlyle, he expresses the hope that such an investigation will take enquiry beyond the commonly held belief that 'the Fine Arts, at best, involve only certain questions of taste, about which there is no disputing'.[141] Yet if Dyce is here proclaiming the establishment of a 'science', he also makes it clear that the deeper understanding of the theory and function of the fine arts leads to an essentially moral position. It is this that he demonstrates in the familiar pattern of development from Egyptian, to Greek, and then to Christian art. The ideal in Greek art is even more greatly disparaged than it was by Eastlake, becoming 'nothing more than *reality* itself, under its most embellished form' and being totally devoid of all

moral content. Christian art, on the other hand, 'exercises itself on types altogether different, and has for its drift to interest the moral sentiments, rather than to charm or flatter the sense'.[142]

These sentiments of Dyce are not only more extreme than Eastlake's in their espousal of Christian art, they also bring in a new severity. For Dyce's eyes, sensuousness is not merely an absence of higher spirituality, it is also essentially opposed to it. Thus he draws on Raoul-Rochette to support him in the assertion that,

> In brief, through the whole system of Christian art there is somewhat of a forbidding, mortified, and humbled exterior, derived from the character of the religion in which it originates, by which it is distinguished from the attractive and (not to use the word in a bad sense) the *sensual* qualities of the classical school.[143]

His view of the development of Christian art bears out this total separation of the sensuous from the Christian. The 'Christian–Pagan', late Roman, art is followed by the 'Barbaric', the Byzantine, after which Christian art reaches its 'highest point' in the 'ascetic', that is, the art of the Middle Ages. The Renaissance is termed 'Pagan–Christian', and is seen entirely in terms of a pagan revival, while later art is simply styled sensual, the 'vulgar and unspiritual imitation of nature'.

Yet this total rejection of the sensuous also leads to a rejection of the inspired visionary element that appears so strongly in Schlegel. In Christian art the asceticism becomes associated with intellectualism. Having rejected the idea that physical beauty is the criterion of excellence he removes the fine arts, as he sees it, from the 'mechanical and scientific . . . into the higher province of the science of the mind'. It is this intellectual approach that makes the establishment of aesthetics possible for him. Yet, however much Dyce admired the concept of aesthetics, he did seek to destroy the autonomy that had led to it being established, for his moral intellectualism leads him to end up with the conclusion that painting is, in fact, 'a section of the science of morals'.[144]

The views of Pugin and Dyce reveal how broadly the revivalist interpretation of aesthetics had spread during the 1840s, and how little it had to do now with the writings of the Schlegels and other German theorists. Soon these essays were to be followed by more extensive historical studies by English writers, notably Mrs Anna Jameson's *Memoirs of the Early Italian Painters* (1845) and the highly popular *Sacred and Legendary Art* (1848), which introduced the English to an iconographical interpretation of mediaeval art; Lord Lindsay's *History of Christian Art* had made its appearance in 1847.

It was this interest in revivalist art theories and historical interpretations, in fact, that stimulated the first translations of some of the most significant aesthetical writings of the German Romantics. However, by this time the proselytizing spirit was so strong that many of these works were presented in a guise whose dogmatism went quite against their original intentions. Thus the 'Catholic Series' included amongst its tracts not only Novalis's *Die Christenheit oder Europa*[145] but also Schiller's *Aesthetische Briefe*[146] and Schelling's *Über das Verhältnis der bildenden Künste*

zu der Natur.[147] Towards the end of the decade, in 1849, Bohn's Standard Library completed the cycle by bringing out an edition of Friedrich Schlegel's aesthetic works.[148]

In many senses the association was an unfortunate one, for it encouraged those not involved in the proselytizing of the revivalists to be wholly antagonistic to German philosophers. The poet and critic George Darley—whose reviews in the *Athenaeum* (1834–46) represent the most enlightened art journalism of the period—attempted to redress this one-sided view of German art theories. Aware of the values of speculative critical methods, he sought to ally this, as Eastlake had done, with English pragmatism.[149] Yet his views were too modestly presented to arouse general interest. Instead, the revivalists were left to the mercy of a more vigorous and wholly opposed critic, John Ruskin.

From the time of his emergence as the defender of Turner in the first volume of *Modern Painters* in 1843, Ruskin based his position on an absolute pragmatism. The 'truths' that he sought were objective and demonstrable:

> I have accordingly advanced nothing in the following pages but with accompanying demonstration, which may indeed be true or false—complete or conditional, but which can only be met on its own grounds, and can in no way be borne down or affected by mere authority of great names.[150]

While principally involved in the first two volumes of *Modern Painters* in stating his views on objective observation and the faculty of awareness, he took time off in his third volume, *Of Many Things*, to attack what were to him current misapprehensions. Of these 'German Philosophy' seemed to him sufficiently significant to merit a special appendix. In this he confesses to being brought 'continually into collision with certain extravagances of the German mind, by my own steady pursuit of Naturalism as opposed to Idealism',[151] and goes on to conclude that while there might be little harm in the speculations of 'Kant, Strauss, and the rest of the German metaphysicians and divines', they are on the whole expendable, since what truths they do propound are obvious ones. Ruskin, who was proud of not having read the works he dismissed, is here perhaps being rather ungrateful; for through his heroes Carlyle and Coleridge he had, in fact, absorbed an understanding of the faculty of the imagination and of the artist's function as the revealer of a section of the universal truth that is based, ultimately, on the opinions of Kant and Schiller.[152] Nevertheless he had attempted to set limits to the imaginative faculty of the observer, which is discussed in section two of part three, 'Ideas of Beauty', in Volume II, and in his investigation in Volume III of the 'Pathetic Fallacy'. For here the concept of a distinction between 'objective' and 'subjective' is scornfully dismissed, and the first order of poet is seen as the one who masters the enthusiasm of his imagination and 'perceives rightly in spite of his feelings'.[153] But even here he ends up by seeming to admit what he is attacking when he allows that there are men 'who, strong as human creatures can be are yet submitted to influences stronger than they, and see in a sort untruly, because what they see is inconceivably above them'. 'This last is the usual condition of prophetic imagination', he adds; a

sentiment to which Schiller would not have taken exception. Perhaps the only difference is that what appears to Ruskin as 'a sort of untruth' allowable in exceptional circumstances, was for the German Romantics what Novalis called the 'ultimate reality'.[154]

But Ruskin did not simply oppose the Germans on the grounds that they were, to use George Eliot's term, 'cloudy metaphysicians'.[155] The association of the moral nature of the artist with the condition of the society in which he lived, led him also to see German speculation as immoral. Here the word 'Aesthetics' becomes the key to his misinterpretation. Like Kant, he finds the word unacceptable as a term to apply to the appreciation of beauty on etymological grounds.[156] Having traced the word to its Greek source, however, he then assumes that the contemporary use of the word must be similar, and condemns the approach as amoral and sensualist. In a later footnote to this passage he cites the aesthetic movement as evidence that his suspicion of the term has been justified.[157] His own substitution, 'Theoria', represents the 'full comprehension and contemplation of the Beautiful as a gift of God'.[158] If this seems close to the doctrines of the apologists of Christian art, Ruskin comes even closer when he argues that the Christian's perception of beauty is more profound than that of the pagan and is indeed so perceptive as to be aware of the beauty that lies behind visual ugliness: 'the Christian Theoria seeks not, though it accepts and touches with its own purity, what the Epicurean sought; but finds its food and the objects of its love everywhere in what is harsh and fearful as well as in what is kind'.[159]

There seems in fact to be little to choose here between Ruskin's 'Christian Theoria' and 'Aesthetics' as it had been defined by Dyce.

As Steegman has pointed out, the emergence of these sentiments in Ruskin's writings occurs in the second volume of *Modern Painters*, published in 1846 after he had absorbed the writings of such revivalists as Rio, and developed a love of early Italian art that was to make him so sympathetic to the Pre-Raphaelites.[160] Yet Ruskin was to remain as opposed to the German brand of Pre-Raphaelitism as he was to the German form of transcendentalism. It was this sentiment that led him to attack Dyce's *Christabel* in 1855 as an example of the 'false' school of Pre-Raphaelitism, of which the Germans were the prime protagonists. Once again, it was naturalistic observation that provided the watershed between the two. The Germans were no more than religious hypocrites, blindly copying the form of ancient masters, and unaware of the true devotion of humbly observing the spirit of God as it is manifested in nature.[161]

It was a similar suspicion about the departure from natural models that made Ruskin condemn the expressionist side of the Germanic style in art as well. In the first volume of *Modern Painters*, when discussing the wild exaggeration of Rosa's branches, he exclaimed: 'All departure from natural forms to give fearfulness is mere Germanism; it is the work of Fancy, not of Imagination.'[162]

In view of this emphasis it is interesting to compare Ruskin's defence of the Pre-Raphaelites in his letter to *The Times* in 1851 to Friedrich Schlegel's defence of the Nazarenes in 1819; particularly in connection with the relationship of naturalism and archaism:

As far as I can judge their aim . . . the Pre-Raphaelites intend to surrender no advantage which the knowledge or inventions of the present time can afford to their art. They intend to return to the early days in this one point only—that, as far as in them lies, they will draw either what they see, or what they suppose might have been the actual facts of the scene they desire to represent, irrespective of any conventional rules of picture-making; and they have chosen their unfortunate though not inaccurate name because all artists did this before Raphael's time, and after Raphael's time did *not* this, but sought to paint fair pictures, rather than represent stern facts; of which the consequence has been that, from Raphael's time to this day historical art has been in acknowledged decadence.'[163]

Friedrich Schlegel—as has already been seen—also dismissed the notion that his protégés copied the technical naïveties of the quattrocento.[164] In fact his article could have been known to Ruskin, since it was published in English translation two years before the English critic wrote his letter.[165] But the question of influence is not—for once—the appropriate one. For despite their agreement in condemning a mannered adoption of mediaeval gaucheries, there still remains a fundamental difference in the positive reasons they find for emulating the spirit of the primitives. While Schlegel placed the main emphasis on the continuation of a spiritual tradition hallowed by religious practice, Ruskin placed it upon honest and direct observation. This was for him a spiritual activity since 'the study of art was the study of nature, God's second book'.[166] The English critic could, after all, have had little sympathy for a view that placed above 'truth to nature' what one reviewer referred to as 'the fundamentally symbolic character of beauty'.[167]

CHAPTER III

The Depiction of German Subjects by British Artists

IT HAS already been mentioned that the interest in contemporary German art was in many ways conditioned by the broader concern for the cultural achievements of modern Germany. In the case of the response to German aesthetics, the correlation was particularly close. There were some enthusiasts of German literature and philosophy, furthermore, who developed a similar passion for modern German art. However, this was not always the case. There is little evidence, for example, of Carlyle taking an interest in the artist contemporaries of Goethe, Schiller and Jean Paul. Even those English artists who depicted German subjects did not necessarily have any concern for the German art of the period.

The growth in the depiction of German subjects in the early nineteenth century is a phenomenon that inhabits an intermediary area between the broad interest in German culture and the more limited interest in German art. Before proceeding to the discussion of the stylistic influences of the latter, therefore, it seems advisable to make a survey of the scope of the former. Nearly two hundred artists are known to have depicted German subjects in one form or another during the period 1815–60.[1] The work of many of these has disappeared and can be accounted for only through the titles of pictures exhibited. Much of the information in this chapter, therefore, is of a limited nature. It can, however, indicate the extent of the activity and show significant tendencies in the themes favoured. Furthermore, it can also place in context the work of those better-known artists—like Blake, Fuseli, Turner, Prout, Maclise and Rossetti—who did from time to time depict German subjects. With these artists at least, some discussion can be entertained about the nature of their response to contemporary German culture and the extent to which this coincides—if at all—with an interest in the pictorial art of Germany.

Before discussing the separate types of subjects treated, the overall growth of numbers is worth commenting upon. To some extent this reflects the growth in the number of pictures exhibited and books and prints published during the period. But even when allowances are made for this, and the figures are proportionately adjusted, the increase seems to be a significant one. In Figure C of the Appendix the figures obtained from the annual fluctuations of exhibited works have been given in both relative and absolute terms; and in both cases they show three waves of increase.

36. J. M. W. Turner: *The Bright Stone of Honour (Ehrenbreitstein), and Tomb of Marceau, from Byron's 'Childe Harold'.* 1835. Oil (93 × 123). Private Collection. London.

37. ★C Stanfield. *Heidelberg.* From *Travelling Sketches on the Rhine,* 1833.

The first grows from the end of the Napoleonic Wars to a peak in the mid-1820s. The second reaches its highest in the early 1840s. Finally there is a smaller resurgence in the mid-1850s, although this does not completely counter the beginning of a decline around 1860. It is interesting to see that these waves bear a correlation to those in the graph produced by Professor B. Q. Morgan in his *Bibliography of German Literature in English Translation*.[2] Although economic factors undoubtedly played their part in these fluctuations they seem also to reflect the discovery of German culture by successive generations. In the 1820s there was the somewhat elitist enthusiasm of the romantics for the metaphysical fantasy of German literature. In the 1840s there was the more systematic exploration of German culture by the early Victorians.

To facilitate discussion, the themes depicted have been divided into four basic areas. These are (in descending order of size) topography—which includes views of German towns and scenery as well as depictions of local life; literary themes; portraits; and historical themes.

TOPOGRAPHY

That topography should be the most numerous class is hardly surprising. Landscape—thanks largely to the activities of the water colourists—was by far the most popular of exhibited subjects in Britain in the early nineteenth century. Within this vast group German scenes never accounted for more than a small minority. They never rivalled the depiction of English scenery and only came near to those of France and Italy in the early 1840s.[3] The interest in depicting German scenery must be viewed in the context of the rapid increase in travel abroad after the end of the Napoleonic Wars. The new British travellers came from a wider social field than the aristocrats of the eighteenth century. There were fewer who had the taste and resources for taking an artist with them on their journeys—as William Beckford had done with John Robert Cozens in 1782. They were more likely to buy souvenirs of their travels from the exhibiting societies of London or in the form of books of engravings. The artists who toured abroad to provide the material for this market tended to follow the paths mapped out in such well-known guidebooks as Mariana Starke's *Travels on the Continent* (1820). Encouraged by the growing ease of travel and the romantic taste for the mediaeval and exotic these guidebooks led artists and travellers to a wider variety of places than those habitually visited on the traditional Grand Tour. In the 1820s Northern Europe became more popular, and by the 1830s more adventurous travellers were visiting Spain, North Africa and the Eastern Mediterranean.

It was in the 1820s that Germany began to become a tourist area. On the whole there were few visitors who went there exclusively. Usually the journey was an extension of a visit to northern France or the Netherlands—as was Turner's visit of 1817. As with Turner, such tours habitually took in the Rhine (particularly the stretch between Cologne and Mainz); and often such tributaries as the Mosel, Main and Neckar. Increasingly such visits would lead further to the Swiss Alps. It was less

common to go further into Germany and visit Bavaria—though the growing fame of Munich in the 1830s altered this to some extent. An even less common route— though one undertaken by Turner in 1835—was the northern journey from Hamburg up the Elbe to Dresden and thence across Bohemia to Vienna.

The interest in German scenery appears to have been in no way conditioned by an awareness of German landscape painting. As has been mentioned in Chapter I, the British view of the latter was a very dim one. The concern was for picturesque scenery, local customs and historic sites. Most artists who depicted these did so in a manner that was indistinguishable from their treatment of other parts of Northern Europe. With the exception of a handful of German-born artists like Siegfried Bendixen and J. C. Zeitter none of the painters specialized in German views. Germany was simply part of their repertoire of continental subjects.

An analysis of the areas depicted shows that nearly two-thirds of the German views were of the Rhineland (Appendix, Figure B). Well over half of the remaining third were of Bavaria and Austria. These are hardly surprising results in view of the pattern of travel mentioned above. The scenic and historic attractions of the Rhine were particularly strongly emphasized in travel literature. William Howitt, who remarked that the Rhine was 'the way by which the great bulk of travellers enter Germany', gave the common opinion that it was 'certainly the most beautiful of all' in his *Rural and Domestic Life of Germany* (1842).[4] While conceding that the mountains were not as lofty as the German Alps, he said

> they are about as lofty as most other of the German hills; are more varied in their aspect; are full of tradition, of evidences of past history and commotions; and as a vineland, you shall find nothing so extensive, so perfect, or so picturesque in any other quarter of the nation.

The popularity of the Rhine was also supported by literary references. In particular, Byron's *Childe Harold*—perhaps the most popular of his works at the time—gave a vivid account of the Rhineland in Canto Three (1816). For Howitt this 'still remains the most descriptive and most answering in the felicitous truth of its epithets to one's own feelings'. The Rhineland also figured in Scott's *Anne of Geierstein* (1829) and became the subject of a whole work in Bulwer Lytton's *Pilgrims of the Rhine* (1833). Lytton's book also focused attention upon the legends of the Rhineland. Even before this, however, this interest had been associated with topography in J. R. Planché's *Lays and Legends of the Rhine* (1832), which included views by Louis Haghe. It was to be followed by others of a similar nature, such as T. Snowe's *The Rhine: Its Legends, Traditions and History from Cologne to Coblenz* (1839), which was illustrated by A. Butler.

While it is not difficult to see why the Rhineland should be depicted with increasing frequency during the 1830s (Figure B) it is less easy to understand why there should have been a sudden leap in the number of such works exhibited between 1837 and 1838. Certainly there seems to have been no single publication that could have stimulated such a change—although it is worth noting that Lytton's *Pilgrims of the Rhine* had been followed by such popular German travel books as Mrs

Jameson's *Visits and Sketches* (1834), J. Strang's *Germany in 1831* (1836) and Murray's *Handbook for Travellers in Southern Germany* (1837). Whatever the reason, 1838 saw a dramatic leap of nearly 300 per cent to thirty-six Rhineland views on exhibition in London. A few years later, in 1841, there followed an all-time high of forty-three. Numbers remained considerable throughout the 1840s and most of the 1850s. By 1860, however, figures were averaging around half the number in the early 1840s.

It is also difficult to assess how much literary interests affected the selection of sites. Certainly Byron's *Childe Harold* was invoked on occasion, most notably by Turner when exhibiting *Ehrenbreitstein* (Plate 36) in 1835;[5] Bulwer Lytton, Rogers and Longfellow were also used.[6] Such instances, however, are not frequent. On the whole artists tended to have seen the area less dramatically than writers. Byron might speak of

> . . . a work divine
> a blending of all beauties; streams and dells
> fruit foliage, crag, wood, cornfield, mountain,
> and chiefless castles breathing stern farewells.[7]

But David Cox, basing his assessment on paintings he had seen, thought of it as an awkward terrain that fell uncomfortably between the picturesque and the sublime:

> There is mostly a tameness and littleness in the foregrounds of Rhenish scenery; perhaps the hills and castellated knolls are too fanciful in form to be picturesque and not sufficiently large or distant to possess grandeur, unless under extraordinary effects of light and shade. It will, therefore, be desirable to lessen their distinctness against the sky in some parts and to throw the strongest emphasis upon the foreground.[8]

Most artists were content to give the area a certain quaintness. Only Turner, with his mastery of light effects, seems to have been capable of endowing it with any fanciful and transcendent qualities.

Although the volume of German views was at its height in the 1840s, it was in the preceding two decades that the most distinguished painters began to work on such subjects. This was the time when Turner, Stanfield, Roberts, Copley Fielding and Prout were already active in the field. Turner was not a prolific painter of German views, but he was one of the first English artists to tour the Rhine after the end of the Napoleonic Wars. He was to return there and to other parts of Germany on several occasions, the last being 1844. His first visit was in August–September 1817 and followed on an inspection of the field of Waterloo. Although the incentive for studying the famous battleground is clear enough, he was perhaps specifically encouraged to make this journey by Byron's *Childe Harold*. Certainly he put a quotation from *Childe Harold* in the Royal Academy catalogue when he exhibited his *Field of Waterloo* there in 1818.[9] He could also have been inspired by *Childe Harold* to go on from there to the Rhine, since this is the course Byron's hero took. Travelling from Cologne to Mainz, he covered much of the same area. Later, in 1835, he was to use a quotation from *Childe Harold* to accompany his *Ehrenbreitstein*,

a place that he first set eyes on in 1817. Whatever the incentive behind his visit, however, his first response was not a public one. He used the copious sketches he had made to produce fifty-one finely worked watercolours for his patron Walter Fawkes. In these the hills and fantastic castles of the region are seen hazily beyond stately veils of trees and a more prosaic foreground world. Turner did not actually exhibit a Rhineland view until 1826, when he showed *Cologne, The Arrival of a Packet Boat, Evening* at the Royal Academy. This was based on some of his 1817 sketches as well as those that he had made during his second visit to the region in September 1825.[10] As might be expected, this lowland river scene related most closely to the traditions of seventeenth-century Dutch painting. *Ehrenbreitstein* of 1835 is in a quite different mould. Entitled in a characteristic misquotation *The Bright Stone of Honour*, he uses shimmering effects of light to invest the scene with heroic overtones. Following the quotation he used from *Childe Harold* he showed in the foreground the monument to the French Revolutionary General Marceau, who fell at the siege of Ehrenbreitstein in 1796. Behind the hero's tomb there rises the translucent vision of the ruined castle itself which—as Byron put it—'with her shattered wall/yet shews of what he was'.[11] While Turner may have intended a specific political comment here, his use of light symbolism accorded with more general preoccupations in the last stages of his career. The site itself seems to have had a pictorial as well as a semantic fascination for him, for he returned to it several times in watercolours he painted in the 1840s.[12] No other German site attracted him as much; and, while he made tours along the Rhine, Mosel, Danube and Elbe to collect material for his *River Scenery of Europe* series, nothing ever came of this part of the project.

Turner's large oil paintings of German scenes in the 1840s appear to have been prompted by expediency. In September 1840 he made a detour on a journey back to England from Venice to visit Coburg and sketch Schloss Rosenau, the seat of Prince Albert, who had recently become engaged to Queen Victoria. The resulting painting when exhibited at the Academy in 1841 drew forth the sarcastic remark from one viewer that 'German nature may be like German art, not designed to be intelligible to common-place mortals.'[13] If Turner was hoping to gain royal favour by such a gesture he was not successful; for neither this nor any other of his pictures was bought by Albert. The large painting of *Heidelberg* (c. 1840–5), though not exhibited, may well have been begun with an eye towards royal patronage. It showed the castle as it was in the time of Elizabeth, the 'Winter Queen', ancestress of Queen Victoria. *Opening of the Walhalla, 1842* celebrated an achievement of that topical royal Maecenas, King Ludwig I of Bavaria. Turner had visited the Neo-Greek mausoleum for German heroes at Regensburg in 1840. Although relatively well received by the English press when exhibited at the Academy in 1843 it was greeted with amazement and bafflement when it was shown in Munich at the Congress of European Art in 1845. Ludwig himself took no notice of the work dedicated to him; perhaps because it was generally seen as being satirical.[14]

Turner's depictions of German scenery ranged over a quarter of a century, but were sporadic. Other distinguished landscape painters were more consistent in their

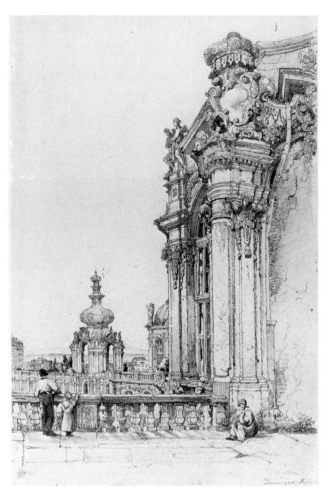

38. S. Prout: *Dresden-Zwinger Palace.*
Watercolour (40.7 × 36.9) Courtauld
Institute of Art, London.

portrayals. Perhaps the most notable of these was Clarkson Stanfield. Quite when Stanfield first visited Germany is unknown. Presumably it was before 1826 when he exhibited *Cologne, on the Rhine* at the Society of British Artists.[15] Over the next decade he was to exhibit several views of the Rhine and its tributaries. These areas were also celebrated in two books of engravings—*Travelling Sketches on the Rhine and in Belgium and Holland* (1833) and *Sketches on the Moselle* (1839). As a marine specialist, it is hardly surprising to find Stanfield giving much prominence to the rivers and breezy atmospherics in his books. However, there is also a tendency to emphasize the dramatic impact of the castles, which comes out particularly in the plates of his Rhenish volume (Plate 37). Stanfield's close friend David Roberts visited the Rhine in the summer of 1830 and exhibited one or two subjects from this area in 1831 and 1832.[16] Closer to Stanfield in manner, however, were the Rhenish scenes of A. W. Callcott.[17]

The most constant depicter of German views was the watercolourist Samuel Prout. Indeed there was hardly a year between 1822 and 1851 when he did not exhibit several German views (Plate 38)—largely of the Rhineland and Bavaria—at the Old Water-Colour Society.[18] Prodigious though this output was, however, it was not exclusive, for he was equally assiduous in supplying Italian and French

scenes. And brilliant though his manner was, there was something almost too predictable in the startlingness of his achievement. Even Ruskin, a great admirer, could be slightly comical about the way Prout displayed his talents at the Old Water-Colour Society:

It remained his privilege exclusively, to introduce foreign elements of romance and amazement into this—perhaps slightly fenny—atmosphere of English common sense. In contrast with our midland locks and barges his 'On the Grand Canal Venice' was an arabian enchantment; among the mildly elegiac country churchyards at Llangollen or Stoke Pogis his 'Sepulchral Monuments at Verona' were Shakespearian tragedy, and to us who had just come into the room out of Finsbury or Mincing Lane his 'Street at Nuremberg' was a German Fairy Tale.[19]

Furthermore, while endowing his subjects with an appropriate sense of fantasy and antiquity, he hardly varied his manner when depicting the different parts of Europe. His German fairy-tale is told in the same language as his Arabian enchantment or his Shakespearian tragedy. In all cases his 'crumbling line' suggested with the same allusive brilliance the intricacies of decrepit old historic edifices. It was a manner that he had evolved in his early years as a recorder of English antiquities for his first employer John Britton. While intended to describe Gothic buildings in the first place, he found that it was also eminently suitable for the Baroque, and it was perhaps for this reason that he included Dresden and Wurzburg in his repertoire. He also remained primarily interested in architecture. Even his Rhineland views rarely give more than glimpses of the broad river and surrounding hills.

Prout also had the distinction of producing the finest illustrated volumes of German views of the period. Both his *Illustrations of the Rhine* (1824) and his *Facsimile of Sketches made in Flanders and Germany* (1833) were lithographic reproductions of drawings the artist made directly onto the stone. They have a spontaneity and brilliance that is quite lacking in the pedestrian work of other topographers of the time, notably Captain Robert Batty, the illustrator of *German Scenery from Drawings made in 1820* (1821), *Scenery of the Rhine, Belgium and Holland* (1826) and *Hanoverian and Saxon Scenery* (1829) or W. Tombleson, the artist of *Views of the Upper and Lower Rhine* (1832).

Prout's one-time pupil James Duffield Harding showed a greater scenic interest in his views of the Rhine. Admired by Ruskin for his ability in handling foliage he concentrated on the verdant banks and vineyards of the area. He is said to have first gone abroad in 1824;[20] however, he exhibited a view of St Goar at the Old Water-Colour Society as early as 1823. The bulk of his German views followed his visit to the country in 1834.

There were only two other watercolourists who still enjoy a high reputation today who regularly exhibited German views: William Callow and Frederick Nash. Both ventured into this area in the late 1830s, after having been associated for a number of years with Paris and northern France. Nash, who visited the Moselle in 1837 and the Rhine in 1843,[21] began to exhibit German views in 1838 and continued to do so regularly until 1853. Primarily noted for his brilliance as an architectural

draughtsman, he seems to have concentrated most on street scenes and views of such noted edifices as the Castle of Elz, Moselle, (1845) and the *Tour des Rats* (1849) on the Rhine. Callow spent ten weeks in Switzerland and Germany in 1838 before returning from a nine year residence in France to settle permanently in London. For the next ten years he exhibited Rhineland views at the Old Water-Colour Society. In 1848 he added to these a view of the *Neu Munster* at Wurzburg. In the 1850s he added Bavarian and Saxon views increasingly to his repertoire—presumably the results of subsequent tours. Surviving until 1908, he continued to exhibit German scenes from all these areas for several decades to come.

The other habitual exhibitors of German views in the 1840s and 1850s— C. Deane, J. Fahey, G. Howse, W. Oliver, W. Robertson, and C. F. Tomkins— are known as little more than names now. Yet these names are perhaps worth noting here since, between them, they provided the bulk of German views during this period. To judge by a couple of surviving oils, C. Deane was an amateurish and rather leaden painter.[22] Yet not all of these painters were so unskilled. W. Oliver— who was dismissed by Redgrave for the weakness of his work[23]—managed to attract the patronage of Prince Albert in 1853. The view of Remagen that the Consort bought shows that artist to have been able to master highly competent, if somewhat overplayed, picturesque effects.[24]

Like the other painters discussed so far, these artists predominantly exhibited Rhineland views. The only painters who consistently favoured other areas were those who were of German origin. Siegfried Bendixen, a native of Hamburg, provided some very rare views of the Harz Mountains after he settled in London.[25] G. E. Hering, who had Munich connections, published *Sketches on the Danube* in 1838 and subsequently showed a number of Bavarian and Austrian scenes. The most prolific of these expatriate exhibitors of German views, however, was J. C. Zeitter. Settling in England around 1840, he showed principally views along the Danube— in both Austria and Hungary—and in the Harz. He exhibited principally at the Society of British Artists and at the British Institution, and never seems to have achieved much recognition. Perhaps his handling was to blame for this; for Redgrave records that his work was 'of the most sketchy character. He seemed without the power to finish.'[26] None of Zeitter's work appears to have come to light in recent times, and its nature can only be guessed at from titles and one or two poor engravings.[27] This is a shame, for such titles as *The Vesper Bell in Germany* and *German Children Loading a Sledge* (1852) suggest that he had a strong interest in portraying local life. Such works would provide a most interesting supplement to that most intriguing publication, G. R. Lewis's *Series of Groups Illustrating the Physiognomies, Manners and Characters of the People of France and Germany* of 1823.[28]

LITERARY THEMES

While the illustration of literary themes took place on a much smaller scale than the depiction of Germany scenery, it is a more significant phenomenon from the point of view of showing a response to German culture (Appendix). Since the number

recorded is so small—amounting to no more than 126 exhibited pictures and thirty-nine illustrated books between 1815 and 1860 it cannot provide a very firm basis for generalizations. However, a number of features do seem worth pointing out. Most striking is the limited range of subjects attempted. In all cases—both those of exhibited subjects and those of illustrations in books—the themes were from works that had already been translated into English. Even such enthusiasts for esoteric German literature as Fuseli and von Holst conformed to this pattern. Furthermore, the subjects selected were considerably more limited than those made available by translation. In his *Bibliography of German Literature in English Translation*, Professor Morgan lists fifty-eight authors who appear regularly in translation (that is, with five or more titles in each of two decades) between 1815 and 1860.[29] If Professor Morgan's criterion were to be applied to the authors illustrated during this period only three would qualify: Salomon Gessner, Goethe, and La Motte Fouqué. Even when one takes the overall figure of all authors and anonymous works which are cited in one way or another in the titles of pictures exhibited or illustrated in books one arrives at no more than fifteen entries: in their order of appearance—Gessner (1815), Goethe (1815), *The Nibelungen* (1817), La Motte Fouqué (1821), Münchhausen (1822), Grimm (1823), Chamisso (1824), Weber (1825), Wieland (1826), Schiller (1833), Bettina von Arnim (1840), Bürger (1847), Freiligarth (1855), Heine (1856), *Tyl Eulenspiegel* (1860).

When one looks at the actual titles of the subjects illustrated one notices that the popularity of the three most depicted authors was not due to a general knowledge of their works. It was rather because these three had each produced one work that entered into the common repertoire of subjects. In the case of Gessner this was *The Death of Abel*; in the case of Goethe, *Faust*; and in the case of Fouqué, *Undine*. Although each of the authors did have other subjects illustrated from time to time, the numbers were negligible compared to that of his most popular work.

This pattern is one that corresponds to the illustration of other authors, both British and foreign.[30] It demonstrates the need of an artist to use subject matter already well known to his audience. Significantly the constant illustration of the three popular German subjects began some years after each had been translated, when they had already appeared in numerous English editions. Yet popularity cannot have been the only criterion for selection, for there were many other widely translated German authors—Kotzebue, Klopstock, Wieland, Schiller, Bürger, Grimm—who did not receive a similar treatment. Nor does topicality appear to have been an overriding factor. None of the subjects was illustrated in a sudden spate. Rather they appeared at a rate of one or two per annum over a number of decades.

Since the three popular subjects emerged in different decades it seems most advisable to consider them chronologically and to relate each to the other subjects of their generation. Gessner's *The Death of Abel* was the first to come and go. Indeed it dropped out of circulation almost completely after 1830. Gessner himself belonged to a much earlier generation than the others. First translated into English in 1761, his popularity reached its height around 1800. The sentimental classicism of his style and

his Arcadian imagery made him very much a man of the later eighteenth century. While his *Idylls* showed his appreciation of the serene aspects of nature at its purest, *The Death of Abel* had the added attraction of being cast in the epic mould. It also had greater emotional impact because it dealt with the first murder and the shock of man's discovery at his own potential for wickedness. Since Gessner had been a painter as well as a poet—his *Letter on Landscape Painting* was also well known in England[31]—his work had an added attraction for artists. Much of it indeed is highly graphic in its descriptiveness. In 1797 an edition of Gessner's works appeared with illustrations by Stothard, a painter whose manner was admirably suited to the mood of the Swiss author. Before that time, however, *The Death of Abel* had already become a subject for illustration. A translation with four stipple engravings by the *émigré* artist Henry Richter had appeared in 1795,[32] and as early as 1791 L. J. Cossé had exhibited *Adam and Eve beholding the first instance of Death in the Murder of Abel* at the Royal Academy.[33] While pictures simply entitled *Death of Abel* cannot be associated with Gessner with any certainty, this particular subject can. For it is a key event in Gessner's epic and is, moreover, one that does not occur in the description of the murder in Genesis. In fact—with or without explicit reference to Gessner—it was the most frequent 'Death of Abel' subject to be specified between 1790 and

39. W. Blake: *The Body of Abel found by Adam and Eve. c.* 1826. Tempera (32.5 × 43.3). Tate Gallery, London.

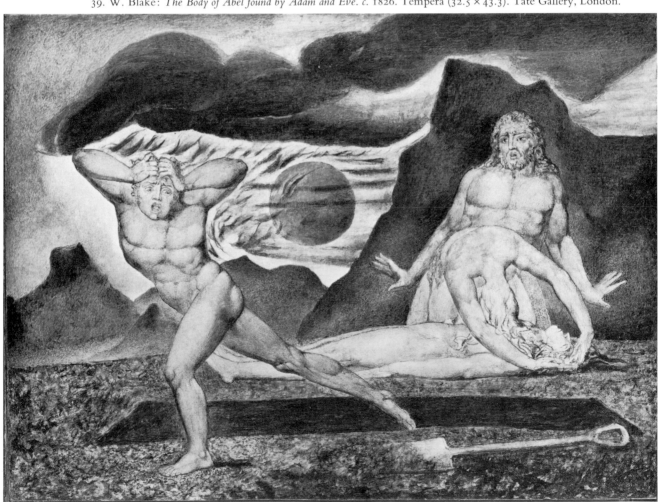

1830. It accounted for twelve of the twenty-five instances. In view of this, it seems highly likely that Blake's *Body of Abel Found by Adam and Eve* (Plate 39) was inspired by Gessner's poem. Certainly much of the imagery in the fourth song of *The Death of Abel*—particularly the violent, expressionist behaviour of Cain and the reactions of Adam and Eve—is to be found in Blake's work. The only major difference between the two is the presence of the grave. In Gessner's account this does not exist, and the song ends with Adam taking the body home for burial.[34] It is true that these features do exist in Blake's own *The Ghost of Abel*. However, this postdates the picture. It was etched in 1822, while a version of the painting was shown at Blake's exhibition of 1809.[35]

While the 1790s saw the beginning of a pictorial interest in Gessner's works, it also saw the literary interest in German *Sturm und Drang* emerging. This was the time when the early dramas of Schiller and Goethe became known, and the emotive dramas of Kotzebue became fashionable. It was also the period when the rediscovery of the folk ballad and the mediaeval saga by *Sturm und Drang* writers began to have an effect on English writers—in particular Scott.[36] The response of English artists to this influx was more guarded. This is perhaps curious, since there existed in their midst the Swiss *émigré* Henry Fuseli, who had been closely associated with the *Sturm und Drang* movement in his youth. Yet the exotic and idiosyncratic manner of the artist was one that few felt qualified to emulate. Fuseli himself revealed many *Sturm und Drang* tendencies in the subjects he chose. He frequently illustrated Northern sagas. His diploma painting for the Royal Academy was *Thor Battering the Midgard Serpent*, an incident from the Icelandic *Edda*, and he depicted themes from the *Nibelungen* on several occasions.[37] Even his enthusiasm for Shakespeare must be seen in this light; for it was under the influence of Bodmer in his native Zurich that he first saw the virtues of the English writer. Like his *Sturm und Drang* associates, however, Fuseli was in no way exclusive in his concern for the literature and sagas of the North. He was equally interested in the productions of ancient Greece, and sought to find the general human experiences in all literature and mythology rather than dwell on local colour. This can be seen in his mature pictorial style as well. While the work that he executed as a youth in Zurich and during his first years in England shows the influence of sixteenth-century Swiss engravings, this 'Teutonic' cast disappeared after his stay in Rome (1770–8). Henceforth he treated classical and Nordic subjects alike in a dramatic Italianate mannerist style that is strongly indebted to Michelangelo. Like his friend Herder, he seems to have believed that the material of Northern poetry and culture should be couched in a universal, classicizing language. He certainly showed little interest in those works of modern German literature that emphasized their Teutonic background. It is highly appropriate that he should have been the illustrator of Wieland's epic fantasy, *Oberon* (Plate 40)—he provided pictures for the second edition of William Sotheby's translation of this, which was published in 1805.[38] While dealing with romantic adventures and magic occurrences, Wieland's narrative was related with a sophisticated gracefulness, which Fuseli responded to in his own designs. It is interesting in this context to note that the only work from the younger generation of German Romantic writers that

Fuseli was drawn to illustrate was the touching fairy-tale *Undine*. Significantly his treatment was ironic.[39]

While many of Fuseli's designs—notably the *Nightmare*—became highly influential, his illustrations of Nordic sagas appear to have had little impact. He did, however, encourage Flaxman to work on some illustrations for Wieland's *Oberon*; a project that the artist reported to his sister in a letter of 1804.[40] However, nothing became of the idea beyond a series of preparatory sketches. Perhaps Flaxman—who found Milton too immaterial to illustrate—did not feel at home with the fantastic events of Wieland's narrative. Apart from two isolated pictures—one by J. Johnson exhibited in 1826 and one by G. Pope exhibited in 1852—Wieland does not seem to have inspired any other English artists either.

The impact of the poet Gottfried Bürger was to be a more lasting one. Wieland's interest in legends was rather playful, but Bürger sought to revive the spirit of traditional ballads. Such poems as *Lenore* and *Der Wilde Jager* used a simple direct language and powerful, infectious rhythms which were aided by a bold use of onomatopoeic effect. Both deal with the supernatural in a chilling way—Lenore being dragged to her death by a phantom of her dead lover, and the cruel huntsman being condemned to be pursued by devils for ever. Both were strongly dependent upon folk legends—*Lenore* was based on the English tale *The Suffolk Miracle*. *Der Wilde Jager* and *Lenore* were both the subject of popular adaptations by Walter Scott in the 1790s, although it was the latter that became more generally appreciated. Hailed as an example of the 'wild and eccentric writings of the Germans',[41] it made a sudden appearance in a startling spate of translations (five in all) that followed the publication of the first volume of Bürger's collected works in Germany, in 1796.[42]

Yet, despite the appreciation of the drama and fantasy of the poem by a generation already familiar with the gothic novel and Young's *Night Thoughts*, there were still reservations in the English responses. One of the translators, J. T. Stanley, objected to the ambiguity of the end, the irresolution as to whether the supernatural event is a reality or a dream. He therefore added a final verse of his own to suggest it was the latter. Even Blake—who produced designs for this edition—tended to emasculate the force of the narrative in his vignettes. Only in the frontispiece (Plate 41) did he match the spirit of the work, producing a summary of the most dramatic moment in the poem, when the horse leaps with William and Lenore down into the open grave. It was a design that he was sufficiently pleased with to reuse some years later in 1809 for his watercolour *The Genius of Shakespeare*.[43] A more popular series of illustrations to *Lenore* were those by Lady Diana Beauclerk, which accompanied the 1799 edition of W. R. Spencer's translation. Skilfully combining expressionism and sentiment they were sufficiently successful to be reprinted in 1809, and were well enough appreciated as bowdlerizations of Germanic excess to be compared by a reviewer in the *European Magazine* in 1821 to the 'brocken' scene in Retzsch's *Faust* outlines.[44]

After a slight decline in popularity after 1800, *Lenore* revived in popularity in the 1840s.[45] It was then that it was translated by Dante Gabriel Rossetti and that Maclise produced his illustrations for Julia Margaret Cameron's translation.[46] Yet curiously,

despite this renewed interest, it did not generate any independent paintings. Perhaps the expressionist fantasy proved extreme for this later generation of artists. Certainly Maclise's illustrations play this side down in favour of a spurious archaism.[47] The only Bürger poem to generate pictures independent of book illustration in England was *Der Wilde Jager*. Westall exhibited a painting on this theme at the Academy in 1832, and R. B. Davis in 1853.

The decline that *Lenore* temporarily experienced after 1800 was symptomatic of that of all German literature in England at the time. Perhaps, as Stokoe suggests, this was because the excesses of the *Stürmer und Dränger* were beginning to pall and gain subversive overtones, while the more lyrical and transcendent archaism of the Romantics seemed as yet too obscure. The only two writers of the late eighteenth century to survive this decline in strength were the two who had themselves developed away from *Sturm und Drang*: Goethe and Schiller. There is, it is true, a 'dip' in the number of translations of their works in the first two decades of the nineteenth century.[48] But both revived in the 1820s and remained firm favourites throughout the rest of the century. They became, in fact, the most translated of all German authors. According to Morgan, Goethe had been published 770 times and Schiller 377 times in English translation by 1927. The only other authors to exceed 300 publications were the brothers Grimm, who appeared 308 times.[49] In the case of both Goethe and Schiller the visual image appears to have played a significant part in their revivals in England. Both were the subjects of outlines by the highly popular illustrator Moritz Retzsch. Retzsch's *Faust* outlines, originally published in Germany in 1816, became generally available in England in 1820. His outlines to

40. ★H. Fuseli: Illustration to *Oberon*, 1805–6.

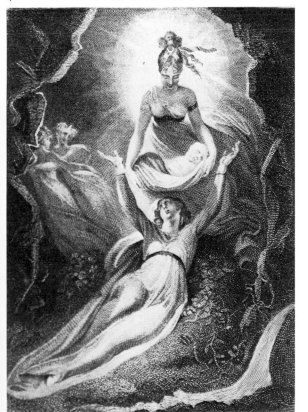

41. ★W. Blake: Frontispiece to *Leonora*, 1796.

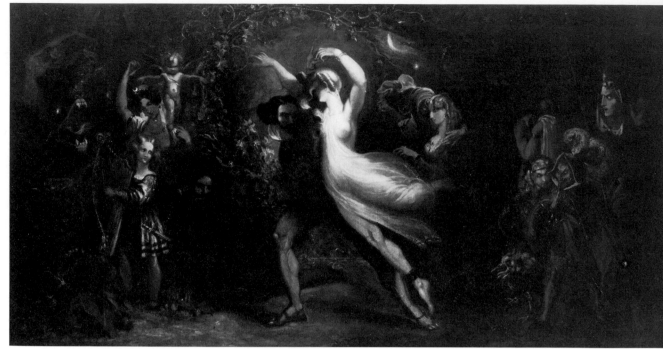

42. T. von Holst: *Faust and Lilith*. 1833? Oil. Private Collection.

Schiller's ballads *Fridolin* and *Der Kampf mit dem Drachen* appeared in English language editions in 1823 and 1824. In all cases they were so popular that they led to pirated imitations by the English engraver Henry Moses. As will be seen in the next chapter, Retzsch's outlines played a critical part in the change of attitude to Goethe's *Faust* in England.[50] It would seem that the artist's sub-Flaxmanesque manner presented these themes in a more familiar and reassuring guise than previously. Later Carlyle was to continue to task of convincing the English that there was nothing wilful or subversive about German fantasy and transcendentalism.

Curiously Schiller, despite his popularity, was very little illustrated by English artists. In fact, between 1815 and 1860 his work was the subject of an exhibited picture on no more than six occasions. This contrasts strongly with Goethe, who was illustrated forty-four times in the same period. Only three of Schiller's works—the plays *Wallenstein* and *Die Räuber* and the poem *Ritter von Toggenburg*—were involved, and the numbers are far too infrequent and sporadic to permit any inferences to be drawn. Nor did the subjects of Schiller inspire any major artist—unless one cares to see in Turner's mention of 'the German invocation upon casting the bell' in connection with his *Hero of a Hundred Fights* (exhibited 1847) a garbled reference to *Das Lied von der Glocke*.[51]

Perhaps the clearest reason why Goethe should have outpaced Schiller to such a degree as a subject for artists is because he had produced a single work that had captured the imagination of the public. *Faust* was responsible for thirty-five of the forty-five times that Goethe was illustrated. The English artists who turned to this theme appear to have leaned to a large degree on the outline illustrations of Retzsch that had first made the work popular in England. They were also aided by two further powerful continental works—the *Faust* illustrations of Cornelius (1816) and

Delacroix (1828). All three influenced the paintings and drawings of Theodore von Holst, the follower of Fuseli, who was the first British artist to exhibit subjects from *Faust*. Holst, who planned to do a series of illustrations to the play, exhibited four scenes to it between 1827 and 1834[52] (Plate 42). An artist with a taste for the exotic and macabre, he appears to have taken most interest in the satanic side of Goethe's play. Indeed the fantasy of the work impressed him so much that he also invented a theme related to it, 'Dream after reading Goethe's Walpurgisnacht'.

In his exploitation of this side of the drama, however, Holst was virtually alone. Only Westall, the illustrator of the *Wild Huntsman*, followed him in attempting a 'Walpurgisnacht' subject when he exhibited *Faust and Lilith* in 1831. Apart from this, illustrators concentrated—almost without exception—on the theme of Margaret. It was the hapless heroine being courted by Faust, brooding at her spinning wheel, tormented by the evil spirit in church, or confessing before the *mater dolorosa*, that monopolized artists' attention. In these, sentiment and beauty were more prevalent than excess. Certainly this is the case in Henry O'Neil's soulful smoothly-painted rendering of Margaret before the Virgin that was exhibited in 1840—as it doubtless was in the work of the young John Rogers Herbert exhibited in 1835. Both these artists were to become involved in the Westminster Hall competitions and came to represent the 'purist' side of the Germanic influence. The more vigorous direction of Holst meanwhile virtually sank without a trace. There was something of a kindred spirit in the *Walpurgis Night* of Dadd (which is not directly from *Faust*) and in the more tenuous relationship with the early Rossetti.

Rossetti's response to Goethe's *Faust* is intimately connected with his knowledge of Retzsch's outlines, and will therefore be discussed in the next chapter. Although it led to the initiation of a prose romance, *Sorrentino*, in 1843 and to numerous designs and plans for Faustian subjects between 1846 and 1848, he never actually completed a painting on the subject.[53] His decision to paint as his first Pre-Raphaelite painting *The Girlhood of Mary Virgin* rather than 'Margaret Tormented by the Evil Spirit' marks a critical moment when the Brotherhood turned their back upon satanic romanticism in favour of primitivism. Yet one close associate, Deverell, carried this ambition further when, under the influence of Rossetti, he exhibited *Margaret in Prison* at the Royal Academy.[54]

The sporadic illustration of other Goethean subjects shows no more system than did the illustration of themes by Schiller. Holst himself exhibited in 1834 *The Seducer*, a scene from the minor early modern drama *Clavigo*, and in 1840 a subject from a highly suspicious piece of Goetheana, Bettina von Arnim's *Correspondence with a Child*. Bettina's book had been translated in 1837 after having created something of a stir in Germany. *Clavigo*, on the other hand, appears to have been little known in England at the time. A scene from another early *Sturm und Drang* drama, *Götz von Berlichingen*, was exhibited in 1838. This choice seems to have been appropriate since the artist, R. R. McIan, was an ex-actor who was noted for his depictions of dramatic Highland scenes. Little is known of the depictor of the sole illustration to *Werther: Charlotte and Werther* by E. Rowley, exhibited at the National Institution in 1855. Yet it is striking that this novel—so proverbially

successful in the later eighteenth century—should have figured so little in the Victorian artist's repertoire. Goethe's ballads, too, hardly ever appear. There was an *Erl King* by a Miss J. Macleod at the British Institution in 1847. In 1858 Frederick Leighton—recently settled in England—exhibited a rendering of *The Fisherman and the Syren* at the Royal Academy.[55] This subject is one of the few reminders of the artist's student years in Germany. Stylistically, however, it has already moved beyond the sphere of Nazarene influence.

Apart from these, the only other Goethe subject to appear in the London galleries was the one that is perhaps now the best remembered: Turner's *Light and Colour (Goethe's Theory)*, which was exhibited at the Royal Academy in 1843. As John Gage has shown, this commentary on Goethe's *Farbenlehre*—which the artist knew from Eastlake's translation of 1840—is far from being simply illustrative.[56] It is rather a critique of Goethe's notion of colour association, which points out the limitations of a fixed relationship between individual colours and distinct emotive states. Like most of Turner's responses to German subjects, it has the dual fascination of showing him reacting to fashionable preoccupations (in this case, German art theory) and providing a highly individual and complex commentary on them.

There hardly seems to be any difficulty in accounting for the preponderance of *Faust* illustrations over other Goethean subjects. Not only was the work itself the most popular of the poet's productions, but it had also been well associated with pictorial illustration before any English artist undertook the theme. However, it is also worth pointing out that much of the play—its *altdeutsch* setting, use of folk legend and inclusion of the supernatural—accorded well with the current expectations of German literature in England. The success of *Faust* coincided with a growing interest in myths and legends. To a large extent this was fuelled by sources within England. But, since the success of Bürger's works in the 1790s, German literature had been looked on as embodying the legends of Northern Europe in their most extreme and fantastic form. While the excesses of *Sturm und Drang* writings began to lose their appeal after 1800, the more charming and innocuous genre of the fairy-tale steadily gained ground. The artfully naïve tales of Friedrich de La Motte Fouqué were especially prized from the time of the first English translation of *Undine*, which appeared in 1818.[57] The extravagant initial enthusiasm for Fouqué's work even reached Blake, who is recorded as having remarked of *Sintram and his Companions*—the fantasia built up from Dürer's *Knight, Death and the Devil*—'this is better than my things'.[58]

Surprisingly Fouqué's work does not seem to have occasioned any book illustrations in England before Miss Gordon's *Illustrations to Undine* of 1843. Indeed before this date the depiction of subjects by Fouqué seems to have been restricted to a number of designs executed by Fuseli and Thomas Griffiths Wainewright around 1820. Between 1819 and 1822 Fuseli produced several drawings for scenes from the story, of which five are extant.[59] Possibly he intended to provide illustrations for a publication, as he had previously done for Wieland's *Oberon*. He also executed an oil painting, which remained unexhibited and unsold during his lifetime.[60]

Whatever Fuseli's motives for treating *Undine* (Plate 43), his interpretation was

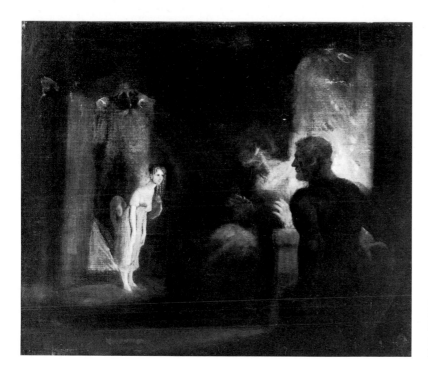

43. H. Fuseli: *Kuhlborn brings Undine to the Fisher Folk*. 1821. Oil (63.5 × 76.5). Kunstmuseum, Basel.

very much in the vein of his earlier illustrations of legends. The story of the water spirit who loved and lost a mortal appealed to him less for its pathos than for its moments of startling supernatural occurrences and amorous vengefulness. When Undine first arrives as a child in the hut of the fisherman and his wife who are to become her foster parents, Fuseli interprets the moment with a dramatic chiaroscuro and frozen rhetorical gestures which greatly magnify the astonishment expressed in Fouqué's text. His depiction of the dénouement, when the ghost of Undine rises from the well to enfold her faithless lover in a fatal embrace, gives the moment an erotic dimension that is unstated in the book. Perhaps Fuseli's failure to make his *Undine* designs known was due to a certain recognition that he had overloaded the theme. They certainly differed totally in mood from those outlines to *Undine* by the German artists Ludwig Schnorr and C. F. Schulze, which were on sale in London at the time.[61]

Wainewright—an associate of Fuseli and Blake who is better remembered nowadays for his poisoning than for his painting[62]—exhibited subjects from *Undine* at the Royal Academy twice, in 1821 and 1823. Since these are no longer extant and the titles recorded in the catalogue are unspecific, it is difficult to comment on the treatment employed. Surviving drawings by the artist suggest an eclectic manner with a leaning towards Fuselian effect. A newspaper review of the 1823 Academy exhibition certainly found Wainewright's contribution unusual and striking: 'a very singular picture, with a powerful display of talent; the composition is well managed and the effect magical.'[63]

On the other hand Wainewright did not admire Fuseli without reservation. Under

115

CHAPTER I.

How the Knight came to the Fisherman.

MANY a hundred years may now have passed since a good old fisherman sate one fair evening before his door and mended his nets. He dwelt in a very beautiful spot. The grassy land on which his cottage was built extended far out into a great lake; and it seemed as if, out of love, this slip of ground stretched itself into the clear, blue, and wonderfully bright waters, and also as if the waters, with loving arms, clasped the fair meadows with their high-waving grass and flowers, and the refreshing shade of the trees. Each seemed the guest of the other, and this it was made both so lovely. Yet was this pleasant place seldom or never

GERMAN POPULAR STORIES,

Translated from the

Kinder und Hans Marchen,

COLLECTED BY

M. M. GRIMM,

From Oral Tradition.

Published by C. Baldwyn, Newgate Street.

LONDON,
1823.

44. *J. Tenniel: Illustration to *Undine*, 1845. Wood engraving by J. Bastin.

45. G. Cruikshank: Title page to *German Popular Stories*, 1823. Etching.

the guise of Janus Weathercock he was working at this time as a reviewer in the *London Magazine* and sometimes expressed misgivings at the extremeness of Fuseli's style. Furthermore, he was an avid admirer of the tamer German illustrator Moritz Retzsch. When first giving vent to this enthusiasm in an article entitled 'Sentimentalities of the Fine Arts' in the *London Magazine* in 1820 he found that the 'lovely and loving Undine' was similar to the work of Retzsch in its avoidance of the harsh mannerisms normally to be found in German art and literature. This at least suggests that he responded to the pathos and charm of Undine more than did Fuseli.

Although the English illustration of *Undine* was scant before 1843, it subsequently became firmly established and remained an equal favourite with *Faust* throughout the rest of the period. Indeed between 1843 and 1860 there were only three years in which one or more designs for the tale failed to appear in one guise or another. The pictures that survive show a totally different approach from that adopted by Fuseli. For the most part they can be related to the vogue for fairy paintings that sprang up in the 1840s. Unlike the depiction of English fairy subjects—in which scenes from *A*

Midsummer Night's Dream and *The Tempest* predominated[64]—these tended to have a discernible Germanic tinge to them. Above all, they showed the influence of those German illustrators like Retzsch, Neureuther and Sonderland who will be discussed in the following two chapters. This was certainly the case with the *Undine* that was exhibited by Maclise at the Academy in 1843. Executed at a time when the artist was fast gaining a reputation as a leading exponent of 'Germanism' it was noticed by *The Times* for a 'stiffness of outline and exuberance of invention that characterize one of the German border engravings'.[65] The interweaving of spirits and forest foliage that surround the protagonists in this work does suggest that Maclise had been looking carefully at such sources. Indeed—as will be seen in Chapter V—such a method became commonplace in his art at the time.

Similar stylistic influences can be found at work in the book illustrations to *Undine* and other works by Fouqué that were executed after this date. They are especially noticeable in Tenniel's illustrations to *Undine* (Plate 44) of 1844, Henry Selous's to *Sintram* of 1848 and John Franklin's to the *Four Seasons* of 1855. Only Edward Corbould's illustrations for *Minstrel Love* of 1845 appear to have evaded the tendency. His more dashing 'troubadour' style was to be a great influence on Burne-Jones in his early years.[66]

If the popularity of Fouqué's writings as pictorial subjects can be related to the vogue for German illustration, this is emphatically not the case with the finest of all English nineteenth-century illustrations to German fairy-tales, Cruikshank's etchings for the brothers Grimm's *Kinder und Hausmärchen*. Like Goethe's *Faust* and Fouqué's *Kunstmärchen* these *Volksmärchen* first became noticed in England around 1820. Cruikshank's etchings accompanied the first English language selection of these carefully collected folk tales, which appeared as *German Popular Stories* in 1823. That an artist noted for his satirical and comic designs should have been chosen to illustrate these stories says much about the levity with which they were received in England; a spirit very different from that of their German editors, who set out to preserve and enshrine the culture of the people. The preface of the first English edition remarks that the stories were intended 'to tickle the palate of the young',[67] and Cruikshank emphasized the point by providing a frontispiece (Plate 45) in which a group of figures roaring with laughter are shown seated around a fire. By 1826, however, the stories had been sufficiently assimilated for it to become clear that such a frontispiece was inappropriate, and for the second edition Cruikshank replaced it with one in which the figures have changed their laughter for rapt attention.[68]

At this time Cruikshank's work still revealed strongly his origins as a political caricaturist—working in the vein of his father Isaac and of James Gillray. If his levity was at times inappropriate for the stories he was illustrating, it did at least have the virtue of being in a popular tradition that was as imaginative and vigorous as the narratives themselves. Ruskin, who considered that Cruikshank's 'modern grotesques . . . have the most sterling value of any belonging to this class in England', compared the illustrations of Grimm, in quality, to the etchings of Rembrandt.[69] This, of course, is a grotesque itself in its degree of exaggeration. Yet

it is true that Cruikshank's designs were far more inventive than those created for *Märchen* by such contemporary German illustrators as Schwind, Richter, Speckter and Pocci.

Following the lead of Cruikshank, the German *Märchen* remained for some time an easy butt for English satirists. In 1827 the heavy-handed A. H. Forrester illustrated a series of *Eccentric Tales* attributed to a mythical 'Baron Kosewitz'. Although actually etched by Cruikshank, the pictures show little of that artist's brilliance or inventiveness. Forrester was an artist of minor talent who attempted to keep in the public eye by mimicking topical interests. If the results are rarely uplifting, they can provide a useful indicator of tastes. In his lengthy career he commented in his way on several generations of Germanic fashions. After having lampooned the Grimms, he turned his attention to Retzsch's *Faust*.[70] Finally with the advent of the tales of Hans Christian Andersen and the illustrations of Count Pocci in the 1840s, he produced a *Comic Nursery Tales* full of such droll figures as Gruffel Swillerdrinken.

The spirit of irreverence, which Forrester shared with Cruikshank, did not survive long into the Victorian era. In 1839 the Grimms' tales reappeared in a more unequivocal juvenile guise under the title of *Gammer Grethel*. The illustrations in this case were a combination of those by Cruikshank and the ones designed for the original German edition by the Grimms' younger brother Ludwig Emil Grimm. While the illustrations of both artists were re-engraved on wood for this edition, there was no confusing their styles or approaches. A comparison between E. Grimm's illustration to *Rosebud* (Plate 46) and that by Cruikshank to *The Goose Girl* can make this clear (Plate 47). While Cruikshank appears to be ebullient and fanciful, Grimm emphasizes archaic charm and naïvety. When a further series of Grimms' tales were brought out in 1846 under the title of *The Fairy Ring*, they were illustrated by Richard Doyle in a manner that combined mild humour and archaism (Plate 48). Doyle was clearly influenced by the *Gammer Gurton* series that Henry Cole (under the alias of Felix Summerley) had instigated in 1845 and whose illustrations, in the hands of such artists as John Franklin, already showed a leaning toward the decorated page style of contemporary German artists.

This is not the place to chart the influx of the work of German illustrators to German stories into England in the 1840s. To some extent the channels by which these occurred have been indicated in Chapter I;[71] while those aspects which were stylistically important for English artists will be discussed in Chapters IV and V. There is, furthermore, some discussion of the phenomenon in recent English publications.[72] It is worth pointing out, however, that it was in the area of children's illustrations that this invasion was most strongly felt. The artists who were most frequently used by English publishers—Adrian Ludwig Richter, Otto Speckter and Count Pocci—produced works in a simple, charming, Biedermeier style that had few connections with the didactic purism of contemporary German historical artists. Their art was more of a direct response to the revived folk tale—and the success of their interpretation in England in the 1840s reflected a new understanding of this kind of narrative.

46. (left) ★L. E. Grimm: *Rose-Bud*. Illustration to *Gammer Grethel*, 1839. Wood engraving.

47. (below left) ★G. Cruikshank: *The Goose Girl*. Illustration to *Gammer Grethel*, 1839. Wood engraving.

48. (above) R. Doyle: Title page to *The Fairy Ring*, 1846.

Amounting to no more than thirty-one instances, the German historical subjects exhibited in London during the period 1815–60 are even less susceptible to generalization than are the literary ones. Yet, once again, there are some recurrent topics that seem to reflect popular interests. The very occurrence of German subjects seems significant; for before the Victorian era there were none at all. In fact the first—W. H. Kearney's *Luther's Conference with Cardinal Catejan at Augsburg, A.D. 1520*—was shown in 1837. The subject was portentous, for the largest group was to represent the early years of the Reformation as embodied in the careers of Luther and—in two cases—Melancthon. Between 1837 and 1858 ten such pictures were exhibited—nearly one-third of all the German historical subjects. By contrast, there were no explicitly Catholic German themes.

The interest in Luther and the Reformation in England hardly needs any explanation. However, it is noticeable that the first depiction of such a theme occurred a year after the first publication of Luther's autobiography in English.[73] Even more influential was J. H. Merle D'Aubigné's important *History of the Great Reformation*. This appeared in thirteen English editions between 1838 and 1855, and was frequently used as a source for pictures on the lives of Luther and Melancthon.[74] It is also significant that the highest concentration of such subjects should have occurred in the early 1850s, following the strong outburst of anti-Catholic sentiment that greeted the re-establishment of the Catholic hierarchy in England in 1850.

There is no single dominant theme in the political subjects exhibited. Ten in number, they ranged in time from R. R. McIan's *Dieter von Weiler . . . arming for the Faustrecht of Weinsberg, 1491* to J. E. Hodgson's *German Patriot's Wife of 1848*. However, it is noticeable that there were more subjects from the eighteenth and nineteenth centuries than from earlier periods, and that amongst these Prussian themes predominated. Given that state's ascendancy and the Anglo-Prussian diplomatic links of the period this is perhaps not surprising.

There are only two other themes that show any tendency to recur—lives of musicians, and the origins of the printing press. Between 1847 and 1858 there were seven of the former—five from the life of Mozart and one each from the lives of Haydn and Beethoven. By contrast there were only two depictions of a German painter. Both—hardly surprisingly—were of Dürer. *Albert Dürer in Nuremberg* was shown by that unrepentant Germanist William Bell Scott at the National Institution in 1855. The other Dürer subject—*Dürer presenting a picture to Luther*, exhibited by J. Noble at the Society of British Artists in 1858—was taken from D'Aubigné's *History of the Great Reformation* and was, perhaps, more an affirmation of Protestantism than a celebration of German art. German authors fared even worse. There were no pictures celebrating their lives—though the tomb of the medieval poet Walter von der Vogelweide made an appearance in a picture by W. Field exhibited at the Royal Academy in 1860. Doubtless the greater attention paid to German musicians reflects the greater hold that German music had over the

popular mind than did other forms of German culture. This is also reflected in the amount of biographical literature then current. Such well-known works as M. H. Beyle's *Lives of Mozart and Haydn* had been available in English translation since 1818. Far more important was the appearance of E. Holmes's classic *Life of Mozart* in 1845. The first Mozartian pictures appeared two years later at the Royal Academy. Like all subsequent ones, they were based on passages from Holmes's *Life*.

Between 1850 and 1854 three pictures relating to the early history of printing were exhibited: H. C. Selous's *Gutenberg showing to his wife his first experiment in Printing* (British Institution, 1850); S. A. Hart's *Three Inventors of Printing—Gutenberg, Faust, and Scheffer* (Royal Academy, 1852); and W. J. Grant's *Legend of the First Effort in Printing—German Merchant cutting Figures on a Tree* (Royal Academy, 1854). The theme of the last was taken from a history of the Reformation and stressed that connection between the spread of learning and Protestantism that was so strongly emphasized by D'Aubigné and other commentators at the time. More generally, all three subjects can be compared to the admiration that 'an idealistic age that regarded education and learning as the spearhead in the moral regeneration of man'[75] felt for that English innovator of printing, Caxton. Maclise's *Caxton's Printing Office*—begun in 1849 and first exhibited at the Royal Academy in 1851—was an immense success.[76]

None of these recurring themes—the Reformation, modern Prussian history, music and printing—appears to have emerged out of any direct interest in Germany. They seem, rather, to reflect those features of German life which—for quite separate reasons—related most to English interests. It is significant in this context that of all the artists who painted these works only two—William Bell Scott and Henry Courtney Selous—appear to have been influenced at all by German art in their style of painting.

PORTRAITS

The number of portraits of people known to be German that were exhibited in London during the period 1815–60 was fifty-four. Although this is a larger number than that of the German historical subjects exhibited it is a less significant one proportionately. The overall number of portraits exhibited during the period far exceeded that of historical subjects. The distribution of the German portraits is also unrelated to that of the topographical, literary and historical subjects. These last all show a gradual increase in numbers to a peak in the 1840s and early 1850s; the largest number of portraits, on the other hand, occurred just after the Napoleonic Wars and in 1828–9. Between 1830 and 1838—when the other categories were beginning to rise—there were no portraits exhibited at all. After that there was a small trickle—amounting to approximately one every other year.

The subjects of these portraits tended to reflect political and social interests rather than cultural ones. The relatively large number of portraits after the Napoleonic Wars was due mainly to the depiction of the leaders of Britain's allies. Blucher occurred four times in 1815. There was also a portrait of Metternich by Lawrence shown at the Royal Academy in that year. In 1816 there was another representation

of Blucher and one of the Archduke of Austria. Subsequently, dynastic interests were most present in the depiction of important personages. In the years following his marriage to the heir to the English crown Leopold of Saxe-Coburg appeared three times: in 1817 (the year of his wife's death), 1819 and 1823. In the year of his marriage to Queen Victoria a portrait of Prince Albert appeared in the Royal Academy. This was the result of an astute move by the painter George Patten, who had hastened to Rosenau upon hearing of the betrothal.[77] In 1844 a portrait of Albert's brother Prince Ernest was exhibited, and in 1848 one of the Duchess of Saxe-Coburg. Prussian dignitaries also occurred in the 1840s; the King himself in 1842 and the Prussian ambassador to London, Baron Bunsen, in 1843 and 1850. Other portraits of German princes and aristocrats occurred sporadically—as in the case of W. H. Watts's portrait of the Prince of Hesse-Homburg of 1819. There were also some portraits of commoners—for the most part female. On the whole, few inferences can be made from these. Mrs McIan's portrait of *Eine Frankfurter Künstlerin*, exhibited at the British Institution in 1839, is of some interest, however. It suggests a recent visit to Germany, which would account for her husband's sudden burst of German subjects in 1838 and 1839.

The portraits of Germans made famous by their achievements can usually be related to a recent visit or some other immediate cause of interest. Of the portraits thus represented, C. Moore's *Bust of Gotzenburger a distinguished German painter* (exhibited 1827–8) was the outcome of Götzenburger's visit to England of 1826. E. Williams's *Portrait of the Eminent German Artist, Moritz Retzsch* of 1851 coincided with the work Williams did for Mrs S. C. Hall's article 'A Morning with Moritz Retzsch' in the *Art Journal*.[78] Amongst literary figures, Von Holst's portrait of Bettina von Arnim—exhibited at the Royal Academy in 1839—came two years after her notorious *Goethe's Correspondence with a Child* was published in England in 1837.[79] Another notorious figure, the phrenologist Dr Spurzheim, appeared twice in 1828, following successful lecture tours of England.

Perhaps the only portraits in this category that can be related to other themes are the three depictions of German musicians that occurred in the 1850s. These were N. Barnard's *Bust of Beethoven* (Royal Academy, 1851), C. Bacon's *Sketch for a statue of Mendelssohn* (Royal Academy, 1857) and A. Grass's bas-relief of Beethoven, Mozart, Handel and Bach (Royal Academy, 1859). All were posthumous and all were sculptures—presumably of a commemorative nature and reflecting similar interests to the historical 'Lives of musicians'.

★　　★　　★

While bearing little upon the main topic of this study, the list of portraits does complete the outline of the range of German subjects engaged in by English artists during the period 1815–60. From this it can be seen that it is only in the sphere of literary themes that any significant correlation can be made between the topics chosen and the current concern about German art. This association will help form the background for the next two chapters, where it will be seen that the pictorial image could play a crucial role in familiarizing the British with a German subject.

CHAPTER IV

F. A. M. Retzsch and the Outline Style

WHILE THE outline engravings of the Saxon artist Friedrich August Moritz Retzsch are little known today, and even less appreciated, their fame and success in Victorian England was astonishingly great. Circulated throughout Europe and the Americas during the middle decades of the last century, these books of illustrations, depicting for the most part plays and poems by Goethe, Schiller, Bürger and Shakespeare,[1] were usually received with mild praise; yet in England they excited a strong and long-lived enthusiasm. Here the market was so large that Retzsch specifically directed his later work, especially the Shakespeare outlines, towards England, where works continued to sell long after they had been forgotten elsewhere. His *Faust* illustrations, for example, which did so much to make this play one of the most respected pieces of German literature in England, were still being published in London in 1893, seventy years after they had originally appeared in Germany.

One cannot dismiss this peculiar attraction as one of mere superficial appeal. While it would appear to be the case, according to the accounts of contemporary novelists, that Retzsch's outlines were an essential adornment of the cultivated lady's drawing-room, they were also objects of study and inspiration for some of the most eminent writers and artists of the period: amongst others, Byron, Shelley, Flaxman, Maclise, Millais and Rossetti. For these at least, Retzsch was an artist of significance; and it would seem that, above all, this significance lay in the clarity and dramatic power of his visualizations.

To Retzsch's contemporaries this was no minor achievement; for the ability to present the subject matter of a picture effectively was a central concern of post-Kantian aesthetics, and as such greatly expanded the significance of illustration. Indeed the Romantic interest in discovering correspondences between the arts led to an exploration of this genre as the pictorial equivalent of verbal description. Early examples of this can be seen in the illustrations of Runge, whose *Taschenbücher* decorations far transcend the vignettes of his rococo predecessors, and also in Blake, whose interweaving of text and picture reveals an interest in simultaneousness of effect and concurrence of meaning. While this relationship of illustration and text, greatly aided by the development of wood engraving, became a standard usage in the mid nineteenth century,[2] other implications of the relationship between word and picture had developed. In the books of outline illustration that became popular, verbal description became replaced by a continuous pictorial narrative.

The use of narrative sequence was hardly unfamiliar to Western art before this time. However, the reviver of this tradition, Flaxman (plate 49), achieved a new significance for the process, because by choosing to have his drawings engraved in

49. *J. Flaxman: Illustration to *La Divina Commedia di Dante Alighieri*, Rome, 1793.

outline he demonstrated a means of approximating more closely to verbal narrative. This technique, made popular by neoclassical theory and refined as an engraving style by its use in archeological drawings,[3] had both the advantage of grasping the essential features of a depiction and of providing the means of quickly (if exactingly) reproducing a sufficient number of designs to follow the incidents of a verbal narrative closely. In this way illustrations could provide a comprehensible account of a narrative by themselves, and dramatic moments, in particular, could be shown in close sequence. In Flaxman's Dante illustrations, for example, the different stages of the poet's encounter with Paolo and Francesca are represented in several scenes, almost closely enough to resemble a strip cartoon.[4]

When A. W. Schlegel published the first German review of Flaxman's outlines, he did not overlook such implications. In the well-known article in the *Athenaeum* of 1799, he contrasted this synoptic form of illustration favourably with more laborious styles of engraving which, he said, tended to become prosaic through the inclusion of irrelevant detail. Only the minimal method of outline, he felt, was comparable to the contractions of the poetic form:

Their signs become almost like hieroglyphs, like those of the poet. The imagination is incited to complete the picture and to continue to create independently according to the stimulation it has received. By the contrast the finished painting holds it prisoner through its all too accommodating satisfactoriness. Just as the words of the poet are actually magic formulae for life and beauty (even if one does not observe their components or their secret power),

so it appears to be true wizardry how, in a successful outline, so much soul can dwell in a few delicate lines.[5]

It is perhaps interesting to note, in view of this quotation, that creative outline was used almost exclusively to represent poetic and dramatic literature. Although not wishing to exaggerate its significance or suggest any direct influences, Schlegel's article does seem to pinpoint the thought-processes that led outline to occupy such an accepted position in early-nineteenth-century illustration. Rather than merely exhibiting the properties of Winckelmann's *edler Einfalt*, outline became associated by the early Romantics with the poetic form, and its heiroglyphic quality was emphasized. Certainly the German use of outline, particularly that of Runge and the Nazarenes, must be viewed in this light, as must the large number of outlines of contemporary German poems which occurred at this time.

In England, on the other hand, where no apologist of the standing of Schlegel expounded the virtues of the style, Flaxman's innovations caused less stir.[6] The use of outline to illustrate contemporary poems was infrequent and eccentric; none more so than that by William Hawkes Smith, who published his outlines to Southey's *Thalaba* in 1818. Entitling the work *Essay in Design*,[7] he was conscious of a necessity to defend the technique; but his defence of outline was far from the metaphysical speculations of Schlegel. The considerations that he favoured were far more pragmatic. The minimal nature of the designs made outline, he felt, 'peculiarly adapted to fill the few leisure hours of a person whose days are devoted to commercial or professional pursuits', and he added, by way of compensation to such people, that 'Design, when executed in outline, has nearly the same *mental* effect as when they are completely filled up.'[8]

Despite such eminently practical reasoning, the 'mental' effect of design remained obscure to most English art lovers, and it was not until the appearance of Retzsch's modification of Flaxman's practice that the style began to find popular adherence. Retzsch, having taken up Flaxman's method of following the narrative closely—particularly at its most dramatic parts—had made the style more immediately intelligible by enlarging his subjects with anecdotal incidents.

Flaxman himself was well aware of the difference of approach and, while considering Retzsch's *Faust* outlines to be 'the best he has seen since the publication of his Homer',[9] objected to their over-detailed rendering. Crabb Robinson, who showed Flaxman Retzsch's *Faust* (Plate 50) in 1817, recorded:

He objected to the minuteness of the detail—the artist, he says, does not properly understand the nature of outline—every line should be significant—instead of a variety of articles in Faust's study, there should be just a volume or two and a crucible to indicate Faust's pursuits, but no more.[10]

But this economy of means, which was so suitable for bringing out Flaxman's genius for design and which gained him the respect of serious writers and artists on the continent, was far from the intention of Retzsch. Like his English admirers, Retzsch preferred outline at the anecdotal level; and, to many, Flaxman's designs appeared cold, lacking and unnatural by comparison. Thus Ruskin, who

predictably condemned outline as much as he did German painting for its lack of 'truth', could give Retzsch his qualified approval, because his outlines 'had more real material in them than Flaxman's, occasionally showing true fancy and power'.[11]

Enchanted, like many contemporaries, by the simple sentiment of Retzsch's work, Ruskin felt at ease with a use of outline in which the imagination is not challenged to 'ergänzen und nach der empfangenen Anregung selbständig fortzubilden', but accepts all too easily the discursive renderings. Using categories borrowed from Coleridge, Ruskin cites Retzsch as an example of 'fanciful' as opposed to 'imaginative' art, on account of the specific detail that he applies to his ideas. Retzsch, then, exists on the lower level of Ruskin's pantheon; but it is one, nevertheless, that concedes him the virtues of honest, clear depiction. And it was these virtues, above all, which were the kernel of his success in England. Concentrating on the elucidation of the meaning of each scene, his works were engagingly simple, and often seemed to present the obscurities of modern German literature in a more palatable form. As one reviewer put it:

> We have heard Germans say that we Englishmen cannot comprehend Faust. With that we have nothing to do here. We understand Retzsch, very much to the honour of the poet he illustrates, very much to his own honour, and very much to our own gratification.[12]

The difference of approach to outline on the part of Flaxman and Retzsch is very much tied up with the different circumstances under which they evolved their styles; whereas Flaxman's first outlines were designed amidst the neoclassical fervour of Rome in the 1790s, Retzsch developed under the 'Frühromantik' stimulus of Napoleonic Germany.

Born in Dresden in 1779, Retzsch attended the academy there from 1797 to 1799, studying under the academicians Toscani and Grassi—a painter whose classicizing rococo manner later brought him into conflict with the Nazarenes when he was sent to supervise the German Academy in Rome in 1816.[13] Retzsch led an uneventful life, and apparently never travelled outside his native Saxony. Furthermore, he was something of a recluse by nature, and soon after his election to a professorship at the Dresden Academy in 1824, he retired to a country cottage in the neighbourhood.[14] To judge from the comments of visitors,[15] his melancholy dissatisfaction led him to turn from outward events to the protection of supernatural goodness. Certainly he cut himself off from his German contemporaries, and his artistic development does not appear to have moved beyond the influences of his youth. Like so many artists around 1800, he turned from classical subjects to modern literature, illustrating first of all the writings of Gessner and Fouqué. At about the same time he began to design for the currently fashionable *Taschenbücher* and *Almanachen*. These illustrations were in a classicizing sub-rococo style—a manner similar to that of his Dresden contemporaries Schultze, Naecke, Opiz, and Ludwig Schnorr.

The taste for illustrating contemporary German writers, which grew with the patriotic fervour of the Napoleonic Wars, inclined particularly towards Goethe, by then already the grand old man of German literature. It is hardly surprising,

therefore, that his 'national drama' of *Faust*, appearing as it did in 1808, should have inspired so many illustrators. In designing a set of *Faust* illustrations, Retzsch was pursuing a trend followed by numerous other Germans, notably Cornelius, Naecke, and Opiz.[16] He was unique, however, in earning Goethe's approval for his designs. When the author saw them on his visit to Dresden in 1810, he lost no time in recommending them to Cotta, who finally published them in 1816.[17] Goethe, whose own illustrations to *Faust* are far from mediaeval and who viewed the archaizing tendencies of the younger German artists with concern, seems to have found considerable consolation in the classically based style of Retzsch. But, like Retzsch's English admirers, it was the descriptive power that appears to have struck him most. Speaking about Retzsch to Joseph Stieler in 1828 he said, 'Attempts have often been made to depict this poem. I hold the opinion, however, that it is not really suitable for the visual arts because it is too poetic. Retzsch has grasped more the real action that can be represented.'[18]

In view of this, it is interesting to remember that of all the Faust illustrations submitted to Goethe only those by Retzsch were in outline—the technique that Schlegel had associated with poetic form, and that Goethe himself had praised in Flaxman's illustrations and the Riepenhausens' *Polygnautus* designs.[19] Also, unlike Pforr—whose outlines to Götz von Berlichingen had been shown to Goethe with little success—Retzsch had kept close to the format of Flaxman's productions. Indeed, despite the widespread vogue for outline, Retzsch was the first German artist to follow Flaxman to this degree. Like Flaxman, he presented many scenes from the narrative he was illustrating—twenty-six plates in the case of *Faust*—and used several to emphasize the dramatic moments. In the first act, for example, we are shown Faust's study both before and after the entry of Mephistopheles (Plates 50–1) and, later on, the witch's kitchen before and after Faust has taken the magic potion, both the wounding and the death of Valentin, and both Faust's entry and his departure from Gretchen's cell.[20]

In style, too, Flaxman's technique is specifically referred to in many of the gestures and poses of the figures, as well as in the decorative character of the compositions. Even Flaxman's peculiar sentiment seems to emerge in certain scenes, such as the meeting in the summer-house, with its intertwined figures of Faust and Gretchen (Plate 52). But all these elements are overlaid, as has already been mentioned, with detail and anecdote. The 'Germanic' morphology of the work is, of course, partly called for by the nature of the play; but, while Cornelius and the other Faustian illustrators use this as a cue to indulge in full-blown mediaevalism, Retzsch keeps the Gothic associations down to the level of detail. Only in the use of frontal perspective—as in the witch's kitchen—is there any more fundamental allusion to fifteenth-century art. The main criteria of his style remain those of Flaxman's, expanded to fit the requirements of his subject matter.

Retzsch, unlike Flaxman, engraved his own works. Thus, while inspired by Flaxman's designs, he turned to other outline styles for the elaboration of his work. From Carstens's *Witches' Kitchen* drawing (Plate 53), which seems to have formed the basis for his own version (Plate 54),[21] he appears to have borrowed much of his

'Germanic' morphology. In handling the alliance of outline with detail, he appears to have learned much from contemporary French reproductive engravers, especially Normand, whose outlines of works of art in Paris were well known in Germany.[22] By a skilful use of half-suggested lines, Retzsch was able to maintain a measure of the compositional purity of Flaxman even in his most complex designs, and avoid the confusion encountered in the works of many other illustrators. To emphasize the main characters of his scenes, furthermore, he tended to thicken and modulate their outlines, producing an effect of slight relief, and at the same time drawing attention to the dramatic potential of the protagonists. By these means, then, Retzsch was able to achieve a clarity in his outlines that is missing in those of such rivals as Ludwig Schnorr and C. F. Schultze.[23] Retzsch's elaborations are in the interests of greater visual or anecdotal information about the subject, and he never allowed them to obscure the basic elements of the composition.

The vogue for outline illustrations in Germany was relatively short-lived, being superseded by lithography and wood engraving—techniques far more suited to the requirements of German Romantic art—and it is only in the work of a handful of classicizing artists, notably Bonaventura Genelli,[24] that one finds a more prolonged usage of it as a creative medium. Retzsch, by retaining outline to depict the varied subjects of modern literature in an anecdotal and detailed manner, became an anomaly in the Germany of Richter, Rethel and the Munich illustrators. Living in retirement in his Saxon cottage, he had little to do with the new school of historical illustrators, but pursued the aesthetic standards of his youth. His style, if becoming further removed from pure outline, remained within the Flaxman format up to his death in 1854. His sentiments, too, both in the subjects he chose to illustrate and in the works of his own invention, did not move beyond an early Romantic sensationalism, revealed in a fascination for the contrasts of evil and innocence, the plight of young maidens, and the realm of spirits and churchyards.

Without his sales abroad, these outmoded productions would no doubt have been ignored by German publishers long before the 1850s; but with these markets, especially that of England, Retzsch's selling power remained strong. Significantly,

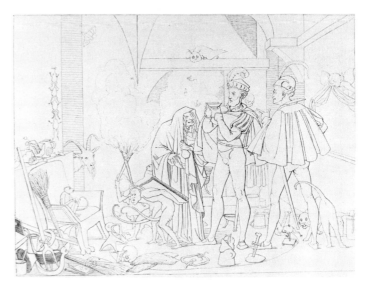

50. (facing page left) F. A. M. Retzsch: *Bist du Geselle*. Plate 3 of *Umrisse zu Goethes Faust, Erster Teil* (Outlines to Goethe's *Faust*, part one), Stuttgart, 1816.

51. (facing page right) F. A. M. Retzsch: *Du bist noch nicht der Mann*. Plate 4 of *Faust*, 1816.

52. (above left) F. A. M. Retzsch: *Bester Mann!* Plate 17 of *Faust*, 1816.

53. (left) A. J. Carstens: *Faust und Mephisto in der Hexenküche* (Faust and Mephistopheles in the Witch's Kitchen). *c.* 1794. Pen. Staatliche Kunstsammlungen, Weimar.

54. (above) F. A. M. Retzsch: *Nur Frisch Hinunter!* Plate 9 of *Faust*, 1816.

his later engravings were mostly of Shakespearean plays. His own compositions, *Fancies*,[25] first approved of by the English visitors to his cottage, were originally published in England, appearing later in Germany only in an amended version. The subscription list to his *Chessplayers*,[26] which was so popular in England, remained pathetically small, for this extravaganza on a mediaeval theme was no longer to German taste. Of the Germans who did defend his work, most were literary figures of a declining generation, such as Goethe himself,[27] increasingly unfashionable in his views on art in post-Napoleonic Germany, and the Dresden art historian and antiquarian C. A. Boettiger.[28]

This success of Retzsch's work in England, which has to some extent been chronicled elsewhere,[29] constituted a formidable chapter in the mis-interpretation of German art and literature. It was Retzsch's work, above all, that was generally seen to represent the most admirable elements in German culture, and it was his interpretations of Goethe, Bürger and Schiller, rather than the works themselves,

that were best known; furthermore, it was his compositions rather than those of the Nazarenes and their followers that, until the 1840s, were the most highly regarded.

Of no work is this more true than the outlines to *Faust*. While attracting limited interest in Germany outside Goethe's immediate circle, they became the principal means through which *Faust* was known and appreciated in England. Appearing on sale in 1819, they rapidly became a fashionable success, and soon led to an English edition of the engravings, as well as a pirated version, Henry Moses's re-engravings of the plates, published by Boosey and Company in 1820.[30]

Before that time, Retzsch's engravings had only been known amongst a small number of Germanophiles in England. The first set of illustrations to arrive in England were those sent by Mrs Perthes to Crabb Robinson in January 1817, only a few months after they had been printed in Germany.[31] These, which he described in his diary as 'a very interesting work à la Flaxman', he showed to several of his friends, including Flaxman himself,[32] but he does not appear to have had anything to do with gaining them a wider public—his interests lying mainly in the sphere of German literature. In 1818, the engravings were shown to the bibliophile Dibdin when he visited Cotta's shop in Stuttgart. In his account of the incident,[33] Dibdin records how he sent some of them to an unspecified friend in England because he had 'never seen anything before more original and tender'; and also (possibly wise after the event, since his book was not published until 1821) he 'predicted' a great success for the work in England. Despite this, however, he too does not appear to have had anything to do with its actual promotion.

The first person to import Retzsch's outlines for sale was the bookseller J. H. Bohte, in 1819. Bohte, the most enterprising German bookseller in London, imported a large number of German engravings at this time[34] yet none achieved the phenomenal success of Retzsch's work. Even allowing for the fact that Bohte, a personal friend of Boettiger's, might have given special promotion to the work, it is astonishing to see how quickly it was taken up. By 1821, not even Bohte's special English edition could satiate the market, and Moses's inferior reworkings found a ready sale.[35]

This success was, moreover, in the face of the distinct coolness with which Goethe's play itself had been received; for the necessarily fragmentary nature of the work and the earthly death of Gretchen seemed to place it, both morally and aesthetically, beyond the limits of English taste. This was certainly the opinion of its first reviewer, William Taylor of Norwich,[36] and the disapproval with which Madame de Stael viewed it in her influential *De l'Allemagne* did not help matters.[37] Crabb Robinson, one of the few defenders of the work, had little success when trying to recommend it to his English friends, and even Coleridge, when asked by Murray to translate the work, had refused, feeling the task to be futile.[38]

Retzsch's ability to transcend cultural dissimilarities where Goethe's text had failed was due not simply to the way in which he gave each of his subjects a precise and explicit delineation, nor to the acceptable classical mould in which he cast his illustrations, but also to the way in which his interpretation softened the whole content of the drama. This is made quite clear in contemporary comments. Dibdin,

for example, in his objections to the conclusion of the play (and apparently indifferent to the fact that this was only the first part of the drama) expressed a commonly held English view. When talking of Retzsch's illustrations, he said,

> These latter are more to my taste than the performance of Goethe; for the whole composition is but a fragment . . . and seems to be written for no other earthly purpose but that of showing the capriciousness of an unregulated imagination, and the power of softening down the grossness of vice, by the aid of magic and conjuration. If the young man *must* be punished for the indulgence of a vain and idle curiosity, let him be so without the sacrifice of the amiable and unsuspecting Margaret[39]

Having failed to comprehend the epic dimensions of the text, he then turned to Retzsch's plates, and dwelt on the sorry sight of Gretchen at the spinning wheel and the poignancy of the garden scene where Mephistopheles leers knowingly behind the loving figures of Gretchen and Faust. Though he could not provide Gretchen with the reprieve that so many English readers of *Faust* longed for, Retzsch could at least focus attention on her beautiful innocence, wring hearts at her sorry plight and make Mephistopheles unequivocably diabolical.

Similar comments, equally unflattering to Goethe, were made in the many reviews of Retzsch's outlines that appeared at this time. The most enthusiastic, by the lively and erratic Thomas Wainewright under his pseudonym Janus Weathercock in the *London Magazine*, leaves no doubt about the superiority of Retzsch over Goethe. Of the plates, he writes:

> One fault they have, if it be one: they are not entirely in unison with the style of the author they profess to illustrate. They are composed, nearly throughout, with equal judgement, fire and taste; whereas the wild, and in the teeth of incongruities, pathetic tragedy of Goethe flutters doubtingly between the topmost height of sublimity and the bottomless pit of self-satisfied absurdity.[40]

Other German painters when compared to Retzsch fared no better than Goethe had done. Of the Germans in general, Wainewright writes: 'In painting they have forced a monstrous alliance between the sublime manner of Goltzius, Spranger, John Aback, C. van Mander, etc. etc. and the dry, ludicrous, matter-of-fact work of old Durer.'[41] In this vein, Cornelius's illustrations to *Faust* (also on sale at Bohte's) are characterized as being 'of mingled metal—silver and lead; but, unfortunately, the lead bears undue proportion to the other of an hundred to one'.[42] Retzsch's suave line, his gentle and unobtrusive inclusion of Germanic elements and facile narrative were preferred to Cornelius's relative harshness by all except Flaxman himself.[43] Apart from stylistic considerations, however, Retzsch, by using the narrative form of outline, had a distinct advantage over Cornelius; for the latter's nine illustrations formed no visual alternative to a texual narrative. Sometimes, as with *Vor dem Tor*, Cornelius's scenes were clearly selected for visual reasons rather than for the elucidation of the narrative. Furthermore, his interpretation of the drama was not so sympathetic to English expectations. Against Retzsch's demure

131

55. F. A. M. Retzsch: *Mein schönes Fräulein*, Plate 10 of *Faust*, 1816.

56. P. von Cornelius: *Fausts Begegnung mit Gretchen* (Faust's Encounter with Gretchen). 1811. Pen (38.8 × 35.5). Städelsches Kunstinstitut, Frankfurt-am-Main.

account of the encounter of Faust and Gretchen, Cornelius's overt gestures must have seemed crude (Plates 55–6); and in the last scene of the drama Cornelius emphasized the religious dimensions behind the story, while Retzsch appealed once more to sentiment, emphasizing the plight of Gretchen. Whereas Cornelius's Gretchen kneels secure, protected by her visionary angel, Retzsch's Gretchen throws up her hands in one final gesture of touching despair.

Through Retzsch's *Faust*, Goethe's work itself became better known, the first full translation appearing as a direct result of the success of Retzsch's outlines.[44] The translation was, however, an undistinguished work, and those that succeeded it were for some time very little better. It was Retzsch's *Faust* that remained the popular work. In his first novel, *Vivian Grey*, a telling satire of current fashions, Disraeli refers to Retzsch, rather than Goethe. While impressing Julia Manvers with his great erudition, the hero of the novel exclaims: '"Ha! You have Retzsch's Faust there. I did not expect on the drawing-room table at Château Désir to see anything so old, and so excellent."' He then pronounces a fashionable comment on Gretchen: '"How beautiful Margaret is" said Vivian, rising from his ottoman and seating himself on the sofa by the lady. "I always think that this is the only personification where Art has not rendered language insipid."'[45]

It was Retzsch, and not Goethe, whose fine sentiments on the ancient legend of Faust won the lady for Vivian Grey, and Retzsch who remained as late as the 1830s the more highly esteemed. With writers too, a knowledge of Goethe often came or even remained through Retzsch; and, while Carlyle could rail against the misunderstandings of his contemporaries in his articles in the *Edinburgh Review*[46], Byron, Shelley and Lamb took very different views. Thus Shelley, on receiving Retzsch's *Faust* at Pisa in 1822, was far more impressed with it than he had been by Goethe's text. When writing to Gisbourne, he said,

I never perfectly understood the Hartz Mountain scene until I saw the etching; and then Margaret in the summer-house with Faust! The artist makes one envious that he can sketch such things with calmness, which I only dared look upon once, and which made my brain swim round only to touch the leaf on the opposite side of which I knew it was figured. Whether it is that the artist has surpassed *Faust* or that the pencil surpasses language in some subjects I know not . . . but the etching certainly excited me far more than the poem it illustrated.[47]

After the success of Retzsch's *Faust* in England, Cotta commissioned further works from the artist. This time, the poet chosen was Schiller, whose works Cotta had also previously published. Outlines to *Fridolin* appeared in 1823, and to *Der Kampf mit dem Drachen* in 1824.[48] This time the works arrived in England with great rapidity. Boettiger, secure in the knowledge of the *Faust* success, could write to Bohte:

> In the Kunsblatt No. I of 1823 you will find announced by the publisher Cotta 8 Outlines to Schiller's *Fridolin* by our excellent painter Retzsch. If you come, as we are all hoping, to Leipzig for the Fair and to Dresden, then you can perhaps engage in a little speculation with the *Fridolin*—seeing that Retzsch's *Faust* found favour in England.[49]

As with the *Faust* illustrations, both the *Fridolin* and *Drachen* illustrations were produced in special editions by Bohte; with English translations of the texts. But, as before, demand exceeded supply, and Henry Moses made his own engraved imitations.[50] This highly gratifying sequel to the *Faust* venture appears to have made it clear to Retzsch that his real market lay abroad, especially in England. It was also becoming increasingly obvious that it was his style, rather than the works that he was illustrating, that was providing the basis for his success. Certainly the piratical Moses made no attempt to modify the Retzschian manner beyond a redrawing of certain protagonists' private parts in the interests of English decorum.[51]

Soon Retzsch was followed by England's own illustrators, who started applying the manner to English literature. Inevitably, Shakespeare was the first candidate for such treatment. It was the most shameless of these, Charles Knight's publication in 1825 of outlines to *The Tempest* which he spuriously attributed to Retzsch, that seems to have decided the artist to corner the English market with his own Shakespearean illustrations. In 1825 Boettiger, noting the English plagiarism, announced Retzsch's decision in his *Artistisches Notizenblatt*;

> In England, where all his work has been re-engraved by Moses, they have begun to produce Shakespearian designs in Retzsch's manner: these, however, have met with little success. Now Retzsch will himself undertake a similar project for England, and will begin with Hamlet.[52]

Significantly, Retzsch changed his publisher for this new venture, moving to Ernst Fleischer, a Leipzig publisher who unlike Cotta had offices in both London and Paris, and was therefore in a much better position to deal with international trade. From the start, the Shakespearean illustrations were published with captions in

French, German and English, together with an explanation of the plates and text by Boettiger in the language of the country in which the copy was being sold. Through these means Retzsch now succeeded in making his original work sufficiently available to make the kind of pirating that Moses had indulged in unprofitable. The only reworking of Retzsch's plates—a reduced version of the *Hamlet* outlines that was published by Ackermann in 1829 as part of a series of Shakespearian illustrations by a number of different artists—appears to have been made in connivance with Ackermann's business acquaintance Boettiger.[53]

While having defeated the pirates, Retzsch was certainly not without competitors in his Shakespeare venture. Two of these, the Englishman Frank Howard and the German Ludwig Ruhl, both pre-empted Retzsch's first Shakespearian outlines, the *Hamlet*, by a year, and continued their own series for a considerable period.[54] However, neither of them achieved popular acclaim, for while both of them executed their outlines with skill they lacked Retzsch's inventive sense of narrative.

It was this quality that Retzsch was now exercising to the full. Already in the *Faust* illustrations he had delighted in adding small symbolic touches of his own—such as the St George and Dragon on the stove in Faust's study. Now, with the *Hamlet* outlines— perhaps emboldened by his previous success— he indulged in a more

57. F. A. M. Retzsch: Prologue, Plate 2 of *Hamlet*, Leipzig, 1828.

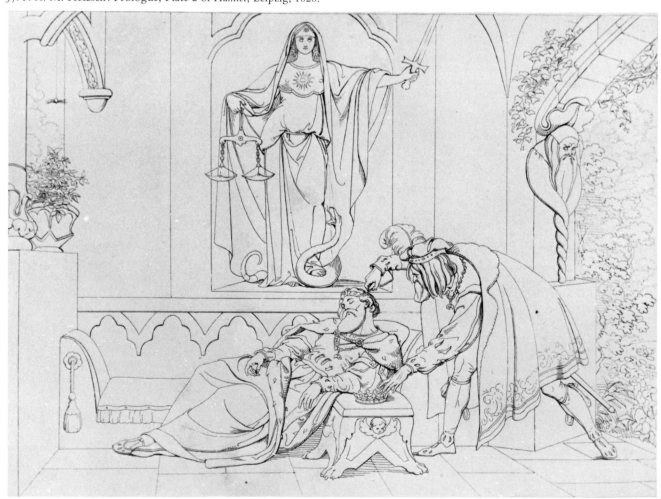

substantial addition to the text. The whole set of illustrations is given a *leitmotiv* by the inclusion of a prelude, showing a representation of the murder of Hamlet's father, accompanied by easily read symbols of justice, vengeance and despair (Plate 57). All these are elaborately referred to in the introduction written by Boettiger, who could not refrain from pointing out to the reader that this scene bears a 'significant' resemblance to the murder in the play scene. Retzsch also makes use of other juxtapositions, such as in Hamlet's soliloquy, and in the madness of Ophelia, but, while these help to unite the drama, he retains the prime feature of his *Faust* illustrations and emphasizes the dramatic movement of the play. As a reviewer observed in the *Foreign Quarterly Review* for 1828, Retzsch differed from most other contemporary illustrators in his penchant for illustrating the active rather than the contemplative moments of the play;[55] and, as in *Faust*, one finds these pinpointed by the use of two or more representations in close sequence. Thus Hamlet's responses to the Ghost grow and fade, and the churchyard scene rises to a crescendo of interlocking arms as Hamlet leaps into the grave of Ophelia (Plate 58). His use of detail is—partly due to the nature of the play—a little fuller than before. But he nevertheless retains his sense of design and gesture—although the latter, especially in the disappearance of the Ghost, tends to remind one more of the position of the

58. F. A. M. Retzsch: Act V, Scene 1. Plate 13 of *Hamlet*, Leipzig, 1828.

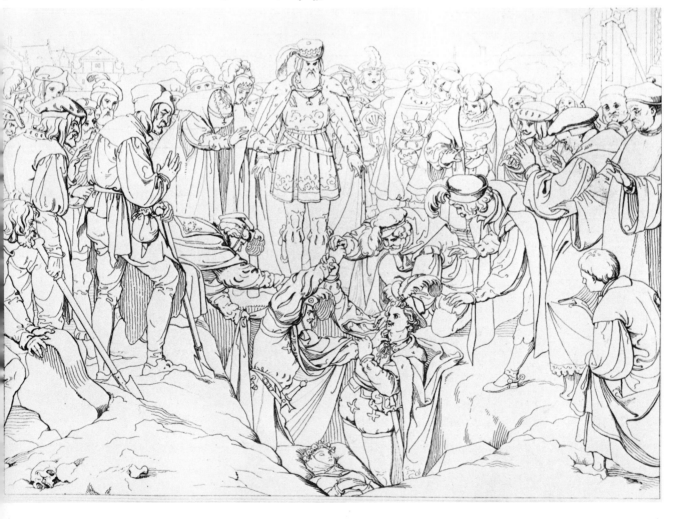

outline in the development of the cartoon strip than of the intensity of Shakespeare's play.

Retzsch's manifest theatricality tended to advance rather than deter the respect for his works as historical compositions. One reviewer even went so far as to recommend to Retzsch the use of actors as models to heighten this effect, and gives descriptions of the plates in the most dramatic terms. Describing the appearance of the Ghost of Hamlet's father, he writes:

> Hamlet's face is in profile, the nose aquiline, but not hawkbilled—his countenance expressive of the most intense feeling directed at the supernatural appearance—while the outstretched throat and the whole action of the limbs and body evince the undaunted, the reckless purpose of his soul to obey the summons.[56]

It is hardly surprising that Retzsch's work, evincing these characteristics, should be more popular in England than the controlled productions of the new historical schools of Germany before the Westminster Hall competitions of the 1840s. Using the maximum of expression, without resorting to the mannerisms that caused the Fuselian painters so much adverse criticism, he outdistanced English painters on their own subject matter, enchanting the public by his ability to conceive and characterize the most dramatic moments in the most powerful of Shakespeare's tragedies. In the outlines that followed *Hamlet* he took on subjects like *Lear* and *Macbeth*,[57] while English artists at the time were restricting themselves to the more fanciful of Shakespeare's plays, such as *The Tempest* and *A Midsummer Night's Dream*.[58]

These Shakespearian outlines turned Retzsch into something of an institution in England. They were certainly well known enough to be used for lampoon and satire. In 1829, for example, they formed the basis of the punning *Wretches Outlines to Shakespeare*, an Edinburgh publication on the resurrectionists Burke and Hare.[59] Other outlines of Retzsch's were also exploited by satirists. In 1835 A. H. Forrester published a rough parody of the *Faust* illustrations that served to damage his rather than Retzsch's reputation.[60] Even as late as 1846 Retzsch's *Chessplayers* (Plate 59) were adapted by Richard Doyle to lampoon the machinations of Louis Philippe (Plate 60).[61]

Retzsch's English success led him to be viewed increasingly as a creative artist in his own right, rather than as a mere illustrator. This tendency can been seen in the growing number of reviews devoted to his publications, in which his personal contribution to Shakespearian and other subjects is appreciated. As his idiosyncratic inventions were studied in closer detail, the pleasant fact emerged that, besides being a superb dramatizer, Retzsch was also a sound moralist. From being the *cause célèbre* of the satanic Wainewright and the bizarre von Holst, Retzsch became the idol of such worthy Victorian ladies as Mrs Jameson, Mrs Hall and Mrs Howitt, and his illustrations appeared not only amongst those in high society, but also in the

59. F. A. M. Retzsch: *Die Schachspieler* (The Chess Players). 1827. Pen. Staatlichen Graphische Sammlung, Munich.
60. ★R. Doyle: *No Match for the Old One*. From *Punch*, 21 November 1846, p. 202. Wood engraving.

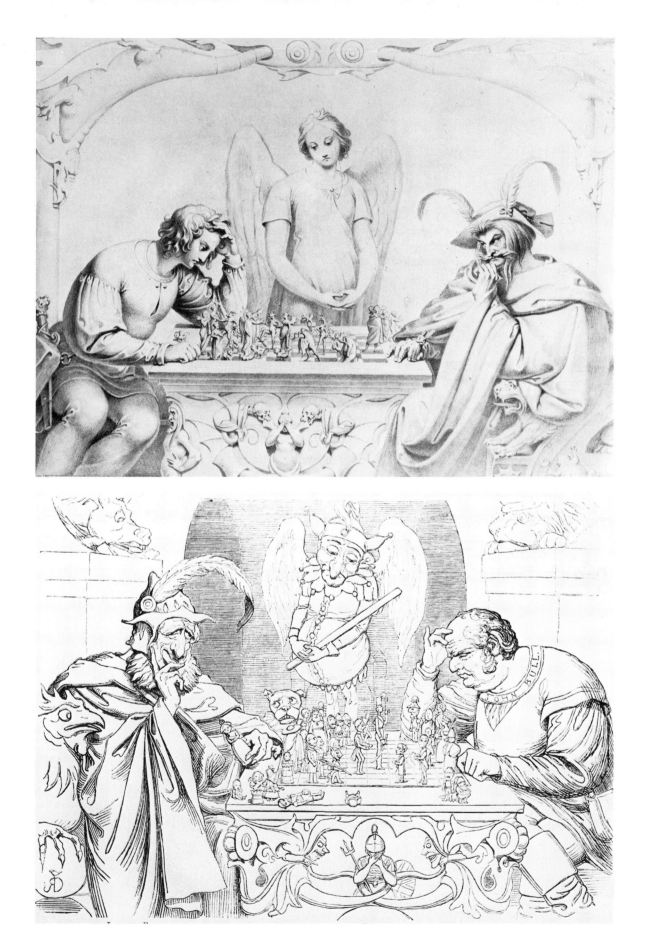

bourgeois home. In 1839 Mary Howitt felt sufficiently moved by the nobility of his work to send him a fan letter in somewhat shaky German:

> Your work is understood and highly treasured. I am certain it would be a pleasant sight for you to see an English family circle, not a little acquainted with the literature of their own and foreign countries; to see how they sit down in the evening perhaps for the thousandth time to study Retzsch's Outlines . . . how they discover in every line, in every single attractive feature, some previously unnoticed evidence of ideal beauty.[62]

This aspect of Retzsch was first pointed out by Mrs Anna Jameson who, in her *Visits and Sketches at Home and Abroad* of 1834, included a description of her visit to Retzsch's secluded cottage outside Dresden where, untroubled by the world, he could nurture his naïve, almost childlike faith. She mentions that he had painted an angel above his easel 'which should smile upon him out of heaven'[63] and protect him from evil. Furthermore, she was so struck by this quality of his mind that, while admiring his illustrations to German and English poets, it was his own inventions that monopolized her attention. Seeing the *Fantasien*, a series of birthday drawings for his wife, she urged Retzsch to have these published in England. These drawings, representing love, innocence, and his own poetic genius beset by the evils of the world—which reveal a mentality already made plain in his interpretation of the Gretchen tragedy in *Faust*—struck Mrs Jameson as possessing a deep moral truth. For, as she comments: 'with all this luxuriance of imagination, there is no exaggeration, either of form or feeling; he is peculiar, fantastic, even extravagant— but never false in sentiment or expression.'[64]

Encouraged by Mrs Jameson, Retzsch set about engraving these works. They appeared in 1835 with an introduction by Mrs Jameson, where she developed her conception of Retzsch as a visual poet ('The pencil is to him what the pen is to *other* poets') and set a new standard for morality in art.

> On the whole, this attempt to address the moral sentiments and the imagination through the medium of design may be considered new in this country, and I am inclined to think that the pure and graceful feeling, the novelty and ingenuity displayed in these fancies, could strike at once, and make a way into the heart for the beautiful moral lesson or poetical sentiment which will be far beneath the surface.[65]

Mrs Hall and Mrs Howitt, who both subsequently made the pilgrimage to Retzsch's cottage, both echo Mrs Jameson's interpretation of Retzsch the moralist,[66] and Retzsch was soon able to publish independent engravings, such as the *German Lovers* and the *Chessplayers*, in England with great success.[67] It must be remarked, however, that these subjects were probably slightly misinterpreted by English enthusiasts, for Retzsch's fascination with evil seems often highly morbid, and it is rarely that virtue is represented in the ascendancy. Nevertheless, to the Victorians, they fitted well into the concept of morality fortified by restrictive example, and their appeal through sentiment was sufficiently strong to enable them

to survive a number of changes in taste. Consequently, one finds that Retzsch retained his high appeal not only throughout the craze for revivalist German art in the 1840s, but also far beyond it. S. C. Hall, whose wife wrote such a glowing account of their visit to Retzsch,[68] continued to publish in the *Art Journal* some of the 'fancies' that Mrs Jameson had overlooked, while the *Faust* illustrations were republished in 1834 and 1839, twice in 1843, 1852, 1875, 1879 and 1893.[69] During this time, the decline of outline engraving was offset for Retzsch by the appreciation of his power of visualization and the 'truth' of his sentiment, the latter playing a large part, as has been seen, in winning him the favour of Ruskin against great technical odds. Even Holman Hunt, the most anti-German of the Pre-Raphaelites, had respect for Retzsch's manner,[70] and at the time of Retzsch's death in 1857 his fame in England was as strong as ever. The *Art Journal* could write at that time:

> Of his works, so well known and so deservedly appreciated wherever art is admired and loved, it is scarcely necessary for us to speak: notwithstanding their German origin, they have a freshness and richness of conception, a freedom of execution united with a delicacy, and a feeling of pure, natural poetry, that one rarely sees in works of this kind by German artists; but then Retzsch was not a 'Schoolman', except as a genuine pupil of nature.[71]

Thus one finds that Retzsch's popularity actively survived three generations. Arriving in England with the upsurge of interest in German literature after the Napoleonic Wars, his competent extension of the outline technique and his pleasing interpretation of Schiller and Goethe made him highly fashionable. Then, with the growing morality of the 1830s and connected concern over the lack of high-minded historical art, his work was seen increasingly in terms of its moral content, a constituent that was, as with his interpretation of German literature, more immediate in its appeal than that of many other German artists; and it was this appeal of content that further secured his position after the brief Germanic spell of the 1840s, and which made his designs acceptable to Ruskin and the Pre-Raphaelites. It was only with the growing aestheticism of the later nineteenth century that Retzsch gradually began to fade into the oblivion in which he now exists; though even as late as 1908 he merited a mention in a general work of reference like the *Chambers' Encyclopaedia*.[72] In his peculiar and slightly naïve style, there appears to have been some particular blend of qualities that was irresistible to Englishmen of the mid nineteenth century: a highly abstracting technique used in a specific and anecdotal manner, obscure subject-matter made comprehensible, strong moral sentiment expressed through the intriguing symbolism of threatened virtue—all these appear to have contributed to his success, providing the qualities of 'high' art that often seemed lacking in English work, yet at a level that was immediately accessible.

The vast output of material by Retzsch was viewed by English artists in many different ways, but he appears to have had most influence in the fields of outline technique and the interpretation of subject-matter.

In outline engraving, his influence was decisive, opening up this field to common

practice. His modification of Flaxman's technique offered, for the first time, a genuine alternative to other forms of historical and poetic illustration. Since the late eighteenth century, illustration had developed in England as strongly as in Germany, with the work of artists like Stothard and Fuseli, and such nationalistic projects as the Shakespeare and Milton Galleries. But, apart from Flaxman, there had been few attempts to apply outline techniques to literary subjects.[73] The limitation of Flaxman's technique or, it would seem, the limitations of outline itself restricted subjects to pure figure compositions, a genre that was awkward to apply to English poetical subject matter. Flaxman himself had made it clear to Crabb Robinson that his reason for illustrating Dante as opposed to Milton was not because he considered Milton an inferior poet—quite the reverse—but because Dante was richer in subjects that lent themselves to pure figure compositions.[74] Retzsch, however, presented an example that had both grace and adaptability. The outline style, with all the esteem that it commanded, now became applied to a far wider range of subject matter.

Apart from Moses's re-engravings of *Faust*, the first and most persistent application of outline was to Shakespearian drama, and among these, *The Tempest* appears to have offered the right degree of fantasy for a Retzschian treatment. Certainly, this play seems to have had an almost uncanny fascination for outline illustrators, right up to the version by Noel Paton in 1845.[75] In 1825 there were no fewer than three outline versions of *The Tempest* under way. Apart from the forged 'Retzsch' *Tempest*, published by Charles Knight, two young historical painters, Joseph Severn and Frank Howard, were seeking to establish their reputations with outlines of the same play.

Joseph Severn, who had gone to Rome with Keats in 1820, and at this time proudly described himself as the only English artist in Rome seriously concerned with historical painting,[76] mentioned in his letters his plans to produce a series of outlines of *The Tempest*, for which he had secured several subscribers and, perhaps equally important, a German engraver. In 1825, however, hearing of the Knight production, he wrote to his father, deeply concerned with these engravings 'in the manner of Wretch's Faust',[77] asking for a copy of it to be sent to him. Whether he was deterred by this is not known. There are certainly no further mentions of the project, so it seems probable that despite promising beginnings it was abandoned. It is, however, significant that he should have considered the project so soon after Retzsch's success.

Frank Howard, on the other hand, designed his *Tempest* outlines, which appeared in 1827, as the first of a long line of Shakespearian illustrations. Howard, the son of Flaxman's friend Henry Howard, had had first-hand contact with Flaxman's art, since he had engraved some of his Aeschylus designs.[78] It was Retzsch, however, whom he was emulating in these illustrations. Although there are few overt references to Retzsch's *Faust*, the derivation is unmistakable and certainly did not escape his contemporaries. As a vitriolic review in Schorn's *Kunstblatt* said, Howard 'relates to the work of Herrn Retzsch as a mediocre copy does to an excellent original, or the work of an imitating student to that of the master.'[79]

Nevertheless Howard's work appears to have sold moderately well. The series

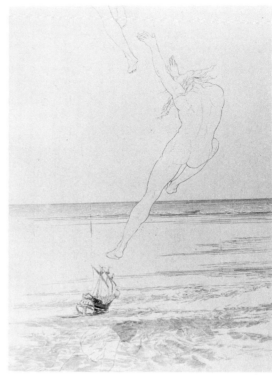

61. (above left) F. Howard: Plate 7 of *Twelfth Night*, 1828. Etching.

62. (left) F. A. M. Retzsch: *Trauben Trägt Weinstock*. Plate 6 of *Faust*, 1816.

63. (above) D. Scott: *The Spirit of the South Departs*. From *Scenes from Coleridge's Ancient Mariner*, Edinburgh, 1837.

continued until 1833, by which time he had made his way through ten Shakespearian plays; and later on in the century his works were reprinted—most notably in the *Howard Shakespeare* of 1876, which contained 375 of his outlines.[80] Lacking Retzsch's style and vigour, they nevertheless show the great difference Retzsch had made to outline illustration. In contrast to Hawkes Smith's work, the varied outline allowed spatial depth to be efficiently represented, and the detailing of the costumes is more decorative and less confused. As with Retzsch, too, the forms of the main figures are preserved by the use of a relief outline, so that the compositional qualities of each design are not lost. However, Howard was not an artist of Retzsch's conviction, and his characterizations are often insipid. His figures are too self-consciously positioned to carry the content of the scenes effectively, and his shortcomings as a draughtsman are all too obviously shown by the exacting technique of outline. If one contrasts, for example, his drinking scene from *Twelfth Night* (Plate 61) with Retzsch's *Auerbach's Keller* in *Faust* (Plate 62) one can see how

weak Howard's characterization is. Furthermore—perhaps as a result of the prodigious number of outlines that he was producing—he did not follow the dramas with Retzsch's completeness, even though he adopted a similar format.

The English penchant for depicting the more fanciful Shakespearian plays, evident in the great popularity of *The Tempest* as an outline subject, can be seen in the choice made by Howard. In contrast to Retzsch's fascination with the tragedies, Howard concentrated on such works as *Much Ado about Nothing, Twelfth Night* and *A Midsummer Night's Dream*. Like Stothard and Flaxman, Howard was mainly concerned with achieving graceful design, rather than with the intense development of a dramatic situation preferred by Retzsch. He may have been able to copy Retzsch's technique, but he was either unable or unwilling to follow the implications of Retzsch's use of narrative.

Another aspirant history painter to take to outline in the 1830s was David Scott. His outlines to *The Rime of the Ancient Mariner* of 1837,[81] though rich in drama and fantasy, do not bear any close relationship to Retzsch's style (Plate 63). Nevertheless Coleridge's son, when wishing to compliment him on the productions, felt it was appropriate to hail him as 'the English Retzsch'.[82]

At this time Retzsch's style also appealed to a number of illustrators who were later to become practitioners of the German manner. Of these H. C. Selous, whose *Tempest* (Plate 64) came out in 1836,[83] adhered the most closely to the work of his mentor. Not only is the format identical to Retzsch's, with each plate accompanied by a text in four languages, but Retzsch is specifically referred to in the introduction as a rival.[84] Since Retzsch had by this time already produced two of his outlines to Shakespeare plays, Selous had a wide range of Retzschian material to draw from. He took over not only the gestures and details of Retzsch's figures, but also the inventions and elaboration of small fantastic creatures. No less Retzschian are the designs for *The Pilgrim's Progress*, with which he won the London Art Union outline competition advertised in October 1842,[85] (Plate 65) and, even after he had changed to the Germanic woodcut style in the 1840s, he continued to produce outline on occasion, such as the *Scenes from the Life of Moses* of 1850.[86] However, while the technique of these later outlines still shows some debt to Retzsch, the physiognomies of the protagonists have now become more reminiscent of Munich. With Selous, in fact, one arrives at a new generation of illustrators who, unlike Moses and Howard, were prepared to accept the 'Germanic' elements in Retzsch's work. This change, in itself a sign of the crisis of confidence that the English historical painters were undergoing in the 1830s, is most evident in the work of John Franklin, the illustrator, who was to become one of the leading figures in the introduction of the German woodcut-style illustrated book into England.[87] Franklin's outlines for *The Ballad of Chevy Chase* of 1836 are totally Retzschian in format and morphology (Plate 66). His outlines entitled *Tableaux from Ainsworth's Admirable Crichton* of 1837, on the other hand, already reveal an impatience with Retzsch's method, for many of the compositions bear the unmistakeable imprint of the French *Romantiques* (Plate 67).

Between 1842 and 1846 the habit of designing outlines was deliberately

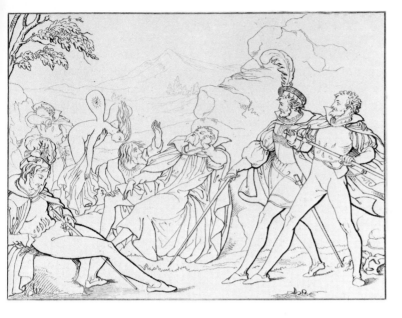

64. (left) ★H. Selous: Plate 4 of *The Tempest*, 1836.

65. (middle left) ★H. Selous: *Christian resists the Persuasions of Pliable and Obstinate*. Plate 4 of *Pilgrim's Progress*, 1844.

66. (lower left) J. Franklin: Plate 10 of *Chevy Chase*, 1836. Engraving.

67. (above) J. Franklin: Plate 1 of *Admirable Crichton*, 1837.

encouraged by the Art Union of London who organized in these years competitions for 'consecutive series of designs in Outline, illustrative of some epoch of British History, or of the works of some British author'.[88] According to the organizers the response was large. The first competition, advertized in October 1842, judged in April 1843 and won by Selous's Retzschian *Pilgrim's Progress* (Plate 65), elicited thirty sets—including a *Prometheus Unbound* by Noel Paton, a *Griselda* by Tenniel, and a *Comus* by F. R. Pickersgill. The next competition, won by Thomas Rimer's *Castle of Indolence*, brought in thirty-two.[89]

However, if certain of the young history painters of these years were to persist in the technique popular opposition to the manner was also arising. On 10 January 1846 *Punch* associated the habit of working in outline with the 'rage for everything German', and surmised that even the most intimate area of British culture, children's rhymes and fairy-tales, were now no longer exempt: 'though we have no objection to the Germanizing of shop-boys and lawyers' clerks we cannot tamely submit to seeing the operation performed upon cherished nursery tales of our infancy'.[90]

Punch then went on to demonstrate its point by considering how 'RETSCH—or, as the lovers of simplicity have styled him—WRETCH' would treat 'Old Mother Hubbard' (Plate 68) and 'Tom Tom the Piper's Son'. Although *Punch* did not blame the Art Union for this habit in its article on 'The Classic German Mania', it was to do so two months later on 28 March in its demonstration of the physiognomic peculiarities of 'The German School'.[91]

The artist who provided the outlines for 'The Classic German Mania' is not named. It may well have been Richard Doyle, who frequently used the outline manner for his cartoons. In 1849 he was to produce his own outline book, *Manners and Customs of ye Englyshe*[92] (Plate 69).

At a commercial level, the turning away from pure outline showed itself in the way that outline books became encrusted by sumptuous Gothic borders, as in the case of Lady Dalmeny's illustrations to *The Spanish Lady's Love*—also a product of 1846.

68. (right) *The Classic German Mania*. From *Punch*, 10 January 1846, p. 32. Wood engraving.

69. (middle) ★R. Doyle: No. 32 of *Manners and Customs of ye Englyshe*, 1849. Engraving.

70. (far right) ★T. von Holst: *The Chess Players*. From *People's Journal*, 1846. Wood engraving.

Besides this, the growing taste for formal and hieratic designs led to Retzsch's theatricality being brought, at last, in question. A commentator in the *Edinburgh Review* in 1846, acknowledging how much greater Retzsch's influence had been on English outline than had that of Flaxman, felt that this had been entirely to the detriment of the true nature of the style;

We say, therefore, with due respect to the genius of Retzsch that it is very questionable whether the popularity which his illustrations have obtained has been favourable to the development of English art; or whether the defects of his drawing, which are just as certain as their merits, have not been more imitated than his excellences. There seems to us to be a strong tendency, among our present illustrators in outline, to aim at effects which, in order to produce the proper expression, or even to be distinct or intelligible, require the aid of colour and light and shadow—to indulge in complicated groups, and to deal in violent attitudes and arrangements which seem borrowed from theatrical tableaux, rather than from the combined simplicity and variety of nature.[93]

Yet even at this stage Retzsch's reputation as a conceiver of ideas remained, and his compositions were still used as a source of inspiration by artists.

In terms of subject matter, Retzsch's most significant contribution was probably his interpretation of *Faust*. It is hard to calculate how much he might have contributed to the vogue for illustrating scenes from *Faust* that is evident in the 1820s and 1830s.[94] One artist whose work definitely bears Retzsch's imprint was Theodore von Holst, the English artist of German origin, who combined Fuselian elements with those of the German revivalists and the French *Romantiques*. A friend of Wainewright and Bulwer Lytton, his art shows a preoccupation with macabre and satanic elements, which he drew from diverse sources, and in which the Faustian element is particularly strong. Not only did he design a series of illustrations to *Faust*,[95] but he also created extravaganzas related to this subject. G. Schiff has shown how *The Dream after Reading Goethe's Walpurgisnacht*, which is dated 1827, contains borrowings from both Cornelius's and Retzsch's *Faust*.[96] As well as this, however it

YᵉWYNE·AVLTS·ATYᵉDOCKS·SHOWYNGE·A·PARTYE·TASTYNGE·

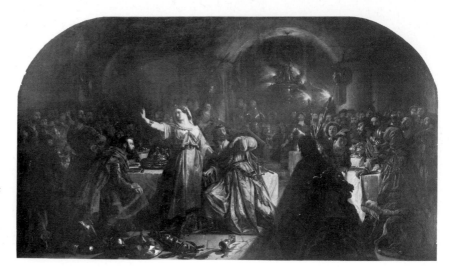

71. D. Maclise:
The banquet scene
from *Macbeth*.
1840. Oil
(183 × 305).
Guildhall Art
Gallery, London.

would seem that one of Retzsch's compositions was actually the germinating source for the whole design of the picture. Retzsch's *Faust Asleep in his Study*—an extravaganza around the moment when Mephistopheles creeps out in the first scene—is similar to Holst's work both in content and in design.

A more striking association of ideas comes in a later composition painted—to judge from the somewhat equivocal evidence of a contemporary wood engraving[97]—when Holst had moved away from his Germanic style of the 1820s and under the influence of Delacroix. This work, *Satan Playing with a Man for his Soul* (Plate 70), seems to be related to Retzsch's highly popular engraving *The Chessplayers* (Plate 59), published in 1836. Both show a knight playing a game of chess with the Devil, and, although both artists could have derived such a theme independently, the treatment and sentiment do seem to be surprisingly close. While Retzsch's work is smaller in format, the poses of the protagonists in the two pictures are similar—the Devil calmly waiting, the knight staring anxiously at the board—and in both poignancy is given to the subject through the indication that the knight is losing; even if Retzsch indicates this by a far more precise use of symbolism than von Holst.

It would therefore seem that von Holst, if never interested in Retzsch's actual outline technique, was affected by his ideas and visualization. He is known to have visited Retzsch in Dresden at least on one occasion, in 1829,[98] and his own macabre fantasy comes closer to that of Retzsch than to any other contemporary artists in Germany or England. Both of them had a Faustian concern for man's dealings with the supernatural.

Retzsch's morbid fantasy also seems to have provided inspiration for the delicately balanced mind of Richard Dadd in the days before the outbreak of his insanity in 1843. His *Walpurgis Night*, an illustrated poem in manuscript,[99] is manifestly Faustian in its inspiration. However, while to judge from the introduction the literary source was Shelley, the illustrations are certainly related to Retzsch's *Faust*, both in the use of outline and in certain of the more fantastic designs, notably the *Ascent to the Brocken*. Since this scene as it was depicted by Retzsch had

146

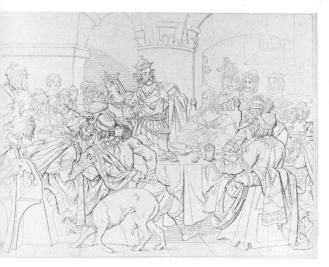

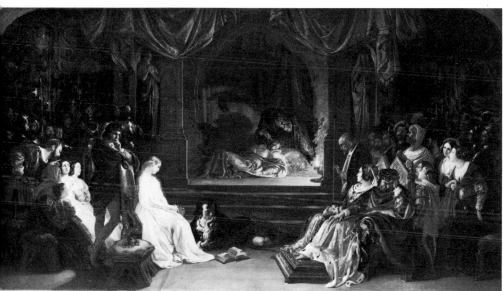

72. (above left) F. A. M.
Retzsch: Act III, Scene 4.
Plate 9 of *Macbeth*,
Leipzig, 1833.

73. (left) D. Maclise: The
play scene from *Hamlet*.
1842. Oil (152 × 274),
Tate Gallery, London.

74. (above) F. A. M.
Retzsch: Act III, Scene 2.
Plate 6 from *Hamlet*, 1828.

struck Shelley with particular force in 1822,[100] the separate literary and pictorial
sources of Dadd's work can hardly be seen as incompatible.

Retzsch was also a useful source-book for more conventional history painters,
and his compelling visualizations appear to have lain behind a number of Academy
successes. Maclise, in particular, seems to have found sustenance for the darker side of
his own fantasy in Retzsch's morbidity. He owned copies of the German artist's
outlines to Shakespeare, Goethe and Schiller[101] and drew from them freely. The
first work to reveal such an influence was his *Banquet Scene from Macbeth* (Plate 71),
exhibited at the Royal Academy in 1840,[102] which has unmistakable affinities with
Retzsch's rendering of the scene (Plate 72). *The Play Scene from Hamlet* (Plate 73),
which took the Academy of 1842 by storm, is unashamedly a pastiche of the *Play
Scene* (Plate 74) and *Prologue* (Plate 57) of Retzsch's *Hamlet*—even to the extent of
borrowing the same scheme of biblical and allegorical references.[103] A few years

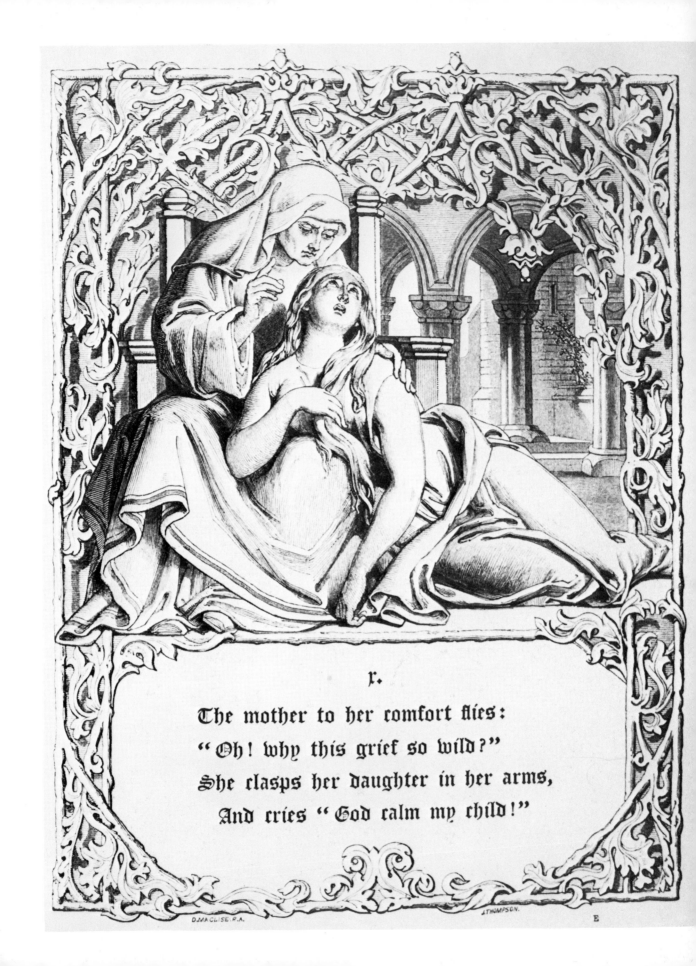

x.

The mother to her comfort flies:
"Oh! why this grief so wild?"
She clasps her daughter in her arms,
And cries "God calm my child!"

D.MACLISE.R.A. J.THOMPSON. E

later, in 1846, Maclise was to base several of his *Lenore* illustrations (Plate 75) on those of Retzsch (Plate 76), although anachronistically mediaevalizing the subject under the influence of the 1840 edition of the *Nibelungen*. That such a procedure should have seemed appropriate is a further instance of how by 1846 the outline style was becoming outmoded.

Despite their declining fortunes, both the outline style and Retzsch's peculiar manner of presentation impressed the Pre-Raphaelites in their early years. As students in London in the mid-forties, it is hardly surprising that they should have come into contact with such works. They had before them, moreover, the example of Madox Brown, who made a series of outlines to *Lear* (Plate 77), which show a knowledge of Retzsch's version (Plate 78), in Paris in 1844[104] when he—as he later said in a letter to C. Gurlitt—was first looking at German prints.[105] Rossetti early incorporated Retzschian motifs into his personal mythology. Having known Retzsch's *Faust* from childhood,[106] he made use of themes in these outlines in both his early drawings and writings. William Michael Rossetti recorded of his brother that in 1843, while still at Sass's; 'Under the influence of Byron and of Retzsch's outlines to Goethe's *Faust*, he had already begun to write and illustrate a prose romance on diabolism, *Sorrentino*, in which the Devil, as principal character, thwarts the course of true love.'

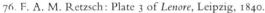

75. (left) ★D. Maclise: *The Mother to her Comfort flies*. Page from *Leonora*, 1847. Wood engraving by J. Thompson.

76. F. A. M. Retzsch: Plate 3 of *Lenore*, Leipzig, 1840.

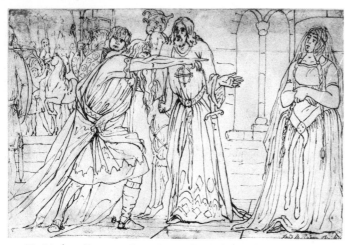

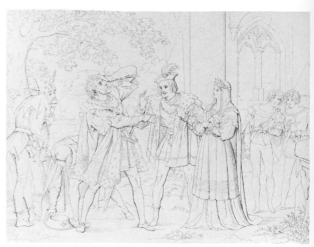

77. F. Madox Brown: *Lear Curses Goneril's Infidelity*. 1844. Sepia (18.7 × 27.5). Whitworth Art Gallery, Manchester.

78. F. A. M. Retzsch: Act I, Scene 4. Plate 4 of *King Lear*, Leipzig, 1838.

Unfortunately Rossetti later discarded the manuscript, but this brief description of the plot gives one some indication of the part played in it by Retzsch's influence. As has already been pointed out, it was Retzsch's treatment of the Gretchen tragedy in *Faust* that had particularly attracted English critics, the contrasts of good and evil presented in the characters of Gretchen and Mephistopheles being one of the more immediate and engaging aspects of the drama. As a reviewer in the *Foreign Quarterly Review* observed,

> There are two strong feelings uppermost in our minds when we look at these exquisite productions: the one is the tenderest commiseration for the unfortunate Margaret, and the other the consciousness of the torment which the demon incessantly inflicts on the being whom he pretends to serve.[107]

At this time Rossetti, who did not yet know Goethe's text, followed other English commentators and concentrated on the Gretchen tragedy. Even later on, in 1846, when Rossetti was studying German and had read Goethe's work,[108] the Retzschian interpretation seems to have retained some hold on his imagination, for of the Faustian drawings that he made from that year[109] the surviving ones show many preoccupations similar to those of Retzsch. One, an invented subject, *Mephistopheles Listening outside the Cell of Gretchen*, bears some affinities to Retzsch's *Garden Scene*, where Mephistopheles laughs knowingly at the couple from behind a bush (Plate 79). In another (Plate 80) the gesticulations of the figures are reminiscent of those in the final plate of Retzsch's *Faust*, Part One (Plate 81).

In the same year, still under the Faustian influence, Rossetti wrote his *Blessed Damozel*. In this poem, as Willoughby suggested,[110] both the situation of the Blessed Damozel and her vision of the assumption of her lover bear strong affinities to the final scene in *Faust*, Part Two, where Faust rises up to heaven where Gretchen is waiting for him. Willoughby also suggested that the inspiration for this poem may, in fact, be based on Retzsch's outline of the scene rather than on the description in Goethe's play. Certainly the Retzschian representation of Faust's assumption

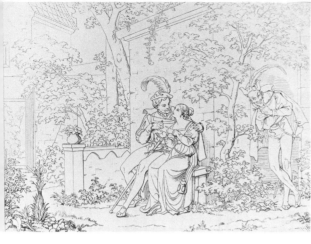

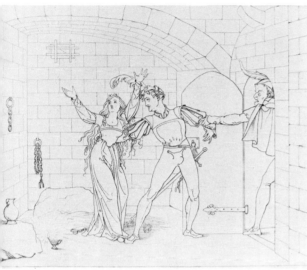

79. (above left) F. A. M. Retzsch: *Mein Mädchen da*. Plate 19 of *Faust*, 1816.

80. (above) D. G. Rossetti: *Last scene from Faust*, part I. 1848. Pen (27.9 × 21.73). Professor Allen Staley.

81. (left) F. A. M. Retzsch: *Auf! Oder Ihr seid Verloren*. Plate 29 of *Faust*, 1816.

contains a number of elements that are absent from Goethe's description, but which do occur in the *Blessed Damozel*—notably the representation of Faust as 'new-born' and the accompaniment of choirs of angels (Plate 83). Although Rossetti would hardly have to have been dependent upon Retzsch for such features, it is interesting to see them appearing in an illustration that he undoubtedly knew.

Rossetti's Faustian obsessions later became submerged beneath his more familiar Dantesque and Arthurian interests. But at the time of the foundation of the Pre-Raphaelite Brotherhood it was still a predominant concern. Indeed one of the three themes that he toyed with for his first picture as a member of the Brotherhood was 'Margaret Tormented by the Evil Spirit in Church'.[111] Furthermore, in the same year, Deverell—at that time very much under Rossetti's influence—exhibited a *Margaret in Prison* at the Academy.[112] It is tempting to believe that this was the same composition as the one he had submitted to the Cyclographic Club earlier in the year, and which had been criticized for being 'nothing more than a reworking of Retzsch'.[113]

82. (upper left) J. E. Millais: *Isabella*. 1848. Pen (20.3 × 29.4). Fitzwilliam Museum, Cambridge.

83. (lower left) F. A. M. Retzsch: Plate 11 of *Faust, Zweiter Teil*, Leipzig, 1834.

84. (upper right) J. E. Millais: *The Death of Romeo and Juliet*. 1848. Pen (21.6 × 36.8). Birmingham Museum and Art Gallery.

85. (lower right) F. A. M. Retzsch: Act V, Scene 3. Plate 13 of *Romeo and Juliet*, Leipzig, 1836.

Even Holman Hunt, who deplored the Germanic influences that Rossetti had absorbed,[114] found qualities to admire in Retzsch's imagination. Admitting the impact of a series of outlines 'in Retzsch's manner' at the gathering on the evening on which the Brotherhood was founded, he added that he admired the way in which these illustrators had 'dared to follow their fancies and had escaped the crippling yoke' of the academic schools of Germany.[115]

Yet it was Millais—another anti-Germanist—who was most literal in his emulation of Retzsch at this time. His four lunette designs of the *Ages of Man*—dated by J. G. Millais to 1845 and 1848, but most probably, as Mary Bennett surmises, belonging to the latter year[116]—show a mastery of the Retzschian outline manner to be expected of an aspirant history painter of the 1840s (which Millais had certainly been at the Academy Schools). There is, moreover, a direct quotation in the figure of Youth from a group of lovers in Retzsch's outlines to Schiller's *Song of the Bell*.[117] Millais's outline of *The Death of Romeo and Juliet* (Plate 84), signed and dated 1848, can also be related to Retzsch's portrayal of the same scene (Plate 85). This is not just in the composition, but also in the peculiar fascination for grotesque gestures and details. This quality can be seen in several of the outline designs that Millais was in the habit of making in 1848 and 1849. There is some evidence to suggest, moreover, that he was at this time contemplating the production of a book of outlines. Holman Hunt records how he and Millais decided in 1848 to design a series of etchings for Keats's *Isabella* which they hoped to get published as a book, the first project after the formation of the Brotherhood.[118] Hunt does not specify the nature of this book, but, if the outline design of 1848 now in the Fitzwilliam Museum, Cambridge, is related to this project (Plate 82), it is hard to believe that what they had in mind was not an outline book. The framing, horizontal format and centrally placed inscription beneath, all relate it to that genre. Stephen Calloway has recently shown that this composition has affinities with an outline design by Selous.[119] This is certainly the case, though it is remarkable to see how Millais has enlivened the composition with such deliberate gaucheries as the unrelieved line of feasters to the right of the table, the boarskin on the wall and the gestures of Isabella's brothers. None of the English imitators of Retzsch was as uninhibited in his exploitation of the grotesque as Millais.

Perhaps, as Ruskin and Hunt suggested, 'Fancy' was the key to Retzsch's appeal. To the artists who borrowed from his work he was, as he was for Mrs Jameson, a 'poet working in pencil', admired both for the power of his narrative and the singularity of his ideas. His sentimentality, too, gave him an advantage over his more rigorous compatriots, for he stirred the imagination without resorting to erudite expediencies. Both Ruskin and Jameson admired the 'naturalness' of his ideas: the quality that seemed to make moral truths as self-evident as visual truths. At a time when didactic pictures were much in vogue his ability to combine narrative vigour with symbolic embellishments of a moral nature made him seem a great and admirable designer—for he combined qualities that were of prime importance in the aesthetic values of early Victorian England.

CHAPTER V

The Decorated Page and the Woodcut Style

IT HAS already been seen in the previous chapter how the influence of Retzsch mingled with that of the revivalists in England in the 1840s, so that many of his designs and motifs became recast in a more schematic setting, while the expressive physiognomies of his protagonists became replaced by the graver gestures of Teuton-like heroes and, in the case of book illustration, his outlines became enmeshed in Düreresque hatchings. The adaptations that Maclise made for his *Lenore*, for example, show this process at work (Plates 75–6).

Such transformations are symptomatic of both sides of the Germanic influence: the stylistic and the didactic. On the one hand it shows the tendency towards simplicity, linearity, balance and frontality to be found also in the history painting of the period, while on the other there is a concern for the elucidation of content, the presentation in the most direct way possible of a meaningful and significant narrative. When it comes to a consideration of the types of narrative involved this aspect cannot be separated from changes in literary taste, in particular the growing vogue for the archetypal format of the ballad, the revival of interest in myths and sagas, and the simulation of these by such contemporary poets as Tennyson. The tendency to regard Germanic culture as fundamentalist both in its 'transcendentalism' and in its primitivism underlies the appreciation of the more archaizing productions of contemporary German literature, such as Goethe's *Faust*, Bürger's *Lenore* and the Grimms' *Kinder und Haus Märchen*; and the illustration of these by English artists provided an imaginative source that was to become applied to the illustration of history and myths in general.

However, before discussing the implications of the vogue for German literature for English illustrators, one should consider first the development of pictorial archaisms by German illustrators themselves.

When A. W. Schlegel complained of the prosaic effect that the detail of illustration can have upon a passage of poetry,[1] he omitted the corollary of his remark: that illustration can present an idea or image with greater vividness than words. Yet this observation, which had lain at the basis of the theological justification for the illustration of religious texts at least since the thirteenth century,[2] was by no means unfamiliar to the nineteenth century. Goethe himself had confessed how the *vollkommene Einbildungskraft* of an artist of the quality of Delacroix could engender visualizations—in this case to his own *Faust*—which outpaced even his own conceptions,[3] and the religious revivalists considered the potential of illustration as an aid to imagination from a viewpoint close to that of the mediaeval Church. A reviewer in the *Ecclesiologist* in 1845, for example, took grim pleasure in

155

pointing out how 'a child who would probably have heard, and many times had heard, the History of the Adorable Passion unmoved, was melted into an agony of tears when Albert Dürer's woodcuts were shown and explained to her.'[4]

Yet there are many ways in which an illustration can accompany or comment upon a text. While the outline illustration tended to substitute picture for word—creating a visual sequence that is in itself an alternative narrative—the archaizing illustrated book sought a different equation. It tended to take on the function of an exegesis. Its principal feature was the decorated page, in which illustration and text were bound together in close proximity by a continuous border. Thus in Maclise's sumptuous edition of *Lenore* each page is surrounded by a decorative border intended to evoke the 'style' of the text, which brings the illustration itself into simultaneous juxtaposition with the section being illustrated.[5] Nor was this method reserved for shorter poems. In longer works, epics, and at times even in novels—where illustrations were relatively infrequent—an illustrative continuity was preserved throughout the work by the repetition of the border on every page.

The illustrations themselves—often revivalist in style—frequently referred to prototypes in mediaeval and Renaissance book illustration. And, as in history painting, there was no intention of taking imitation to the point of direct copying. The criticism that Owen Jones's chromolithographic reproductions of illuminated manuscripts received in the *Ecclesiologist*[6] shows how aware contemporaries were of the incongruities inherent in attempting to reproduce mechanically works whose whole quality depended upon their being made either by hand or with the aid of the simplest machinery.

A closer analogy exists in the illustrated books produced by Blake—works that attained precisely the interpenetration of text and illustration that was the aspiration of the artist of the 1840s. Yet here, too, there is not an exact identity of purpose, for Blake was producing limited hand-finished editions, while the later artists had to work according to the standards imposed by mass production. The type of book that fulfilled these requirements was innovated first on the continent, and thus one finds once more, as with outline, that a method first used creatively by an Englishman is only generally adopted in England after it had been developed elsewhere.

The technological background to this change is a very important factor in the development of illustration, for book production, unlike history painting, is a commodity highly susceptible to market considerations. The spread of education and philanthropic endeavour throughout Europe during the early nineteenth century had created by 1840, for the first time, a wide reading public.[7] To meet this expanded market, new techniques were evolved, both in printing methods and pictorial reproduction, to produce more ambitious and cheaper books. The new popular market brought a particular demand for easily reproducible illustration—a demand that was met by the establishment of such pictorial magazines as *Punch* (1841) and the *Illustrated London News* (1842).[8]

The technique that was most closely associated with this development—and one that was used from the start exclusively by both *Punch* and the *Illustrated London News*—was the technique of wood engraving. Of all the new techniques of the

nineteenth century it was the one that might have seemed at first to be the least promising. Others certainly exceeded it in virtuosity and range. Lithography, invented by Senefelder in 1798,[9] had found favour on account of its rapidity and versatility. It was this technique indeed that was first employed in the revival of the illuminated book, for both Strixner and Owen Jones used it to imitate the characteristics of a manuscript.[10] Similarly, steel engraving developed rapidly after its innovation in the second decade of the nineteenth century on account of its high definition and durability.[11]

Wood engraving was certainly less versatile than either lithography or steel engraving. An improved version of the mediaeval woodcut, it still lacked the freedom of lithography or the precision of steel engraving. Yet it had one great advantage which made it ideal for the mass production of books. By its being produced by a surface method, rather than by an *intaglio* method like most reproduction techniques, it could be printed together with the typeface. When wood engraving was used, therefore, the printer was saved the additional expense and trouble of having to print on the page twice. Furthermore, the relief nature of the wood block made it easy to produce stereotypes from the original, a feature that was first exploited by Charles Knight, and which enabled the *Illustrated London News* to reach a circulation of 66,000 in its first year of production.[12] Consequently, once it had become accepted as a viable technique, the success of wood engraving in the book world was rapid. Wherever an illustration had to be combined with a large amount of text, its advantages were evident. Other techniques would be reserved for full-page illustrations and for the production of high-quality works of limited circulation. This situation remained operative until the 1880s, when the introduction of photogravure undermined the wood engraver's market.[13]

Thus one finds in the 1840s a confluence of aesthetic and economic interests. Both the artist and the popular publisher were aided by the unique advantages of the wood engraving—its ability to integrate text and illustration. It is perhaps for this reason that the return to the use of wood in printing proved to be the most successful of all nineteenth-century revivals.

Yet before its economic potential had been realized, wood engraving had to overcome the apparent aesthetic disadvantages of its limited range. The Newcastle artist Thomas Bewick pioneered the production of high quality wood engravings, yet his works still appeared rough-cut to many of his contemporaries and aroused as much curiosity as admiration.[14] Even his pupil William Harvey, who introduced further technical refinements like the underlaying process, found it difficult to gain acceptance for the method as a reproductive medium for high-quality publications.[15]

It was, in fact, on the continent, that wood engraving first began to become respectable; and during the 1830s a considerable number of Bewick's most talented pupils went to France and Germany to gain a type of employment that they could not find in England. This emigration, noticed in the *Art Union* as a national scandal,[16] is very evident in the wood engravings of French and German illustrated books of the period, such as the edition of Molière's works illustrated by Johannot

and engraved by I. Thompson *et al.* in 1835 (Plate 86).[17] In Germany, the work of Bewick's pupils proved far superior to the productions of earlier engravers like Gubitz[18] and in the major publishing town of Leipzig a whole colony of English engravers was established whose prowess was used as an advertising feature for many of the ventures they worked on.[19] Their influence—particularly that of William Nichols[20]—can be seen in the emergence of a new generation of German engravers of the standard of F. Unzelmann[21] and J. Jungtow.[22]

According to S. C. Hall, it was the success of these foreign productions that finally convinced the English of the usefulness of wood engraving as a quality reproductive medium.[23] Certainly he himself looked to foreign productions when publishing his own first illustrated book, *The Book of British Ballads*, in 1842—a work in which he hoped to show, as he stated in the preface, that 'the embellished volumes of Germany and France were not of unapproachable excellence in reference to design or execution'.[24] And the expansion of wood engraving in England during the early 1840s—an expansion that led to the establishment of such notable firms as the Dalziel brothers[25]—is dramatic.

The early recognition of the qualities of English engravers on the continent was conditioned by a more widespread appreciation of the qualities of the illustrated book itself. In Germany, the interest in wood engraving came after nearly half a century of designing decorative pages. While Blake's framing book designs had remained an isolated phenomenon in English art, this form had become an accepted form of book production in Germany; the more so since it seemed to be an integral part of the revival of national art. The Nazarenes turned from the start in their

illustrations to design methods that are directly reminiscent of mediaeval art. In his illustrations to Götz von Berlichingen of 1810, Franz Pforr designed a frontispiece in which the framing surround is given a distinctly Düreresque caste, and he also made use of the method of incorporating a text in the middle of his design.[26] Pforr's illustrations were never published, but they were well known amongst his immediate circle. A more public influence—and one that may have affected Pforr himself—was the publication in 1808 of Strixner's lithographs after Dürer's *Randzeichnungen* to the Emperor Maximilian's *Gebetbuch* (Plate 87). It seems likely that the rich grotesques in this work may have affected the design of Cornelius's frontispiece to his illustrations for Goethe's *Faust* (Plate 88).[27] However, such designs were never used by Cornelius as more than a frontispiece design and the full employment of the decorative border had to wait for the next generation, in particular for Eugen Neureuther, one of Cornelius's pupils in Munich. It was this painter's lithographs *Randzeichnungen zu Goethe's Balladen und Romanzen* published in 1829 (Plate 89) which first stimulated an international interest in this type of book design.[28]

Neureuther's success lay largely in his skilfully ability to combine archaism with Biedermeier charm. The book is overtly based upon Dürer's prayer-book. Not only do the figures and scenes surround the text enmeshed in a similar display of virtuoso penmanship, but each lithograph is printed in a differently coloured ink—reminiscent of the different tints used on the separate pages of the prayer-book by Dürer. At the same time, however, Neureuther did not completely abandon the more contemporary idea of the vignette. His borders are less continuous and

86. (far left) ★T. Johannot: Vignette to *Oeuvres de Molière*, Paris, 1835, I, p. 715. Wood engraving.

87. (middle) J. N. Strixner: Page 43 of *Albrecht Dürers Christlich-Mythologische Handzeichnungen*, Munich, 1808. Lithograph.

88. (left) P. von Cornelius: Title page to *Goethes Faust, c.* 1815. Pen (48 × 34.1). Städelsches Kunstinstitut, Frankfurt-am-Main.

89. ★E. Neureuther: *Heidenröslein*. From *Randzeichnungen zu Goethes Balladen*, Munich, 1828. Lithograph.

90. ★J. Hasenclever: Page 11 of Reinick, *Lieder und Bilder*, Düsseldorf, 1843. Etching by T. Janssen.

are often arranged asymmetrically around a main picture. The style of drawing, too, is only superficially *altdeutsch*. Neureuther had acquired his penchant for border designing while working with Cornelius on the Glyptothek frescoes, where he was detailed to execute the grotesques. This re-enactment of the Raphaelesque tradition had caused him to become known as the 'Giovanni da Undine' of Munich;[29] and his figure drawing, as well as some of his decorative motifs, reveals a close knowledge of High Renaissance art. The Gothic element, indeed, is only introduced where, as with the frontispiece to Cornelius's *Faust*, it enables a display of ingenuity. Through a gradual transformation from naturalistic foliage to arabesque, the vignette on the page is brought into a harmonious relationship with the printed text that the design surrounds.

Neureuther continued to work in this charming and modest style. Other German artists, however, responded not so much to the charm of these works as to their technical challenge. During the 1830s *Randzeichnungen* became so demanding a vogue that even a naturalistic painter like Menzel produced a set in this manner.[30] The most notorious works in this style were produced by the artists of Düsseldorf, in particular J. B. Sonderland. Like the work of Retzsch, Sonderland's *Bilder und*

Randzeichnungen zu Deutschen Dichtungen, first published in 1838, achieved sufficient international acclaim to be republished in Paris, London, and Frankfurt simultaneously. In a gesture characteristic of ambitious German artists of the period, the English edition was dedicated to Prince Albert—although in this case the gesture doe not appear to have produced any results.

Sonderland's use of border design was so extensive that it almost completely filled the page. Using etching as his medium, he abandoned himself to a convolution and intricacy that far exceeded the range of the lithographs and wood engravings by which Neureuther's designs were printed. Each design shows great ingenuity in creating a pattern that often symbolizes the content of the poem. Unfortunately, however, this very elaboration of the method tended to obscure the original intention of border design, for often the design was so elaborate that there was not enough space for the full poem to appear on one side, and the remainder had to be printed like a postscript on a subsequent page. What had been used by Neureuther to integrate the book emerges in Sonderland as no more than a series of display pages which break up the continuity of the text.

The culmination of this type of work amongst Düsseldorf artists came with the joint project for illustrating the poems of their fellow artist Robert Reinick (Plate 90).[31] Like Sonderland's work, this *Lieder und Bilder*, which ran as a series from 1839 to 1843, was published internationally. Like Sonderland's *Bilder und Randzeichnungen*, too, the interest in creating an elaborate design had usurped any consideration for an overall integration of illustration and text, and the artist rarely left space on his page for more than the first verse of the poem he was illustrating. Here the situation was aggravated by a sense of competitiveness, for not only was each plate planned by one of Germany's leading illustrators, but insets of different samples of their work were placed on the title page of each volume. Apart from virtuosi like Sonderland, Pluddermann and Hasenclever, artists of more significant talent were drawn into the project. Schwind, Rethel, Richter and Speckter all contributed to the series, and it is a mark of their status that none of them were enticed into competing with the Düsseldorfers' showmanship. Schwind produced a full-page illustration; Richter and Speckter separated their borders from the text by simply ruling lines around them; and Rethel produced a design (Plate 91) that is as clear and integrated as his best *Nibelungen* illustrations.

Yet, even if these artists seem to have realized the aridity of the senseless elaboration of technique, this series of samplers remained one of the most popular German productions both in Germany and abroad. In England the first volume was on sale already in 1839, and by 1842 demand seems to have exceeded supply; for in that year the importer of German books and prints, Hering, felt 'induced to yield to the repeated entreaties of the public and his friends to bring out a companion volume, in a similar manner, illustrating the well-known ballads, national airs, drinking songs, etc. of Germany'.[32]

If it had not been for the growing use of wood engraving, this vogue for border illustration might have been nothing more than an esoteric curiosity. By the early 1840s it had already become a form that had little application outside the expensive

picture book. When the method was applied to wood engraving, however, it not only entered the field of cheaper publishing, but was restored once more to a significant function: the production of a continuous accompaniment to the text. In this sense, the technical limitations imposed by the less versatile technique of wood engraving had the salutory effect of reducing the elaborateness of the decoration and concentrating on the linear aspects of the design.

One of the first uses of wood engraving for this purpose appeared in a production of Neureuther's—his designs for Herder's *Der Cid* of 1839[33] (Plate 92). Owing to the practical advantages of the technique, Neureuther was now able to extend his border designs for the few elaborate plates of the Goethe illustrations to cover a text of several hundred pages. Each song was headed and terminated with a page illustration surrounding the verses, while the other pages were unified with these by being encased in a related decorative border. Although Neureuther modified his manner for this work, his drawing still displays much illusionistic virtuosity. Lacking the suppleness of his lithographs, these illustrations fail to exploit fully the design potential of the new medium. It is a failure that also occurs in the illustrations to the *Nibelungen* that he worked on in collaboration with Schnorr, and which were published in 1843.[34] With tasteful flourishes of scrolls and foliage he still cut holes in the page in which to set his illustrations.

Before the publication of Neureuther's *Nibelungen*, however, the artist had been outpaced by a more advanced production, the edition of the *Nibelungen* published at Leipzig to celebrate the fourth centenary of printing, in 1840. This work, illustrated by Eduard Bendemann and Julius Hubner, aided by a number of other artists including Alfred Rethel, showed a greater understanding of the problems of designing for a page of two-dimensional text. While Neureuther's designs were connected to the text by thin borders, which like the arabesques in his earlier works acted as a median between illusionism and flat design, the borders of the Leipzig *Nibelungen* were thick and surrounded the designs without any illusionistic compromise. Furthermore, the designs themselves were not placed asymmetrically as Neureuther's vignettes had been but appeared in the centre of the page at the beginning of each strophe. On the unillustrated pages the heavy borders were also more effective than the thin lines of Neurcuther in creating the sense of a fully integrated book. Although the scheme was undertaken originally by Bendemann and Hubner alone, it was actually Rethel, brought in to help finish the commission in time,[35] who was most aware of the potential of the method. While both the main protagonists found it hard on occasions to marry their figurative style to the design as a whole, Rethel displayed the radical draughtsmanship that was later to make *Auch ein Totentanz* one of the major graphic productions of the nineteenth century. It was Rethel alone who shaded his works with broad cross hatching that was reminiscent of the simpler technique of the woodcut, and which created a homogeneity throughout the design.

The *Nibelungen* commission must have been a significant one for Rethel, for it was the first time that he had undertaken any major designing for wood engravings. Previously he had produced, at the age of nineteen in 1834, a series of outline

91. *A. Rethel: Page 9 of Reinick, *Lieder und Bilder*, Düsseldorf, 1843. Etching.

92. *E. Neureuther: Stanza 41 of *Der Cid*, Munich, 1839. Wood engraving.

lithographs to Adelheid von Stolterforth's *Rhenischen Sagenkreis* (Plate 18), which while displaying signs of expressive draughtsmanship had not greatly taxed his powers as a graphic designer. In the *Nibelungen*, however, he was confronted with a more rigorous situation, and responded to it with such masterful designs as *Wie Iring erschlagen wird* (Plate 93) in which he dispensed with the background and intertwined the protagonists with a motif of thistle leaves that seems to prefigure elements in the work of Burne-Jones.[36] In other designs his balancing of subject, border and text are hardly less radical (Plate 94).

The *Nibelungen* of 1840 represented a high point in the achievement of mid-nineteenth-century book design in Germany. Although it might seem over-elaborate today, it was the first commercially produced book to use the decorated page to achieve a consistent integration of drawing and text. Its quality was certainly appreciated at the time, as Hall's *Book of British Ballads* shows. In October 1841 it was sent by Prince Albert, recently appointed president of the Fine Arts Commission, to the Prime Minister, Peel, as an example of the kind of design that British artists should emulate.[37] Nor was the interest in the work confined to official circles, for the original subscription list contained over 200 London subscribers.[38]

If the 1840 *Nibelungen* marks the culmination of the decorated page style of

illustration in Germany, it also showed the application of a wood engraving technique that depended upon the simplicity and vigour of the woodcut for its effect. Once again it was Rethel who realized the full implications of this type of illustration, and took it to its furthest point.

In the decade that followed the production of the *Nibelungen*, Rethel worked little as a book illustrator. Preoccupied with the Aachen commission, which was eventually to cost him his sanity, he had little time for ephemera. Only the traumatic events following the Revolutions of 1848, in particular the uprisings that he witnessed in Dresden in May 1849,[39] led him to consider once more the medium of illustration.

This time, however, it was the overtly populist side of wood engraving—its cheapness and its proclivity for direct and simple statement—that attracted. His allegory on the consequences of revolution, *Auch ein Totentanz* (Plate 95), is presented in a sequence of six vigorous prints which unite the material of Holbein's *Dance of Death* with the narrative conventions of Hogarth's modern moral subjects. Here, as with outline illustration, the pictorial narrative is in itself complete. The accompanying verses at the bottom of each plate are no more than an

93. ★A. Rethel: *Wie Iring erschlagen wird* (How Iring was Slain). Page from *Das Nibelungenlied*, Leipzig, 1840. Wood engraving by F. Unzelmann.

94. ★A. Rethel: *Wie die Königin den Sall Verbrennen Liess* (How the Queen had the Hall burnt down). Page from *Das Nibelungenlied*, Leipzig, 1840. Wood engraving by W. Nicholl.

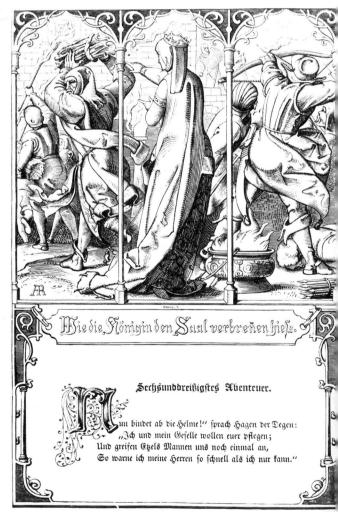

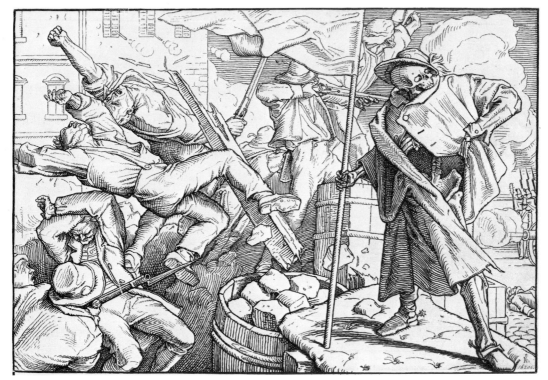

95. *A. Rethel: Plate 4 of *Auch ein Totentanz* (Another Dance of Death), Dresden, 1849. Wood engraving.

elaboration of the content of the pictures, and were, in in fact, written after the illustrations had been designed. Much of the simplicity and breadth of the designs relates to Rethel's training as a monumental painter. Yet they have all the immediate rhetoric required of a popular print. The compositions are dynamic and clear, the gestures unambiguous, the shading and detailing bold and schematic—unashamedly based on the cutting techniques of the sixteenth century.

Encouraged by the success of these works, Rethel had determined to produce more popular moralities and to set up a wood engraving studio for the purpose.[40] Before he lost his reason in 1853 he had produced three more single designs on the theme of the 'Dance of Death', showing Death as Friend (Plate 96), Avenger, and Servant. Two at least of these were stimulated by contemporary experiences—the Avenger from Heine's description of a cholera epidemic in Paris, and the Servant from a sudden death witnessed in the house of Carus at Dresden.[41] In all these there is the same archaic clarity as in *Auch ein Totentanz*. Like this work, too, they were internationally successful, and both Ruskin and Baudelaire could hail them as effective revivals of a graphic tradition.[42]

Rethel's prints were the most striking and possibly the most influential of the revivals of the woodcut style. Yet one cannot end this outline of German archaizing illustration without a reference to the swan song of the Nazarenes, Julius Schnorr's *Bilderbibel* (Plate 97). The culmination of a lifelong ambition, this pictorial Bible, which comprised in all 240 illustrations, was finally published in 1851. Already, certain of the illustrations, together with those of imitators like G. Jäger, had appeared in Cotta's illustrated Bible of 1844,[43] but these had merely been insertions

165

into a text rather than the independent series of pictures that the final work comprised. Like Rethel's engravings, these simple and direct designs were successful in meeting their popular market. In 1860 they were published in Britain, and subsequently ran into several editions.[44]

The excitement and interest caused by the publication of the 1840 edition of the *Nibelungen* was symptomatic of the growing interest in book design in England in the 1830s. As yet, however, this interest had only marginally affected book illustration. Typographers like Pickering had already achieved a purity of design that was to become a standard for other printers for over a century[45] but, while there had been considerable interest in the revival of sixteenth-century book styles, notably in the Chiswick Press,[46] the revival of the decorated illustrated book had not yet become a major concern.

The first move towards an expansion in the scope of book illustration in England came from populist rather than revivalist sources. The first publisher to appreciate the value of extended illustration appears to have been Charles Knight, whose *Penny Magazine* (1832–45) and *Penny Cyclopaedia* (1833–44) were the first to present information in a tabloid form.[47] Knight, a member of the Society for the Diffusion of Useful Knowledge, adopted this form of popular illustration for didactic purposes. He does not appear to have paid great attention to the finer points of the arrangement of the material he presented, however. Even when he went in for more expensive types of publishing, such as the *Illustrated Bible* and the *Arabian Nights*, both of 1839—for which he used such skilled engravers as William Harvey and illustrators of the standard of John Gilbert[48]—the designs appear as no more than muddled vignettes.

Knight's essays in this more expensive type of book towards the end of the 1830s were a response to the new interest in the illustrated book. For like other English publishers he had experienced the chagrin of seeing the emergence of highly elaborate books in France and Germany engraved by skilled English wood engravers.[49]

At first, interest seems to have been directed more towards French than towards German books. The French had indeed been more assiduous than the Germans in producing books with wood engravings during the 1830s. The edition of Molière's works illustrated by Johannot had appeared as early as 1834. In 1839 there appeared the even more sumptuous edition of Bernadine de Saint Pierre's *Paul et Virginie*. This was illustrated by Johannot, Huet and Meissonier, and provided much scope for the prowess of the English engraver Orrin Smith. Since the book appeared in English translation in the same year, this would have struck the English community with particular force.[50]

Yet if the French were the first to fully appreciate the value of the wood engraver for the illustrated book they were less concerned with the pictorial integration provided by the decorated page. In books like *Paul et Virginie* such archaism is avoided in favour of the more conventional use of the vignette.

By 1839, however, English booksellers were already stocking the first of the German decorated-page books, such as Neureuther's *Der Cid*.[51] Response to this

style of illustration appears to have been rapid, for already in 1840 Owen Jones—recently returned from his study of the Alhambra—brought out as his first book an illustrated edition of Lockhart's *Spanish Ballads*.[52] For the first time a revivalist decorated border appeared in an English-published book. While Jones was himself responsible for the borders, the illustrations were provided by a variety of artists. Of these, Henry Warren—later to work on Hall's *Book of British Ballads*—seems already to have taken an interest in a Germanic style of illustration. Not only do his forms frequently have a 'Teutonic' morphology, but he made full use of the pictorial conceits of the decorated page, and in one place even made his figures thread their way through the verses of a poem (Plate 98).

Jones himself was more independent in his pursuit of the archaic. He may have responded to the German revival of the decorated page, but there was nothing Germanic about the details of his designs. For these Jones turned directly to Celtic and Spanish sources.[53] Above all, he wished to direct attention towards the beauty

96. ★A. Rethel: *Der Tod als Freund* (Death the Friend). Dresden, 1851. Wood engraving by J. Jungtow.

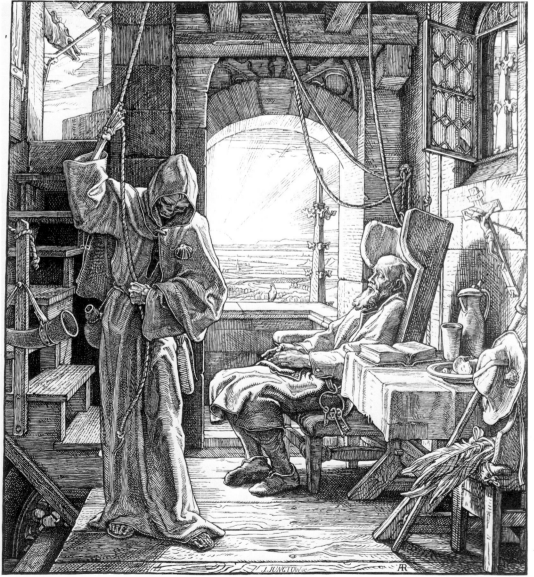

97. (right) *J. Schnorr
von Carolsfeld: *Abraham's
Servant and Rebecca*. From
the *Bible in Pictures*, 1860.
Wood engraving.

98. (middle) *H. Warren:
Illustration to *Lockhart's
Spanish Ballads*, 1840.
Wood engraving.

99. (far right) *J. Franklin:
Genevieve. Page from
The Book of British Ballads,
1842. Wood engraving
by T. Williams.

of the mediaeval illuminated manuscript, and he was soon to experiment in producing expensive facsimiles of these by means of chromolithography.[54]

Nevertheless Jones was not unappreciative of the quality of contemporary German illustration. If he was not himself influenced by their designs he still supplemented the old master designs in his illustrated prayer-book of 1845 with seven drawings by Overbeck and one by Naeke.[55] English artists were confined to illustrating those parts of the book that related to the contemporary performance of ceremonies.[56]

The most significant response to the German decorated-page book, however, was the *Book of British Ballads*, which was published by S. C. Hall in 1842. As is made clear in his recollections,[57] Hall's intention here was one of direct emulation of the 1840 *Nibelungen*. His confidence in having surpassed his rival was such that he dedicated the work to Ludwig of Bavaria. Ludwig, most ungraciously, did not acknowledge the dedication. Hall says in his recollections that this was due to a technical error in the way in which the book was presented to the King.[58] However, Ludwig may also have agreed with Nagler that the work 'failed to overshadow the work of this kind illustrated by E. Neureuther and the Düsseldorf artists'.[59]

If Hall's book is not as consistent a production as the 1840 *Nibelungen*, it was certainly undertaken with extreme care and seriousness. Instead of choosing established professional illustrators, Hall turned to the new generation of historical

168

painters—what Bell Scott was later to refer to as the 'rising talent' of the time.[60] Besides Bell Scott and his brother David, these included three members of 'The Clique'—Dadd, Frith and O'Neil. There were also a number of artists who were later to win recognition through the Westminster Hall competitions—Noel Paton, Warren, Townsend, Richard Redgrave and Herbert—as well as the short-lived Thomas Sibson.[61] Amongst those later to distinguish themselves as illustrators were Tenniel—also a Westminster Hall victor—and John Gilbert. Hall took great care to see that the artists were fully aware of his intentions. According to Bell Scott, all the artists were gathered together in a series of meetings at Hall's house. First they were shown books and prints, and after these had been studied Hall would himself recite a Ballad. Then wood blocks would be handed out to the artist who seemed best suited to illustrate that particular work.[62] This detail is interesting, for it suggests that the layout of the pages had been determined before a particular artist had been chosen to illustrate a ballad.

Hall does not mention in his autobiography who was responsible for the general layout of the book. One artist does, however, seem to have been more deeply involved in the project than the others. This was the illustrator John Franklin, whom Hall called the 'sheet anchor' of the whole production. Not only did he illustrate far more of the ballads than any other single artist (fifteen in all, while Scott and Corbould illustrated four, Ward and Gilbert three, and the rest one each), but he was

169

also clearly more conversant with the decorative conventions that he was working in. His fascination with intertwined figures and arabesques (Plate 99) as well as the 'Teutonic' morphology of his figures certainly fit in with Bell Scott's characterization of him as 'an admirer of the middle ages, with a style of drawing like that of the then living Munich School',[63] and help to explain why Hall should have used him so extensively.

Little is now known about the career of this artist, but his illustrations to Hall's *Book of British Ballads* appear to be the first work in which he shows a distinct leaning towards the style of German illustrated books. His career as an illustrator had begun six years earlier, when in 1836 he produced a series of outlines to the *Ballad of Chevy Chase* in a manner similar to Retzsch (Plate 65). As this choice of subject indicates, he was from the start interested in the illustration of romances and sagas—a choice that gained him much employment during the 1840s. His next two works—outlines to *The Admirable Crichton* (Plate 66)[64] and illustrations to Ainsworth's *Old Saint Paul's*[65] were characteristically 'romantic' in conception—though this time leaning more towards the dramatic style of such French illustrators as Devéria and Huet. In Hall's *Book of British Ballads* he had his first opportunity of designing for wood engravings and appears to have found here his true medium. The change in his manner is clearly demonstrated when one compares his illustrations to Chevy Chase in this work to his previous outlines on the same subject (Plate 100). While the motifs

100. ★J. Franklin: *Chevy Chase*. Page from *The Book of British Ballads*, 1842. Wood engraving by Armstrong.

101. ★D. Maclise: *But why stands Leonora there?* Page from *Leonora*, 1847. Wood engraving by J. Thompson.

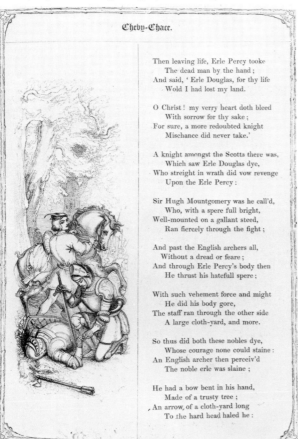

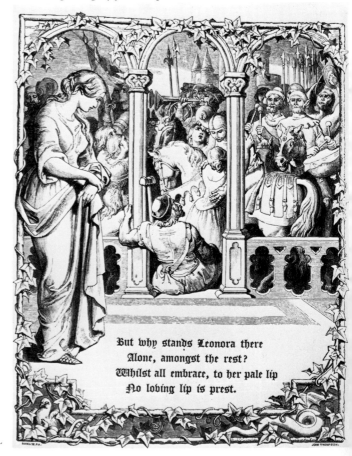

are often identical, he has completely altered his drawing technique. In the place of flowing lines are rugged contours and carefully hatched shading. There is also a new inventiveness, for his later drawings are full of additional conceits, including a highly Germanic monogrammed shield.

After working on the *Book of British Ballads* Franklin continued to function as an illustrator for more than two decades.[66] Yet, while producing highly charming designs for such distinguished and popular books as Felix Summerley's *Gammer Gurton* series,[67] he never achieved a popular reputation. In his advocacy of a Germanic illustrating style he was soon to be outclassed by more gifted artists, in particular Tenniel and Maclise.

Hall, too, was soon to lose ground in this field before more accomplished competitors. While the *Book of British Ballads* was a popular success,[68] his next production, *A Midsummers Tale*, sold poorly. Although admitting in retrospect the shortcomings of the text, Hall continued to defend the work as a pictorial production, claiming 'As far as the illustrations (numbering nearly 200) go— regarded either as drawings or engravings—no work so perfect has issued from the press this century.'[69] Yet, even if the illustrations are often of good quality, the general design and arrangement is patchy—possibly a reflection of the absence of Franklin in this venture. In any case Hall, a sound financier, seems to have recognized that he had lost the initiative in this type of work, and confined his artistic activities in future to his magazine and the reproduction of paintings.

Meanwhile the 1840 *Nibelungen* and the *Book of British Ballads* seem to have opened a new field of exploration for British designers and illustrators. The growing mediaeval craze—which was lampooned both visually and verbally in such works as the *Ingoldsby Legends*[70]—provided a ready market for the publication both of ballads and of illuminated books.

While much of the work produced was of a strictly commercial nature, the interest in mediaeval books also provided scope for some serious designers. Owen Jones's work has already been mentioned. His illuminated books were rivalled in magnificence after 1843 by those of Joseph Cundall, the printer, who produced the first of Felix Summerley's works, the *Gammer Gurton* series, which were a more modest version of the *Nibelungen* design. His Book of *Christmas Carols*[71] of 1845 also shows a similar format, with a greatly embroidered display of Gothic detailing. A more independent figure was the designer Noel Humphreys, who openly criticized the academicism of German illustration and design.[72]

Amongst the artists working as illustrators during the 1840s, Maclise was certainly the most adept at showing his inventiveness in the illustration of ballads. In 1845 his illustrated version of Thomas Moore's *Irish Melodies* was published—a work that vies more with Reinick's *Lieder und Bilder* than with the 1840 *Nibelungen*; for many pages allow for little more than a single verse to appear in it. The *Art Union* may have seen the 'severity of the German school' in this,[73] but the *Athenaeum* seems nearer the mark with its objections about the extravagance of the designs.[74]

Maclise's next major illustration project was *Leonora* (Plate 101). Published in 1847, it shows a similar extension of the principle of the 1840 *Nibelungen*. If Maclise's

171

fantasy is more rigorously controlled by the decorative borders in this case, the effect is still more concentrated and heavy than the German work, since the proportion of border and illustration to text is greater. Once again the *Athenaeum* hit the mark when it considered Maclise to have out-Germaned the Germans:

> In style we know of no German work that surpasses this—essentially German in character—in the fancy and vigour of design, or equals it in the beautiful execution of the wood engraving. Maclise is as German as the Germans themselves:—and though we do not object to find in such a work Maclise winning the race of ornamental decoration, yet we would rather see him taking an original course of his own than following that of his continental brethren.[75]

Certainly Maclise had been a very close student of German books for this work. While the choice of scenes—as well as many of the groupings of the figures—came from Retzsch's *Lenore* outlines (1840), the layout often reveals direct borrowings from the 1840 *Nibelungen*. The page, for example, which shows Leonora watching the return of the soldiers, bears an obvious relationship to Rethel's *Wie die Königin den Saal verbrennen Liess* (Plate 94), both in the tripartite division of the page, and in the use of the figure viewed from the back watching through the arches. In one sense Maclise certainly followed the style of the *Nibelungen* too closely, for he gave his figures the same mediaeval trappings—despite the fact that the poem is actually

102. J. E. Millais: *Garden Scene*. 1849. Pen (28 × 20.3). J. A. Gere.

103. ⋆A. Crowquill: *The Student of Jena*. Page from Bon Gaultier, *Book of Ballads*, 1848. Wood engraving.

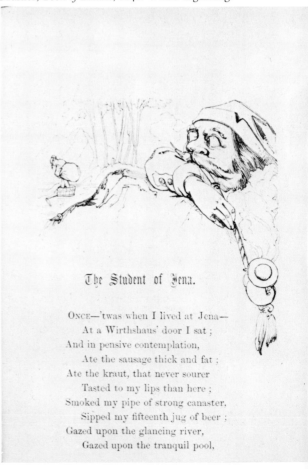

The Student of Jena.

ONCE—'twas when I lived at Jena—
 At a Wirthshaus' door I sat;
And in pensive contemplation,
 Ate the sausage thick and fat;
Ate the kraut, that never sourer
 Tasted to my lips than here;
Smoked my pipe of strong canaster,
 Sipped my fifteenth jug of beer;
Gazed upon the glancing river,
 Gazed upon the tranquil pool,

describing events supposed to have taken place in the eighteenth century.

Maclise's *Leonora* marked the height of the vogue for the decorated-page book. It is symptomatic of the retreat from this style that the very design of Leonora watching the return of the soldiers should in its turn have been borrowed a year or so later by Millais to produce a design whose delicacy and sentiment expressed a contrary interpretation of the mediaeval illuminated page (Plate 102).[76] Meanwhile the ballad book format had been most successfully satirized when the *Book of Ballads* of 'Bon Gaultier' (i.e. Theodore Martin and W. E. Aytoun)—which had been published in 1845 as a parody of the ballad style of Lockhart, Tennyson and Uhland—was reissued in 1848 with pared-down decorated-page illustrations by Crowquill, Doyle and Leech (Plate 103).

At the time when the conventions of the decorated page were losing their appeal, the appearance of Rethel's *Auch ein Totentanz* (Plate 95) emphasized a different side of the German revival of the woodcut style. For if the ballad book was an expensive and elaborate production this aimed at cheapness and simplicity. Its intention had been overtly propagandist; and if there was little need in England for the same kind of political directive the value of such wood engravings for social and moral instruction was not overlooked. Indeed it seemed to answer the call for cheap 'instructive' prints which had been called for by the *Ecclesiologist* and the *Art Union* earlier in the decade.[77]

104. ★F. R. Pickersgill: *The Woman taken in Adultery*. Page from *Six Compositions from the Life of Christ*, 1850. Wood engraving by Dalziel Bros.

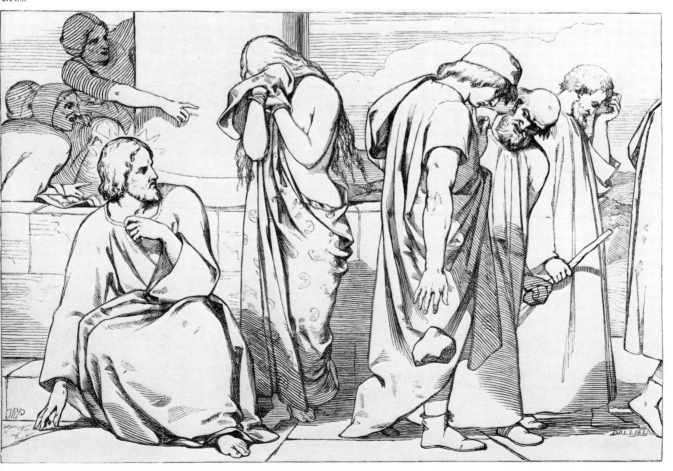

It was the Dalziel brothers who first attempted to adapt Rethel's example to the English market. In 1850 they undertook as 'the first commission at our own cost . . . a set of drawings to illustrate "The Life of Christ". Desiring to follow the example of Rethel's "Dance of Death" which had just been published in Germany at a very small price.'[78]

The venture was in fact very closely modelled on Rethel's (Plate 104). Not only were the plates identical in size and number (six), they also were printed with the same buff-coloured secondary tone in an attempt to bring the areas of the broad shading closer together. In their manner of engraving they went too close to the woodcut style for the liking of the artist they had commissioned to make the drawings, F. R. Pickersgill. A veteran of the outline manner, he took exception to the 'bits of black' that they had introduced into his designs.[79]

The Dalziels managed to better the price of Rethel's engravings—their plates cost one shilling while his sold at one and six—but they did not better his woodcut style. In Rethel's plates the simple shading and contours are modulated to suggest simultaneously volume, lighting and texture; there are no dead areas of smooth parallel lines, as there are in the Dalziels' work. The positive qualities of the German method were recognized by Ruskin in *The Elements of Drawing* when he commented that,

> when an artist is reduced to show the black lines either drawn by pen, or on the wood, it is better to make these lines help, as far as may be, the expression of texture and form . . . You will see that Alfred Rethel and Richter constantly express the direction and rounding of surfaces by the direction of the lines which shade them.[80]

The Dalziels' attempt to produce 'high class art at what was then thought to be a nominal price' was, as they admitted, 'not responded to'.[81] Yet they continued to persist in this type of didactic religious art and were later to be more successful with Millais's *Parables of Our Lord* (1864) and *The Dalziel Bible Gallery* (1880).

The attempt of the Dalziels—who hailed from Bewick's native town of Newcastle—to adopt a woodcut style emphasizes the degree to which priorities in wood engraving had altered during the 1840s. In 1839, as the *Art Union* pointed out,[82] the prestige of English wood engravers had been so high that colonies of them were established in the publishing centres of France and Germany. Yet, while the expertise of the English engravers was appreciated, their methods of engraving were increasingly felt to be unsympathetic to the graphic styles of German artists. It was for this reason that Menzel gave up using the Anglo-French firm of Best and Leloir for his illustrations to the *History of Frederick the Great* in favour of such German engravers as Kretschmar and Unzelmann whom he trained to cut in a manner sympathetic to his draughtsmanship.[83] The main distinction between the English and German methods of cutting at this time was that the English engravers, following Bewick, made use of positive white lines in their engravings. While this might have been more faithful to the nature of the wood engraving process it was less effective as a means of reproducing pure penwork—which is what the German

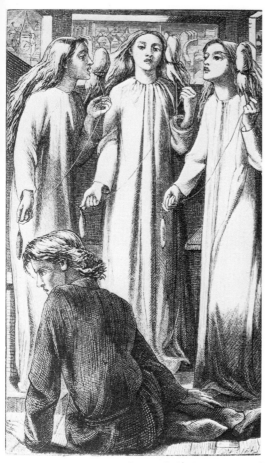

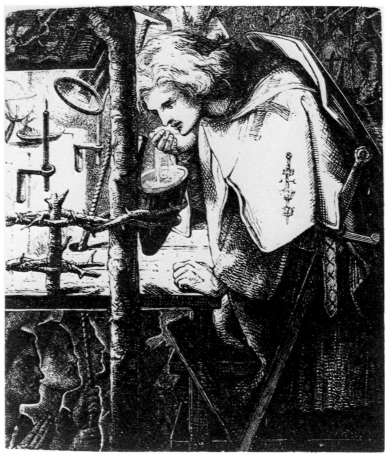

105. *D. G. Rossetti: *The Maids of Elfin Mere*. From *The Music Master*, 1855. Wood engraving by Dalziel Bros.

106. *D. G. Rossetti: *Sir Galahad*. From Tennyson, *Poems*, 1856 (Moxon edn.). Wood engraving by W. J. Linton.

artists wanted. The only English engravers to survive in Germany long after 1840 were those like Bewick's old pupil John Allanson and William Nicholls—an engraver of some of the 1840 *Nibelungen* plates (Plate 94)—who completely assimilated the German techniques. A large part of the success of Rethel's wood engravings had depended on the close relationship that had built up between him and the Dresden studio of wood engravers run by Hugo Bürchner. This studio had already been schooled in the requirements of the woodcut style by Adrian Ludwig Richter—the artist whose designs were so often mentioned by Ruskin and the Pre-Raphaelites in connection with those of Rethel.

No engraver working in England ever practised a woodcut style to the extent that the Germans did; but after *The Life of Christ* the Dalziels came closest to it. They were at their best when reproducing the lines of hard-edge draughtsmen, in particular the 'Düreresque pencilling'[84] of John Tenniel, drawn on the block with a 6H pencil. The justice of Rossetti's complaint that they had made his design for Allingham's *Maids of Elfin Mere* (Plate 105) 'as hard as a nail'[85] can be appreciated when it is compared with the results obtained from a Rossetti design by an engraver the artist approved of, W. J. Linton (Plate 106).

Linton's greater sensitivity to the linear freedom and tonal variety of Rossetti was

closely connected to his manner of engraving. Called by his one-time pupil Walter Crane the 'last master of the white line',[86] Linton insisted that it was only through the positive use of white lines—the actual marks made by the engraver— that wood engraving could become more than a mere method of mechanical reproduction.

Linton was one of the casualties of nineteenth-century commercialization. A traditional craftsman–artist—trained in a trade, and gifted manually and mentally to work in it creatively—he was forced by pressures of mass production to act as a surrogate machine. A poet, ardent socialist and old Chartist, he sought to return engraving to the creative condition in which it had flourished under Bewick. The lack of opportunity for this to be exercised to more than a minor degree no doubt explains the shrill tone of his instructional manual, *The Masters of Wood Engraving*, published towards the end of his career in 1889. There is hardly a page in the opening chapters of this in which 'white line' is not referred to. German engraving, where the lines of the pen were followed exactly, was to him no more than supreme technical skill. 'German fac-simile is most admirably good', he admitted, 'but white line alone is art.'[87]

Ironically, it was the circle of William Morris who were most responsive to such 'fac-simile' engraving in late Victorian England. By the time that Burne-Jones began designing for wood engravers Rethel had achieved establishment status; for, as is known from Walter Crane's reminiscences, the German master's eight famous plates were on permanent exhibition as 'examples of wood engraving' in the South Kensington Museum by 1859.[88] Unmindful of the arguments in favour of 'white line', Burne-Jones admired instead the 'craftsmanship' of an engraving style that presented forceful designs clearly and effectively. For him this contrasted severely with the illusionistic effects favoured by English commercial wood engravers. In 1862—at a time when Victorian graphic illustration is now thought to have been at its height—Burne-Jones considered that 'wood engraving in England was at its last gasp'.[89] It was the engravings of the designs of Richter and Rethel that gave him 'fresh hope of what might yet be done' in this field. Keen to find some 'channel besides a painting into which he might pour the stream of his ceaseless imagination', he took to heart the example of Rethel's work. Writing to his sister in 1862 he said,

> In engraving every faculty is needed—simplicity, the hardest of all things to learn—restraint in leaving out every idea that is not wanted (and perhaps fifty come where five are wanted)—perfect outline, as correct as can be without effort, and, still more essentially, neat—and a due amount of quaintness. I really do not think anyone in England could have engraved the Rethels.[90]

It was his intention to publish '100,000 wood-cuts as big as *Death the Friend* or bigger' (Plate 96), and, while he certainly did not achieve that, he and Morris continued both the decorated page and the woodcut style in such works as the Kelmscott *Chaucer* (1895). It is fitting, perhaps, that a revival that was undertaken with such proselytizing aims should have received its greatest response in that circle in England which tried most urgently to re-unite political awareness with the mediaeval dream.

CHAPTER VI

The German Manner and English History Painting

THE EFFECT of German art in determining new directions in historical painting in this country is perhaps the best-known aspect of the German influence. Certainly in view of the impact it had on determining the course of the Westminster Hall competitions and the subsequent fresco decorations of the Palace of Westminster, it was the aspect that caused the greatest amount of controversy at the time. The story of the development of these projects is already well known,[1] and a detailed survey of the artists concerned would lead to little more than a gratuitous elaboration of recently published material. Furthermore, it might also obscure the crucial distinction between those few major artists such as Dyce, Maclise, and Madox Brown for whom the study of German art provided a fundamental change of aesthetic outlook, and the more numerous practitioners such as E. M. Ward and J. C. Horsley for whom it was an expedient and easily forgettable experience.

This chapter, therefore, will concentrate on the changes in pictorial practice that the awareness of German methods in monumental art brought about amongst English historical artists. These transformations were far more fundamental than the opportune adoption of a 'German manner'—the depiction of Teutonic heroes of a bombastic disposition that were so aptly satirized in *Punch*[2] (Plate 107)—for after this fashion had disappeared, there remained a new attitude towards gesture, design, choice of style, and the function of art that played a strong part in the aesthetic standards of the Pre-Raphaelites and other purist artists of the late nineteenth century.

As has already been mentioned in the Introduction, it was the implications of this change—the fear of the pictorial limitations that a dogmatic approach would bring to the English artist's much prized naturalist tradition—that lay at the basis of the controversy over monumental and historical painting in the 1840s. To a large extent, the misgivings of such antagonists as Benjamin Robert Haydon were overstated. Even those most frequently accused of 'Germanic' tendencies did not wish to subvert any traditional qualities in English painting. Just as the 'democratic' method was scrupulously maintained through the competition system in the Parliamentary commissions, so Eastlake, Dyce and Maclise, even at their most severe, retained a respect for the sensuous qualities of art.

A more fundamental distinction between the pro-revivalist and anti-revivalist factions was their relative acquaintance with the practices of the modern Germans. For such artists as Dyce and Eastlake, who had personal contacts amongst the

107. *The German School*. From *Punch*, 1846. Wood Engraving.

German painters, it was possible to hold reservations about the finished work of Schnorr, Kaulbach, Cornelius and Overbeck, while admiring their intentions and select aspects of their techniques.

The roots of this pictorial tendency amongst history painters lead back, as they do with other aspects of the German influence, to far before the 1840s, to the formative period of the generation who were, at the time of the Westminster Hall competition, approaching middle age. As has already been seen, the art of the German revivalists first reached an international public in Rome, and it was amongst the community of English artists in Rome that the first English painters came across this new extreme.

It would indeed have been difficult for the English artists returning to Rome after the years of exclusion caused by the Napoleonic Wars to remain unaware of such a phenomenon as the Nazarenes and, with the exception of Henry Sass,[3] they do not appear to have done so. Not only was the work of the Nazarenes sufficiently well known to be the subject of articles in the English press as early as 1817, but also the close contacts with Prussia and Hanover gave English visitors a privileged position in viewing the work of the new German masters.[4]

While artists of the older generation like Lawrence, Turner and Wilkie all took a critical interest in the Nazarenes, this art was to have more direct implications for the younger historical painters who came to Rome. These artists faced, while still undergoing their training, an approach to painting which contradicted much that they had previously learned.

178

To some extent these young painters were already prone to confusion, for, while they had matured in a country with a strong painterly tradition, their academic training had already prepared them for the higher requirements of the 'Great Style'— that 'beauty and simplicity' and 'nobleness of conception' of which Reynolds had spoken.[5] French neoclassical art presented little problem to them; its dramatic repertoire easily led it to be condemned for 'extravagant action, glaring colour, and false feeling',[6] which could be associated with Reynolds's warning against copying 'theatrical pomp and parade of dress and attitude'.[7] The Germans, on the other hand, could not be so lightly disregarded. Their high-minded subject matter, integrated design and ascetic style seemed (despite its too primitive eclecticism) to contain many of the highest principles of the Great Style. If the English could not follow a similar path, they must at least recognize the qualities of those who had.

The confusion that so many English history painters felt in the face of this exemplary yet inimitable art is typified in the reactions of Joseph Severn. Severn, the same man who accompanied the dying Keats to Rome in 1820, had presumably seen both the Bartholdi frescoes and the cartoons for them when he wrote to C. R. Leslie in 1821:

> The Germans here are certainly a great race of artists. Their manner is not to be tolerated, for they imitate Perugino and Giotto. Colour and effect they keep away from as pestilence—but in chalk cartoons they produce such beauty of compositions, expression, and character that I set them beyond all other painters . . . I do not know any pictures (the rooms of Raphael excepted) that give me such delight—but mind, the Germans are full of abomination in everything but character, expression and composition—and for these I could look at their pictures for ever.[8]

From these contradictions, there remains the admiration for 'character, expression and composition', qualities that Severn felt could be distinguished from the other elements of Nazarene art. Their archaism remained a mystery to him, for he seems to have had little sympathy or understanding at that time for their religious intention and tended rather to described their art in terms of purely visual standards.

Severn was hardly even a second-rate painter, but his opinions are worth noting, not only for the time at which they occur, but also because of the central position that he occupied in Roman society at this time. Ambitious to become a major historical artist, he was considered by the Germans as one of the foremost English painters.

His contacts with German artists, in fact, occurred very early. Introduced to Conrad Metz by a letter of recommendation from Lawrence when he arrived, he soon made the acquaintance of 'an old German landscape painter who was a friend of Allston' (probably Koch).[9]

By 1822, he was selling his works to German patrons,[10] and he remained on such intimate terms with the German community, that when he finally left Rome in 1838 they organized a large farewell party in his honour.[11] Through such esteem and his own charming manner, he was enabled to act as go-between for the two

nationalities in Rome. As Dyce commented to Hope Scott, when giving him instructions for his visit to Rome: 'Severn is everybody's man.'[12]

Nevertheless, despite such intimacy, use of Nazarene methods remained cautious and restrained in Severn's work; even in his religious painting, he attempts no more than superficial simplifications. His fantasia *The Vision of St John the Evangelist* for the Basilica of S. Paolo Fuori le Mura—which gained him the singular distinction of being the only Protestant painter of the time to have a picture placed in a Catholic church in Rome[13]—shows a return to early Renaissance forms for the representation of the Virgin and the Evangelist; but he remains true to the English tradition by clothing the whole in respectably Venetian tonalities. Failing to realize that the Nazarene qualities of clarity and compositional strength can only be achieved at the expense of a sacrifice of more illusionist properties, he attempted to combine the salient characteristics of both English and German painting, without achieving either.

Inspired by the success of German artists, Severn dreamed of creating a cycle of works devoted to the 'golden age' of English history, the Elizabethan era.[14] Despite many commissions from his aristocratic contacts in Rome, however, this plan never materialized. Yet Severn never gave up his ambition. Years later, in 1843, he sent a cartoon to the Westminster Hall competition, and was rewarded with a premium.[15] The design, *Queen Eleanor Sucking the Poison from the Wound* (Plate 108), imitates the symmetrical composition that was commonly associated with the Munich manner, but there is little rigour in the drawing, and he softened the gestures sufficiently to give himself ample scope for sentiment in the figures. Perhaps his friendship with Mr Gladstone, who wrote to him at the time assuring him of the success his cartoon would have,[16] was not uninfluential in this decision; for in general the performance was regarded as disappointing.[17] Nevertheless he still retained currency as a Germanist, and it was to him that the family of Lord Monsen turned to complete the decorative scheme at Gatton Park that had been laid out by Cornelius.[18]

As English artists and patrons became more acquainted with the requirements of didactic painting, Severn's shortcomings became more evident. He was not successful in any of the subsequent Westminster Hall competitions, and had little to recommend him to the young aspirants of the day. Rossetti, who obtained an introduction to him through a family acquaintance, was soon disillusioned with his work, and turned to more substantial figures like Madox Brown for guidance.[19]

Meanwhile other English artists who were in Rome in the 1820s were reacting in a more far-reaching way to the ideals of the Nazarenes. Of these, Eastlake was to be most influential in the propagation of revivalist attitudes in England. While his main significance was to be in the field of art theory and organization, his decisions were coloured by his own experience in reconciling the Nazarene aspirations with his own training and inclinations. Despite his more thorough investigation of the issues, he experienced difficulties similar to Severn's in assimilating them into the English tradition. Accustomed as a pupil of Haydon to a liberal interpretation of the Great Style, he was only able to compromise his penchant for tonal contrasts and Venetian colouring to a limited degree.

Eastlake's contacts, like Severn's, had been close and immediate. Having met Bunsen by chance on the way to Rome to take up his position in the Prussian Embassy,[20] he formed connections in these diplomatic circles, and must, presumably, have been one of the earliest visitors to the frescoes in the Casa Bartholdi. He certainly knew them well by 1820, when he wrote his articles on art in Rome for the *London Magazine*.[21] By this time, he had also become sufficiently interested in German culture to have learned German, and had translated both Bartholdi's book on Italian *Banditti*, and August Kestner's *Über die Nachahmung in der Malerei*. Whereas the first is probably more significant in connection with his own travels, which included a visit to Greece (on the basis of which he contributed drawings with German and French artists to the 'Duchess of Devonshire's' *Aeneid*), and his tendency to paint Italian genre scenes of a sensational nature, the second was important as evidence of his interest in the German controversy over revivalism that had broken out following Goethe's attack through Meyer of the 'Neu-deutsch Patriotische-religiös Kunst'.

Already, in his *London Magazine* article on modern art in Rome, one finds Eastlake considering the revivalist claim to have returned to a 'spiritual' beauty when he stated:

08. ★J. Severn: *Queen Eleanore*. From Linnell, *The Prize Cartoons*, 1845. Lithograph.

For simplicity, holiness and purity, qualities which are the characteristics of the scriptural scenes, no style was better adapted than that of the Germans. This style has little or nothing to do with reality; it diffuses a sort of calm and sacred dream. To censure it for being destitute of colour and light and shade, would be ridiculous; such merits would, in fact, destroy its character . . . they have dignified their style by depriving the spectator of the power of criticizing the execution.[22]

To remove the Nazarenes beyond the bounds of critical censure is perhaps a counsel of despair, but it does at least show an acknowledgement of aesthetic standards alien to those in English art. Eastlake realized, as Severn did not, that a criticism of the Nazarenes on the basis of their inadequacies in colour and chiaroscuro was insufficient. To make the distinction clearer, Eastlake ends, in fact, by making the summary distinction between English and German art which was to become one of the clichés of the 1840s: 'The English have the matter, and the Germans have the mind of art.'[23]

To an artist as serious-minded as Eastlake, such a division presented agonizing problems; for, while he believed in the intellectual and moral superiority of German art, he could not bring himself to abandon the more accustomed path of visual appeal. Sadly, he acknowledged himself as belonging among the admirers of the pagan Greek art that had been contrasted by Kestner to that of the Middle Ages and the German revivalists. As he wrote to his patron Jeremiah Harman in 1821:

While I think that a painter's only chance of success is to follow his own bent, I sometimes regret that mine is a decidedly heathen taste, for I see more to allure me in the beauty and simplicity of a classical dream than in the less plastic and less picturesque materials of my own faith—the very excellence of which is that it does *not* appeal to the senses. I have thought, indeed, that the two might be united in sacred landscape, for the scenery of the East has always been fine, but I cannot help thinking, with respect to history painting, that all the machinery of art—the picturesque—has little to do with Christianity, the purity of which is better expressed by the early Italian painters and present German painters, than by Venice, France, or England.[24]

In the pictures that he painted in Rome, then, one finds little that is indebted to the Nazarenes. His *chef d'oeuvre*, the *Isodas* of 1827 (Plate 109), is a tastefully presented classical subject, full of the 'machinery of art' that he had talked about in the letter to Harman. Referring overtly to the Elgin marbles and Flaxman, its actions have become frozen through too cautious a presentation of form, and its protagonists, pedestalled in the foreground, look scarcely more alive than statues.

Nevertheless he still attempted at times to unite religious art with his tastes for classicism and genre. Approaching sacred art, as he had indicated in his letter to Harman, through the medium of landscape, he attempted to modify his successful

109. C. L. Eastlake: *The Spartan Isodas*. 1827. Oil (188 × 254). The Trustees of the Chatsworth Settlement.

110. C. L. Eastlake: *Pilgrims in sight of Rome*. 1841. Oil (81.5 × 104). Private collection.

183

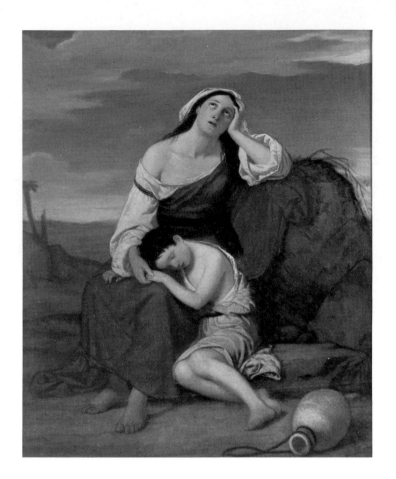

111. C. L. Eastlake: *Hagar and Ishmael*. 1830. Oil (50.7 × 58.4). Royal Academy, London.

112. (far right) C. L. Eastlake: *Christ Lamenting over Jerusalem*. 1841. Oil (96 × 148). Tate Gallery, London.

genre themes in a Bellinesque mode. The results, such as his *Blind Woman led to Mass by a Young Girl*[25] of 1824, or his often repeated *Pilgrims in Sight of Rome*[26] of 1827 (Plate 110), can hardly be called the sensory painter's answer to Nazarene high-mindedness; for the thoughts that arise from such incidents remain firmly on the level of the anecdotal.

In 1830, Eastlake was elected a member of the Royal Academy, and, perhaps sensible of his new status, celebrated the occasion by painting as a diploma picture his first biblical subject since his juvenile *Jairus' Daughter* of 1812. The resultant *Hagar and Ishmael in the Desert* (Plate 111)[27] seems to owe more to Guido Reni than to the Nazarenes. Not only was the subject—a depiction of innocent suffering—one which gave Eastlake full rein to exhibit his customary modest sentimentality, but he made ample use of a baroque repertoire of gestures. Nevertheless there are in the compositional structure of the work signs of a greater firmness than before, and this quality was to become more marked in his subsequent pictures.

By this time, to judge from his unpublished article written for the *Quarterly Review*,[28] he had adopted a more moderate interpretation of 'Christian Art' which, like that of later German critics and artists, could reconcile the sentiments of the primitives with the pictorial forms of later ages.

He may well have been helped in reaching this conclusion by viewing the more modified works in Munich by Cornelius and Schnorr who, as Waagen was later to

say, 'Soon opened their eyes to the case that a deep religious feeling, as proved by the works of Raphael and those of the early time of Michael Angelo in the sixteenth century, is quite compatible with the most developed forms of art.'[29]

When in Munich in 1829 Eastlake had not, it is true, felt any particular liking for the works of Cornelius, which he considered to be of interest to 'those who judge their pictures by their descriptions'.[30] With Schnorr, on the other hand, he formed a friendship which was to be maintained over decades through a lengthy correspondence.[31] Schnorr, an admirer of Ghirlandaio, was perhaps the most anecdotal and engaging of the Nazarene painters; even his colours—the most difficult part of Nazarene painting for their English contemporaries—were richer and more distinguished than the childlike reds and blues of Overbeck or the metallic tones of Cornelius.[32] Certainly Eastlake must have felt some sympathy for Schnorr's work since he was prepared to arrange for the sale and exhibition of a number of his productions in England.[33]

Whether Schnorr's influence was formative or not—and one must remember that one of Eastlake's patrons thought their work sufficiently similar to mount together[34]—Eastlake's art moved towards a greater asceticism during the 1830s. Religious subjects become more frequent: in 1834 he painted a *St Sebastian*[35] and in 1839 this was followed by *Christ Blessing Little Children*. This latter work may well have been inspired by Overbeck's often repeated treatment of the same theme.[36]

Despite the classical profile that Eastlake gave to Christ and the dramatic chiaroscuro of the setting, it shares the centralized disposition of the figures that can be found in Overbeck's work. Characteristically, however, Eastlake disguised the symmetry of the design by introducing picturesque modifications of the poses. Meanwhile his ever popular *Pilgrims in Sight of Rome* had been undergoing a rigorous revision. Indeed he even recreated it as a frieze-like mural for the Marquis of Lansdowne.[37]

After 1840 Eastlake's official capacities and scholarly activities limited the time he could devote to painting. However, until 1855 he maintained a regular, if diminished, output. During these later years, religious themes occurred with even greater frequency. In 1841, he produced *Christ Lamenting over Jerusalem* (Plate 112), a work whose lunette shape—and even the subject matter—might have been suggested by the popular print of E. Bendemann's *Jews in Exile*[38] (Plate 113). In 1843 he painted two more versions of *Hagar and Ishmael*, in 1840 a *Good Samaritan* for Prince Albert, and in 1853 a *Ruth and Boaz*.[39] Like the genre scenes and portraits that he continued to turn out at this time, these works still have a strong element of the sensuous and, indeed, the biblical scenes chosen were on the whole admirably suitable for the expression of sentiment. Yet at the same time there is a tendency towards a greater rigour in gesture and design. This comes out most strikingly in the composition of his 1843 version of *Hagar and Ishmael* (Plate 114). Here Eastlake has completely reworked his conception of the event. In contrast to the earlier version, the chiaroscuro has virtually been eliminated and the horizon line raised so that the figures appear against a flattened ground. Furthermore, they are no longer expressing rhetorical gestures of despair, but are united in a simple and noble action—that of Hagar tending to Ishmael with the meagre water jug which was all that they had been given. What had once been seen as a subject of horror—similar to that of Ugolino—now becomes a moment of quiet heroism. When it was exhibited in the Academy, the *Art Union* reviewer noticed both the high-mindedness and the pictorial rigour of the work. After having praised the 'severe simplicity which best becomes a pure and lofty style', he continued:

> Mr. Eastlake's feelings evidently incline to the earlier rather than the later schools of Art. He amalgamates his figures but little with his backgrounds, but he obtains perspicuity by an inflexible breadth of style. His works have a religious severity, we had almost said sanctity of effect, which reminds us strongly of the earlier schools of Italy, and which no other artist of this age has achieved.[40]

The *Art Union*, always mindful of status, exaggerated. Touching though Eastlake's picture is, its simplicity is more noticeable for its neatness than its severity. Perhaps Eastlake was himself aware of the limitations of his gentle style, for in his later years he rarely attempted works on a large scale or which included more than a

113. E. Bendemann: *Die trauernden Juden im Exil* (Jews in Exile). 1832. Oil (183 × 280). Wallraf-Richartz Museum, Cologne.

114. C. L. Eastlake: *Hagar and Ishmael*. 1843. Oil (75 × 94). Sold Christie's, 9 October 1964 (lot 102).

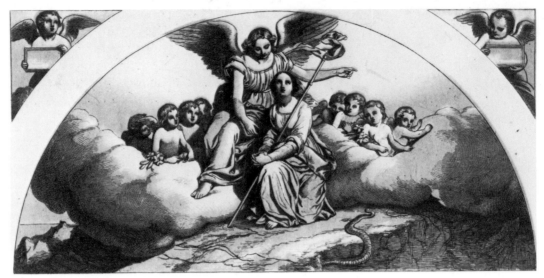

115. ★C. L. Eastlake: Scene from *Comus*. From *The Decoration of the Garden Pavillion in the Grounds of Buckingham Palace*, 1846. Lithograph by L. Gruner.

few figures. As Secretary to the Fine Arts Commission, he was hardly in a position to enter the Westminster Hall competitions, yet there is little to suggest that this was a great sacrifice for him. Characteristically, his one essay in mural painting in the 1840s was of a private if distinguished nature. In 1844 he was one of the eight painters who frescoed lunettes for Prince Albert's summer-house in the grounds of Buckingham Palace.[41] Possibly, as Lady Eastlake claims, the idea of employing artists on this project—originally a decorative scheme designed by L. Gruner—was actually suggested by Eastlake.[42] Certainly the principal intention was to provide the opportunity for an experimental use of fresco before the Palace of Westminster was placed at the disposal of the history painters. Eastlake's own contribution was modest (Plate 115) and in the least visible part of the octagonal room selected for the paintings. The design is a simple one, yet this is perhaps more appropriate than the ambitious works of many of the other painters, for the theme chosen for the pictures was *Comus*. The Raphaelesque treatment of the forms, too, is perhaps inevitable; a man with Eastlake's sense of historical precedent was hardly able to avoid here a tribute to the lunettes of the Farnesina.

As a painter, Eastlake's influence was limited, and probably did not extend much beyond the mild and simple religious works of his pupil W. C. T. Dobson.[43] Yet his gift for compromise was not lost to the art world of the 1840s, for as Secretary to the Fine Arts Commission he was able to sympathize with and modify Prince Albert's didactic concept of state patronage. Furthermore, through the circle of friends that he had acquired amongst German artists and scholars, he was able to provide English artists with important technical information about mural decoration.[44]

Without his informed and tactfully presented knowledge of German art and ideals, one feels that the direction of State patronage would have been very different at this time, and certainly its passage would have been less smooth. He even managed to hoodwink Haydon for a time. But when the old master finally discovered what his most gifted pupil was up to he reacted with fury at the betrayal.

The fact is, I see through his quiet plan. Dyce, a most vicious artist, he recommends, then Herbert, another—and both German. The result will be frightful, for the German system of ornamental or unsound art first, and the figure or sound art after—the reverse of Bowring and the Lyons School—and a race will come out who will poison, and must poison, the art.[45]

Haydon's assessment, inflamed by personal failure and antagonism to a system that placed design on an equal footing with rhetoric, was of course exaggerated. Eastlake was not attempting to dupe the English into Germanism, but trying to engineer a compromise. If Haydon understandably could not be sympathetic to such distinctions, other accounts exist which analyse more precisely Eastlake's position:

very few, if any, of those who make invidious comparisons between English and German artists are prepared to say that they would wish to see German art, such as it is, transplanted into this country. They find in it, however, unity and completeness, something which is, be it good or bad, so peculiarly and fully expressive of German habits of thought and consistent with their traditional character, that, independently of its general merits, and even in spite of the comparatively little sympathy which Englishmen have with the German ideal of art, leads them to acknowledge its power and to propose for imitation that which in reality, they would not wish to see imitated.[46]

The author of this letter was none other than Haydon's 'vicious' Germanist, William Dyce. Perhaps more than he knew, Dyce was describing in these words, his own dilemma as well as Eastlake's. An equally high-minded artist, he looked as much as Eastlake to the creation of a great national school of history painters. However, he was as wary as Haydon about capitulating to foreign influence, and did all he could to suggest indigenous methods of achieving his aim. Amongst other measures, he proposed the creation of a museum of British art,[47] and even the adoption of a local archaism—hoping to revive a 'national character' by drawing on the sources of British mediaeval art.[48] Yet he was too aware of the issues of the day to overlook the achievements of his contemporaries abroad, and was, as often as not, brought back to a consideration of the work of German artists.

Dyce is perhaps the most problematical artist in the history of the impact of German art in England. He was considered by many of his contemporaries and succeeding generations to be the epitome of Nazarene influence in English art, yet this was an inference that he himself consistently denied.[49] Both his son[50] and James Dafforne, who wrote his obituary in the Art Journal,[51] also took great pains to suggest that Dyce's interest in mediaeval art was quite independent of the Nazarenes, yet it is still generally assumed that the relationship was close and decisive.

As Keith Andrews points out,[52] the exact course of his development during the time when he was in Rome in the 1820s, cannot be determined until some further documentary or visual evidence comes to light; but it is nevertheless possible to draw some inferences from the material that exists.

According to his biographers, it was during this second visit to Rome, in 1827,

that Dyce's art first began to exhibit primitivistic tendencies. During his first visit, in 1825, the young student of the Academy had devoted his time to the study of Titian and Poussin, with results that can be seen in the *Bacchus Nursed by the Nymphs of Nyssa* (1826; Aberdeen Art Gallery) he painted on his return. Certainly the company he was in during the first visit would not have helped him to appreciate the Nazarenes, for he travelled to Rome with the miniaturist Alexander Day, the reputed owner of the Casa Bartholdi who, according to the *London Magazine*, cursed Bartholdi 'all' inglese . . . for having daubed his walls with mock Masaccios and Albert Durer'.[53]

It was during his second visit to Rome, which lasted one and a half years, that Dyce established his friendship with Overbeck. According to Dafforne, this contact first occurred when Severn was showing some German painters a Madonna that Dyce had been painting. The Germans, apparently, were greatly impressed, and decided to raise a subscription to buy the work when they thought that Dyce was being forced to leave Rome on account of financial difficulties. Only the discovery that Dyce was leaving Rome at the command of his father prevented the project from being effected.[54]

Dafforne cited this story to support his assertion that Dyce was unaware of the art of the Nazarenes until the end of his stay and that he had previously begun to work as a revivalist. Yet both these assertions are questionable. His earlier friendship with Day would have made it difficult to be ignorant of the activities of the Germans, and these artists were, in any case amongst the most conspicuous in Rome at the time. On the other hand, there is little to suggest that the Madonna that Dyce painted at this time was revivalist in style. The subject of the work is not evidence in itself, for

the Nazarenes were not the only painters of religious works at this time, and amongst English artists both Severn and Lane had produced devotional works in the 1820s which had little to do with revivalist art. Contemporary reports of Dyce's Madonna suggest that, far from arousing unanimous approval amongst the German community, it was the object of heated controversy. An account in the *Kunstblatt* reports how Dyce 'was extremely highly regarded by some German artists, and was for a long time an object of curiosity as well as conflict'. In talking of the artist's merits, it appears that it was his colouring, above all, that was beyond criticism: 'The future will show us which party was right. But this much is certain; that he possessed a great talent for colour.'[55]

This was hardly a surprising quality for Dyce, as a British artist, to possess. His devotion to the art of Titian was to remain indeed throughout his life, eventually furnishing the subject for a late work, *Titian's First Essay in Colour* (1857).

Dyce's second visit to Rome—and possibly a subsequent one in 1832[56]—seems to have been every bit as much the occasion of a spiritual as an artistic crisis. An Episcopalian by upbringing, he was feeling—like so many other future Anglo-Catholics during this period of Catholic resurgence—the attractions of Roman Catholicism. One Roman acquaintance of great importance to him from this point of view was, to judge from subsequent correspondence, Dr Nicholas Wiseman, then dean of the English College, and later to become the Cardinal, notorious for his evangelistic zeal. Even Dyce's connections with Overbeck, who was himself a convert, seem to have been as close on a spiritual as on an artistic level. Certainly, when Overbeck mentioned Dyce in a letter to Steinle in 1834, he referred to him not as a painter, but as a potential ordinand for the English College. Overbeck's letter

116. (far left) W. Dyce: *The Judgement of Solomon*. 1836. Tempera (150 × 246). National Gallery of Scotland, Edinburgh.

117. W. Dyce: *Paolo and Francesca*. 1837. Oil (132 × 160). National Gallery of Scotland, Edinburgh.

confirms the story that Dyce had been suddenly recalled to Scotland by his father, and expresses the hope that he would soon return to Rome to complete this vocation.[57]

Whatever the truth about Dyce's work in Rome is, it is certainly clear, as Allen Staley has pointed out,[58] that the works painted by Dyce on his return to Scotland show no signs of archaism. The explanation for this recorded by Holman Hunt— that Dyce gave up 'Pre-Raphaelite' painting for want of success with religious art in Scotland—would appear to need some examination, too,[59] for Dyce certainly continued to paint religious works after his return.[60] The few of these that survive, such as the *Judgement of Solomon* of 1835 (Plate 116), do not reveal even modest deviations from the Venetian mode, and are even less ascetic than the *Hagar and Ishmael* that Eastlake produced at this time.

The development of Dyce's art in the late 1830s and early 1840s suggests, in fact, that his primitivism was acquired by gradual degrees. From his *Paolo and Francesca* (Plate 117), which he sent to the Scottish Academy in 1837 (and which he regarded as his most important painting during his time in Scotland), it would seem that his stylistic 'primitivism' at this time was only just beginning. The picture is more restrained than his *Judgement of Solomon*, but it is closer to the style of Delaroche, whose works he could have seen in Paris in 1832, than it is to anyone he might have met in Rome. There is certainly little in it to suggest Overbeck; the design is based on one of Flaxman's Dante illustrations,[61] while the colouring and tonality are still rich in luminosity and chiaroscuro.

It was in this year that Eastlake 'rescued' Dyce from his Edinburgh obscurity, and enabled him to play an active part in the attempt to improve British design standards by giving him Papworth's job as principal of the Government Schools of Design. His work there and his reports concerning the introduction of a broader and more efficient application of design to commercial art, presenting a radical policy that eventually led to his resignation in 1843,[62] is to a large degree tangential to the present discussion. However, these activities are at least worth noting here, inasmuch as they also relate to his ideas on painting and the function of historical art. For, just as he felt that ornamental design should take the limitations of the material and function of the object as its initial criteria, so it seemed to him that painting should never lose sight of its prime function: its didactic purpose. Experiencing Cornelius's example of the craftsman master–pupil relationship in his fresco procedure in Munich, and impressed by Waagen's statement concerning the craftsman-like nature of the artist,[63] he saw painting in terms of its social function, calling it in one place the 'science of morals'.[64]

This train of thought also led him to differentiate between style in panel painting and mural decoration. Painting when viewed as the adornment of a wall was, as he said in his evidence for the inquiry into the Government Schools of Design in 1849,[65] essentially ornamentation. In this context, fresco painting was a decorative activity, while panel painting, a free-standing form of art, was not. Just as

118. W. Dyce: *The Holy Trinity and Saints*. 1849. Oil (135 × 88). Design for fresco in All Saints', Margaret Street. Victoria and Albert Museum, London.

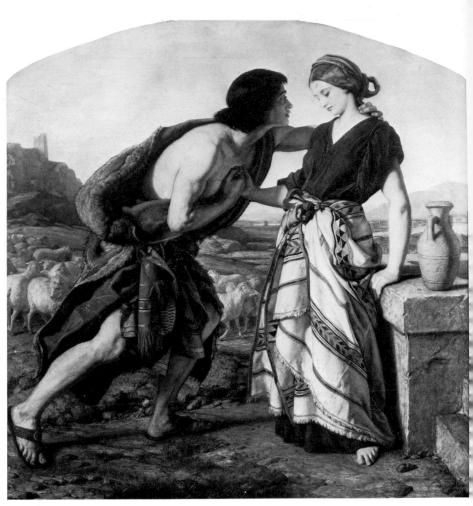

119. W. Dyce: *Jacob and Rachel*.
1853. Oil (58 × 58). Kunsthalle,
Hamburg.

120. J. Schnorr von Carolsfeld:
Jacob and Rachel. 1826. Pen
(27.9 × 25.8). Kupferstich-Kabinett,
Dresden.

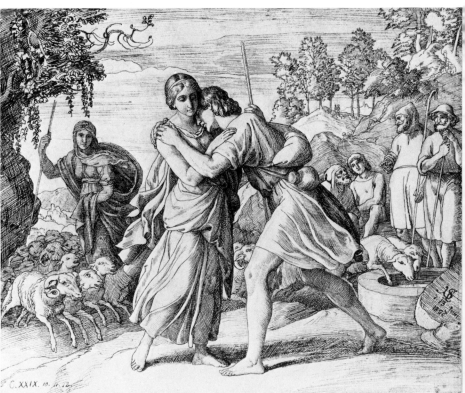

illusionistic carpets were a denial of the true function of the carpet, so *trompe l'oeil* in mural decoration distracted the spectator from the true function of this art: the representation of moral truths in a synoptic manner. In panel painting, on the other hand, illusionism was completely appropriate. As he said when contrasting the two: 'The one kind strives to embellish the *realities* of life; the other, to give us pictures of some higher condition of humanity.'[66]

Thus Dyce could, without any personal contradiction, concurrently paint a reredos for the Ecclesiologists' show church in an Italian Gothic manner (Plate 118), a biblical scene *Jacob and Rachel* (Plate 119) for the Academy that gave a naturalistic emphasis on geographical and historical accuracy, and a schematic allegory on 'Religion' for the Queen's Robing Room at Westminster (Plate 121). Each has a different function and requires a different treatment.

It was this clarity of thought that made Dyce's contribution to the decorations of the Palace of Westminster so crucial, for he was the artist who had worked out an approach to mural painting in the greatest detail. Indeed it was not until Dyce had successfully completed his fresco *The Baptism of Ethelbert* (Plate 143) in 1846, that the Fine Arts Commission finally felt that they could safely allow the other painters to proceed with their work.[67]

Yet, despite the leading role that Dyce played in the initiation of fresco painting in the Palace of Westminster, he was far from being the prime mover in the Germanization of English history painting. Not only did he retain the severest reservations about the Germans' methods and base his own technique principally upon the Italian frescoes that he had studied at first hand during his tour in Italy in 1845, he also failed to become active as a history painter in London until the Germanic craze was already well under way. His main concern from 1837 to 1843 had been with his educational and ecclesiastical schemes. He exhibited nothing at the Royal Academy between 1840 and 1843 and does not appear to have been sufficiently interested in the Palace of Westminster project to become a contributor to the Westminster Hall competition of 1843. Indeed he did not even enter the second competition in 1844 until emphatically urged to do so by Eastlake. Even then he produced no more than the minimum requirement, a fresco copy of a portion of a mural he had been working on in the Chapel of Lambeth Palace.[68]

Dyce therefore entered the field of the revival of English history painting a number of years after the time when a period of study at Munich had become an advisable practice for young aspirants. Like these younger artists, Dyce had made a visit to to Munich—albeit a brief one—when on his continental tour of 1837. He was later to be extremely rude about the kind of fresco painting that he saw there.[69] But, although there are many fundamental differences between Dyce's manner of painting and that of the Munich school, he does at least seem to have respected the 'unity and completeness' he grudgingly allowed them in his letter of 1841,[70] and used it to convey his narratives through strikingly simplified designs. As with Eastlake, the most important contact for Dyce in Munich was Julius Schnorr, who was then still working on his *Nibelungen* frescoes in the Residenz. Dyce was provided with a letter of introduction from Eastlake; and it was enough for Schnorr

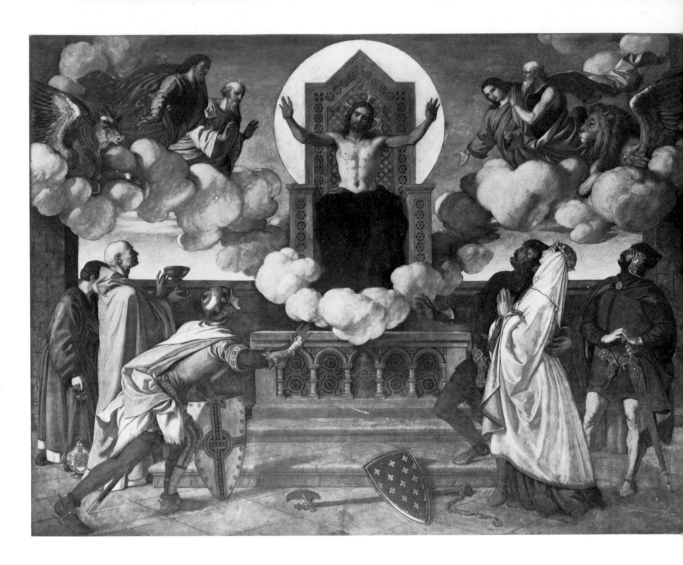

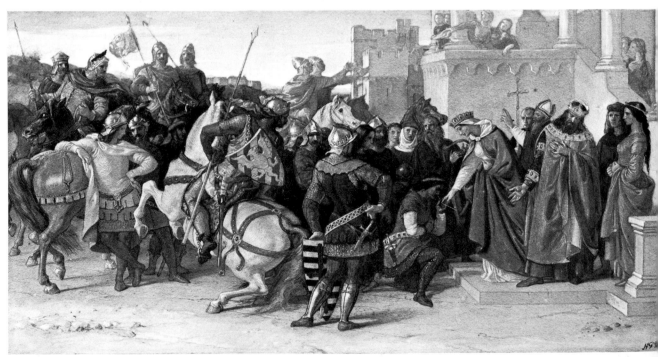

to be told that Dyce was the man who had created a 'gran sensazione parmi i Tedesci' in Rome with his Madonna.[71] The two artists must have created a favourable impression on each other, for they corresponded considerably in later years—mainly in Italian, for Dyce never learned German.

Like Eastlake, Dyce seems to have found Schnorr's narrative style more attractive than the art of Cornelius and his followers, and one finds an indebtedness to this aspect of Schnorr's work in Dyce's later designs. At times the debt was specific, as in the two figures in his *Jacob and Rachel* (Plate 119)—the last biblical panel painting that he created before responding to the religious art of the Pre-Raphaelites—which bear a strong resemblance to those in the design that Schnorr created for his *Bilderbibel* (Plate 120). They fall back on the format of large, centrally placed figures which convey narrative through those simple, clearly delineated yet dynamic gestures that made Schnorr's *Bilderbibel* such an authoritative work in the late nineteenth century. Although Schnorr's *Bilderbibel* was not published in England until 1860,[72] Dyce had already seen the designs when he visited Munich in 1837, and he had recommended them to Hope Scott in 1840.[73] A similar influence can also be seen in the chivalric vision of Dyce's frescoes for the Queen's Robing Room. The design for *The Departure on the Quest for the Holy Grail* (Plate 122) in particular seems, as Keith Andrews has pointed out,[74] to hark back to Schnorr's *Battle of Lipadusa* (Plate 123). Indeed the prancing horse viewed from the back to the left of the central figure in Dyce's picture is almost identical to one in a similar position in the work by Schnorr.

121. (left) W. Dyce: *Religion—The Vision of Sir Galahad*. 1851. Fresco (341 × 427). Queen's Robing Room, Palace of Westminster.

122. (lower left) W. Dyce: *The Departure of the Knights of the Round Table on the Quest for the Holy Grail*. 1851. Watercolour (23.2 × 44). Rejected design for Queen's Robing Room. National Gallery of Scotland, Edinburgh.

123. (below) J. Schnorr von Carolsfeld: *The Battle of Lipadusa*. 1816. Oil (102 × 170). Kunsthalle, Bremen.

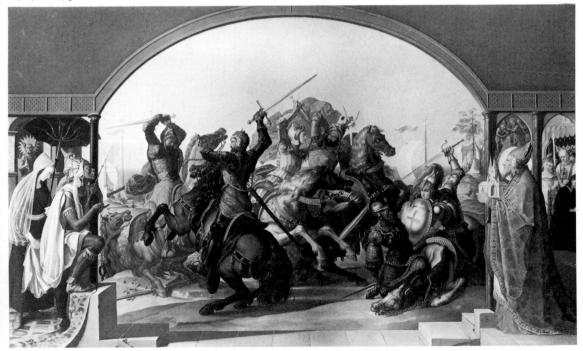

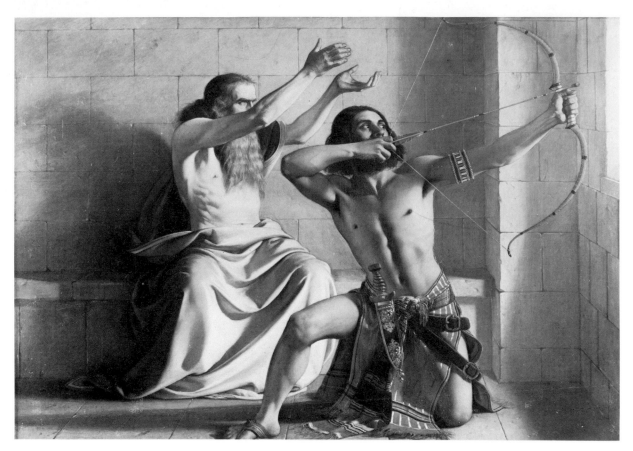

124. (above) W. Dyce: *Joash shooting the Arrow of Deliverance*. 1844. Oil (76 × 89). Kunsthalle, Hamburg.

125. (right) W. Dyce: *Madonna and Child*. 1838? Oil (103 × 80.5). Tate Gallery, London.

126. (middle) W. Dyce: *Madonna and Child*. 1845. Oil (80 × 58.5). Her Majesty the Queen.

127. (far right) W. Dyce: *Madonna and Child*, *c*. 1845? Oil on slate (78.7 × 60.2). Castle Museum, Nottingham.

Apart from such specific borrowings, one can trace a growing rigidity in Dyce's manner during the years following his return from Munich. The distance that he covered becomes clear when one compares his last major work in Scotland, the *Paolo and Francesca* of 1837 (Plate 117), to the picture that heralded his resumption of activities as a full-time artist following his directorship of the Government Schools of Design, the *Joash Shooting the Arrow of Deliverance* (Plate 124), exhibited at the Royal Academy in London in 1844. The change in type of theme—from fated love scene to evocation of duty—is significant in itself, and it is accompanied by a harsher light, tauter lines and a more concentrated form of design. While the sentiment of *Paolo and Francesca* centres around the expressions of the protagonists, *Joash* is impersonal, the expressions on the faces being partially obscured and made subordinate to the rhythm of the design. If one accepts—as seems reasonable—that the Madonna in the Tate (Plate 125) is the one exhibited by Dyce at the Royal Academy in 1838,[75] one can trace a similar change affecting his treatment of identical themes; for his Madonna of 1845 has a much harsher appearance (Plate 126). The Tate Madonna—which might have been influenced by Raphael's *Tempi Madonna* which Dyce could have seen in the Pinakothek in Munich[76]—emphasizes maternal sentiment; the 1845 Madonna, religious devotion. One can see the degree to which Dyce was trying to increase the severity of effect in the 1845 Madonna by comparing it with a study for it (Plate 127).[77] In the final version the handling is much sharper, and Dyce has also raised the background to achieve a flatter effect.

Despite his distinction between fresco and panel painting, this increased severity

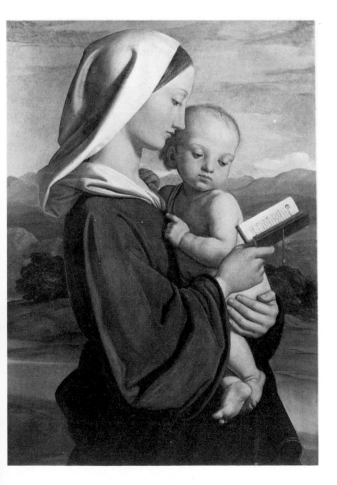 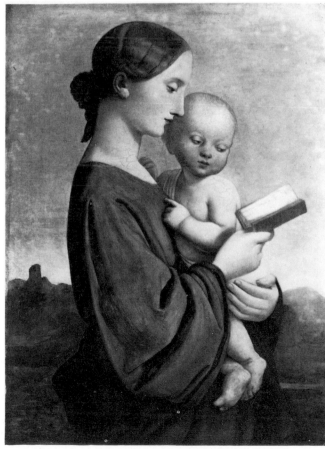

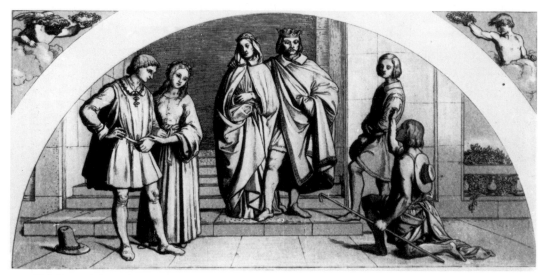

128. ⋆W. Dyce: *The Bridgewater Family reunited*. From *Decoration of the Garden Pavilion*, 1846. Lithograph by L. Gruner.

also reflected Dyce's current preoccupation with fresco. The patronage of Prince Albert, too, must not be discounted in considering the style of this, his most primitive production. This year, the year of the fresco competition, saw the highpoint of Germanic hardness in English art, after which most artists began to soften their manner under the pressure of mounting criticism. Dyce, too, was considered to have betrayed his earlier style at this time. Frau Bunsen, the English wife of the Prussian ambassador to England, wrote to Kestner complaining of the direction that English art had taken. When commenting on the frescoes in the Royal Garden Pavilion, she could only approve of Dyce's lunette, *The Bridgewater Family Reunited* (Plate 128). Yet even so she adds a stricture on Dyce's change of style: 'strangely his former sense of beauty has left him . . . Dyce has sunk into the new papism, and become, severe, pointed and dry.'[78]

By this time Dyce's 'Neuen Papismus' was of a strictly Anglo-Catholic kind, and there was no question of him sharing Pugin's obsession with Overbeck.[79] Even in this year his 'sharf, spitzig, und trocken' style was distinguishable from that of the Germans. His lunette in the Garden Pavilion still retained, to judge from Grüner's lithograph of it, a far greater degree of illusionism than anything by the Munich school or Overbeck's circle. In the Osborne Madonna, too, there remains a decisive amount of realistic presentation. The face of the Virgin is not generalized, and the light and cast shadows are more than a convention of modelling. His panel paintings, in particular, have a far higher degree of illusionism and concern for historical veracity than do most German works, and often seem closer to the historical paintings of Paris than of Munich. Indeed more than one contemporary critic drew attention to the French appearance of much of Dyce's work; in particular *Joash Shooting the Arrow of Deliverance* (Plate 124) which seemed closer to Horace Vernet's vogue for depicting biblical scenes in contemporary Arab costume than it did to the mediaevalizing garments favoured by the Nazarenes.[80] His *Jacob and Rachel*, too, despite its borrowings, attempts a rendering of the costumes and scenery of the Holy Land that is quite alien to Schnorr's quattrocentist interpretation.

200

If more discerning critics could understand the difference between Dyce's approach and that of the Germans, this was equally clear to Eastlake. As secretary of the Fine Arts Commission it was his duty to inspect and report on the murals as they were completed. His comments on Dyce's fresco of *Sir Tristram* in the Queen's Robing Room (Plate 129) are particularly revealing since they centre around the problems of conception and execution as they relate to allegorical painting. When he had inspected the fresco, Eastlake wrote to Dyce with unstinting praise:

> I have lately inspected the best German works of the kind, and sincerely assure you that there is, in my opinion, no comparison between your painting and those I have seen at Berlin, Dresden, and elsewhere, so far superior are yours, most especially in colouring.[81]

Such praise must have gratified Dyce, who had always insisted upon the inadequacies of the Germans in this respect. Yet the assessment leaves out the qualities of greater concern to the Commission—the qualities of conception and design. To gain Eastlake's opinion on these, one must turn to the report on Dyce's work that he gave to Prince Albert:

> Having lately inspected the best German works of the kind in Berlin, Dresden, and elsewhere, I cannot but feel that Mr. Dyce's frescoes are superior in colouring and general command of the method. He does not, under the present circumstances, compete with the Germans in magnitude of design or multitude of figures—nor in the grasp of thought which such comprehensive themes suggest, and in which the German artists show their great intention.[82]

To compare Dyce's small vertical panel with vast monumental schemes from the point of view of complexity of composition and range of thought was hardly, as Eastlake himself admits, a fair procedure. Yet his criticism does nevertheless contain a valid point. Dyce, for better or worse, never achieved the overpowering monumentality of such German designs as Cornelius's *Apocalypse*, one of the works that Eastlake would have been able to inspect in Berlin. If *Tristram* is not the best work with which to make such comparisons, Dyce's *Religion, The Vision of Sir Galahad* (Plate 121) offers a better opportunity. Here a comparison might be made with Overbeck's *Triumph of Religion* (Plate 8), a design familiar to both Dyce and Eastlake through the cartoon for it in the Royal Collection. While the subjects are not exactly comparable, both deal with the interaction of the spiritual and the physical, the manifestation of religion in the visible world. In both there is a heavenly and an earthly sphere, in which Christ appears at the top of the composition, and the humans below. True to the principles of didactic art, both present their allegory by means of a symmetrical design. Yet Dyce's composition appears thin beside the complex groupings that occur in Overbeck's; the spectators below, despite their dramatic gestures, are insufficient to balance the solid form of Christ on his throne above. Furthermore, though Dyce prefixed his subject with the title *Religion*, he shows no interest in developing the allegory. The subject remains essentially the depiction of a specific event which is to be taken as an example of the manifestation of religion. Overbeck, on the other hand, presents a complete

elaboration of his idea. His picture is, as his description of it makes clear, no less than a commentary on the history of Western art since the birth of Christ.[83]

From Eastlake's point of view these differences were to the disadvantage of Dyce. Today they might seem to leave scope for a freshness and simplicity which is all too lacking in the exhaustive catalogue of Overbeck's composition. In any case Dyce can hardly be accused of failing here in his main objective. His desire at this time was to work as a religious painter, and the Palace of Westminster project was fast becoming a burdensome duty for him. Indeed, according to Dafforne, it had never been his intention to decorate the Queen's Robing Room.[84] He had suggested the project to Prince Albert as being one suitable for Maclise, an artist who was certainly closer to German monumental painting in the complexity of his designs.

Dyce was, in fact, little in tune with the more secular side of the historical revival of the 1840s. He had originally been attracted to Overbeck on account of the German's religious purity, and his own work has much more that is comparable to the first Nazarene works executed in Rome than to the later didactic schemes. Even his borrowings from the designs of Schnorr were modified in the direction of simplification. When the youthful pictures of the Pre-Raphaelites appeared he recognized here an enthusiasm for the fresh and spontaneous side of quattrocento art that was similar to his own, and during the 1850s he moved rapidly towards an assimilation of their style.[85] The emergence of the Pre-Raphaelites also brought out sharply the differences between Dyce's primitivism and the intellectual idealism of Eastlake. Whereas the former patronized them and literally saved their reputation by forcibly making Ruskin admire Millais's *Christ in the House of his Parents* (Plate 153), the latter vowed to have them excluded from the Academy.[86]

Despite Dyce's accomplishment as a fresco painter, and the primitivism of his style, he was not sufficiently influential to counter the direct influence of the Germans. Long before his involvement in the Westminster Hall competition of 1844, many young artists had been visiting Munich to study directly from the leading German masters. The students of the Academy had been encouraged towards this action as early as 1839, when the secretary and professor of painting Henry Howard made appreciative mention of the art to be found there in his Academy lectures.[87] The events of the next two years—the establishment of the Fine Arts Commission, Prince Albert's presidency of it, the visit of Cornelius, the rumour of the employment of German artists at Westminster and, perhaps, the editorial policy of the *Art Union*—must all have directed the attention of aspirant history painters towards Munich. Furthermore, while no overt mention of Munich occurs in the conditions of entry to the competitions, the advertisement for the first competition, published on 25th April 1842 and signed by Eastlake, ominously remarked in the closing paragraph that the judges would be 'disposed to mark their approbation' of works which showed a 'precision of drawing . . . and a style of composition less dependent on chiaroscuro than on effective arrangement'.[88]

Nine of the main contestants in the Westminster Hall competitions are known to have studied in Munich between 1838 and 1845,[89] and many more minor artists and aspirant painters must have followed their example. For the most part, they studied

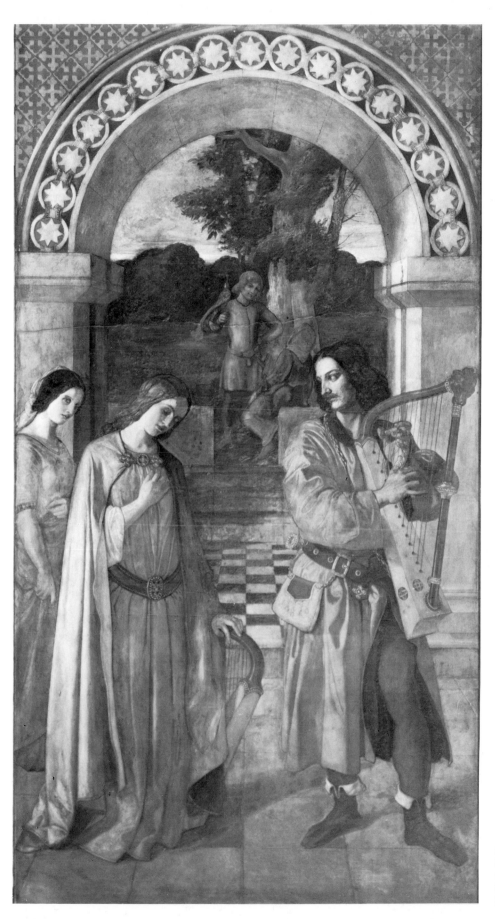

129. W. Dyce: *Courtesy—*
Sir Tristram Harping.
1851. Fresco (341 × 170).
Queen's Robing Room,
Palace of Westminster.

under Schnorr, Cornelius or Kaulbach, sometimes—as in the case of Thomas Sibson and William Cave Thomas—establishing close personal relations with their masters.

For artists who did not travel to Munich, much information concerning the fresco techniques of the Germans was obtained and published with the competition directions by Eastlake in his capacity as secretary to the Fine Arts Commission.[90] Information was also provided for Eastlake directly through various of the English artists, such as Cave Thomas and H. J. Stanley, who were studying in Munich.[91]

After 1846, when the principal decorators of the Parliament buildings had been selected (not always by as democratic means as the competition would have suggested),[92] this habit of studying in Munich rapidly declined, and with it the more superficial aspects of the German influence in English historical art.

In this 'prizewinner's' style, one finds the principles of German historical painting reduced to a number of clear-cut issues. The 'effective arrangement' which was mentioned in the competition prospectus seems to have been generally interpreted as the symmetrical type of composition that Hunt later referred to as the 'German balance of composition'. At the same time the didactic nationalism of Munich played an equally strong part. Eastlake himself had selected this aspect in his first report to the Commission, when he stated: 'If we are to look to the Germans, the first quality which invites our imitation is their patriotism.'[93]

In the first competition prospectus the scope of subject was limited to the appropriate patriotic choice of British history, Spenser, Shakespeare or Milton.[94] However, the competitors themselves were more directed than this, for, as Professor Boase remarked, the subjects submitted were remarkable for dealing for the most part with topics concerned with the formation and growth of British culture.[95] A majority of the subjects fell between the time of the invasion of Caesar and the

130. T. Sibson: *A Saxon Town*. c. 1843. Pencil (13.3 × 18). Yale University Art Gallery.

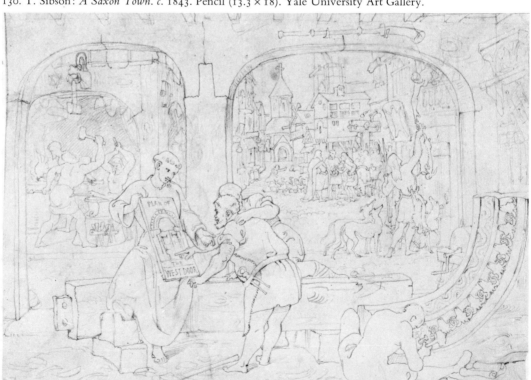

Norman conquest, during which period the main constituents of British society were felt to have been formed. The most popular single subject, depicted ten times, was the 'Conversion of the Saxons by Saint Augustine'.

By comparison with the vogue for druidic subjects in the late eighteenth century, this new interest in national identification was characterized by a greater sense of historical development. In this, the broader aspects of the Teutonic influence in English culture at this time played their part, for, just as the German Romantics had emphasized their racial origin and identity, so the English now went back not to the bardic mysticism of the Celts but to their direct ancestors, the Anglo-Saxons. Associations with this race were emphasized since they were thought to have established democratic government, trial by jury, and also effected the conversion of England to Christianity. It was this attitude that fired the enthusiasm of the younger historical artists, and tended to make the identification with German artists, who were seen as possessing a similar cultural origin (even if their present manner of government left much to be desired), even stronger.

This tendency can be seen most strongly in the work of the artists who went to study in Munich. These were the artists who, significantly, tended to concentrate most strongly on Anglo-Saxon subjects. Most characteristic of these was Thomas Sibson, a young historical painter whose early death cut short what was considered by his friends to be an immensely promising career.[96] While living in Munich in 1840–2 he studied under Kaulbach, whose influence on him was so strong that he continued to send him his designs for approval after he had returned to England. The tone of the letter he sent with his *Saxon Arts* (Plate 130) leaves no doubt as to the esteem in which he held Kaulbach:

My dear Friend and Master,
 In this journey of ours through the world, the stages or points are not many to which we love to refer; but these are life's strongholds; and to them the heart returns, that it may refresh itself when weary. I now look back to the days I passed in your studio as to the most towering of these. I can still feel, as I have often felt, while under the immediate influence of your works, a silent eloquence pouring from them into my heart; an eloquence which rouses the imagination and fills the mind with suggestive thoughts.[97]

After complaining about the 'Babylon where I am once more set down'—the London art world—he then goes on to describe his own work. In this, it becomes clear that Sibson's clearness of direction was very much centred around the didactic purpose of art, for which he would no doubt have found a sympathetic ear from one of the creators of the Hofgarten frescoes. Sibson's Saxon subject is used as an allegory on the civilizing effects of this first English society. The scene, he says,

is intended to show the beneficial working of Christianity and education. It represents a Saxon town, where men work in consent, and shape new material into use. As the houses of that day were chiefly of wood, I have chosen the carpenter's shop as the foreground subject of my picture. He is making a church

205

door for a priest, for the priests still continued to be the presiding spirits over the useful arts.

This purpose that is expressed in Sibson's picture is made more explicit by the form of composition that he employed: one that again revealed his Munich training. The 'architectonic' structure of the picture is closely related to the frame, into which the episodes of the picture are fitted—the incidents of peaceful Saxon society that take place behind the carpenter's shop, leading up to the church in the background—while the main figures are arranged around the components of this compositional division.

In looking at the compositions that were submitted to the successive Westminster cartoon competitions of 1843, 1844 and 1846,[98] one can see how these principles gradually came into currency amongst historical painters, as the Germanic craze reached a crescendo, and as it became clearer that the Commission was favouring artists with a Germanic style. Thus Armitage, the pupil of Delaroche who won first prize in the 1843 competition, was passed over in the later competitions, while Germanists like Cave Thomas were thrown into absurd prominence. Of the artists who finally received commissions in the Palace of Westminster, Dyce, Maclise, Herbert, Cope, Tenniel and Horsley at least, modified their styles considerably in response to German didactic art.

Of the prize winners of the first competition, to judge from the Linnell lithographs of their works, all except J. Z. Bell and G. F. Watts had taken the judges'

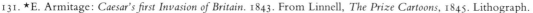

131. ★E. Armitage: *Caesar's first Invasion of Britain*. 1843. From Linnell, *The Prize Cartoons*, 1845. Lithograph.

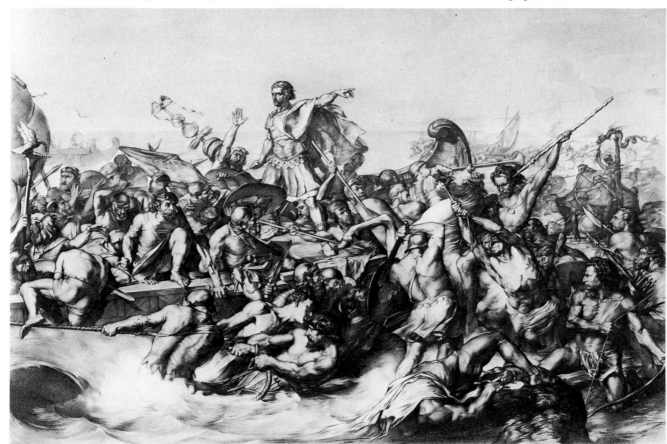

advice concerning 'precision of drawing' to heart, and produced a superficial resemblance to the hard, terse 'shaded outline' manner of the Munich school. However, few of the contestants at this point took their interest in German art beyond a superficial imitation of this manner.

The chief prize-winning cartoon, Armitage's *Caesar's invasion of Britain*[99] (Plate 131), leaned, as has already been mentioned, towards French history painting. This was so apparent, indeed, that some malcontents spread rumours that Delaroche had worked on the cartoon in person.[100] The treatment of the invading forces is monumentally dramatic. Like Gericault's *Raft of the Medusa* (from which some foreground figures appear to have been borrowed) the composition leads up to a figure pinnacled against the sky, the whole starting from a bastion of battling bodies, and aided by dramatic lighting variations. Most of the other cartoons also contributed to such values, making use of *repoussoir* forms to pinpoint a central figure who carries the apex of the action. This is very evident in the *Boadicea*[101] by Selous which is largely dependent on a foreground arrangement of somewhat incongruous nude figures who lead up to a spotlit Boadicea. Cope, in his *First Trial by Jury*[102] (Plate 132), was more modified in his design. He depended heavily upon a Raphaelesque form of composition, with bastions of onlookers to enhance the protagonists. Parris's *Joseph of Arimathea*,[103] a far quieter subject, is also surrounded by introductory figures, placing him well in the centre of the picture at the apex of a circle.

132. ★C. W. Cope: *The first Trial by Jury*. 1843. From Linnell, *The Prize Cartoons*, 1845. Lithograph.

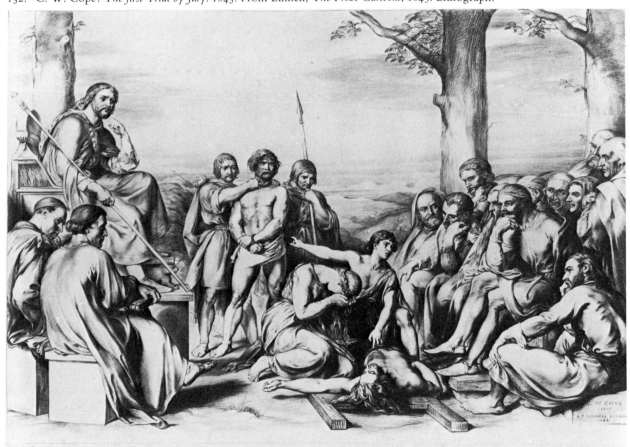

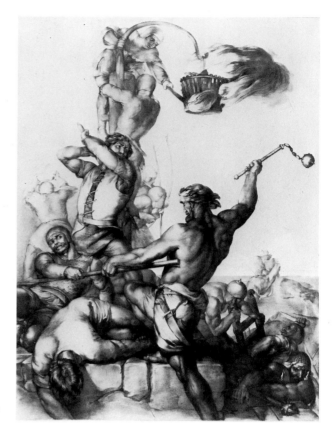

133. (right) ★H. J. Townsend: *The Fight for the Beacon*. 1843. From Linnell, *The Prize Cartoons*, 1845. Lithograph.

134. (far right) ★W. C. Thomas: *St Augustine Preaching*. 1842. From Hunt, *Book of Art*, 1846. Wood engraving.

135. (lower right) ★J. C. Horsley: *St Augustine Preaching*. 1843. From Linnell, *The Prize Cartoons*, 1845. Lithograph.

By contrast, the cartoons submitted by artists who had already had contact with Germany do not subscribe, on the whole, to these more traditional conventions of history painting. H. J. Townsend's composition *The Fight for the Beacon*[104] (Plate 133) is a most dramatic subject, but his treatment of the design (regarded by some to be the best in the competition—and as good as anything that had come out of Germany) reveals his Munich leanings.[105] In the manner of Cornelius, though hardly with his accomplishment, he freezes the action into a linear design, in which even the ball swinging on the end of the chain is held in precise tension. Although the scene is taken from a low viewpoint, the arrangement of the figures is flattened, the beacon being used to extend the vertical axis of the forms.

Probably the most strongly Germanic composition was Cave Thomas's *St Augustine Preaching to the Saxons*[106] (Plate 134). Like Sibson, Thomas took trouble to bring out the historical implications of his subject and attempted to emphasize the beneficial effects of Christianity. In contrast to Horsley's dramatic treatment of the same theme (Plate 135)—in which the moment of Ethelbert's conversion is portrayed—this picture shows the Christians ministering to the Saxon people. As St Augustine appears on the left of the composition, the Druids disappear on the right. The Saxons remain, listening beneath a steadfast oak; while in a background vignette one of Augustine's priests instructs a group of Saxons before a ruined stone circle.

The composition is conducive to reflections of this kind. Unlike Horsley's stage-

like arrangement, this work is designed as a flat composition in which the background is divided into a pair of vignettes. St Augustine appears on the left side of the picture, with his retainers behind him, and the Druids on the extreme right. The tree forms the central division of the picture, uniting with the frame in a manner similar to that in Bendemann's *Jews in Exile* (Plate 113). In this way the picture is based on the tripartite balance so evident in many large German history paintings, rather than on the dramatic apposition of central forms that was the heir of neoclassical history painting.

In the fresco exhibition of 1844, where the requirement of producing an example of fresco as well as a composition presented more exacting demands on the artists, a closer assimilation of German art is evident—especially amongst the successful contestants. This time the choice of subject was left to the artist. The result was an even greater inclination towards didacticism, for the only new category of subject that emerged was the large-scale allegorical figure. Cave Thomas's *Philosophy*[107] (Plate 136) was so Germanic as to be almost a caricature, with its stern, impassive face, hierarchic seat, and Teutonic helmet; it gained him a commission for the House of Lords. Horsley submitted two works: *Prayer* and *Peace*[108] (Plate 137)—far more emblematic productions than his composition of the previous year—of which *Peace* was successful. The other four artists to receive awards—Dyce, Redgrave, Cope,

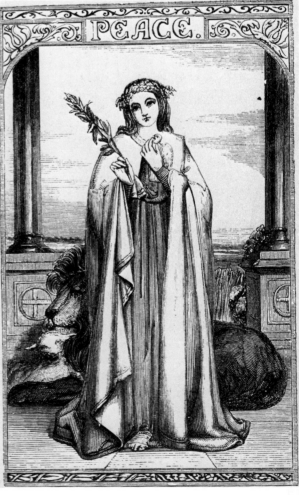

and Maclise—all produced works that showed an awareness of Germanic design in varying degrees. Redgrave's figure, *Loyalty*, is framed in a Gothic arch[109] (Plate 138), Cope's *Meeting of Jacob and Rachel*[110] (Plate 139) has a decidedly Nazarene flavour, and Maclise's *Knight*[111] (Plate 140) already has the crowded surface of his Germanic style. Dyce's small contribution, an extract from his Lambeth fresco, can hardly be considered from a compositional point of view. The Lambeth picture itself, however, showed a rhythmic frontality[112] (Plate 141).

The final competition of 1845 was related to specific subjects for the six frescoes in the House of Lords. The six prize-winners already mentioned had been commissioned before the competition, but this did not exclude a possible alteration as a result of the new works exhibited. Such a procedure obviously caused great concern to many artists, and the uncertainty of these procedures—especially considering the large amount of energy and time that the production of monumental works required—brought financial hardship to many contestants. In this case the greatest sufferers were Cave Thomas and Richard Redgrave, whose commissioned works were regarded as inadequate. Both were subsequently dropped from the project. Furthermore, no replacement was found for either, despite a certain amount of interest in Madox Brown's representation of *Justice* (Plate 142) which was expressed by Haydon and in the press.[113] Thomas's subject,

136. (facing page left) ★W. C. Thomas: *Philosophy*. 1844. From Hunt, *Book of Art*, 1846. Wood engraving.

137. (facing page right) ★J. C. Horsley: *Peace*. 1844. From Hunt, *Book of Art*, 1846. Wood engraving.

138. ★R. Redgrave: *Loyalty*. 1844. From Hunt, *Book of Art*, 1846. Wood engraving.

139. (left) ★C. W. Cope: *Jacob and Rachel*. 1844. From Hunt, *Book of Art*, 1846. Wood engraving.

140. ★D. Maclise: *The Knight*. 1844. From Hunt, *Book of Art*, 1846. Wood engraving.

141. (far right) ★W. Dyce: *Consecration of Archbishop Parker*. Chalk study for fresco formerly in Lambeth Palace Chapel. Victoria and Albert Museum, London.

'Justice', was finally awarded to Maclise after the success of his *Spirit of Chivalry* (Plate 145), while Redgrave's subject, 'Prince Henry, afterwards Henry V, acknowledging the Authority of Chief Justice Gascoyne', was given to Cope.

While all four selected artists had shown a penchant for rigorous design during the competition years, the final works reveal changes in allegiance. Although Dyce and Maclise contributed works that show a respect for the vertical compartments in which they were painting, both Cope and Horsley attempted to modify the more dramatic and illusionistic style of their academy paintings to the situation.[114] Nor was this distinction related to the different types of subjects—three historical and three allegorical—in the scheme. In the representation of Religion, for example, it was Dyce who was chosen to depict the historical event—the 'Baptism of Ethelbert' (Plate 143)—and Horsley who was awarded the allegorical representation (Plate 144). Nothing could have been more out of character. Horsley represented his subject in a strictly episodic manner, despite its abstract nature, by showing monarchs and bishops at prayer. Nor did he allow himself any liberties with perspective—despite the difficulties of fitting his composition into a vertical format. Consequently one finds that all his figures have sunk to the bottom of the composition so that there is little room for a comprehensive representation of the subject. Dyce, dealing here with an episodic subject, nevertheless retained a formal frontal design, in which the presentation of the incident is the major concern. Many of the motifs reflect Dyce's recent study of Italian frescoes. As Robyn Cooper has pointed out, the baptism group has strong affinities with that in Masaccio's

Brancacci chapel frescoes; while there are references to Pinturricchio in the background crowd.[115] Yet, like the modern Germans, Dyce schematized the early art he borrowed from. There is much concern for 'balance' in the tripartite grouping of the figures, and this is emphasized by the three arches behind. The design is extended by the construction of a parapet on which Ethelbert's subjects stand and watch the event. Besides this, the perspective of the picture was chosen without reference to the high position in which it was to be placed, thus emphasizing its function as a decoration, rather than as *trompe l'oeil*.

Both of Maclise's two allegories, the *Spirit of Chivalry* (Plate 145) and the *Spirit of Justice* (Plate 3), were treated in a manner similar to Dyce's *Ethelbert*, and contrast strongly with Horsley's *Religion*, which lies between them. Like Madox Brown's version of *Justice* in the 1845 competition (Plate 142), the figures in this design are extended vertically in a centralized composition. Although there is more concern for supporting accoutrements than in Dyce's picture (in which the principal action is placed on its own in the foreground), Maclise's symbolism is more figurative than that of Horsley. Horsley's protagonists pray to a vaguely lighted sky, in which a cross coincides with the natural source of light, while Maclise's supplicants stand before an allegorical embodiment of Justice.

The first picture that showed this interest by Maclise was his *Hamlet* of 1842 (Plate 73). The source for the conception of this work, as with his equally striking *Macbeth* of 1840, was Retzsch.[116] The *Hamlet* differs from the *Macbeth*, however, in the way he extended Retzsch's design, making it more architectonic—perhaps in response to

213

142. F. Madox Brown: Study for the *Spirit of Justice*. 1845. Watercolour (75.7 × 51.7) City Art Galleries, Manchester.

143. W. Dyce: *The Baptism of Ethelbert*. 1846. Fresco (551 × 291). House of Lords, Palace of Westminster.

some of Neureuther's designs.[117] In any case, framing has now become an important matter, and the composition has a tripartite arrangement in which the dividing arches fit in with the rounded edges of the frame. It is no coincidence, either, that he should also be exhibiting an interest in framed compositions in his book illustrations at this time.[118]

Such distinctions reveal a difference of choice rather than a difference of knowledge of German monumental art; for both Cope and Horsley had stronger connections with Germany than did either Dyce or Maclise. Cope had studied in Munich in 1845 with Heinrich Maria Hess,[119] while Horsley was a personal acquaintance of the Berlin artists Wilhelm Hensel and Eduard Magnus through the close relations between his relatives the Callcotts and the Mendelssohn–Bartholdi

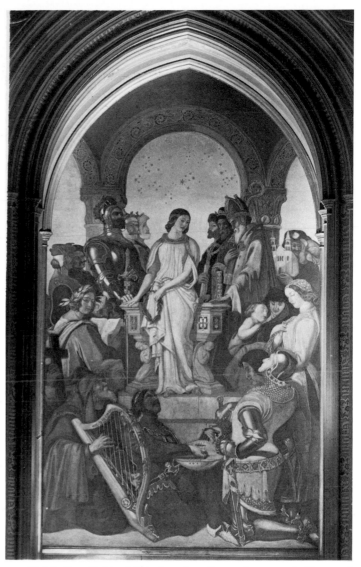

144. J. C. Horsley: *Spirit of Religion*. 1847. Fresco (551 × 291). House of Lords, Palace of Westminster.

145. D. Maclise: *Spirit of Chivalry*. 1847. Fresco (551 × 291). House of Lords, Palace of Westminster.

family.[120] Cope, as is made clear in his reminiscences,[121] never took German monumental history painting completely seriously. After finishing his works in the House of Lords, he undertook a series of historical paintings in the Peers' Corridor, where his penchant for narrative found a happier outlet.[122] Horsley soon gave up monumental painting and returned to anecdotal subject pieces.[123]

Of the four decorators of the House of Lords, Maclise was the one who emerged most clearly as an artist with a natural bent towards monumental painting. Already considered the leading historical artist of the day, he had during the 1840s been modifying his taste for the dramatic and macabre in the interests of greater clarity of form and rigour of design. It was a process that was to extend beyond the period of the Westminster Hall competitions, eventually leading to the achievement of the

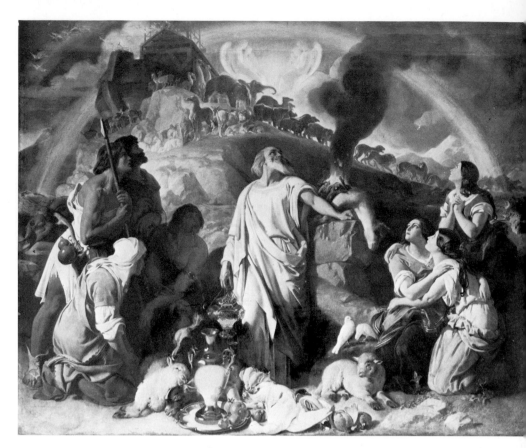

146. D. Maclise: *Sacrifice of Noah*. 1847. Oil (205 × 254). City Art Gallery, Leeds.

147. ★G. Jäger: *Dankopfer Noahs*. From Cotta, *Bibel mit Bildern*, Stuttgart, 1844. Wood engraving.

two masterpieces of English nineteenth-century monumental art, the *Meeting of Wellington and Blücher at Waterloo* (1859–61) and the *Death of Nelson* (1863–5) in the Royal Gallery in the Palace of Westminster.[124]

Despite the fact that he did not actually go to Germany until 1858, Maclise was one of the most deliberate emulators of German monumental painting during the 1840s. Yet one should be as careful in labelling him a Germanist as one should be with Dyce. Like Dyce, he turned to the Germans to strengthen his sense of composition and powers of draughtsmanship. While he showed a greater tendency than Dyce to imitate the Teutonic morphology in his figures, he took no interest in the religious ideals of the Nazarenes. Above all it was the secular artists—in particular Retzsch and Rethel—who attracted him. He showed no more inclination than Dyce to sit at the feet of a German master—in the way that Sibson and Cave Thomas had done; and in 1845, the same year that Dyce, vociferously avoiding Munich,[125] had gone to Italy to prepare for his House of Lords fresco, Maclise had prepared for his by going to Paris.[126] There he expressed particular admiration for the work of Delaroche, whose *Hemicycle* in the École des Beaux-Arts he visited frequently.

Maclise's admiration for Delaroche is significant; for the French artist had managed to combine a rigour of composition with the more sensory qualities of the French *Romantiques*. Indeed it was such a synthesis that Maclise himself attempted. Even such a severe work as the *Sacrifice of Noah* of 1847, for which he was taken to task by the contemporary press,[127] retained this dual objective (Plate 146). The composition itself is unmistakably Germanic, with its centralized, circular form, large-scale figures and raised background. Indeed it may well be based on one of the current German biblical illustrations, such as those in the recently published Cotta *Bilderbibel* (Plate 147). Yet at the same time he attempted to retain a sensuousness through the use of dramatic studio lighting and the luxuriant still life that spills out into the foreground. His fresco for the House of Lords has a similar combination of detail; this was to remain a common feature for Maclise's work of the 1850s, and it is only in his large designs for the Royal Gallery that he managed to harmonize this love of incident with a powerful enough design to create a work of truly heroic magnitude. Perhaps this was because these works betray a new influence—that of the vast Campo Santo cartoons of Cornelius that Maclise would have seen on his visit to Berlin in 1859.[128]

While the majority of the other competitors for the Westminster Hall competitions rapidly sank into oblivion, a few of the less-recognized contributors were later to achieve fame for paintings and designs of a rather different nature. For them the monumental craze of the 1840s may have been an unfortunate experience, but it was also one which marked their future development. John Tenniel won a premium and a commission in the 1845 competition with his *Justice*; a work whose 'variety of expression' reminded the *Times* reviewer of 'Retzsch's happiest creations'.[129] He subsequently went to Munich to perfect his technique; and if the resultant *St Cecilia* fresco in the Upper Waiting Room was an uninspired performance, the rigorous drawing manner that he acquired was to characterize his later cartoons and illustrations.[130] Noel Paton, another premium winner of 1845,

217

was less impressed by the Munich style. An admirer of Blake, his *Spirit of Religion* shows a luxuriance and dynamism which was later to distinguish his fantasies and fairy pictures[131] (Plate 148). In the place of a group of static allegorical figures, the human soul is represented struggling 'upward and onward' freeing itself from a phantasmagoria of earthly vanities.

The most intriguing implications of the German manner were in connection with an artist who received no award at all. Madox Brown, who contributed to both the 1844 and the 1845 competitions, brought the imprint of the 1840s history painters into the circle of the Pre-Raphaelites. Hunt was later to deplore the effect that the 'influence of the German cartoon or architectural style' had had on Brown and the degree to which this threatened the work of Rossetti;[132] yet at the time there can be no doubt that he was a stimulating and formative influence. Trained in Belgium, he first became aware of German contemporary history painting through the prints that he saw in the print shops in Paris.[133] In 1844 he settled in London. The two vast cartoons that he contributed to the Westminster Hall competition of that year were *Adam and Eve* and *The Body of Harold brought before William the Conqueror* (Plate 149).[134] He also submitted an encaustic sketch of the latter which may in itself have prejudiced his chances, since the conditions of entry stated specifically that artists should contribute examples of their work in fresco.[135] However, the cartoons themselves also attracted little interest. While the surviving *Body of Harold* shows a severity of drawing suitable for the required 'style of decoration less dependent on chiaroscuro than on effective arrangement',[136] it still reveals a sensationalism that betrays his Belgian training.

The decisive change in Madox Brown's art appears to have taken place between this time and the exhibition of 1845. The design that he submitted then, *Justice* (Plate 142), shows the same interest in allegorical personification, flat symmetrical design, and Teutonic morphology that can be found in the successful design of Maclise. It was on this occasion that he was described by the *The Times* as 'one of the numerous Germanic race'.[137]

To some extent this change must have been due to Madox Brown's assimilation of the artistic climate that he found when he came to settle in London; for Brown lived in a studio at Tudor Lodge, the 'nest of studios' which contained, amongst other aspirants, Armitage, Frank Howard and John Tenniel.[138] One of the most influential must have been William Cave Thomas, an artist for whom Brown always maintained the highest respect, and with whom he shared a studio. With Thomas he could not only have learned the technique of fresco as it was practised at Munich,[139] but also have discussed the handling of allegorical representation. At this time Thomas was preparing his own design for *Justice* and it is perhaps significant that Brown should have chosen to illustrate the same subject for the 1845 competition. Their treatments of the theme, to judge from the description of Thomas's work,[140] had a number of points in common. Not only were their compositions arranged in a similar three-tier system, but some of the characters—such as the poor widow with her child—are the same in both cases. Brown's work, however, seems to have been the better thought out. The distinctions between

148. ★J. N. Paton: *Spirit of Religion*. 1845. From Hunt, *Book of Art*, 1846. Wood engraving.

149. (below) F. Madox Brown: *The Body of Harold brought before William the Conqueror*. 1844–61. Oil (105 × 123.1). Sketch for cartoon exhibited in Westminster Hall, 1844. Subsequently reworked. City Art Galleries, Manchester.

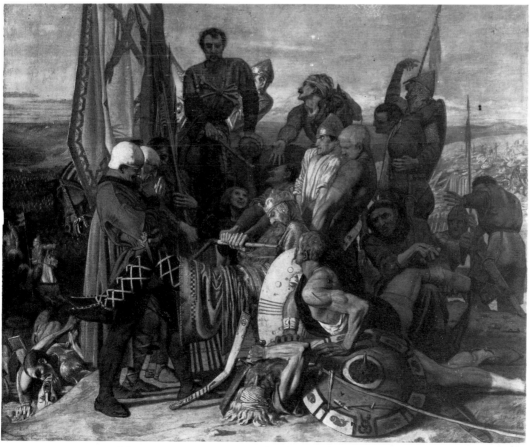

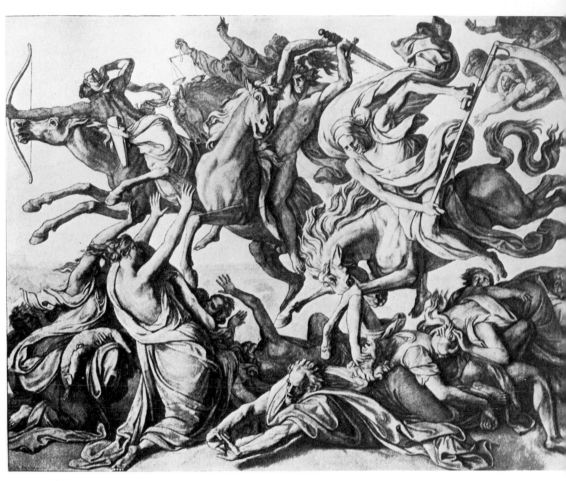

152. F. Madox Brown: *Work.* 1852–6. Oil (135 × 196). City Art Galleries, Manchester.

allegorical figures and protagonists are clearly made, while in Thomas's work they are intermingled.

During the year that Brown subsequently spent in Rome he had the opportunity of studying the compositions of both Overbeck and Cornelius at first hand.[141] As he was later to record, he was moved by those of the former and impressed by those of the latter—in particular the *Apocalypse* design (Plate 150). It was in Rome that he began to design his *Seeds and Fruits of English Poetry*—later to become *Chaucer at the Court of Edward III* (Plate 151)—a work that extended both the composition and the allegorical presentation of subject-matter that one finds in the *Justice*. Yet, if Madox Brown made use in this composition of the 'German balance of composition' that he had learned in London, the *Chaucer* shows in other respects less rather than more Nazarene influence. The primitivism that Brown showed here—the cusped Gothic frame and the naïve· angular figures—recalls a degree of extremism which the Nazarenes had long left behind them. During this journey Brown was, in fact,

150. P. Cornelius: *Four Riders of the Apocalypse.* 1845. Chalk (472 × 588). Destroyed. Formerly National-Galerie, Berlin.

151. F. Madox Brown: *The Seeds and Fruits of English Poetry.* 1845–53. Oil (86 × 117). Ashmolean Museum, Oxford.

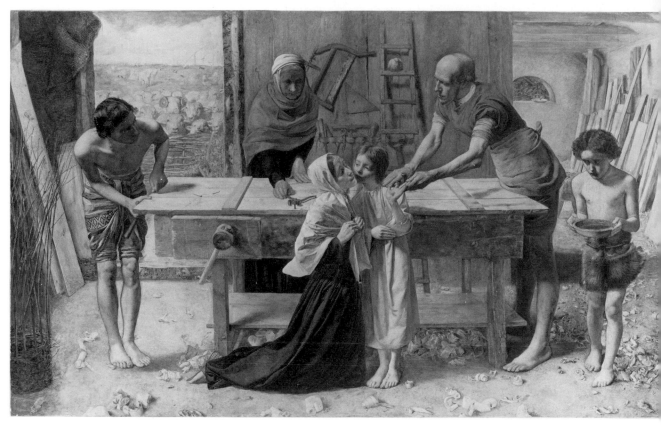
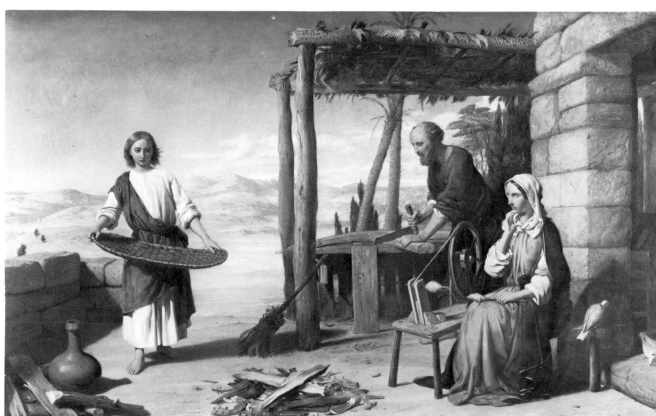

responding more directly to early Italian and Northern art. Above all it was the bright colours of the former and the detailed realism of the latter—in particular Holbein, whose *Dead Christ*, which he saw in Basel, moved him more profoundly than any other single picture—which were to form the basis of his new 'early Christian' style.

While emphasizing the influence of German monumental art on Brown's use of framing designs and symmetry, Hunt ignored the degree to which the older artist put these methods to new uses. In *Work* (Plate 152), for example, Brown used them to provide a structure for a modern life painting that would make clear its heroic and allegorical implications. Members of the Brotherhood, too, were in the habit of using symmetry to lend authority to certain works. It is this quality that prevents *Christ in the House of his Parents* (Plate 153) being confused with anecdotal genre. The same cannot be said for its thematic precursor, Herbert's *Our Saviour Subject to his Parents at Nazareth* (Plate 154), which was exhibited at the Royal Academy in 1847. For this work, despite its sleek surfaces and devout postures, is informally arranged. It is in no way hieratic. From this point of view Millais's picture—despite its startlingly unidealized execution—is closer to Overbeck's version of the legend (Plate 155). The engraving by Steifensand after this appeared in the first part of *Die Vierzig Evangelischen Darstellungen aus dem Neuen Testament* in 1847,[142] and was available in London print shops by 1848.[143] Millais may have seen the design in one of these, or even at the Combe's in Oxford.[144] However, the question of direct influence is not really the point here, for it is quite clear that Millais's version is radically opposed to Overbeck's in all but the use of symmetry and the use of clear controlled gestures. The point is that these were qualities of the German Manner

153. (upper left) J. E. Millais: *Christ in the House of his Parents*. 1849. Oil (86 × 140). Tate Gallery, London.

154. (lower left) J. R. Herbert: *Our Saviour subject to his Parents at Nazareth*. 1856. Oil (81 × 130. Replica of picture exhibited at Royal Academy in 1847. Guildhall Art Gallery, City of London.

155. (left) *F. Overbeck: *Puer Jesus in Fabrica Josephi*. Plate 9 of *Die Vierzig Evangelischen Darstellungen*, Düsseldorf, 1847. Engraving by X. Steifensand.

that still had relevance for the Pre-Raphaelites. Even Hunt was to use such balanced designs—as in *Valentine Rescuing Sylvia* (1851)[145]—although he may have been correct when he repudiated the effect of Brown on his work; for he was by this time in the grips of other 'Germanists'. Cave Thomas was known and admired by the Brotherhood who respected him as a 'learned and severe draughtsman'.[146] A more personal influence for Hunt was Dyce, who aided him during the critical period following the attacks on the Pre-Raphaelites in 1850. Amongst other jobs, Dyce set Hunt to make a copy of his *Jacob and Rachel* (Plate 118); and the simple inverted V of the embracing figures in this composition, as well as the pastoral setting, may well have provided Hunt with a starting point for *The Hireling Shepherd*[147] (Plate 156).

Perhaps more revealing still for Hunt's relationship to the German Manner was the often repeated observation made when the *Light of the World* (Plate 157) was exhibited in 1853, that it was based on a contemporary German print.[148] According to J. B. Atkinson this print was an engraving by Gottfried Rist after Philipp Veit's *Christ Knocking on the Door of the Soul* (Plate 158)—a work that has recently been brought to light.[149] While both Hunt and Ruskin took pains to point out the differences in handling and details of symbolism between the two, neither could deny a basic similarity of concept and directness of presentation.

While it would be easy to exaggerate the implications of such specific cases, it does

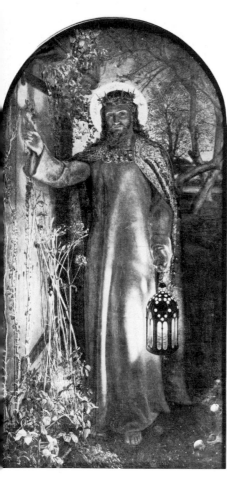

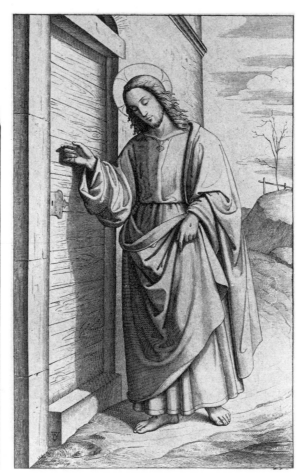

seem to be the case that, without an absorption of the archaic modes of presentation revived by the Germans, the moralizing art of the Victorians—particularly that of the Pre-Raphaelites—would have lost much of its force and directness. The compositional arrangements favoured by the Pre-Raphaelites—the frontal designs in which the most meaningful parts of the picture could be brought firmly to the foreground without any of the softening effects of coulisses, and even the obsession with frames that emphasize the surface patterns of the picture—have their roots in the Germanic craze of the 1840s. The simplified forms—however much reviled—had brought with them a new rhetoric, in which meanings were conveyed by simple movements rather than by exaggerated gestures and facial expressions.

It was perhaps the Pre-Raphaelites who were to put these tendencies to most effective use. Possibly for this reason one can excuse Hunt his antagonism to German art; it was he and his colleagues who turned what had become a moribund movement once more into a living idea. The last word on the matter should be left to Hunt's fellow-opponent of German art, John Ruskin. When defending the *Light of the World* from the 'envious charge against it of being plagiarized from a German print', he concluded: 'All I can say is, that I shall be sincerely grateful to any unconscientious persons who will adapt a few more German prints in the same manner.'[150]

225

Ladye Marie.

The cold pale moon was shining
 On thy cold pale cheek ;
And the morn of the Nativity
 Had just begun to break.

III.

They carved thee, Lady Mary,
 All of pure white stone,
With thy palms upon thy breast,
 In the chancel all alone :
And I saw thee when the winter
 moon
 Shone on thy marble cheek ;
When the morn of the Nativity
 Had just begun to break.

IV.

But thou kneelest, Lady Mary,
 With thy palms upon thy breast,
Among the perfect spirits,
 In the land of rest :
Thou art even as they took thee,
 At thine hour of prayer,
Save the glory that is on thee
 From the sun that shineth there.

V.

We shall see thee, Lady Mary,
 On that shore unknown,
A pure and happy angel
 In the presence of the throne ;
We shall see thee when the light
 divine
 Plays freshly on thy cheek,
And the Resurrection morning
 Hath just begun to break.

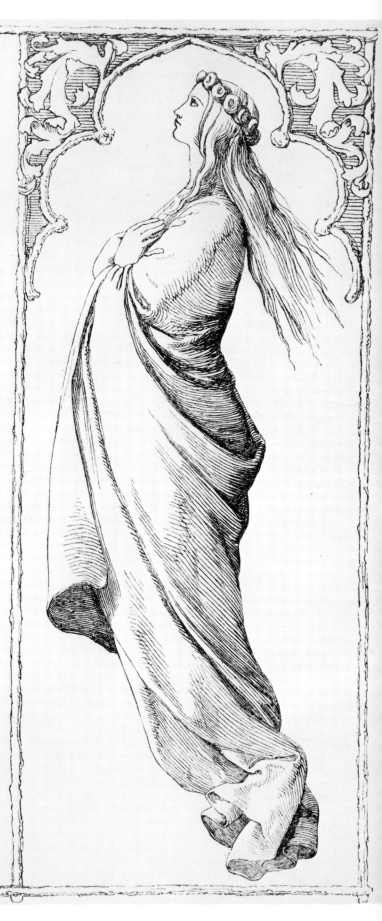

CHAPTER VII

Dyce and Ecclesiastical Art

WHEN THE arch-patron of Anglo-Catholicism, A. J. Beresford Hope, came into contact with the work of Dyce and Horsley through their involvement in the project for decorating All Saints', Margaret Street, in 1849, he commented: 'Strange that there should be this little knot of painters who have gone back to the old models, and with whom we have had so little communication. No doubt they must have thought us narrow-minded prigs for not having found them out.'[1]

That he should have been so unaware of the efforts of English religious revivalist painters for so long is indeed remarkable. Equally so was his grudging praise of the finished mural by Dyce. This he called 'a piece of success unlooked for and surprising'.[2] It was, after all, over three years since Dyce and Horsley had begun to be referred to as 'Puseyite' in the English press,[3] and two years since their Catholic counterpart John Rogers Herbert had gained the epithet 'Puginesque' through the exhibition of his painting *Our Saviour Subject to his Parents at Nazareth* at the Academy in 1847[4] (Plate 154).

The professed ignorance of Hope and Butterfield reflects above all the lack of confidence that the English church restorers had in the ability of English artists to furnish the kind of ecclesiastic decoration they were after. For just as the rigour required by monumental art might seem to some to be fundamentally at variance with the sensuous nature of the English tradition in painting, so it was wondered whether the 'devotion, majesty and repose of Christian art'[5] could be achieved by practitioners of a 'materialist or *Naturalistic* style'. For, as the author of the above designation, the reviewer of Rio's *De l'art chrétienne* in the *Ecclesiologist*, said of religious projects: 'If their execution be confided to wrongly-minded and materialist individuals, objects may be introduced of a directly or indirectly debasing tendency.'[6]

Certainly neither Catholic nor Anglo-Catholic revivalists had previously been much inclined to take the risk. When in 1841 Beresford Hope had wished to commission stained glass as a part of his first Ecclesiological venture, the decoration of Kilndown parish church, he had turned to Munich;[7] and more recently Pugin had complained in an open letter to Herbert, published in the *Builder* in 1845, that the total failure of the Government Schools of Design to provide artists 'who would combine all the spirit of the mediaeval architects and the beauties of the old Christian artists with the practical improvements of our times' had meant that he had 'actually been driven to seek efficient assistance from the Flemish and German operatives'.[8] Furthermore, while Pugin sought to remedy this situation in the area of ornamental

159. ★W. Dyce: *Ladye Mary*. Page from *Poems and Pictures*, 1846. Wood engraving.

design through the formation of his own firm of Pugin and Hardman, he had severe misgivings about the introduction of paintings into his churches. 'Our Northern Churches are not well calculated for wall painting', he explained;[9] and indeed the only time when a mural was introduced into one of his churches—the *Last Judgement* by Eduard Hauser, a follower of Overbeck, above the chancel arch in St Giles', Cheadle (1845)—it was due to circumstances beyond his control.[10]

Pugin's antipathy to murals (though not, of course, to stained glass) was shared by many ecclesiastic architects. Butterfield, for example, preferred the pure decorative effects of 'structural polychrome' to the encrustations of figure paintings, and apparently had no hand in the decision to engage Dyce to decorate the chancel of All Saints', Margaret Street.[11] Indeed only George Edward Street amongst the major architects of the period appears to have been active in encouraging mural paintings in churches. The projects he sponsored range from such modest schemes as the decoration of St Peter and St Paul, Sheviock, Cornwall, with copies of works by Overbeck and Fra Angelico (1851) to the engagement of G. F. Watts to paint a *Last Judgement* over the chancel arch of St James the Less, Pimlico (1861); and he frequently called for the revival of mural painting in the pages of the *Ecclesiologist*.[12]

Such a situation underlines the predicament of Dyce. As a pioneer reviver of 'Christian art' in Britain he was continuously facing a conflict of roles: a conflict between the academy painter and the church decorator.

Much of this conflict has already been encountered in the account of Dyce's work as a history painter. In the field of religious art, however, it touched him even more deeply, for this was his preferred field of activity. A deeply devout man, he had contemplated taking holy orders before becoming a professional painter.[13] His High Church allegiances, too, were deep rooted, for he came from that part of northern Scotland which had resisted Presbyterianism in the sixteenth century and had remained Episcopalian.[14] His knowledge of church ritual was extensive and widely respected. In his youth he had written articles dealing with such matters as the Jesuits and the garments of Jewish priests.[15] In the 1840s, long before he came to the notice of Beresford Hope, he had been advising priests on church ritual;[16] and when he did finally come into contact with the great Ecclesiological patron, their correspondence dealt not only with the paintings Dyce had been commissioned to execute at All Saints', but also with most aspects of that church's appointments. Indeed Dyce appears to have been used freely as an ecclesiastical advisor—almost to the point of exploitation.[17] He often had what must have been the galling experience of being asked to express opinions on other artists' work while not being invited to undertake any commission himself—as when he advised Keble on the design of the windows of the church at Hursley.[18] However, this situation is not altogether surprising, for he first came to the notice of the Ecclesiologists not as a religious painter, but as a general reviver of archaic forms. In 1841, before he had undertaken any church commissions, he came to prominence as the founder of the Motet Society, an organization dedicated to restoring the old religious music style of the Laudian church.[19]

Dyce's difficulties in becoming recognized as a religious painter stemmed back to

the time of his second visit to Rome when, according to Stirling Dyce,[20] he first came into contact with Overbeck and Wiseman. For, while Dyce may have been inspired by this pietistical circle to ally his religious with his artistic aspirations, he seems to have been prized amongst the revivalists every bit as much for the former as for the latter. Overbeck indeed not only held out hopes for Dyce's conversion, but also expected to see him become a priest[21]—a course that another young English painter, William Davies, took, under his influence.[22]

If the channeling of young English painters towards the priesthood might suggest certain reservations about their pictorial achievement on the part of Overbeck, this feeling appears to have been reciprocal. As Dyce was to make clear later in his career, his emulation of the spiritual art of the past did not imply the rejection of the present. For it was necessary for an artist to address his contemporaries. The Nazarenes, he felt, had merely copied the outer forms of mediaeval art, thereby losing the ability to convey a spiritual power equal to that of the Middle Ages.[23] It is impossible to say how far Dyce had reached toward this conclusion in 1829, but by 1834 he was certainly aware of this viewpoint, for it had been put to him in a letter by his former fellow-protégé of Overbeck, William Davies:

> Mr. Overbeck here is painting in his usual manner talks much of you but I am sorry to see art so declining in his art as well as other modern works. His pictures are indeed merely an imitation of antiquity without the spirit or solidarity of past ages . . . though the monuments of antiquity remain to be seen as usual, though the books are still to be read which explain them we as the age rolls onwards are incapable of receiving instruction from them.[24]

Certainly the necessity of addressing a contemporary public was uppermost in Dyce's mind when in 1843 he raised objections to the S.P.C.K.'s intention of producing a cheap popular edition of the *Life of Our Lord* with reproductions of old masters: 'It seems to me just as unwise to reproduce (supposing it possible) the models of art of the fifteenth and sixteenth century with the view of *popular* instruction as it would be to preach the sermons of those ages in modern pulpits.'[25]

Dyce's own manner varied radically according to the audience he was adressing; and it was only when he was addressing Prince Albert that his art came close enough to that of the Nazarenes to run the risk of confusion (Plate 125). Before the mid-1840s there is little even in his religious painting to connect him with the German revivalists. Before he made his second visit to Rome his art was most strongly inspired by the Venetians; and the Madonna that he painted reputedly under the inspiration of Overbeck was admired first and foremost for its handling of colour.[26] Indeed it seems likely that it was the concept of the Christian artist rather than the methods of the Germans that were most influential to him at this time.

This distinction may well account for the ambivalence of Wiseman to Dyce's work. In their correspondence subsequent to Dyce's stay in Rome, Wiseman seems always to have been encouraging, but clearly did not look on Dyce as the kind of Christian artist who would flourish in revivalist circles in Rome, and also failed to obtain any employment for him amongst the Catholics in England. Thus in 1834,

when Dyce wrote to tell the rector of the English College of his desire to return to Rome and paint such an unequivocally Catholic scheme as a cycle on the life of the Virgin, the latter replied with ecstatic enthusiasm. He told Dyce how,

> to see that you have cherished within you bright and pure in spite of the smothering atmosphere around you, where portrait painting and scene painting or what is very akin to it form the surest careers to success for a young artist, to see one who dares to admire and longs to imitate the old, symbolic, Christian and truly chaste manner of the ancients is refreshing indeed to the mind; it is like listening to a strain of Palestrina, after a boisterous modern finale.[27]

Yet he held out no hopes of Dyce being able to find employment in Rome. For he continued:

> I do not know whether the wish to paint your symbolic designs of the B.V. excludes every other place but Rome for its fulfilment. Here it would be difficult not to say impossible to procure such a commission; but if you have courage enough to make the first step in a new and beautiful track, before the eyes of our own countrymen, and raise a new style and new school in England where I am sure you would have many admirers, I can from this moment promise you place and opportunity and room enough to put all your designs in execution.

Presumably Wiseman was hinting here at the opportunities that the re-establishment of Catholic institutions in England should provide for the Christian artist. Certainly he was kept well acquainted with these through his connections with Lord Shrewsbury. Yet when Dyce wrote to Wiseman a few years later in 1838 in hope of being recommended as a painter for a new 'Catholic cathedral' in London, the latter treated the proposition with a greater degree of caution;

> I am sorry to say that I have no sort of information respecting any design to build a cathedral in London, beyond the mere circumstance of such a thing being desired and remotely intended. I shall have to write to Mr. Pugin soon, and shall say all in my power to take you into his councils, should he have any such great work in hand.[28]

It seems curious that Wiseman should not have heard of the plans to build St George's, Southwark, a church intended to have the status of a cathedral.[29] However, perhaps there were other problems connected with Dyce's request—not least Pugin's known aversion to having wall paintings in his churches.

As it happens, there seems to have been no contact between Pugin and Dyce on this or any other ecclesiastical venture. No doubt Pugin's own extreme Catholicism would have made him wary of Dyce, the Anglo-Catholic. Soon he was to make a friend and convert of John Rogers Herbert,[30] an artist who turned from popular romantic subjects to such Puginesque visions of Pre-Reformation England as *The Boarhunters Refreshed at St Augustine's Monastery Canterbury*.[31] Herbert was to become an active propagandist for the Catholics at the Academy during the 1840s, exhibiting such works as the *Introduction of Christianity into Britain* in 1842[32] and *Sir*

Thomas More and his Daughter in 1844.[33] He was, furthermore, active as a church painter at St Mary's College, Oscott, where Pugin was a lecturer from 1840. Besides painting panels for the chapel there he also painted for the college portraits of Dr Wheedel, its president, Pugin and Wiseman.[34]

Meanwhile, if Dyce's relationships with the Catholic revivalists proved unproductive, he had established firm relationships with influential patrons of the burgeoning Anglo-Catholic movement. By 1840 he was well acquainted with two politicians with High Church sympathies, James Hope Scott and his close friend William Ewart Gladstone. The former, whom he knew from his Edinburgh days, he advised on his journey to the continent in 1840, when he gave him instructions for visiting Overbeck in Rome and Schnorr in Munich.[35] The latter was to prove a great support to Dyce during his years at the Government Schools of Design, when Gladstone was vice-president, then president, of the Board of Trade. He also bought Dyce's *Jessica* from the Royal Academy in 1843.[36]

Dyce had first met Gladstone in 1828,[37] but their relationship was not a close one until Dyce settled in London in 1838. At that time Gladstone was a promising young Parliamentarian in the Tory party, with close affinities to the 'young England' faction. Like Dyce he had once had thoughts of becoming a priest, and brought his religious interests into his subsequent career. Although he rejected any notion that he was a Puseyite, he saw the Church of England as an essentially Catholic body. For him this was a crucial point for demonstrating the legitimacy of the Anglican Church and for emphasizing the necessity of it being established. Indeed in two rather eccentric treatises, *State and Church* (1838) and *Church Principles Considered in their Results* (1840), he depicted the Church of England as the one true Catholic Church.[38] Dyce did not go as far as this, but he was equally emphatic in his view of the Church of England as being both legitimate and Catholic, claiming that the Roman Catholics 'have never practically dared to deny that with us remains the apostolic succession, that ours is the hierarchy; that the Church of England . . . is descended, by an unbroken line of succession, from the apostles and founders of the church Catholic.'[39]

Any hopes that Wiseman might once have had of Dyce's conversion must have been abandoned by the time this pronouncement was made in 1841. By this time, too, Dyce and Gladstone were collaborating on a number of religious projects. Gladstone was a founder member of Dyce's Motet Society,[40] and Dyce provided Gladstone with advice in the planning of the chapel of Trinity College, Glenalmond—the college set up by Gladstone and his father, together with Dean Ramsay and James Hope Scott, for the training of young Scotsmen in the Episcopalian ministry.[41] They were also collaborating on a pictorial project, for since 1839 Gladstone had been corresponding with Dyce about the selection of illustrations for a *Life of Our Lord* to be published by the S.P.C.K. in a cheap edition with a view to popular instruction.[42]

The history of this scheme is symptomatic of the problems Dyce faced in becoming recognized as a religious painter. While he originally welcomed the idea as an alternative to the projects he had discussed in vain with Wiseman, Gladstone

had not intended the commissioning of any new designs. Having just returned from a tour of Germany and Italy, where he had read Rio's *De la poésie Chrétienne* and developed a passion for early Italian and German pictures, he had been thinking of selecting works from the old masters to be engraved for his instructional book. For Dyce, such a procedure would imply both a dereliction of duty on the part of the contemporary artist and the risk of failing to communicate with a nineteenth-century public. Even after he had withdrawn from the scheme in September 1841 on the grounds of the pressure of his work at the Government Schools of Design he continued to air his views on the subject to Gladstone. As late as 6 December 1843 he was writing to Gladstone calling for a 'true estimate of the vocation of an artist and of the use of art' and pointing out the necessity of creating modern religious designs for popular instruction.[43]

If Gladstone was inclined to be sympathetic to Dyce's views, his collaborator and old Oxford friend Thomas Acland was not. Not withstanding Dyce's argument of contemporary relevance, Acland supported the use of designs drawn from old masters on the grounds of cheapness and popularity. 'When once the plan has thus gained a footing', he wrote to Dyce, 'it would be easier to introduce gradually original designs on the plan you suggest of keeping on the old keynote like the Germans.'[44] This had in fact not been quite what Dyce had suggested, though he had conceded the need of the contemporary religious artist to evoke the archaic in his work. As it happens he fell in even more closely with Acland's wishes, drawing up a list of suitable old masters for copies to be made from, and suggesting that George Richmond might be chosen as an artist to follow on these with a few original compositions.

His own participation was restricted to the provision of a copy of a Perugino. Perhaps his growing involvement with the Government Schools of Design prevented him from doing more. He was by this time complaining bitterly to Gladstone of the amount of work he had to do there, and went as far as to say on 4 September 1841 that he was losing the power of drawing through want of practice.[45] Presumably it was for this reason that he eventually withdrew even his copy of Perugino, declaring it was unfit to submit, and was 'neither Perugino nor himself'.[46]

Despite his concern for a contemporary manner, Dyce seems to have been more willing to accept Germanic conventions in graphic art than in painting. This was a common enough—indeed almost an axiomatic—preference, and can be seen clearly enough in his own drawing style of the 1840s.[47] The design he made after Perugino cannot now be identified, but he himself felt it to 'approach so nearly to the character of the German etchings from the works of Overbeck and others that I am disposed to recommend the trial of an etching by Gruner.'[48]

Perhaps Dyce had in mind the frontispiece after Overbeck's *Pieta* that Gruner had engraved for Wiseman's *Four Lectures on the Offices and Ceremonies of Holy Week* (1839) soon after his arrival in England in 1838.[49] He had certainly known Gruner in Rome, and had been informed of his imminent arrival by Wiseman. However, Dyce's admiration for the German engraver well outlasted this period, for in 1851 he

recommended his employment to the Bishop of Brechin, when the latter wanted an engraving of a holy subject.[50]

It was no doubt with the work of Gruner in mind that Dyce favoured the use of line engraving rather than wood engraving for the S.P.C.K. project. As it happened, however, the few illustrations that he did provide for publishers were largely reproduced in the latter medium, which was then so much in the ascendancy. If such designs as those for James Burn's Anglo-German anthology *Poems and Pictures* (1846) did not appear exactly as Dyce would have wished them to (Plate 159) they did nevertheless demonstrate a distinction between the purist Nazarene style and the more secular German woodcut manner emulated by John Franklin, another of the contributors to *Poems and Pictures*, whose work reminded the *Athenaeum*, 'as usual, of his profound erudition in the contemporary vignette art of Germany; like Mr. Carlyle, he has studied that which is German so deeply, that it has become part of himself.'[51]

Of Dyce, on the other hand, this reviewer said, 'They who like that style which has been termed "Puseyite" wherein undoubtedly he is first, will find the illustrations to the Ballad of Lady Mary much to their taste.'

The 'Puseyite' style was much to the taste of the *Ecclesiologist* which, linking the contributions of Cope and Horsley with those of Dyce, saw them as providing a new direction for religious illustration:

Mr. Dyce, Mr. Cope and Mr. Horsley, in particular, have contributed some very fine drawings, which really entitle us to expect the greatest things from English art when properly encouraged. Indeed, is not this being shown in all departments? There can be little doubt that some such style as that of this volume ought to be adopted in illustrating church books now, should this be attempted.[52]

While Dyce's style in these illustrations might seem to belie his remarks about the inadvisability of reproducing 'the models of art of the fifteenth and sixteenth century', it was their updating of mediaeval gestures as much as their direct archaism that aroused admiration. It was this synthesis of ancient and modern that made them seem so peculiarly suitable for emulation by the *Ecclesiologist*. Indeed they were specifically contrasted to Owen Jones's chromolithographic reproductions for Murray's illustrated prayer book on this point:

Nothing can be more ridiculous than such a book as Mr. Murray's illustrated edition of the Prayer Book, or indeed than any attempt to revive illumination now. The miniature style was most beautiful while it flourished; but it has been since superseded by other developments in art.[53]

Despite such encouraging reviews, Dyce never pressed to produce the kind of illustrated book that the *Ecclesiologist* called for. Stirling Dyce might have said that his father had early planned to design 'a series of pictures or engravings, forming the chief incidents in the life of Our Lord . . . as a means by which the moral sentiments of the masses would be interested and the early instruction of children benefited'.[54] But despite the attempts of Gladstone—following the debacle of the S.P.C.K.

project—to procure a commission for him along these lines, Dyce preferred to give priority to other artistic endeavours.[55]

It is in Dyce's religious paintings that one finds the problem of modernity being most fully explored. Here the issue was even more urgent, since the matter had become one of heated controversy during the 1830s. If Dyce was in Rome in 1832 he would have learned of the sensation that the French painter Horace Vernet had been causing with his attempts at historical exactness which started with *Judith and Holofernes* in 1831 and culminated in the painting of *Rebecca at the Well* in modern Arab dress.[56] In any case, he would certainly have heard of the controversy through his Edinburgh colleague David Scott, who made reference to the divergent approaches of French and German painters in his journal of his stay in Rome in 1834.[57]

Vernet's own reasons for adopting a contemporary mode for religious paintings may have been relatively light-hearted. He had recently returned from a trip to North Africa, and no doubt wanted to turn his studies there to good and novel use. In a later statement made before the French Institute in 1848 he had defended his choice on the grounds that the observation of contemporary Arabs and their habits (which he assumed to be unchanged since biblical times) could give a truer picture of the past than any of the traditions of the church. To illustrate his point he described how the sight of a girl fetching water from a well had explained for him an obscurity in the passage describing Rebecca at the well in the Bible.[58]

The counter-argument of Overbeck and his circle was emphasized by Wiseman in his *Four Lectures on the Offices and Ceremonies of Holy Week*. Starting from the conventional Catholic premise that the traditions of the Church carried equal spiritual authority to the evidence of the Bible, he went on to argue that the representation of religious scenes by the old masters was a more faithful guide for conveying the message of Christianity than any first-hand knowledge of Palestine. The old masters had painted under the direction of the Church and had even based their costumes and compositions on ecclesiastical robes and ceremonies. Fra Angelico's frescoes on the life of St Stephen in the Vactican were, he felt, a supreme example of this.[59]

However Dyce first came into contact with these arguments, his inclination towards historical veracity in biblical scenes occurred at the same time that a new rigour of design could be noted in his style—with the *Joash Shooting the Arrow of Deliverance*, exhibited at the Academy in 1844 (Plate 123). Certainly the reviewers related Dyce's attempt to reconstruct the costume of pre-Christian Palestine to Vernet's innovation. For the *Kunstblatt*—whose editor, Ernst Förster, as a pupil of Cornelius's could be expected to follow the Nazarene line—the advantages of the new procedure were questionable:

> I am not sure that the artist has not made a mistake in losing religious and poetic content for the sake of gain—a so-called true history; for these are of such barrenness that they either appear prosaic—as in the case of 'Rebecca' or shocking—as in the case of 'Judith'.[60]

The *Art Union*, on the other hand, welcomed the treatment, claiming to have 'long contended for oriental character as a propriety in scriptural art' and feeling the figure of Joash to reveal 'the better parts of the Oriental as he now is, and as he was in the days of Solomon'.[61]

Dyce himself evidently encountered a certain amount of opposition from his High Church supporters, for he wrote defensively in a letter to Hope Scott about the work: 'I fear you were disappointed because you looked for certain characteristics of works by the *ascetic* painters of the early schools—if you did, excuse my saying that you ought to have been disappointed.'[62]

He then explained the distinction between secular and sacred representations of themes, emphasizing that the picture in question belonged to the former category, and should be judged accordingly. And, in case there should be any objection to a painter of devotional subjects producing academy subject-pieces, he suggested a symbolic rationale for the work: 'The picture is not a devotional kind, I admit; but to those who look beyond the surface it may serve to symbolize the arm of secular power directed by the Church.'[63]

It is indeed possible to interpret Dyce's unusual and erudite theme in this light. The representation of the descendant of David shooting the arrow of deliverance at the behest of Elisha for the defeat of Aram certainly shows a deference of secular to ecclesiastical authority. As an Establishmentarian and Anglo-Catholic such a theme would no doubt have been specially meaningful to him—as it would have been to Hope Scott and to Gladstone.

It would probably be inaccurate to suggest that all Dyce's religious subject paintings at this time have a consistent symbolic programme; but he certainly exploited the opportunity offered by public commissions to emphasize the relationship between ecclesiastical and secular authority. In the same year that *Joash* was exhibited, Dyce was painting as his first mural the *Consecration of Archbishop Parker* for Archbishop Howley in the chapel of Lambeth Palace (Plate 140). Although Howley is far from being remembered as one of the champions of the Ecclesiologists, his redecoration of Lambeth Chapel showed a concern for the revived interest in church ritual. Furthermore, the subject that was chosen for Dyce's fresco was one that affirmed the traditional authority of Anglican orders. The occasion of the consecration of the first of Elizabeth I's archbishops in Lambeth Palace in 1558 was one which saw those 'eight canonically consecrated bishops of the reigns of Henry VIII and Edward VI who had escaped or survived the Marian persecution, merging any differences of private opinion, and making common cause in the preservation of the line of the Anglican Episcopate'.[64]

Even Dyce's work in the Palace of Westminster is consistent with these interests; The *Baptism of Ethelbert* (Plate 142) represents the moment when the monarchy in England first accepted the authority of the Catholic Church, while the artist saw the 'pictured adventures of Arthur and his Knights' in the Queen's Robing Room as 'forming a series only with respect to their allegorical or moral signification'.[65] The dominance of the spiritual in this signification would have been clearer if Dyce had been allowed to execute his original choice for the large panel on the north wall, *The*

235

Departure of the Knights of the Round Table in Search of the Holy Grail (Plate 121), which was vetoed by Prince Albert.[66] Both physically and thematically this design would have led towards the west wall. Here, the altar-like disposition of the murals, which centre on *Religion—the Vision of Sir Galahad* (Plate 120), emphasizes religious devotion as the supreme virtue personified in the Arthurian legends. Dyce had also wished to make a similar point by installing an altar-like arrangement of panels beneath the *Baptism of Ethelbert* in the House of Lords, but Barry had not allowed it.[67]

The historicism that Dyce developed in his panel paintings of religious subjects was accompanied by a growing naturalism of effect which eventually superseded it. Thus, as Allen Staley has demonstrated, a development can be seen from the quasi-Palestinian settings of *Joash* (1844), *St John leading the Blessed Virgin Mary from the Tomb* (1844–60) and *The Meeting of Jacob and Rachel* (1850) (Plate 119) to those begun after 1850, such as *Christ and the Woman of Samaria* (Plate 160), which are set in British scenery that the artist knew at first hand.[68] Undoubtedly, as Staley suggests, this development was intensified by Dyce's contact with the Pre-Raphaelites; amongst this group Hunt at least appreciated the *plein-air* concessions in Dyce's manner of painting. When considering Dyce's relationship to the artists of the past, he said

> He was not as many modern painters have been, a mere plagiarist of their postures and expressions; in his work could always be seen some sweet trait from the freshness of the passing day over and above the culture of the great masters whose living representative he made himself.[69]

Dyce's *Jacob and Rachel*—the work that Hunt made a copy of in 1850[70]—certainly combines the 'freshness of the passing day' with 'the culture of the great masters'. The rigorous, Nazarene-based design and formalized drapery is set in a brightly lit landscape. But even his last works involved a compromise between directly described scenery and conventionally posed figures.

This restriction in Dyce's art is a critical one, for it helps to locate his position in the controversies concerning revivalism, and to explain why his pictures seemed so much more innocuous to opponents of the tendency than did those of the Pre-Raphaelites.

The crude assumption that there was a correlation between the Catholic revival in religion and the mediaeval revival in art, that—as the *Illustrated London News* put it in 1846—'the Puseyism of art is the complement of the Puseyism of theology',[71] was one frequently made to chastise those artists who seemed to be taking the taste for the archaic to the point where it seemed to subvert contemporary conventions of naturalism and academic standards of pictorial beauty. Such arguments were strictly circumstantial, however, and only applied in special cases—such as that above, where Dyce's Madonna of 1846 (Plate 125) was under review.

Such circumstances particularly affected the light in which contemporary German religious art was viewed. In the *Illustrated London News* review of Dyce's Madonna, the Germans were held to be the instigators of a false direction:

236

Germany has fallen into the most deadly of art-heresies. She is wasting her rising energies in desperate efforts to re-animate dead forms. What vitality is shown in her schools is the hideous mockery of life which the galvanized corpse exhibits under operation of the battery.[72]

On other occasions, however, the Germans could be seen as the defenders of the traditions of Christian art in the face of modern sensationalism:

A very brief consideration of the respective tones of the different schools of Europe suffices to show which is best qualified to illustrate the Holy Scriptures. Everything that has hitherto been done shows the extreme difficulty of departing in any wise from those accepted forms which have prevailed from the youth to maturity, and thence to decay, of the Italian schools, and which have been revived by the German schools in our own day. In the French school the Euripidean *mise en scène* imitative of David's have in the present day become less dramatic: they are simply theatrical—a quality utterly out of the pale of sacred effect.[73]

This opinion—taken from a review of the illustrated Cotta Bible in the *Art Journal* in January 1851—might seem to be at variance with that magazine's former championship of 'oriental character as a propriety in scriptural art' in 1844. Yet, while it would hardly be surprising to find a change of editorial opinion over a space of six years, this was not in fact the case. The Cotta Bible reviewer may have praised the Germans' use of accepted forms, but he still took them to task for insufficient

160. W. Dyce: *Christ and the Woman of Samaria*. 1865. Oil (34.3 × 50). Birmingham Museum and Art Gallery.

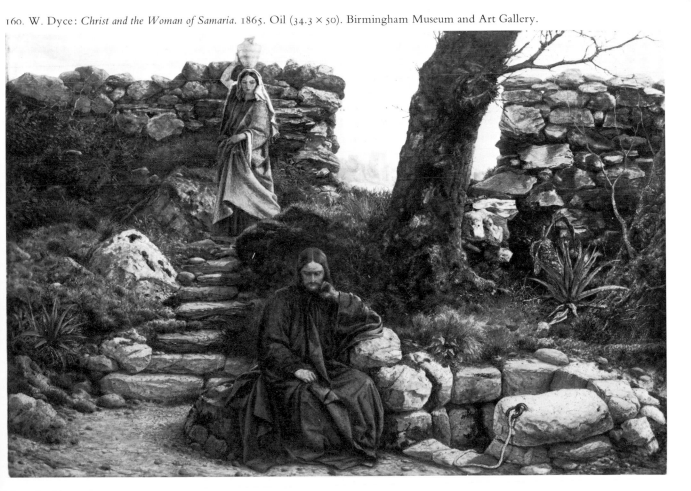

knowledge of archaeology and such anachronisms as the inclusion of 'modern-bound books and psalters' in the place of scrolls and parchments.

While the *Art Journal* could—and almost invariably did—praise the Germans for reviving the authentic forms of devotional art when reviewing individual productions by these artists, it too was in the habit of chastising them in a manner similar to that of the *Illustrated London News* review of Dyce's Madonna when associating them with English revivalist works. Thus in the *Art Journal* attacks on the Pre-Raphaelites during the summers of 1850 and 1851[74]—that is, both before and after the enthusiastic reception of the Cotta Bible—the Germans are cited as the source of the 'ridiculous' tendency of going back to the infancy of art. The 'Puseyite' slur was also revived by citing a letter written by Wilkie in 1826 that claimed that Schnorr 'has married a Catholic and has changed his religion to feel more devotedly the scriptural subjects of his art', and adding: 'We shall not be surprised if some of the present sect follow the same example, notwithstanding Mr. Ruskin says he has had letters disavowing their inclination to Puseyism.'[75]

In fact the *Art Journal* premise was ill founded. Schnorr remained a staunch Protestant throughout his life. Furthermore, it must have been clear that the Nazarene style was supported by Protestants as well as Catholics in Germany, for the Bible that Cotta had illustrated was in fact the translation by Luther.

Yet if the Germans could be cited conveniently as a warning to British revivalists they could not be accused of perversities as extreme as those of the Pre-Raphaelites. For all their 'desperate efforts to re-animate dead forms' and 'insufficient knowledge of archaeology'[76] they could not be held to have indulged in wilful distortion. For this aspect of Pre-Raphaelitism a different tradition was cited, that of the Gothic artists of the North. In the *Art Journal*'s censorious article of July 1851 it was stated that the Pre-Raphaelite School 'more properly might be called the gothic school' and that 'their pictures have not one quality in common with the works of the Italian Masters'.[77]

This view was shared even by those Anglo-Catholics with whom the Pre-Raphaelites were supposed to be in sympathy. The *Ecclesiologist*'s Academy reviewer of 1850, while appreciating the Christian intentions of Millais and Holman Hunt, makes a clear distinction between their revivalism and that of Dyce and his adherents. After praising *Jacob and Rachel* for 'the effect of its graceful and pure outline and pure colour', he turns to censure 'Mr. Millais, a very young man' who

> has exhibited a mystical Holy Family at Nazareth. While however adopting the style of the early German school, he has unhappily produced its grotesqueness, so that in spite of the great merits of his picture, we should be very sorry to see it quoted as a type of the revived Christian School of England.[78]

More to their taste was Dyce's protégé William Dobson, who 'emulates the early Italian painters, of which one trusts Mr. Hunt and Mr. Millais would not be unmindful'.[79]

Like the Nazarenes, Dyce could not be accused of emulating the 'grotesqueness' of Northern Gothic. Even at its most ascetic his art was modelled on the Italians, as

238

the *Illustrated London News* acknowledged when calling his Madonna 'a dead imitation of the early Umbrian school'.[80]

The relatively hostile reception of Dyce's 1846 Madonna was undoubtedly due to its archaic manner. It can be taken as an extreme in his art, painted at the same time that he was working on his House of Lords fresco when his revivalist tendencies were at their greatest. Yet the manner of this picture is not a consequence simply of the time at which it was painted. It was also due to its theme. For here, unlike *Joash*, was a work that was undoubtedly of a devotional kind.

Although Dyce's letter to Hope Scott in 1844 implied that devotional pictures— as opposed to historical ones—were to have the characteristics of 'the *ascetic* painters of the early schools', he unfortunately did not develop this notion further. A similar distinction was made, however, a few years later by Mrs Anna Jameson in the first volume of *Sacred and Legendary Art* (1848). For Mrs Jameson, devotional pictures were to be defined as ones that 'portray the objects of our veneration with reference only to their sacred character, whether standing singly or in company with others'.[81] Historical religious paintings, on the other hand, described some event: 'A sacred subject, without losing wholly its religious import, becomes historical the moment it represents any story, incident, or action, real or imagined.'[82]

Mrs Jameson then went on to defend the 'artless solemnity' to be found in devotional works, observing: 'It is curious to find the critics of the last century treating with pity and ridicule, as the result of ignorance or a barbarous unformed taste, the noblest and most spiritual conceptions of poetic Art.'[83] And if she thus accounted for the hieratic designs and lack of realism in such works, she also found a reason for their 'so-called *anachronisms*': 'We must remember that the personages here brought together in their sacred character belong no more to our earth, but to heaven and eternity; for them there is no longer time or place.'[84]

Since the 1846 Madonna shows such an understanding of the schematic and 'anachronistic' nature of devotional art, it seems strange that Dyce should not have been more active as a painter of altarpieces. Indeed, he seems to have discouraged employment in this direction after the mid-1840s. Although he painted a Deposition altarpiece in Edinburgh—possibly the 'Deposition in the Bellini or Perugino manner, colour like stained glass' noted by Cope in 1847[85]—he declined to provide an altarpiece for St Paul's, Brighton, in 1846.[86]

Perhaps—as Lindsay Errington suggests[87]—Dyce shared the anxiety of Pusey and other Anglo-Catholic leaders to avoid the taint of idolatory. Certainly he was mindful of the Anglican Church's abhorrence of the 'worship of images' when he wrote: 'The abuses to which certain of the arts had ministered, it must be remembered, led to their being discountenanced by the Church of England: It is vain, therefore, to look for those which the Church abolished, as accessories to devotion.'[88] It might seem hard not to see Dyce's major ecclesiastical venture—the paintings in All Saints', Margaret Street (1850–9)—as an accessory to devotion. But it must be remembered that Dyce's contribution to the chancel was not an altarpiece but a reredos surmounted by wall and ceiling decorations; and as such it had a purely ornamental function. He was equally careful to free his iconography from any

239

Roman Catholic taint. He avoided all 'Neo-Roman' exaltation of St Joseph in the representation of the Holy Family, and interpolated the Protestant hero St Paul into the Crucifixion scene.

Since his first involvement with the status of the decorative arts in his letter to Lord Meadowbank (1837), Dyce had been conscious of the need to distinguish between the principles of ornamental and fine art. It had indeed been his insistence on this distinction that had led to his enforced resignation from the directorship of the Schools of Design in 1843. In 1848 he was still unrepentant of his stand, denying in his *Lecture on Ornament* that the decorative arts were simply an inferior form of the fine arts. The basis of the distinction for Dyce was that the former was concerned primarily with creating a decorative effect while the latter, even at its most ideal, was concerned with illusionistic presentation: 'The power of imitation . . . although to a great extent the ultimate purpose of the instruction in an Academy of Fine Art is, in a School of Design, but the means to an end.'[89] It was for this reason that the training of mimetic powers was not Dyce's primary concern when head of the Schools of Design.

The restriction placed on imitation in mural decoration seems to have encouraged Dyce to see this activity primarily in terms of decoration. Indeed it was this that had led him to state of the differences between panel and mural painting that 'the one kind strives to embellish the *realities* of life; the other endeavours to give us a *picture* of some higher condition of humanity'.[90] It was certainly such qualities that led him to praise the frescoes of Pinturicchio so highly when he saw examples of them in the Vatican in 1846:

> I do not think that in general the merits of Pinturicchio are sufficiently appreciated. Of the older masters he is certainly on the whole the greatest and uniformly good colourist in fresco; and as an ornamentalist (I mean as one who decorated apartments by various kinds of design, whether of figures, stuccoes, or painted arabesques) he stands in his day quite unrivalled. Of course, I presuppose that he was what is now termed a purist or church painter, and that he is to be judged as such.[91]

Dyce's church mural was even more 'purist' than his secular ones at the Palace of Westminster. Even in its present repainted state it is clear that the figures are highly archaic in their treatment. Painted on a gold ground and set in niches, they do not have any of the vestigial naturalism to be found in the·frescoes of the Queen's Robing Room. It is at All Saints', in fact, that he comes closest to the practice of the modern Germans; notably to the church decorations of Hess at Munich and the Düsseldorf painters at Remagen.

Curiously the Anglo-Catholics themselves seem to have been reticent in their appreciation of Dyce's work. Beresford Hope himself might have declared in *English Cathedrals of the Nineteenth Century*, 'Mr. Dyce has shown us what fresco can do to the glory of God';[92] but there was significantly little comment on the project in the pages of the *Ecclesiologist*. Nor can this be ascribed to the society's avowed preference for architecture over painting. Even for members who actively called for

a revival of mural painting in churches Dyce did not seem to provide the answer. G. E. Street, who declared in 1852, 'If we wish satisfactorily to develop a school of Christian artists by giving them work in our churches, it must be done rather by giving them our walls than our windows to work upon',[93] made no reference to Dyce. His own attempts at mural decoration were copies of designs by Fra Angelico, Dürer and Overbeck,[94] and he did not feel that any British artists of a comparable stature had arisen until he came into contact with the Pre-Raphaelites.[95]

Perhaps it was the lack of boldness in Dyce's work that was responsible for this lack of enthusiasm. This was certainly the sentiment expressed by C. L. Eastlake in his *History of the Gothic Revival*. Here the All Saints' mural was described as

> begun at a time when the German *heilige* school was generally considered the best model of taste in decoration, and though Mr. Dyce invested his figures with a grace of colour and arrangement which was all his own, there is a handling in his work that is somewhat out of keeping with the architecture of the church.[96]

Eastlake was ungenerous about those features that Dyce felt separated his art so clearly from that of the Germans. But he was certainly correct in pointing out the difference between the restraint of the painter and the vigour of the architect. Dyce himself was aware of the distinction, though his views on the relative merits of the two approaches was naturally the reverse; when—in the place of the paintings by Horsley originally projected—the nave roof was decorated with bold zigzags designed by Butterfield, Dyce dismissed the additions as 'clown's dress'.[97]

Dyce's designs for stained-glass windows also failed to have a decisive impact. Unlike wall painting, this craft was widely patronized by church restorers before Dyce began to work as a decorator. In 1847 it was described by the *Ecclesiologist* as 'the most interesting of all the branches of Christian art which the Catholic movement in our community has called to life',[98] since here it was felt that there was real scope for technical development. It was, furthermore, a craft whose traditional function in British churches was assured.

Yet if there were many British stained-glass designers and makers at work in the 1840s, there was also a widespread dissatisfaction with their achievements. Ever since Beresford Hope had employed Munich glass-makers at Kilndown in 1841 it had been felt that these artists were superior to such local practitioners as Wailes, Ballentine, O'Connor and Willement. In 1847 the *Ecclesiologist* had conceded that 'Among the painted glass works of present times the first place must we suppose be conceded to that established at Munich by the present aesthetical monarch of Bavaria.'[99]

Three years earlier Pugin—for whom stained glass was also of prime importance—had felt obliged to cease using Wailes as a designer and had started producing his own stained glass. His dissatisfaction was not only with English designers, however, but also with the craftsmen, and he was forced to rely for assistance on 'Flemish and German operatives'. For Dyce the low standard of craftsmanship was also to be blamed on the policies of British glass-making firms. In 1848, after he had found it necessary to intervene to alter the designs by Wailes for

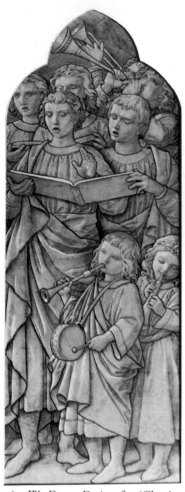

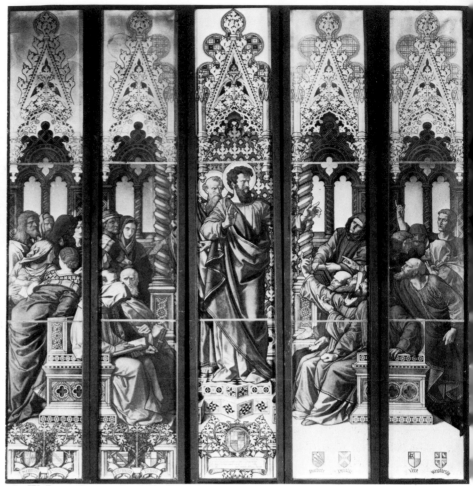

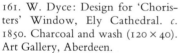

161. W. Dyce: Design for 'Choristers' Window, Ely Cathedral. *c.* 1850. Charcoal and wash (120 × 40). Art Gallery, Aberdeen.

162. W. Dyce: Cartoon for *St Paul Preaching at Antioch*. Laing Art Gallery, Newcastle-upon-Tyne.

Pusey's church at Hursley[100] and attempted to do the same with those by O'Connor for the chapel of Trinity College, Glenalmond, he complained to the Reverend W. Scott: 'The truth is our glass painters are mere money making glaziers who dread the introduction of a kind of art which would require better workmen and so diminish their profits.'[101] It was for this reason that he welcomed the news that the Italian artist Cercati was shortly to be employed on the windows at All Saints'.

Dyce's pleasure that a foreigner should be employed at All Saints' was a relative one; for in his own work he was no more anxious to be confused with the continental revivalists than in his paintings. As in the case of his illustration work, he was first asked to make designs that would be similar to the modern Germans. When Pusey wrote to him in 1842 asking for 'an emblematic representation of charity' as a design for a church window, he took care to stipulate that it should be 'in the style of the modern German school'.[102] In the design that he made some years later, however, for the Choristers' Window, Ely (Plate 161),[103] there is no trace of any modern German influence. Dyce instead went straight back to the quattrocento and

242

modified the design of one of the panels of Luca Della Robbia's Cantoria. Similarly, when he designed the large east window of St Paul's, Alnwick, for the Duke of Northumberland in 1853 (Plate 162), his basis for the subject of St Paul and St Barnabas preaching at Antioch was the tapestry cartoons and frescoes of Raphael in the Vatican.

According to Stirling Dyce, Alnwick had been intended as a demonstration piece by his father. Above all, Dyce had wished to show how the luminosity and colour of mediaeval stained glass could be restored. Unfortunately his plans to supervise the making of the glass were thwarted since, on the advice of Charles Heath Wilson—Dyce's erstwhile collaborator who aroused much antagonism by arranging for Hess to design windows for Glasgow cathedral[104]—the Duke of Northumberland insisted on the cartoons being sent to the Bavarian Royal Glass Manufactory to be executed.[105]

Just as Dyce had primarily objected to the technique of modern German painters, so he made it clear that it was the technique of German glass painters that he disapproved of. Above all he objected to the quantity of white enamelling that the Germans applied to the backs of the glass panels, since this rendered them opaque rather than translucent and dulled the colouring. To avoid this method being used for the Alnwick window Dyce sent his own colour cartoons and 'most explicit and stringent written directions' which 'tied the glass painters to a particular mode of execution *not* German'.[106] Ironically, the success of the colour at Alnwick became an argument in favour of sending to Germany to have glass made—as in the case of Glasgow. Yet even if Dyce's guidance over colour had been recognized as a British achievement, it might not have initiated a new direction. Ever since Pugin had taken the production of stained glass into his own hands, effects of great brilliance—due to the abandonment of heavy cross-hatching, the separate leading of colours, and the combination of separate layers of coloured and white glass—had been achieved. By 1853 the achievement of greater luminosity—if still something to be insisted upon—was no longer the central issue. Far more important were questions concerning the types of designs to be used.

It was on the issue of design that Dyce's window showed itself to be decisively out of date. For, unlike Pugin and Street, Dyce did not accept that there was any fundamental difference between designing for windows and designing for walls. On 2 February 1853 he wrote to Henry Cole on this point, refuting the latter's suggestion that shading should be avoided in stained glass:

Is there an atom of difference in principle between mural painting and the glass painting of any period you like to name? The conditions of course are reversed; but the same men who thought it proper in mural painting to treat part of a wall as if it were a window, thought it proper in glass painting to treat part of a window as if it were a wall. . . There are architectonic properties in both cases which must be maintained; but the way to do that is not to reduce pictures to flat tints of colour without shadow.[107]

Both the Ely and Alnwick windows are faithful to this viewpoint. Not only do

both show a full use of shading and modelling, but they also retain the notion of the window being a picture to the point of ignoring the interruptions of frame, modelling and leading. The singing figures in the choir window are seen as though through an opening, with heads and arms cut by the frame; in Alnwick figures are cut between different lights of the window.

It seems curious that Dyce, who elsewhere insisted on the necessity of adapting design for the medium should have seemed so insensitive to principles that were emphasized by even the most conservative of window-makers. Even James Ballantine, in his *Treatise on Painted Glass* (1845), insisted on the importance of correct leading and the integration of mullions into designs and criticized the Munich glass-makers for ignoring this.[108] No doubt Dyce's stand was due to him viewing glass painting—as did the Munich artists—as a 'branch of high art' rather than as craft, requiring the same academic training and mimetic expertise as the painting of murals.

This attitude was strictly opposed to that of Pugin and Street, both of whom saw glass painting principally as a craft. When Street read his paper on glass painting before the Ecclesiological Society on 9 June 1852 he recommended that the 'middle pointed' style of stained glass was the best to emulate with its clear separated colours and 'absence of shading and perspective', and criticized modern German glass for attempting to 'copy in glass cartoons intended for oil or fresco':

> So, for instance, in the Munich glass at Cologne, or in the church of S. Maria Hilf at Munich, I think everyone's feeling must be—much as he may admire the magnificence of the offering or the boldness of the attempts—that it would have been much more delightful to see such subjects represented on the walls than essayed in windows.[109]

Street could speak on his subject with authority, having made a tour of Germany in the previous year.[110] Nor was his admiration for the modern Germans as painters feigned, for he had recently executed his murals incorporating designs by Overbeck in the chancel at Shevioke. Yet he felt that, as stained glass was to be seen primarily as architectural decoration, it should be treated in a purely schematic manner. Only the 'simplest' of the old masters—he cited Van Eyck, Memling and 'William of Cologne'—could serve as prototypes. Street's view was shared widely by those designers for stained glass who were most closely associated with the Ecclesiologists after 1850. Even where modern German pictures were used, they were simplified to accord with the medium. This can be seen, for example, in the memorial window to Elizabeth Tovey (Plate 163) executed by James Preedy at Church Lench in Worcestershire in 1858[111] which is based on Overbeck's *Death of St Joseph* (Plate 164).

Street had concluded his paper by calling for 'a little Pre-Raphaelitism' in glass painting. By this he meant a return to the first principles of window design. But within a few years such a call had a more specific application, for in 1857—just one year after the Alnwick window was completed—Burne-Jones made his first design for a window, the *Good Shepherd* (Plate 165). If this work drove Ruskin 'wild with

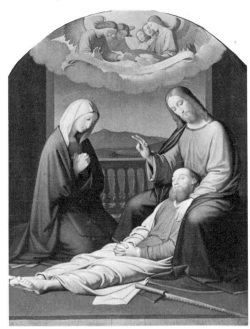

163. (above) F. Overbeck: *Der Tod des Heiligen Joseph* (Death of St Joseph). 1857. Oil (100 × 75). Georg Schäfer Collection, Schweinfurt.

164. (below) F. Preedy: Memorial window to Elizabeth Tovery. 1858. Stained glass. Church Lench, Worcestershire.

165. (right) E. Burne-Jones: *The Good Shepherd*. 1857. Wash and watercolour (129 × 47.5). Design for stained-glass window. Victoria and Albert Museum, London.

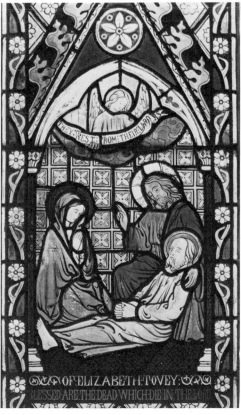

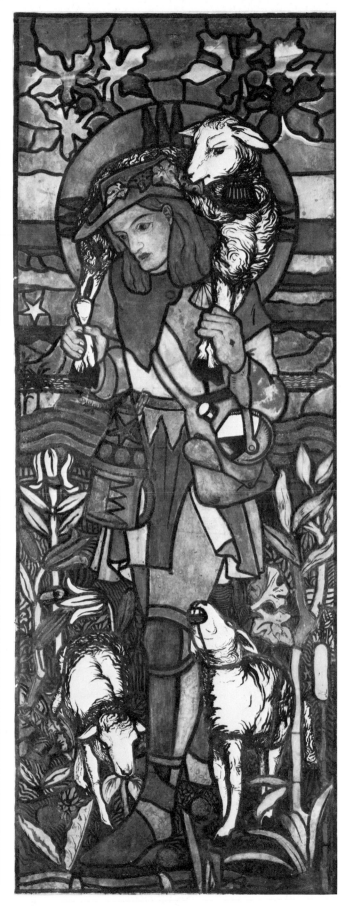

joy' for its representation of Christ as 'a real Shepherd, in such dress as is fit for walking the fields and hills' and for the 'wonderful piece of gothic landscape it contained',[112] it also accorded with the demands of Street in its clarity, separately leaded colours and minimal shading and perspective.

Whether the views of Street (whom Burne-Jones already knew through Morris, who became apprenticed to the architect in 1856) were any direct influence or not, the attitudes of the Pre-Raphaelites turned out to be more in sympathy with the church builders of the fifties than those of the earlier generation of religious artists. This became clear in the course of a debate following the meeting celebrating the twenty-first anniversary of the founding of the Cambridge Camden Society, held in 1860. On this occasion the meeting concluded with a discussion on 'The Tendencies of Praeraffaelitism and its connections with the gothic manner'. Beresford Hope, as chairman, opened the debate on a doubtful note; while he approved of the 'mysticism' of the Brotherhood, he felt that they were hindered by their realist tendencies from giving such sentiments appropriate expression. Consequently,

> as a believer in the spiritualism of gothic art he looked for that school of painting which was a true correlative of that movement not in Praeraffaelitism, but among painters like Dyce and Herbert in England, and on the continent in Overbeck and among painters known as the Düsseldorf school in Germany.[113]

It soon turned out that his opinion was not shared by the painters and architects present. His strongest opponents were Burges, Street and Gambier Parry—the painter who, after having studied at Munich in the 1840s, turned to more primitive sources for his own murals in Ely Cathedral and Highnam parish church.[114] All these saw the Pre-Raphaelites as paralleling the architectural activities of the Camden Society in their 'return to first principles' to 'a pure system of colouring and to nature'. The architects were more impressed by the degree to which artists who strove to use the old masters as a guide rather than as a means of direct emulation paralleled their own creative use of Gothic features, than by the argument that such directness might impair spirituality. Street agreed that the Pre-Raphaelites paid too much attention to detail, but felt certain that, 'if the walls of cathedrals and public buildings were given up to them, they would soon lay aside this fault'.[115] Burges, too, considered that 'we should accordingly now discourage panel-painting and encourage wall-painting'.[116]

Only Street referred to Dyce's murals; and while he did so with courtesy he did not suggest that they provided an example to be followed. It was the murals of the Oxford Union that pointed the way to the future.[117]

The debate—which took place one year after Dyce had completed the All Saints' reredos—must have made hard reading for the artist. While the distinction between the Pre-Raphaelites and the earlier revivalists had been clear from the time of the Brotherhood's earliest exhibited works, and had been raised to a matter of principle by Ruskin, it was a curious irony that the art of these youngest artists should now be championed by members of a society which had always sought to impose ceremonial orthodoxy in devotional art.

246

EPILOGUE

As WITH most movements, that of Germanic tendencies in English art did not come to a sudden end. Long after it ceased to be a topical issue, its effects lingered on. The generation that grew to artistic maturity in the 1840s was still in mid-career in 1861; and, even if most of them had modified their styles considerably by this date, they had not abandoned all their old ways. Some indeed remained very much in the Nazarene mould. William Cave Thomas continued to exhibit works noted for their Germanism as late as 1884. In 1906, the last year of the artist's life, William Michael Rossetti observed that 'in Germany he would long ago have found his proper level and recognition in some professorship of art'.[1] Another dogged Germanist was William Bell Scott, who published the first English book on modern German art as late as 1873.[2]

Indeed, if the measure of interest in German art was its availability, then there would be little reason for suggesting a decline immediately after 1860. The influx of German works into this country had by no means abated in the late 1850s.[3] English patrons continued to purchase works by Overbeck and other Nazarenes after 1860;[4] and, despite growing local opposition, German glass-makers—particularly Mayer of Munich—actually augmented their share of the English ecclesiastical market and persisted right up to the end of the century.[5] In the field of book illustration, some of the Nazarenes and Romantics also increased their representation after 1860. Julius Schnorr's biblical drawings may have been fought over by English connoisseurs in Rome in the 1820s,[6] but it was not until 1860 that the *Bible in Pictures* (Plate 166) appeared in an English edition. This, his first English publication, was followed by six others in the next twenty years. Some of these were further biblical illustrations—illustrations, with E. Bendemann, of the Bible in 1861, and a reissue of the *Bible in Pictures* in 1869. There was also an edition of his *Nibelungen* drawings—*Golden Threads*—in 1880. Other titles in which his work appeared—notably *The Workshop* (1868) and *The Art Workman* (1873)—suggest a more topical association with the concern for the artist craftsman. Another German of the older generation whose English publications blossomed in these years was A. L. Richter (Plate 167). Despite the high reputation he had enjoyed in this country since the 1840s only three English editions of his books were produced before 1860; between 1860 and 1875 there were five: *Nursery Carols* (1862), *The Lord's Prayer* (1870), *As Pretty as Seven* (1872), *Nursery Carols* (2nd edn) (1873) and *Wonder World* (1875).

Nevertheless there were signs that, in spite of this continued activity, the aesthetic impact of German art and art theory was declining. In the first place, the Romantic and Nazarene art that came over in the later period represented little that was new.

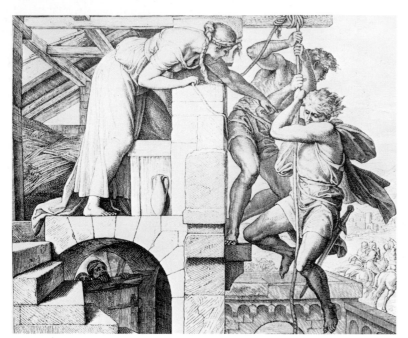

166. *J. Schnorr von Carolsfeld: *The Two Spies escape from the House of Rahab*. From the *Bible in Pictures*, 1860. Wood engraving.

167. *A. L. Richter: *Hansel und Gretel*. Wood engraving.

The artists themselves were at the very end of their careers. The English publications were in fact no more than anthologies and reissues of works that had appeared decades earlier in Germany and had been known to English enthusiasts through English art magazines and print shops for a considerable time.[7] Their emergence in a more accessible form at such a late date suggests rather the time lag between popular and informed taste—as indeed did the current exploitation of the Nazarene style in popular religious prints.[8] It is significant that this period should also have seen a growing awareness in the more exclusive art world of more recent tendencies in Germany—in particular naturalism. Before 1860 little had been known about this in England—beyond an appreciation of the wood engravings after Menzel in Kugler's life of Frederick the Great and the collection of Düsseldorf and Munich landscapes by one or two private individuals.[9] In 1861, however, such art was well to the fore in the Exhibition of the 'German Academy of Art' held at the Piccadilly Galleries.[10] Even more important was the showing of German and Austrian pictures at South Kensington in the summer of 1862 as part of the International Exhibition. Comprising several hundred exhibits, it was probably the largest representation of German nineteenth-century art ever held in this country.[11] In composition it combined a strong representation of the Nazarenes with major examples from a younger generation. Amongst the former, the high point was Cornelius's design for the *Four Horsemen of the Apocalypse*, while amongst the latter, Piloty's *Nero* (Plate 168) revealed a consummate sensationalism that leaned heavily upon the example of French art. As might be expected, this juxtaposition pleased neither the defenders nor the opponents of the German Manner. Writing in the *Art Journal*, Joseph Beavington Atkinson complained that the exhibition had not got enough examples of the 'Modern German School of High Art',[12] and exhorted his fellow countrymen

once more to give their 'profound attention' to such art despite its lack of sensuous appeal:

> Aspiring to the highest range of thought they seem, indeed, somewhat to despise what, in comparison, may appear to pertain but to inferior technicalities. Thus, they condescend not to please; but, on the other hand, they strive to instruct, they seek to elevate, they nobly endeavour to raise the soul to the sublime sphere of heavenly contemplation.

By contrast, he found the 'other schools' of Germany less exceptional. Piloty's vast canvas he conceded was 'a masterpiece', but on the whole he felt that German naturalism had little to offer. By contrast the critic of *The Times* found that it was only the modern works that were in any way remarkable. After mentioning in this context Piloty's *Nero*, Richter's *Handsome Lady*, Knaus's *Funeral in the Forest* and Menzel's *Battle of Hochkirch* (Plate 169) he continued that the visitor will find 'on the whole . . . that eight out of ten of these German pictures have left no impression whatever'.[13] Despite what had been said so often about German ideal art it was a dull, lifeless affair and he concluded that 'It is not probable, so far as we can form an opinion, that this ideal school of Germany will long survive its founders.'

Amongst the idealists only Rethel, 'the most original and powerful designer of the German school', could excite his enthusiasm; but even he couldn't paint. Time was on the side of the anti-idealists, and by 1873 even Atkinson was having to modify his line. In one of his perennial surveys of German art, 'The Present condition of Germany in Contemporary Art' in the *Portfolio*, he conceded:

> Overbeck and Cornelius, when they rendered up their last account, left to posterity fame, but few followers. The men who reign in their stead are not spiritualists after the manner of the Italian Pre-Raphaelites, neither do they make display of muscular Christianity like Michael Angelo and his Teutonic disciple Cornelius; on the contrary, they now give themselves over to Naturalism and realism, and thus add strength to the parties who now rule throughout Europe.[14]

Atkinson was hardly overstating the case, for by this time the academic realism of Piloty had been overtaken in Munich by the more extreme work of the 'Leibl circle' with its overt indebtedness to Courbet. Furthermore, in Berlin Menzel had consolidated the naturalistic style of his early illustrations to the life of Frederick the Great and was producing vast canvases of modern life such as the *Iron Rolling Mill*.[15]

The critical recognition of the changed state of German art was matched by a corresponding decline of interest amongst English artists. Inasmuch as the *avant-garde* looked to contemporary art abroad now, it was to that of France. The early 1860s, after all, was the time when Whistler was settling in London and Poynter was popularizing the style of the French academicians.

Amongst the older generation, those Germanists who stuck doggedly to the Manner—such as Cave Thomas, Bell Scott, Franklin and Selous—gradually sank into obscurity. Only those who modified their style—such as Madox Brown and

Leighton—continued to enjoy notable careers. Leighton's position, indeed, is a remarkable instance of the declining prestige of the Germans. Of all English artists of the mid-century, he was the one who had been most thoroughly educated in the German system. For six years—between 1846 and 1852—he had been centred at Frankfurt studying under that veteran Nazarene Eduard Steinle. Yet, while there remained a certain rigor of draughtsmanship in his mature work that caused critics to refer to his foreign education, his execution and ideals were actually of a very different kind. Already in Rome—where he moved after leaving Frankfurt—he found the Nazarene ideal cold and restrictive. The personal example of Overbeck, in particular, appears to have disappointed him, and there was never any question of his art bearing a serious religious message. His *magnum opus* there, *Cimabue's celebrated Madonna being carried through the streets of Florence*, may have received the praise of Overbeck and Cornelius, but it is quite opposed to their ideals. This is not simply because it is more painterly in execution; it is because it is art, rather than art's function, that is being celebrated in it. Based on the story in Vasari and a reference in Dante it harks back to the days of innocence that the Nazarenes loved. However, it does not show an artist devoutly working for his church, but marching through the streets like a conquering hero, astounding the populace by the evidence of his skill. There is even a hint of irony in the work, too, for in the right corner of the picture there lurks the figure of Dante, who was later to witness Cimabue's eclipse by Giotto. Such a presentation could hardly be more different to that of *The Triumph of Religion in the Arts* (Plate 8), the vast didactic work of Overbeck's that had presided over Leighton as a student in Frankfurt at the Städel. In the younger artist's work what is being celebrated is more the triumph of the arts through religion; the use of a religious genre to display expertise. After successfully showing the work in London in 1855 Leighton repaired to Paris, where the aestheticism in his work became more marked.[16]

Leighton's progress demonstrates that it was not just naturalism that was opposed to the German Manner. There was also a new kind of idealism—less proselytizing and more hermetic—that undermined their position in 'high' art as well. At its most extreme this led to the doctrine of 'Art for Art's sake' in which the notion of the disinterestedness of art led to it being divorced altogether from the real world. Ruskin—a violent opponent of the notion—traced it back to the German development of aesthetics as a discipline.[17] In a sense he was right—perhaps more so than he knew—for the 'disinterestedness' of aesthetic sensations was certainly something that had been pioneered by the German Romantics.[18] Yet it had been French philosophers and writers—Victor Cousin, Gautier and Mallarmé—who had transformed this notion from one of liberation to a recipe for retreat; and it was in this new French guise that it had re-invaded England. The adulation of pure aesthetic sensation not only transformed the activities of contemporary artists—most spectacularly in the case of Whistler—it also led to a re-interpretation of the

168. K. T. Piloty: *Nero among the Ruins of Rome*. 1860. Oil. National Gallery, Budapest.

169. A. Menzel: *Frederick the Great and his Troops at the Battle of Hochkirch*. 1856. Oil (295 × 378). National-galerie, Berlin.

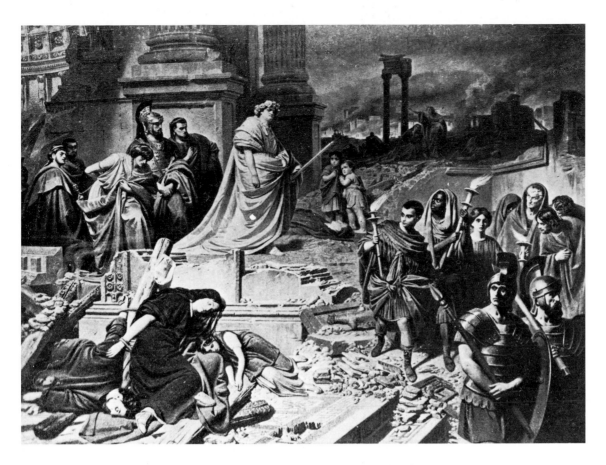

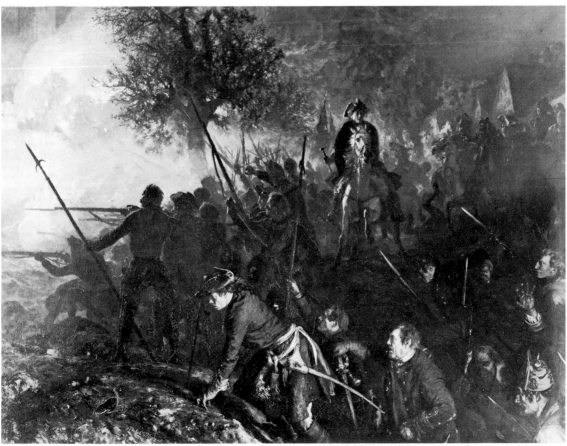

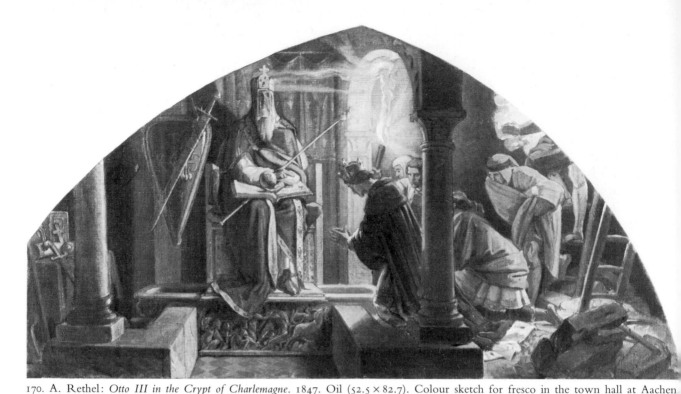

170. A. Rethel: *Otto III in the Crypt of Charlemagne*. 1847. Oil (52.5 × 82.7). Colour sketch for fresco in the town hall at Aachen. Kunstmuseum, Düsseldorf.

past. Through the influence of the writings of J. A. Symonds and Walter Pater the fifteenth century became no longer the period of intense religious faith, but one of pagan aestheticism. Botticelli, rather than Fra Angelico, was now the hero of the age.[19]

If this tendency was opposed to the German Manner, it was hardly contrary to current developments in German idealist art. Just as Menzel and Leibl had established a strong 'naturalist' direction, so Anselm Feuerbach and Arnold Böcklin had innovated a new idealism that was every bit as amoral as the work of aesthetes and Olympians in England. Indeed the immaculate and controlled art of Feuerback is in many ways comparable to the vacuous classicism of Leighton.[20]

It might seem surprising, in view of such analogies, that the new naturalists and idealists in Germany did not arouse more enthusiasm in England. Perhaps this was because English artists had so little need of their example. The new generations of German artists had little—as far as English observers could see—to offer that the French could not offer to a greater degree. Thus, while figures like Piloty, Menzel and Feuerbach received a sympathetic press when their work appeared at the International Exhibitions, they were rarely held up as examples for their English contemporaries.

On the whole one finds that the handful of German artists who did exert an influence in England in the latter part of the nineteenth century did so more on account of their technical expertise than their aesthetic appeal. Almost invariably, too, this influence was exerted in the field of graphic art. It was purely on account of his superlative designs for wood engravings that Rethel was appreciated for so long.

252

Most people who saw his more idealized paintings were disappointed. Ruskin, who was a great enthusiast for *Death the Friend*, pronounced Rethel's Aachen frescoes (Plate 170) to be 'full of power, but wholly valueless' when he saw them in 1859.[21] On the other hand such an unsympathetic commentator on German art as William Sharp could write of Rethel on the basis of his knowledge of the artist's graphic work: 'had he lived (his madness came tragically upon him when he was only forty) he might have been one of the greatest of modern artists. As it is, his drawings and designs have a high value; and their influence has been very considerable.'[22]

Sharp, writing in 1906, was well aware of the excitement that Rethel's work had caused in Pre-Raphaelite circles forty years previously, and the extent to which this had been due to Rethel's apparent revival of the format and ethos of the sixteenth-century woodcut. Indeed the admiration for Rethel must be seen largely as an extension of the concurrent interest for the graphic work of Dürer and Holbein.[23] Like these artists, Rethel represented a more vigorous and realistic form of primitivism than that propagated by the 'purists' in the 1840s.

The new interest in descriptive skill and sincerity caused those German artists of the older generation whose reputations did survive to be seen in a new light. The lyrical work of Schwind and Richter—however sentimental this may now seem—was redeemed by virtue of its unpretentious presentation and its subject matter. Their emphasis upon the life of the people was seen as a healthy antidote to the inflated idealism of the Munich school.[24] And, once again, the quality of the wood engravings through which their work was propagated did much to sustain their reputations. The appreciation of such populist art prepared the way for a more vigorous and irreverent manifestation—the comic pictorial narratives of Wilhelm Busch. Here the lyrical line of the older artists evolved a new expressive plasticity that created a totally new method for the strip cartoon. Appearing first in this country in the anthology *A Bushel of Merry Thoughts* in 1868 (Plate 171), Busch's work ran into twenty-three separate English language editions before 1900.[25]

Busch's art was truly innovatory in a new and developing field of popular art. But by virtue of its very genre it could never rival the reputation of the work of Adolph Menzel. The reputation that this artist achieved with his remarkable illustrations to

171. ★W. Bush: Page from *A Bushel of Merry Thoughts*, 1868. Wood engraving.

Kugler's *History of Frederick the Great* (1840) (Plate 172) became enhanced as graphic artists in England sought to bring a sharper vision and more spontaneous effects into their illustrations. He was emulated by Millais and virtually venerated by Charles Keene.[26] And no commentator doubted that he was the finest of all the German realists. As Sharp wrote in 1906: 'This powerful and original artist is perhaps the greatest whom modern Germany has produced—he is the Goya of Germany. Menzel was the first German Realist.'[27] It is revealing of his status that he should have been the only nineteenth-century German artist—with the exception of Overbeck—to have a monograph on him published in English.[28]

Yet even in the case of Menzel there are limitations to the praise. Much as he was admired as a draughtsman, his painting was viewed in a less enthusiastic light. The observational brilliance and narrative skill that worked so well in the illustrated book seemed to lose conviction when placed on the more demanding level of the independent canvas. When such works as the *Battle of Hochkirch* and the *Iron Rolling Mill* appeared at the International Exhibitions they were praised for their ingenuity, but were felt at the same time to be overelaborate and forced.[29] More and more his naturalism seemed to be at a disadvantage when compared with that of the French. Degas—who himself was a great admirer of Menzel[30]—provided an example of how such stringent observation could be taken beyond the level of narrative to create a new aesthetic. This was certainly the view held by Charles Ricketts when reviewing Singer's monograph on Menzel (Plate 173) in 1906:

A marked affinity between Degas and Menzel survives up to the eighties, when the temperamental difference between the two artists and their nationality asserts itself. Whilst Degas drifts more and more into pattern we detect in Menzel

172. A. Menzel: Illustration from *History of Frederick the Great*, 1840. Wood engraving.

173. (far right) A. Menzel: *The Market Place at Verona*. 1884. Oil (74 × 102). Staatliche Gemäldegaleri, Dresden.

something of the passion to observe merely for its own sake which underlies his vast industry, patience and boundless curiosity. With the great German the thing to say, or the way to say it, becomes too often tangled and confused, and we have works like *The Market Place at Verona* in which the realism has ceased to be genial, and seems to become elaborate and theoretic.[31]

It would be interesting to know which of these developments Ricketts put down to personal and which to national characteristics. Either way the influence is a detrimental one and serves to emphasize that by this time great art was seen as being exceptional, rather than typical, for Germany. The 'elaborate and theoretic' had been so firmly associated with German art in the days when 'mind' was at a supreme premium that they remained the Teutonic norm for those who sought very different qualities in art. Thus while William Bell Scott, 'confessing a very great admiration for German painting, as also for German poetry, and indeed for everything German', praised the 'transcendent theoretical qualities' of German art,[32] William Sharp could use the same equation to arrive at a very different conclusion. Accepting that German artists were 'a congregation of thinkers on life, rather than spectators of life' he added that, 'in the main, Teutonic art in perspective seems far more an intellectual than a strictly artistic development. It has ever lived upon theories, save when lifted by a Dürer of old or a Menzel or a Böcklin today.'[33]

Sharp's perspective is indeed a remarkable one. His suggestion that Dürer was one of the few German artists to avoid theory is almost the exact reverse of the case. That he should have been led to see matters in such a light is a striking instance of the success of the argument in favour of the German Manner in the early nineteenth century.

Yet curiously his further assumption that German art was normally un-exceptional cannot be put down to such local influences. For one finds a similar view being held even by apologists who sought to place German art within an European context. In the twentieth century the greatest of these—Erwin Panofsky—began his monumental book on Dürer reflecting on the fact that Germany, unlike Italy, France, the Netherlands and England, 'has never brought forth one of the universally accepted styles the names of which serve as headings for the chapters of History of Art'. This was due, he felt to the 'curious dichotemy' which marks the German character: 'The Germans, so easily regimented in political and military life, were prone to extreme subjectivity and individualism in religion, in metaphysical thought, and above all, art.'[34] It was this individualism, Panofsky argued, that prevented German art ever achieving 'that standardization, or harmonious synthesis of conflicting elements, which is the prerequisite of universally recognized styles'. On the other hand, this individualism did lead to a rather different kind of contribution:

> thanks to this very same quality [individualism] Germany exerted an international influence by producing specific iconographic types and isolated works of art which were accepted and imitated, not as specimens of a collective style but as personal 'inventions'.[35]

As a refugee Professor Panofsky had strong personal reasons for ascribing the peculiar condition of German art to the 'curious dichotemy' in the German national character. And, while his explanation is more profound and interesting than that of Sharp, it is hardly more convincing.

Today—with less concern for explaining art in terms of national character or seeing phases of art history in terms of national contributions—we are led to reflect more on why it is that art produced in German-speaking countries should have received so little attention abroad. This does not seem to be as much a question of quality as either Sharp or Panofsky would suggest. Certainly most connoisseurs would agree that German art from almost any epoch is undervalued internationally. Perhaps this is simply a matter of taste—an uneasiness at some of the more vigorous features of German art—features that lead to the use of the word 'manner' more readily than 'style'. Yet whatever the reason it is noticeable that the twentieth-century attempts to dismiss the notion of a positive German style accord with the ignorance of this feature in commentaries prior to the nineteenth century. Only in the period covered by this book were German artists admired abroad as a school, rather than as a series of remarkable individuals. It is an admiration that has not stood the test of time; and there must be few, even amongst Germanophiles, who would wish to see this particular judgement reversed. Yet the controversies that the shifts of opinion around this movement involved have laid bare the motives behind it in a particularly instructive way. These motives show how seriously the matter was taken in early Victorian England; and suggest how much the appreciation of a style is at all times a matter of conditioning.

APPENDIX

GERMAN LITERARY, MUSICAL AND HISTORICAL SUBJECTS BY ENGLISH ARTISTS EXHIBITED OR PUBLISHED IN LONDON, 1815–60

THIS APPENDIX has been restricted to publicly exhibited and published works, as it was felt that these would constitute a sufficiently complete group to form a basis for general inferences. This limitation has excluded a number of highly interesting projects—for example the *Undine* drawings and paintings of Fuseli and the *Walpurgis Night* of Richard Dadd. References to such works, however, occur in Chapters I and V.

Figure A on page 264 provides an analysis of the subject matter of works in London exhibitions. As can be seen, there was no sudden increase in the portrayal of German literary, musical and historical themes, although there is a discernible upsurge during the late 1830s. At no time did the number of subjects rival those drawn from English literature and history. On the other hand, the only other modern foreign literature and history to equal it in popularity was that of France (at the Royal Academy in 1840 six English, two German and two French literary themes were exhibited; in 1848 there were eleven English, one German and one French). More significant is the range of subject matter selected and their relative changes in fortune. From the table it can be seen that Goethe, after a slow start, became the undisputed favourite. His *Faust*, depicted thirty-five times, was by far the most popular theme. The next was La Motte Fouqué's *Undine*, which was depicted twenty times. The only other literary subject to reach double figures was Gessner's *Death of Abel*. This was on the wain, however, after its great popularity in the late eighteenth century; and indeed it was only used once as a source after 1837. It is surprising that Bürger's *Lenore*, which remained a favourite with the reading public and which had been illustrated by Blake in the 1790s, should have been used so little as a pictorial source. The musical and historical themes present few surprises. 'Lives of musicians'—especially Haydn, Mozart and Beethoven—were a recurring source. The most popular historical event was the Reformation. At almost all times the number of literary, musical and historical themes was greatly exceeded by the number of views of Germany. The overall figures for both are, respectively, 157 and 860. Again these figures are hardly surprising and are likely to approximate to the overall ratio of subject paintings to landscape. The most remarkable feature of this division—which is demonstrated in Figure B (p. 265)—is the preponderance of views of the Rhineland over views of other parts of Germany. Particularly striking is the sudden leap in the number of views of the Rhine in 1838. Although there were

many publications in the 1830s that helped enhance the popularity of the Rhineland—such as Bulwer Lytton's *Pilgrims of the Rhine* (1834), Mrs Jameson's *Visits and Sketches* (1834) and Stanfield's *Travelling Sketches on the Rhine* (1833)—there seems to be no reason why 1838 should have been the year for such a dramatic increase. The growth of views of other parts of Germany, on the other hand, follows the gentler expansion rate of the literary, musical and historical themes. For the most part these views were of southern German lands, in particular Bavaria, Saxony and Austria.

The overall growth in the number of works relating to Germany cannot simply be taken as an index of popularity. It also reflects a growth in the publishing world and in the number of exhibiting societies. In the case of the latter, the societies cited that were established during this period are: Society of British Artists (1824), New Society of Painters in Water-Colour (1832) and the National Institution (1853). Curiously, the establishment of these societies did not in themselves precipitate a rise in the overall number of German subjects.

ABBREVIATIONS USED IN APPENDIX AND IN NOTES TO THE TEXT

BI	British Institution
E	Engraved by
M	Morgan, B. Q. *A Critical Bibliography of German Literature in English Translation, 1481–1927*, New York and London, 1965 (reprint of 1938 edn.)
NI	National Institution
NSPW	New Society of Painters in Water-Colour
RA	Royal Academy
SBA	Society of British Artists
SPW	Society of Painters in Water-Colour
+	Publication: illustrator's name precedes that of author
★	Engraving after artist named.

APPENDIX

1815
> ‡ Anon. (frontispiece), S. Gessner, *The Death of Abel*, Dean & Munday (M:2306)
> ‡ H. Corbould (frontispiece), Goethe, *Sorrows of Werther*, Lackington (M:2559)

1816
> Mrs Ansley, *The Death of Abel, 'Oh Abel! oh my son!'* (Gessner) (RA:339)

1817
> T. Fielding, *The Death of Abel* (Gessner) (BI:110)
> H. Fuseli, *Chriemhild throwing herself on the body of Sivrit* (RA:265)
> H. Fuseli, *Sivrit . . . surprised by Trony* (RA:304)
> H. Singleton, *Adam and Eve discovering the dead body of Abel* (Gessner) (RA:302)

1818
> † Uwins (frontispiece & title page), S. Gessner, *The Death of Abel*, Walker (M:2307)
> ‡ Cruikshank (frontispiece), Goethe, *The Sorrows of Werther*, Dean & Munday (M:2562)

1819
> H. Singleton, *Adam and Eve discovering the dead body of Abel* (BI:130)

1820
> R. Freebairn, *The Deluge* (Gessner) (RA:1072)
> H. Fuscli, *Chriemhild exposing the body of Siegfried* (RA:131)

1821
> T. Wainewright, *Subject from the Roman of 'Undine'* (Chapter IV) (RA:582)

1822
> ‡ Anon.(12), *Surprising Travels—Adventures of Baron Münchhausen*, Jones (M:6563)

1823
> + G. Cruikshank(12), M. M. Grimm, *German Popular Stories*, Baldwyn (M:3133)
> T. Wainewright, *An attempt from the 'Undine' of De La Motte Fouqué* (Chapter XIII) (RA:301)
> J. Wood, *Adam and Eve lamenting over the dead body of Abel* (RA:301)

1824
> + G. Cruikshank, L.C.A. de Chamisso de Boncourt, *Peter Schlemihl—from the German of La Motte Fouqué*, Whittaker (M:1087)
> W. Ross, *Die Minnesingerinn* (SBA:202)
> J. Wood, *Adam and Eve lamenting over the dead body of Abel* (BI:189)

1825
> T. Cheeseman, *From a German story* (SBA:610)
> C. Heath, After Retzsch (Goethe, *Faust*) (SBA:581)
> T. Wainewright, First idea of a scene from *Der Freischutz* (RA:262)
> J. Wood, *Adam and Eve lamenting over the dead body of Abel* (BI:335)

1826
> S. W. Arnald, (?)Sketch for the *Death of Abel* (sculpture) (RA:1051)
> T. Cheeseman, *From a German story* (SBA:556)
> J. Johnson, *Fairy scene* (Wieland, *Oberon*) (RA:100)
> Miss E. Jones, (?)*The Christian captive of Drachenfels* (BI:29)
> E. G. Physick, *Adam and Eve discovering the body of Abel* (RA:1097)

1827
> ‡ A. Crowquill (ps.), W. F. von Kosewitz (ps.), *Eccentric Tales*
> T. von Holst, *Witches hastening to the Harzgebirge* (RA:604)
> F. Howard, *Incantation* (Weber, *Oberon*) (RA:361)
> E. G. Physick, *Adam and Eve discovering the body of Abel* (SBA:852)
> P. C. Wonder, Scene in *Der Freischutz* (BI:95)

1828
> T. von Holst, *Faust and Margaret—Garden scene* (RA:335)
> T. von Holst, Sketch for the Bohemian *Legend of the Twelve Sleeping Virgins* (RA:530)

1829
> J. Kendrick, *Adam and Eve lamenting over the dead body of Abel* (sculpture) (SBA:856)

259

APPENDIX

1830

⋆+ Anon., *The Remarkable Life of Dr Faustus*, Mason (M:A.138)

 F. Howard, *Weber's overture to 'Oberon'* (RA:355)

1831

 R. Westall, *Margaret at Church, tormented by the Evil One* (RA:I)

 R. Westall, *Faust preparing to dance with the young witch at the festival in the Harz Mountains* (RA:33)

 J. Wood, *Adam and Eve lamenting over the dead body of Abel* (SBA:352)

1832 Nil.

1833

 H. Fuseli, *Scene from a German romance* (S. B. A. Winter Loan Exhibition (25)—owner A. Watts)

 T. von Holst, *Scene from Goethe's Faust* (BI:409)

 J. Zeitter, *Carl Moor* (Schiller, *Robbers*) (SBA:462)

1834

+ Anon., W. Thoms, *Lays & Legends of Germany*, Cowie (M:C.537)

+ A. Crowquill (ps.), *Faust: A Serio-Comic Poem*, King (M:2842)

 T. von Holst, *The seducer* (Goethe, *Clavigo*) (RA:467)

 T. von Holst, *Faust in his study* (RA:483)

1835

 J. R. Herbert, *Margaret—'My poor shattered reason'* (BI:262)

1836

 J. Tenniel, *The Minstrel—from a German romance of the fifteenth century* (SBA:538)

1837

 W. Beattie, *Adam and Eve lamenting the death of Abel* (BI:450)

 W. H. Kearney, *Luther's conference with Cardinal Catejan* (NSPW:138)

 Miss M. Pickersgill, *Thekla at the tomb of the Piccolomini* (Schiller, *Wallenstein*) (RA:588)

1838

 T. von Holst, *The Dice—'Umgebt ihn ihr Geister'* (SBA:430)

 R. R. McIan, *Dietrich von Weiler a German knight of the confederacy called 'Brothers of the Mace', arming for the Faustrecht of Weinsberg, 1491* (SBA:312)

 R. R. McIan, *Scene from Götz von Berlichingen—Adela and Weislingen* (BI:110)

 Mrs Seÿffarth, *Gemile—Andronikos von Seyffarth* (SPW:52)

1839

 S. Bendixen, *Margareta* (Goethe, *Faust*) (SBA:569)

 W. Bewick, *Rudolph the Brave* (RA:564)

‡ G. Cruickshank, M. M. Grimm, *Gammer Grethel*, Green (M:3134)

 J. Hollings, *Margaret alone at her spinning wheel* (RA:275)

 R. R. McIan, *Dietrich von Weder arming for the Faustrecht of Weinsberg, 1491* (BI:364)

 J. B. Walsh, *Itha von Toggenburg—from a German romance* (RA:1098)

 H. Warren, *From a German ballad* (NSPW:283)

1840

 T. von Holst, *Bettina, still in memory beams . . .* (BI:11)

 T. M. Joy, *Faust and Gretchen* (BI:267)

 H. O'Neil, *Margaret before the image of the Virgin* (RA:376)

 P. F. Poole, *Herman and Dorothea* (RA:402)

 H. Warren, *Der Goldschmidt* (NSPW:294)

 H. Warren, *Der König in Thule* (NSPW:170)

1841

‡ F. Corbaux, *Cousin Natalia's Tale*, Cundall (M:C.426)

 J. Lies, *The Minstrel . . . trans. from a German MS. poem* (RA:842)

 H. F. Oakes, *Faust in meditation* (BI:183)

 H. O'Neil, *Thekla at the Grave of Max. Piccolomini* (Schiller, *Wallenstein*) (RA:159)

 H. O'Neil, *Maiden simplicity á la manière de Goethe . . . Margarete pflücht eine sternblume* (BI:169)

APPENDIX

1842

B. Jacker, *Marguerite* (Goethe, *Faust*) (RA:176)
W. H. Kearney, *Richard, coeur de lion, arrested at Berlin, A.D. 1192* (Hume, Vol. II) (NSPW:224)
P. F. Poole, *Margaret alone at her spinning wheel* (RA:389)
J. C. Zeitter, *Wallenstein's Camp* (Schiller) (SBA:112)

1843

‡Chr. Schmidt, *The Red Breast and Other Tales*, J. Burns (M:8307)
A. E. Chalon, *Undine* (portrait of Lady C. Villiers) (RA:1013)
Miss Gordon, *Illustrations to Undine*
H. N. O'Neil, *Margaret at her spinning wheel* (SBA:86)
‡H. Selous, F. de la Motte Fouqué, *Sintram and his Companions*, J. Burns
J. M. W. Turner, *The Opening of the Walhalla, 1842* (RA:14)
J. M. W. Turner, *Light and Colour* (Goethe, *Theory*) (RA:385)
E. H. Wehnert, *Martin Luther reading to his friends the manuscript of one of his pamphlets
 against the abuses of the Romish Church* (M. Michelet, *Memoirs de Luther*) (NSPW:343)

1844

‡Anon., *Popular Tales*, J. Burns (M:C.457)
R. S. Lauder, *Undine* (RA:367)
D. Maclise, *Scene from Undine* (Chapter IX) (RA:277)
R. McInnes, *Luther listening to the sacred ballad* (RA:558)
J. C. Schetsky, *Embarkation of the King of Prussia at Danzig 1st July 1842 . . . sketched on the
 spot* (RA:587)
‡H. C. Selous, et al., F. de la Motte Fouqué, *Wild Love*, Lumley (M:1658)

1845

‡Anon., *German Ballads, Songs, Etc.*, Lumley (M:C.153)
‡Anon., M. M. Grimm (adapted), *Unlucky John*, Dean & Munday (M:3424)
‡E. Corbould, F. de la Motte Fouqué, *Minstrel Love*, J. Burns (M:1720)
‡E. Corbould, F. de la Motte Fouqué, *Thiodolf the Icelander*, J. Burns (M:1686)
‡J. Tenniel, F. de la Motte Fouqué, *Undine*, J. Burns (M:1768)

1846

‡Anon., F. de la Motte Fouqué, *The Two Captains*, Lumley (M:1685)
J. E. Collins, *Leonora—'Alas for her that loveth'* (SBA:352)
‡R. Doyle, M. M. Grimm, *The Fairy Ring*, Murray (M:3135)
T. Jones-Barker, *Faust and Margaret* (Goethe, *Faust*) (BI:456)
W. Rimer, *Scene from Undine—The mysterious discovery of Berthalda's parentage* (BI:282)
E. H. Wehnert, *Providential escape of Henry IV, Emperor of Germany* (NSPW:210)

1847

J. Absolon, *Rustic courtship (Tales of the Black Forest)* (NSPW:276)
C. Jackson, *Ginevra* (Schiller) (SBA:16)
R. J. Lewis, *The death bed of Mozart* (Holmes) (RA:182)
R. J. Lewis, *An incident in the life of Mozart* (Holmes) (RA:1136)
Miss J. Macleod, *The Erl King* (Goethe) (BI:331)
‡D. Maclise, G. A. Bürger, *Leonora*, Longmans (M:865)
H. Pickersgill, *Faust in Margaret's prison* (RA:420)
A. J. Woolmer, *A pastoral* (Schiller, trans. Bulwer) (SBA:399)

1848

S. Bendixen, *Scene from Goethe's Faust—The friar claims for the church the trinkets given to
 Gretchen by Faust* (BI:270)
G. Cattermole, *Scene from the story of Sintram* (SPW:331)
W. Deverell, *Margaret in prison, visited by Faust* (RA:601)
W. C. T. Dobson, *Undine von Ringstettin* (RA:510)
‡H. C. Selous, *Sintram and his Companions*, Lumley (M:1725)

APPENDIX

APPENDIX

‡ J. Franklin, F. de la Motte Fouqué, *The Four Seasons*
 E. Rowley, *Charlotte and Werther* (NI:13)
 W. B. Scott, *Albert Dürer in Nuremberg* (NI:263)
‡ G. Thompson, M. M. Grimm, *Home Stories*, Routledge (M:3142)
 T. Uwins, *In a wood—Ferdinand Freiligarth* (RA:10)

1856
 V. Bouvier, *Marguerite* (Goethe, *Faust*) (SBA:242)
 F. W. Burton, *A tale—Beggars of Oberfranken* (SPW:222)
‡ C. Keene, et al, H. W. Dulcken, *The Book of German Songs*, Ward (M:C.106)
 W. B. Kirk, *Faust and Margaret* (sculpture) (RA:1291)
 H. le Jeune, *(?)Little Gretchen* (BI:246)
 J. Morgan, *Beethoven on his Journey to Vienna* (RA:1050)
 A. Munro, *Undine* (marble sculpture) (BI:545)
 H. P. Parker, *Innocent Love* (Heine, *Reisebilder*) (BI:308)
 W. A. Smith, *Undine* (NI:457)
 Mrs H. Taylor, *Margarete* (Goethe, *Faust*) (NI:384)

1857
‡ Anon., *Voices from the Greenwood*, Bell (M:A.568)
 F. W. Burton, *Faust's first sight of Margaret* (SPW:130)
 T. M. Joy, *The Love Test—a German legend* (RA:520)
 W. Kümpel, *Margaret* (Goethe, *Faust*) (RA:415)
 Mrs M. Robinson, *Margaret and Lizzie* (Goethe, *Faust*) (RA:151)
 ★F. Stone, *(?)Margaret* (E:Simmons)
 F. Stone, *Margaret—'My peace is gone'* (RA:190)

1858
 H. H. Armstead, Design for a medal to commemorate the marriage of Prince and
 Princess Frederick Wilhelm of Prussia (RA:1005)
 F. Danby, *(?)Death of Abel* (RA:290)
 S. B. Hallé, *Margaret—'My peace is gone'* (BI:530)
 J. S. Hodges, *Undine* (BI:485)
 F. Leighton, *The fisherman and the syren* (Goethe) (RA:501)
 J. Morgan, *Mozart's last Chorus* (SBA:115)
 A. Munro, *Undine* (marble sculpture) (RA:1255)
 J. Noble, *It is said about this time Albert Dürer presented a fine picture to his friend Luther*
 (D'Aubigny) (SBA:64)
 ★F. Wyburd, *Luther's Hymn* (E:F. Hunter)

1859
 + Anon., F. de la Motte Fouqué, *Undine*, Bell (M:1776)
 + A. Crowquill (ps.), *The Travels and Surprising Adventures of Baron Münchausen*, Trübner (M:6571)
 W. C. T. Dobson, *Der Rosencranz* (RA:316)
 C. F. Fuller, *Undine* (RA:1329)
 J. E. Hodgson, *The German patriot's wife in 1848* (RA:540)
 Mrs E. M. Ward, *An incident in the childhood of Frederick the Great of Prussia* (Carlyle) (RA:30)
 D. W. Wingfield, *Undine and Huldbrand* (RA:675)
 F. Wyburd, *Undine discovering herself to . . . Huldbrand* (RA:666)

1860
 + A. Crowquill, *The Marvellous Adventures and Rare Conceits of Master Tyll Owlglass* (M:A.80)
 W. C. T. Dobson, *Die Heimkehr* (RA:81)
 W. Field, *Choristers feeding the poets of the air at the tomb of Walter von der Vogelweide* (RA:160)
 G. E. Tuson, *Handel composing the Harmonious Blacksmith* (SBA:372)

FIGURE A

ANALYSIS OF GERMAN LITERARY AND HISTORICAL THEMES IN WORKS EXHIBITED IN LONDON, 1815–60

Column key (each leading dot marks the column position):

- Bürger—*Lenore*
- . Gessner—*Death of Abel; Deluge*
- . . Goethe—*Faust*
- . . . Goethe—other works
- La Motte Fouqué—*Undine*
- La Motte Fouqué—other works
- *Nibelungen*
- Schiller—*Wallenstein; Robbers; Ballads*
- Weber—*Oberon; Freischutz*
- Wieland—*Oberon*
- Others (Literature)
- Gutenberg and early Printers
- Luther and Reformation
- Musicians' Lives
- Others (Historical)

Year	Bürger *Lenore*	Gessner	Goethe *Faust*	Goethe other	La Motte *Undine*	La Motte other	*Nibelungen*	Schiller	Weber	Wieland	Others (Lit.)	Gutenberg	Luther	Musicians	Others (Hist.)	Total
1815																0
1816	1															1
1817		2			2											4
1818																0
1819		1														1
1820		1			1											2
1821				1												1
1822																0
1823		1		1												2
1824		1						1								2
1825		1	1					1		1						4
1826		2					1	2								5
1827		1	1				2									4
1828		1						1								2
1829		1														1
1830								1								1
1831		1	2													3
1832																0
1833		1			1			1								3
1834		1	1													2
1835		1														1
1836								1								1
1837		1			1								1			3
1838				1							2		1			4
1839				2							3		1			6
1840			2	2							2					6
1841				2	1						1					4
1842				2	1									1		4
1843		1	1	1									1	1		5
1844				2									1	1		4
1845																0
1846	1	1		1										1		4
1847		1	1		1						2		2			7
1848		2		1	1											2
1849		2		2										1		5
1850			1						1							2
1851				1	2											3
1852		1		1			1				1	1	1	1		7
1853		1		1							2		3			7
1854		2		1							2		2	1		8
1855			1								1				1	3
1856			4	2							2		1			9
1857		4									1					5
1858	1	1	1	2								1	1	1		8
1859			3								1			2		6
1860											2			1		3
Total	1	15	35	10	20	1	3	7	4	2	28	2	10	8	11	157

FIGURE B

NUMBER OF VIEWS OF THE RHINELAND COMPARED
TO THOSE OF OTHER PARTS OF GERMANY

FIGURE C

OVERALL NUMBER OF
PICTURES WITH German
SUBJECTS EXHIBITED IN
LONDON, 1815–60

	Rhineland / Other	Year	No.	Proportion of total number of works exhibited to nearest .1%
	3 / 0	1815	8	.5
	0 / 0	1816	3	.2
	0 / 0	1817	5	.3
	0 / 0	1818	3	.2
	0 / 1	1819	7	.4
	0 / 1	1820	3	.2
	2 / 1	1821	4	.2
	6 / 0	1822	7	.4
	7 / 2	1823	10	.6
	7 / 5	1824	17	.7
	6 / 1	1825	12	.5
	4 / 3	1826	12	.5
	6 / 3	1827	15	.5
	2 / 1	1828	10	.3
	9 / 2	1829	16	.5
	6 / 6	1830	14	.5
	8 / 5	1831	16	.5
	10 / 6	1832	16	.4
	12 / 2	1833	17	.5
	7 / 5	1834	14	.4
	12 / 2	1835	15	.5
	10 / 11	1836	22	.7
	13 / 9	1837	25	.7
	36 / 8	1838	51	1.5
	29 / 13	1839	50	1.5
	34 / 8	1840	49	1.6
	32 / 4	1841	56	1.8
	21 / 4	1842	38	1.2
	28 / 7	1843	50	1.4
	30 / 6	1844	47	1.5
	22 / 4	1845	38	1.2
	27 / 9	1846	51	1.5
	21 / 5	1847	44	1.3
	20 / 6	1848	39	1.1
	17 / 3	1849	41	1.2
	15 / 12	1850	35	1.0
	17 / 4	1851	32	1.0
	12 / 10	1852	38	1.1
	22 / 9	1853	40	1.1
	25 / 9	1854	51	1.9
	28 / 11	1855	46	1.3
	13 / 9	1856	29	.9
	17 / 4	1857	36	1.0
	15 / 10	1858	42	1.2
	9 / 9	1859	43	1.2
	14 / 9	1860	39	1.1

631 239

NOTES TO THE TEXT

NOTES TO THE INTRODUCTION

1. T. S. R. Boase, 'The Decoration of the Palace of Westminster', *The Journal of the Warburg and Courtauld Institutes*, 1954, pp. 319–58; Q. Bell, *The Schools of Design*, 1963; Q. Bell, *Victorian Artists*, 1967, ch. II.

2. K. Andrews, *The Nazarenes: A Brotherhood of German Painters in Rome*, Oxford, 1964; for the influence of the Nazarenes abroad, see especially ch. VI.

3. V. Plagemann, *Das deutsche Kunstmuseum, 1790–1870*, Munich, 1967, pp. 109, 115.

4. J. B. Flagg, *The Life and Letters of Washington Allston*, New York, 1892, p. 311.

5. H. Riegel, *Geschichte der Wandmalerei in Belgien seit 1856*, Berlin, 1882, pp. 5ff.

6. *Salon de 1846*, XIII, 'de M. Ary Scheffer et des singes du sentiment'; see C. Baudelaire (ed. Pichois), *Critique d'Art*, Paris, 1965, pp. 152–3.

7. See G. Berefeld, *Philipp Otto Runge zwischen Aufbruch und Opposition*, Stockholm, 1961, pp. 164ff; W. Sumowski, *Caspar David Friedrich Studien*, Wiesbaden, 1970, p. 230.

8. *Art Union*, 1839, p.136.

9. See p. 94.

10. e.g. J. C. Dafforne, 'William Dyce', *Art Journal*, 1860, pp. 293–6.

11. Commonly referred to as the 'Fine Arts Commission'.

12. 'Dyce Papers', City Art Gallery, Aberdeen, p. 338.

13. Reprinted in C. L. Eastlake, *Contributions to the Literature of the Fine Arts*, 2nd series, 1870, pp. 37–8.

14. B. R. Haydon (ed. W. B. Pope), *The Diary of Benjamin Robert Haydon*, Cambridge, Mass., 1963, V, p. 79.

15. R. Wornum, *The Epochs of Painting*, 1847, pp. 500–2.

16. A. J. Finberg, *The Life of J. M. W. Turner*, 2nd edn., 1961, p. 311.

17. H. Sass, *A Journey to Italy, 1817*, 1818, p. xlix.

18. H. G. Clarke, *A Critical Examination of the Cartoons, Frescos and Sculptures exhibited in Westminster Hall*, 1844, pp. 56–7.

19. H. Beeley, *Disraeli*, 1936, pp. 56ff.

20. e.g. J. Severn in a letter to S. Kirkup, 20 August 1833: 'a frenchman said Somerset House looked like an exhibition of fireworks'. Keats-Shelley Memorial, Rome.

21. A. B. Jameson, *Visits and Sketches at Home and Abroad*, 1834, I, p. 300.

22. Bell, *Schools*, pp. 57–60.

23. F. K. Hunt, *The Book of Art*, 1846, p. 145.

24. Now destroyed, but reproduced in *Fresko-Gemälde aus der Geschichte der Bayern . . . in den Arcaden des Hofgartens zu München*, Munich, 1829.

25. F. K. Hunt, pp. 2–3.

26. See pp. 85ff, 180ff.

27. Plagemann, p. 33.

28. Parliamentary Papers, 1842, XXV, pp. 105ff. The story told by Madox Brown in his lecture 'Style in Art' that Cornelius told Prince Albert, 'What need have you of Cornelius to come over to paint your walls when you have Mr Dyce?' (F. M. Hueffer, *Ford Madox Brown*, 1896, p. 36), is not substantiated by any contemporary reports.

29. See especially D. Scott, *British, French and German Painting*, Edinburgh, 1841.

30. Catalogues reprinted in Hunt, *Book of Art*.

31. *Art Union*, 1842, p. 142.

32. G. Burne-Jones, *Memorials of Edward Burne-Jones*, 1906, I, p. 255.

33. Hueffer, p. 45.

NOTES TO CHAPTER I

1. e.g. Sir Joshua Reynolds (ed. Wark), *Discourses on Art*, San Marino, 1959, pp. 108, 160.

2. G. Vasari (trans. Du Vere), *Lives of the Artists*, 1912–14, IV, p. 93; The Rhyme of Veit the sculptor is cited, with translation, in M. Baxandall, *South German Sculpture, 1480–1530*, Victoria and Albert Museum, 1974, p. 21.

3. See R. Cooper, 'British Attitudes towards the Italian Primitives', D. Phil., Sussex, 1976, pp. 31–3.

4. M. Pilkington (ed. Fuseli), *A Dictionary of Painters*, 1805, I, p. 169.

5. *Modern Painters*, 1843, I, pt II, sec. VI, ch. I, g10 (Library edn., III, p. 185).

6. *Art Union*, 1839, p. 136.

7. While Menzel's illustrations to Kugler's *Geschichte Friedrichs des Grossen* (Berlin, 1840) were known in England from the year of their publication, it was in the 1850s that he began to exert a strong influence on British illustrators – notably Charles Keene (G. S. Layard, *The Life and Letters of C. S. Keene*, 1893, p. 26).

Wäldmüller's paintings achieved a passing fame in England when he held an exhibition at Buckingham Palace in 1857. One of his paintings, *The Happy Grandmother*, was acquired by Queen Victoria. It is now at Osborne. Prince Albert collected German landscapes from 1842, when he acquired W. Kausse's *View of the Coast*. A number of Munich and Düsseldorf landscapes were recorded in English collections by Waagen in 1851. The most notable of these was that of the Revd C. H. Townshend, which was subsequently bequeathed to the Victoria and Albert Museum in 1868 (C. M. Kauffmann, *Catalogue of Foreign Paintings, Victoria and Albert Museum, London*, 1973, II, pp. vii–viii).

8. See p. 11.

9. See F. Wild, *Gemälde von F. & H. Winterhalter*, Zürich, 1894.

10. For the German community in England then, see C. R. Hennings, *Deutsche in England*, Stuttgart, 1923, chs. VII and VIII.

11. E. J. Passant, *A Short History of Germany, 1815–1945*, Cambridge, 1962, p. 62.

12. *Lady Hamilton's Attitudes* (engr. Piroli), Rome, 1794.

13. V. C. Habicht, *Niedersächsische Kunst in England*, Hanover, 1930, pp. 86ff.

14. L. C. Pickert, 'Die Brüder Riepenhausen, Darstellung ihres Lebens bis zum Jahr 1820', Ph.D., Leipzig, 1950.

15. O. Millar, *The Later Georgian Pictures in the Collection of H.M. The Queen*, 1969, pp. xxvii, xxxi, xxxix.

16. Thieme-Becker, XIV, 1921, pp. 491–2.

17. K. Jagow, *Letters of the Prince Consort*, 1938, p. 106.

18. *Catalogue of the Principal Items on View at Osborne House*, 1966, p. 12, no. 17 (not identified). The two pictures bear Ferdinand Olivier's monogram, and tally with two scenes from a cycle exhibited at Berlin in 1827 (L. Grote, *Die Brüder Olivier und die deutsche Romantik*, Berlin, 1938, p. 388). Apparently there is no record of how these pictures entered the Royal Collection (communication from Oliver Millar).

19. A. Kestner, *Römische Studien*, Berlin, 1850, pp. 171–5.

20. Jagow, p. 108.

21. See p. 6.

22. T. Martin, *The Life of H.R.H. the Prince Consort*, 1875, I, p. 27.

23. For listing of German works, see Appendix II of W. Vaughan, 'The German Manner in English Art, 1815–55', Ph.D., London, 1977.

24. Andrews, p. 126.

25. W. Ames, *Prince Albert and Victorian Taste*, 1967, p. 104.

26. *Art Journal*, 1858, p. 324.

27. Schwind letter to Konrad Jahn, 22 February 1850

(M. von Schwind (ed. Stoessl), *Briefe*, Leipzig, 1924, p. 250).

28. Ames, pp. 142 n.1, 144.

29. The Subjects were as follow:

'Historical'

Armitage	*Battle of Meeanee* (*Art Journal*, 1855, p. 152)
Cope	*Cardinal Wolsey Dying at Leicester Abbey* (*Art Journal*, 1859, p. 264)
Leitch	*Birth of Belphoebe and Amorett* (*Art Journal*, 1857, p. 312)
Maclise	*Undine* (*Art Journal*, 1855, p. 114)
Maclise	*Gil Blas* (*Art Journal*, 1859, p. 138)
Uwins	*Cupid and Psyche* (*Art Journal*, 1855, p. 138)
Van Eychen	*Charity* (*Art Journal*, 1857, p. 32)
Wappers	*Theomeganck at Antwerp* (*Art Journal*, 1860, p. 142)
Delaroche	*The Rock at St Helena* (*Art Journal*, 1860, p. 360)

'Religious'

Corbould	*Go and Sin no More* (*Art Journal*, 1856, p. 232)
Dyce	*Madonna and Child* (*Art Journal*, 1855, p. 76)
Dobson	*The Almsdeeds of Dorcas* (*Art Journal*, 1859, p. 212)
Eastlake	*The Good Samaritan* (*Art Journal*, 1858, p. 13)
Hensel	*Miriam* (*Art Journal*, 1856, p. 192)
Steinle	*St Luke Painting the Virgin* (*Art Journal*, 1856, p. 344)

30. J. L. Roget, *History of the Old Water-Colour Society*, 1891, pp. 385–6.

31. G. Schiff, 'Theodore von Holst', *Burlington Magazine*, 1963, CV, pp. 23–32.

32. Thieme-Becker, xxix, 1935, pp. 582–3.

33. R. Chapman, *The Laurel and the Thorn*, 1945, p. 12.

34. H. Stokes, 'J. F. Lewis', *Walker's Quarterly*, 1929, no. 28, p. 6.

35. E. K. Waterhouse, *Painting in Britain, 1530–1790*, 3rd edn., 1969, p. 7.

36. P. O. Runge, *Hinterlassene Schriften*, Hamburg, 1840, II, p. 501.

37. M. Howitt, *Friedrich Overbeck*, Freiburg, 1886, I, p. 211.

38. J. Joll, 'Prussia and the German Problem' in *The Zenith of European Power*, The New Cambridge Modern History, X, Cambridge, 1960, p. 494.

39. Passant, p. 75.

268

40. L. Schleier (pseud.), *Das Merkantilische Hamburg*, Hamburg, 1838, p. 5.

41. G. F. Waagen, *Works of Art and Artists in England*, 1838, I, p. 6.

42. Runge, p. 131.

43. I. M. Speckter, *Verzeichniss der Kupferstich Sammlung*, Hamburg, 1822; copy in Kunsthalle, Hamburg (Lugt 10233).

44. *Katalogue der Meister des 19. Jahrhunderts in der Hamburger Kunsthalle*, Hamburg, 1969, p. 11.

45. The poet Heinrich Heine was fêted when he came to London in 1827 not on account of his poetry, but because he was the nephew of the celebrated Hamburg merchant Salomon Heine (S. Liptzin, *The English Legend of Heinrich Heine*, New York, 1954, p. 9).

46. R. Lehmann, *An Artist's Reminiscences*, 1894, pp. 156–7.

47. C. Gurlitt, *Die deutsche Kunst des Neunzehnten Jahrhunderts*, Berlin, 1899, p. 146.

48. F. K. Hunt, pp. 118, 121, 179.

49. A. Lichtwark, *Hermann Kauffmann und die Kunst in Hamburg*, Hamburg, 1895, p. 29.

50. Thieme-Becker, 1909, III, p. 302.

51. A. Lichtwark, *Hamburger Aufsätze*, Hamburg, 1917, pp. 121ff.

52. For Dobson, see *Art Journal*, 1898, p. 94; for Bottomley, see Thieme-Becker, 1910, IV, p. 423.

53. R. Lehmann, p. 33.

54. The fullest inventory of this literature can be found in the notes of G. Syamken, 'Die "Tageszeiten" von Philipp Otto Runge und "The Book of Job" von William Blake', *Jahrbuch der Hamburger Kunstsammlungen*, 1975, XX pp. 61–70.

55. *Ibid*.

56. Berefeld, p. 25.

57. H. C. Robinson (ed. T. Sadler), *Diary, Reminiscences and Correspondence*, 3rd edn., 1872, I, pp. 122ff.

58. *Ibid*, p. 156.

59. Runge, I, pp. 355–61.

60. I am most grateful to Dr David Bindman for drawing my attention to this information.

61. Robinson's papers are now in Dr Williams' Library, University of London. H. Marquardt, *Henry Crabb Robinson und seine deutschen Freunde*, Göttingen, 1964, I, pp. 17–20.

62. Runge, II, pp. 59, 131.

63. G. A. Bürger (trans. Stanley), *Leonora*, 1796.

64. The words 'Perthes, Hambro' are written on the page of a notebook kept by Miss Flaxman during her stay in Germany with the Hare Naylors in 1804–6 (B. M. Add. MS. 39, 792 B, p. 2).

65. Berefeld, p. 166.

66. *Vaterlandisches Museum*, II, heft I, 1811, p. 108.

67. Robinson, *Diary*, 1872, I, p. 124.

68. Marquardt, 1967, II, pp. 110–11.

69. *Ibid*, pp. 77–9.

70. Mention of a 'Briefe an Aders' occurs in Sulpiz Boisserée's diary on 20 February 1823 (Stadtarchiv, Cologne). Unfortunately other sections of this diary are not at present available for study.

71. Marquardt, II, p. 57.

72. The dates of the sales are: 22 May 1833, Fosters (Prints and Drawings); 1 August 1835, Fosters; 26 April 1839, Christie's. The only modern German works that Aders is known to have possessed were the Strixner Lithographs of the Boisserée collection (Henry Crabb Robinson Diary, MS. in Dr Williams' Library, University of London, 22 January 1819).

73. A. von Wolzogen, *Aus Schinkels Nachlass*, Berlin, 1863, III, p. 33.

74. J. D. Passavant, *Kunstreise durch England und Belgien*, Frankfurt, 1833, pp. 92–8.

75. Crabb Robinson accompanied Götzenberger to Blake's lodgings on 2 February 1827 (Robinson Diary, MS.).

76. A. Raczynski, *Histoire de l'art moderne en Allemagne*, 1836, I, pp. 270–2.

77. Friedrich Olivier had made a brief appearance as a successful *Freiheitskrieger* in 1814, but does not appear to have met any English artist on this occasion (Grote, pp. 109–10).

78. See p. 36.

79. D. E. Williams, *The Life and Correspondence of Sir Thomas Lawrence, Kt.*, 1831, II, p. 140.

80. 1827 (RA: 1067).

81. M. Wilson, *The Life of William Blake*, 1927, p. 313.

82. Williams, II, p. 140.

83. For Flaxman's admiration of Cornelius, see *Kunstblatt*, 1827, p. 118.

84. Now in the Houghton Library, Harvard College (G. E. Bentley, *Blake Records*, Oxford, 1969, p. 338).

85. Staatliche Museen, Berlin, Kupferstichkabinett, Götzenberger, Nr. 2–4.

86. See Letter from Götzenberger to Crabb Robinson, 9 October 1832 (Henry Crabb Robinson Correspondence in Dr Williams' Library, University of London).

87. Götzenberger decorated the spandrels of the Saloon in Bridgewater House with representations of the muses and virtues after the accession of the second Lord Ellesmere in 1857 (*Survey of London*, 1960, XXX, pt I, p. 497).

88. W. B. Scott, *Illustrations to the King's Quair*, Edinburgh, 1887; for Scott's pictures in the Hall at Wallington illustrative of the English border, see *Sessional Papers of the R.I.B.A.*, XVIII, pp. 31–46.

89. Passavant, p. 92.

90. Waagen, II, p. 233.

91. The numerical list of Aders's paintings now in the National Gallery is: 648, 943, 1078–9, 1939. Numbers 1078–9 come from J. H. Green's collection. Number

943—Bouts's *Portrait of a Man*—was bought from the 1 August 1835 sale by Solly. It later belonged to Samuel Rogers.

92. W. Y. Ottley, *An Inquiry into the Origins and Early History of Engraving upon Copper and Wood*, 1816.

93. J. T. James, *The Flemish, Dutch and German Schools of Painting*, 1822.

94. *Albert Dürer's Designs of the Prayer Book*, published by Rudolph Ackermann in 1817. The introduction contains a history of the work's production. For Dürer's reputation at this time, see M. Levey, 'Dürer and England', *Anzeiger des Germanisches National-museum*, 1971–2, pp. 157–64.

95. See 'Francis Douce', *Bodleian Quarterly*, 1932–4, VII, pp. 359–82.

96. E. Firmenich Richartz, *Die Brüder Boisserée*, Jena, 1916, p. 329.

97. See note 91; for an account of Solly's activities, see F. Herrmann, 'Who was Solly?', *Connoisseur*, 1967, CLXIV, pp. 229ff; CLXV, pp. 13–18; CLXVI, pp. 10–18.

98. F. W. Stokoe, *German Influence in the English Romantic Period*, 1926, p. ix.

99. See Appendix I.

100. W. J. Burke, *Rudolph Ackermann, Promoter of the Arts and Sciences*, New York, 1935, p. 4.

101. See note 77.

102. M. Twyman, *Lithography, 1800–1850*, Oxford, 1969, pp. 13–14.

103. *Kunstblatt*, 1820, pp. 21–4, 410.

104. Twyman, pp. 37–40.

105. See note 94.

106. *Annals of the Fine Arts*, 1817, p. 101.

107. See pp. 159ff.

108. Lawrence Sale, Christie's, 14 May 1830, lot 569.

109. W. T. Whitley, *Art in England, 1821–1837*, Cambridge, 1937, p. 26.

110. Published as a supplement to the Dresden *Abendzeitung*, 1820–34.

111. e.g. *Repository of the Fine Arts*, 1828, p. 105. This apparently follows on Ackermann's promise to Boettiger in a letter of 9 April 1828: 'Mr. Fleischer's work by Retzsch I will promote with all my might for the honour of Germany'. The correspondence between Ackermann and Boettiger is in the Landes-bibliothek, Dresden (Boettiger *Nachlass*, II).

112. See *Artistisches Notizenblatt*, 1828, p. 75.

113. *The German Museum*, or *Monthly Repository of the Literature of Germany, the North and the Continent in General*, 1800, I (frontispiece of Wieland by Nutter after Anton Graff); 1801, II (frontispiece of Klopstock by Nutter after Jens Juel).

114. T. F. Dibdin, *A Bibliographical, Antiquarian and Picturesque Tour in France and Germany*, 1821, III, Letter xxxvii, p. 120.

115. See T. Boosey, *Catalogue*, 1807 (B.M., S.C. 742).

116. *A Catalogue of German Books and Prints now on sale at Henry Escher's*, 1807 (B.M., S.C. 742).

117. Stokoe, p. 49.

118. In the Register 'Fremde Buchhändler welche die Leipziger Messe besuchen', J. H. Bohte is marked as one of 'diejenigen Handlungen, welche zwischen den Messen ausliefern lassen' between 1819 and 1823. After this date the distinction is no longer made in the Register (Stadtarchiv, Leipzig).

119. J. H. Bohte, *Verziechniss deutscher Bücher*, 1814 (B.M., S.C. 762).

120. J. H. Bohte, *A Catalogue of Books*, 1819 (B.M., S.C. 704.1).

121. Boettiger *Nachlass*, Landesbibliothek, Dresden, XII, no. 7.

122. *Handbibliothek der deutschen Litteratur . . . mit einer Vorrede von A. W. Schlegel*, 1825 (B.M., 618g19).

123. *Rundschreibung der Witte Sarah Bohte, 1826*, 29.6; copy in Deutsche Bucherei, Leipzig.

124. *London Magazine*, 1820, I, p. 136.

125. *Kunstblatt*, 1827, p. 118.

126. *London Magazine*, 1820, I, p. 136.

127. See p. 130.

128. *London Magazine*, 1821, IV, p. 658.

129. Jameson, *Visits*, I, pp. 284–5.

130. A. von Stolterfoth, *The Rhenish Minstrel* (ill. A. Rethel), London, 1835; this work seems to have gone unnoticed by the British press.

131. Charles Jügel, *Catalogue of Valuable Prints, Engravings etc. etc. by the most distinguished artists of Germany which are now offered for sale (for the first time in London) at the original German publishing prices*, [c. 1836].

132. *Art Union*, 1839, p. 12.

133. *Art Union*, 1839, pp. 13, 38. Black and Armstrong, 'foreign Booksellers', first appear in B. Critchett's *Post Office Directory* in 1836 (p. 53). The address given—2 Tavistock Street is the same as that formerly used by Black, Young and Young. There is no evidence that they traded substantially in German prints before the *Art Union* advertisement of 1839.

134. See e.g. the full page announcement in the *Art Union* in June 1842 (p. 148).

135. See p. 58.

136. W. H. Hunt, *Pre-Raphaelitism and the Pre-Raphaelite Brotherhood*, 1905, II, p. 104.

137. C. Jensen, 'I Nazareni, Das Wort, Das Stil' in *Klassizismus und Romantik*, Nuremberg, 1966, p. 49.

138. Although there is no separate study of the activities of English artists and connoisseurs in Rome during this period, much information can be found in the following: F. Noack, *Das Deutschtum in Rom*, Berlin and Leipzig, 1927; L. Iannatoni, *Roma e gli Inglese*, Rome, 1945. For Flaxman's Orvieto studies, see D. Irwin, 'Flaxman: Italian Journal and Correspondence', *Burlington Magazine*, 1959, p. 212.

139. C. L. Fernow (ed. Riegel), *Carstens, Leben und Werke*, Hanover, 1867, p. 104.

140. See B. Fothergill, *The Mitred Earl: An Eighteenth-Century Eccentric*, 1974.

141. O. R. Lutterotti, *Joseph Anton Koch*, Berlin, 1940, p. 189.

142. *Ibid*, p. 157.

143. A number of drawings, including a sketch for a picture of the *Rape of Ganymede* 'at which he was at work till within a few days of his death', were bought by Henry Acland from the artist in 1839. These were sold at Sotheby's on 15 November 1973 (nos. 109–12). Other works by Koch that were bought by English patrons that have come to light in recent years are:
(i) *Landscape with William Tell* (Colin Bailey, 'Joseph Anton Koch's *Landscape with William Tell*', *Walker Art Gallery, Liverpool, Bulletin*, 1974–5, V, pp. 60–71).
(ii) *Noah's Sacrifice*, pen and brown wash, 40.5 × 50.7 cm. *Ruth and Boas*, pen and brown wash, 42.5 × 56.0 cm., both dateable to the mid-1820s, possibly pendants (Christie's, 26 November 1974 (nos. 330–1)).
(iii) *Serpentara-Landschaft mit Hirten und Rindern an der Quelle*, oil, 80 × 100 cm., Georg Schäfer Sammlung, Schweinfurt, inv. 1713. 'Provenienz: Englischer Privatbesitz'.

144. Andrews, p. 116.

145. Lutterotti, p. 248; Nott's sale was advertised in the *Hampshire Chronicle*, 10 and 24 January 1842, where 'drawings by Kotch' were mentioned. They were subsequently acquired by Friedrich Wilhelm IV of Prussia, and are now in the Kupferstichkabinett, Dresden.

146. U. Hoff, *The Melbourne Dante Illustrations by William Blake*, Melbourne, 1961, p. 4.

147. W. H. Gerdts, 'Washington Allston and the German Romantic Classicists in Rome', *Art Quarterly*, 1969, XXXII, p. 177.

148. Flagg, p. 60.

149. K. Simon, *Gottlieb Schick*, Leipzig, 1914, pp. 62ff.

150. Andrews, p. 19.

151. K. W. S. Baudissin, *George Augustus Wallis, Maler aus Schottland*, Heidelberg, 1924, pp. 18ff.

152. 1807 (RA: 213, 221, 227, 315, 425).

153. *Catalogue*, Thorwaldsens Museum, Copenhagen, 1961, p. 122, no. 172.

154. Baudissin, p. 19.

155. Now in Hotel Europäischer Hof, Heidelberg; see *The Romantic Movement*, Council of Europe, London, 1959, p. 231, no. 368, ill. 76.

156. K. Lohmeyer, *Heidelberg–Maler der Romantik*, Heidelberg, 1935, p. 214.

157. A *Sunset with the Castle of Heidelberg* was exhibited at the British Institution in 1815 (no. 76).

158. Baudissin, p. 24.

159. Flagg, pp. 42ff, 73.

160. Gerdts, p. 183.

161. Fogg Art Museum; reproduced in Gerdts, pl. 4.

162. Flagg, p. 210.

163. Flagg, p. 102.

164. Flagg, p. 101.

165. Flagg, p. 127.

166. Flagg, pp. 316–17.

167. *Annals of the Fine Arts*, 1818 (publ. 1819) p. 223. The report is actually dated January 1817.

168. *Ibid.*

169. The letters from Bartholdi to Henrietta are in the *Nachlass* Pereira–Arnstein, Staatsbibliothek der Stiftung Preussischer Kulturbesitz, West Berlin (uncatalogued at time of consultation).

170. Bartholdi–Henrietta, 4 December 1816.

171. Possibly the *Flight into Egypt* formerly in the Schackgalerie Munich; Bartholdi–Henrietta, 21 January 1817.

172. Bartholdi–Henrietta, 28 May 1819: 'Lawrence war mit den frescos in meinem Zimmer sehr erfreut und fährst Englander zu mir es zu sehen.'

173. Marcia Pointon, in 'The Works of William Dyce, R.A., 1806–64' (Ph.D., Manchester, 1974, pp. 19ff), has suggested that Schnorr's Protestantism also endeared him to British patrons. In the 1840s his interests in London were pressed by the Freiherr von Bunsen, who was Prussian ambassador to the Court of St James's from 1841 to 1853.

174. Andrews, p. 110; the work is now in the Hamburger Kunsthalle.

175. Bartholdi–Henrietta, I, 8 January 1820.

176. J. Schnorr, *Briefe aus Italien*, Gotha, 1886, p. 204.

177. *London Magazine*, 1820, I, p. 42.

178. 'Frescoes Painted by some German Students', *London Magazine*, 1820, II, p. 149.

179. *D.N.B.*, 1897, XVII, p. 986.

180. Williams, II, p. 140.

181. Lawrence Sale, Christie's, 20 May 1830, lot 134: 'Overbeck: Famine, a cartoon, in black chalk, beautifully composed: NB this was referred to by Sir Thomas Lawrence in his last address to the students of the Royal Academy.'

182. Lawrence Sale, 10 May, lot 120; 12 May, lots 397–400; 14 May, lot 686.

183. John Gage, *Colour in Turner*, 1969, p. 101.

184. M. Starke, *Travels on the Continent*, 1820, p. 377; *Travels in Europe*, 1833, p. 237. For an account of Marianna Starke's career, see F. Haskell, *Rediscoveries in Art*, 1976, p. 107.

185. Lawrence possessed two views of Rome by Catel (*Giornale Arcadico*, 1822, XIV, p. 142) and a view of Naples by 'A German Artist at Rome' (Sale, 15 May 1830, lot 84); in 1819 Catel also painted a view of Lake Albano for Lord Bristol and two views of the Gulf of Naples for Lady Acton (*Giornale Arcadico*, 1819, IV, p. 103).

186. Overbeck, for example, held that the English preferred buying sculpture because it could be seen from both sides (M. Howitt, I, p. 400); the satirist W. Waiblinger has the English say in 'Die Engländer über den Vatikan': 'Schad' ist's wahrlich, dass doch das vatickan'sche Museum eingesperrt ist in Haus, Zimmer und Saal und Gemach. Besser Stünd's auf dem Corso in einer Reihe, so könnte Mann's mit weniger Zeit doch auch zu Pferd besehn' (*Blüther der Muse aus Rom*, Berlin, 1829, p. 193).

187. *Dell' Eneide di Virgilio del Commendatore Annibale Maro* (with illustrations after designs by the Duchess of Devonshire etc.), Rome, 1819.

188. Schnorr, 2 June 1825, p. 294.

189. M. Jorns, *August Kestner und seine Zeit, 1777–1853*, Hanover, 1964, p. 120.

190. According to George Eliot's notes, the incident was supposed to have taken place around 1827 (G. Eliot (ed. A. T. Kitchel), *Quarry for Middlemarch*, Berkeley, 1950.

191. T. Pycroft, *Art in Devonshire*, 1883, p. 40.

192. M. T. Wilson, *The History of the English Church in Rome*, Rome, 1916, p. 7.

193. Jorns, p. 99.

194. Kestner, pp. 110ff.

195. H. Kestner-Köchlin, *Briefwechsel zwischen August Kestner und seiner Schwester Charlotte*, Strassbourg, 1904, p. 89.

196. Bartholdi–Henrietta, 4 December 1816.

197. Jorns, p. 120: 'Riepenhausens Celebrität geht mit der von Cornelius und Overbeck ganz gleichen Schritt, und ich glaube dass sie wohl mehr Bestellung haben als diese'. For details of Kestner's visits to the Riepenhausens' studio with English visitors, see his *Tagebücher* in the Kestnermuseum, Hanover.

198. *Leipziger Kunstblatt*, 1817, no. 114, p. 467.

199. *Giornale Arcadico*, 1819, IV, p. 98; versions of this subject now exist in the Kunsthalle, Karlsruhe, and the Sammlung Schäfer, Schweinfurt, but there is no evidence for connecting either of them with Miss Mellish. The Riepenhausens were in the habit of making numerous versions of their works (E. Börsch-Supan, 'Das Mädchen aus der Fremde' in *Kunstgeshichtliche Aufsätze . . . Heinz Ladendorf zum 29 Juni 1969 gewidmet*, Cologne, 1969, p. 103 n. 34).

200. *Giornale Arcadico*, 1822, XIV, p. 428; a later version of this subject is in the Landesmuseum, Hanover.

201. *Artistisches Notizenblatt*, 1825, p. 87.

202. *Giornale Arcadico*, 1822, XIII, p. 149; now in the Sammlung Georg Schäfer (*Klassizismus und Romantik in Deutschland*, Nuremberg, 1966, no. 140).

203. *Kunstblatt*, 1826, p. 103; present whereabouts unknown.

204. W. Sharp, *The Life of Joseph Severn*, 1892, p. 248.

205. J. Gage, 'Turner's Academic Friendships: C. L.

206. A. Cunningham, *The Life of Sir DAvid Wilkie*, 1843, II p. 277–8.

207. *Ibid.*

208. *Ibid*, p. 277.

209. *Ibid*, p. 318.

210. Haydon, IV, p. 635.

211. A. Raimbach, *Memoirs*, 1843, p. 199. Letter dated 9 January 1827.

212. Margaret Howitt, I, pp. 504ff.

213. Robinson, *Diary*, p. 199.

214. B. Fothergill, *Nicholas Wiseman*, 1963, p. 41.

215. A. M. Steinle (ed.), *E. von Steinle's Briefwechsel*, Freiburg in Breisgau, 1897, I, p. 247.

216. *Statuto della Societa e de' Cultori delle Belle Arti*, Rome, 1829, p. 1.

217. F. Flohr, *Taschenbuch*, 1832 (MS. in Deutsches Institut, Rome).

218. Various reports on the progress of this commission appear in the *Kunstblatt*. On 2 February 1843 (p. 44) it was announced that the cartoon had recently been finished in Rome. By 13 June 1844 the picture was complete and ready for dispatch. There is no account of Hauser having come to England to supervise the installation. The painting, which is in oil, is still in position.

Hauser may have come to the notice of Shrewsbury through the good offices of the French revivalist Comte de Montalembert who had vigorously supported the artist while the latter was in Paris in 1837 (*Gazette des Beaux Arts*, VI, 1860, pp. 86–92). Hauser illustrated Montalembert's *Histoire de Saint Elizabeth de Hongrie* (1836). This was translated by an intimate of Shrewsbury, Ambrose Philips de L'Isle, and published in England, together with illustrations, in 1839.

219. Margaret Howitt, II, p. 108.

220. Steinle, I, pp. 436–8.

221. 'Dyce Papers', II, pp. 103ff.

222. N. Wiseman, *Four Lectures on the Offices and Ceremonies of Holy Week*, 1839, p. vii.

223. See Cooper, p. 223.

224. The fresco is still extant. Extracts from Settegast's correspondence while in England, together with a reproduction of the painting, were published in the *South London Press*, 5 January 1977. I am most grateful to Mr Clive Wainwright for drawing my attention to this.

225. On 10 February 1829; Jorns, p. 200.

226. H. W. & I. Law, *The Book of the Beresford Hopes*, 1928, p. 142.

227. Kaulbach *Nachlass*, Landesarchiv, Munich, VB; W. B. Scott, *Gems of Modern German Art*, 1873, p. 3.

228. C. Justi, *Das Augusteische Dresden*, Dresden 1955, pp. 18–20.

229. See Boerner Sale, 5–6 July 1913, no. 219

(reproduction of Nelson portrait), Leipzig (extract from catalogue in Witt Library).

230. See chapter III.

231. P. O. Rave, 'Das Rheinansichten in den Reisewerken zur Zeit der Romantik', *Wallraff–Richartz Jahrbuch*, 1924, pp. 123ff; M. Schefold, 'William Turner in Heidelberg und am Neckar', *Jahrbuch der Staatlichen Kunstsammlungen in Baden-Würtemburg*, 1968, V, pp. 131–50; E. Maurer, 'Turners Laufenberger Zeichnungen' in *Festgabe für Otto Mittler*, 1960, pp. 217–26; F. Zink, 'William Turner in Heilbronn am Neckar', *Zeitschrift für Kunstwissenschaft*, 1954, VIII, p. 225.

232. Thieme-Becker, VII, pp. 351–2.

233. See E. Bülau, 'Der Englische Einfluss auf die deutsche Landschaftsmalerei des frühen 19. Jahrhunderts, Diss., Freiburg, 1955.

234. Quotations here are from the English translation of 1813.

235. H. Heine, *Die Romantische Schule* (Reclam edn.), Leipzig, 1955, p. 20.

236. *Germany*, 1813, II, p. 389.

237. *Ibid*, p. 394.

238. K. K. Eberlein, 'Goethe und die Bildende Kunst der Romantik', *Jahrbuch der Goethe-Gesellschaft*, 1928, pp. 6ff.

239. Simon, pp. 62ff.

240. *Germany*, 1813, II, p. 400.

241. J. T. James, *Journal of a Tour in Germany*, 1816.

242. Stokes, p. 6.

243. Dibdin, III, pp. 120–9.

244. Plagemann, pp. 27, 67.

245. *Ibid*, p. 26.

246. H. Riedelbach, *König Ludwig I von Bayern und seine Kunstschöpfungen*, Munich, 1888, p. 6.

247. *Allgemeine Deutsche Biographie*, XIX, p. 522.

248. See Mary Howitt (ed. Margaret Howitt), *An Autobiography*, 1891.

249. W. Howitt, *The Rural and Domestic Life of Germany*, 1842, p. 312.

250. See the *Ecclesiologist*, 1847, pp. 25–6.

251. *London Magazine*, 1820, I, p. 136.

252. Eastlake, *Contributions*, 2nd series, p. 126.

253. *London Magazine*, I, p. 42.

254. H. von Einem, 'Peter Cornelius', *Wallraff-Richartz-Jahrbuch*, 1954, XVI, pp. 131ff.

255. *Athenaeum*, 1834, pp. 489, 515, 547.

256. Jameson, *Visits*, I, p. 49.

257. *Ibid*, p. 129ff.

258. *Ibid*, p. 21.

259. *Ibid*, II, p. 137.

260. *Ibid*, p. 139.

261. *Ibid*, pp. 144–5.

262. *Ibid*, p. 144.

263. *Ibid*, pp. 23–4.

264. *Ibid*, p. 39.

265. *Ibid*, p. 137.

266. *Sacred and Legendary Art*, by Mrs Jameson, 1848. The work had run into three editions by 1857, and was still being reissued in 1896.

267. F. K. Hunt, pp. 2–3; see Introduction, p. 9.

268. Jameson, *Visits*, I, p. 268.

269. Her admiration for the Northern primitives which inspired this taste was also limited. The Städel collection in Frankfurt is dismissed as 'not very interesting' (I, p. 89), while Wallraff's collection in Cologne is noticed solely for its classical head of Medusa (I, p. 37). At Munich her main discovery amongst the old masters is Rubens; when viewing the Boisserée collection—despite expressing amazement over Van der Weyden's 'Columba' altarpiece and *St Luke painting the Virgin* (then both attributed to Van Eyck)—she is at pains to point out the technical deficiencies of such works. Even Dürer, whose genius she celebrates in an eulogy at Nuremberg, is praised mainly for having absorbed the culture of the Italian Renaissance. The *Four Apostles* she considers 'quite like Raphael' (I, p. 256).

270. See p. 138.

271. Jameson, *Visits*, I, p. 245.

272. *Ibid*, p. 272.

273. *Ibid*, p. 228.

274. *Ibid*, p. 267.

275. *Ibid*, p. 3.

276. *Ibid*, p. 287.

277. *Ibid*, p. 137.

278. J. Strang, *Germany in 1831*, 1836, II, pp. 364ff.

279. *Report from the Select Committee*, 16 August 1836, p.v.

280. J. Murray, *A Handbook for Travellers in Southern Germany*, 1837, p. 28.

281. W. Howitt, p. 439.

282. *Ibid*, p. 330.

283. *Art Journal*, 1864, p. 62.

284. See Ruskin's tour of Germany in 1858; J. Evans and J. H. Whitehouse (eds.), *The Diaries of John Ruskin*, Oxford, II, p. 540.

285. Jameson, *Visits*, I, p. 52.

286. *Ibid*, II, pp. 51–99.

287. Mrs. S. C. Hall, 'A Morning with Moritz Retzsch', *Art Journal*, 1851, p. 21.

288. F. K. Hunt, p. 4.

289. Raczynski, I, p. 34.

290. A German edition, translated by A. Hagen, appeared simultaneously in Berlin.

291. Raczynski to Eastlake, 15 August 1838 (Letters to C. L. Eastlake, V. & A. MS. 88, p. 14).

292. Flagg, p. 311.

293. Raczynski, III, p. 290.

294. *Ibid*, I, p. 35.

295. H. Fortoul, *De l'Art en Allemagne* (1844 edn.), I, p. 7.

296. *Ibid*, p. 182.
297. *Ibid*, p. 79.
298. *Ibid*, p. 179.
299. *Quarterly Review*, 1846, LXXVII, no. CLIV, pp. 323–47.
300. *Ibid*, p. 331.
301. C. C. Abbott, *The Life and Letters of George Darley*, 1928. p. 113.
302. For full list, see Appendix II in Vaughan.
304. In the first two years, five of the eight artists treated were German. There were Overbeck (1844, p. 13), Cornelius (1844, p. 61), Ernst Förster (1844, p. 288), Carl Heideloff (1845, p. 307) and Wilhelm Kaulbach (1845, p. 338). The others were Thorwaldsen (1844, p. 40), Horace Vernet (1844, p. 169) and Paul Delaroche (1845, p. 46).
303. *Art Journal*, 1865, p. 365.
305. S. C. Hall, *Retrospect of a Long Life*, 1883, I, p. 340.
306. *Art Union*, 1844, p. 195.
307. Hall, *Retrospect*, I, p. 340.
308. *Ibid*.
309. *Gems of European Art*, 2nd series, 1845, p. 63.
310. *Ibid*, p. 61.
311. *Ibid*, p. 64.
312. *Art Union*, 1842, p. 142.
313. See P. Rossiter, 'The First Years of the Art Union', M.A. Report, Courtauld Institute of Art 1975, pp. 18ff.
314. *Punch*, 1846, p. 31.
315. Rossitter, pp. 25–6.
316. *Athenaeum*, 1842, p. 790.
317. One such incident was reported in the *Art Union*, 1844, p. 302.
318. Letter from Charles Bridger to Holman Hunt, 24 June 1848 (John Rylands Library, Manchester).
319. *Athenaeum*, 1842, p. 790.
320. *Ibid*.
321. See *Jahresbericht des Sächsischen Kunstvereine*, 1845, 6 (copies in Landesbibliothek, Dresden).
322. *Kunstblatt*, 1841, p. 4.
323. *Ibid*, p. 308: 'Man erwartet hier den bekannten englischen Maler Eastlake der im Auftrag seiner Regierung untersuchen soll, ob es dienstlich sei in München Frescomaler, für die Verzierung der im Bau begriffenen Parlamenthäuser mit auf die englische Geschichte bezüglich Malerei, zu engagiren.'
324. *Ibid*, 1843, p. 303: 'das erste Idee zur Verzierung des Parlamentshäuser mit Fresken von Cornelius ausgegangen sei'.
325. See letter from Schwind to Genelli, 29 June 1845, in which Genelli is advised to dedicate his 'Wustlings' series to Albert (Schwind, p. 195).
326. Schnorr's letters to Eastlake are in the V. & A. Library (86.M.38); those from Eastlake to Schnorr are in the Landesbibliothek, Dresden (72.inv.15).
327. Eastlake to Schnorr, 20 June 1836 (V. & A.: 86.M.38, fol. 2).
328. Schnorr to Eastlake, 8 January 1842 (Landesbibliothek, Dresden: 72. inv. 15, no. 43): 'Vor einige Jahren haben Sie den Wunsch geäussert allhier einige von Ihren Cartoonen aus den Nibelungenlied auszustellen, Mir dünkt das der Kommende Frühling hierzu eine sehr günstige Gelegenheit darbieten wurde. Ich weiss nicht in wie fern es Ihnen bequem lege dürfte Sie alsdann zu schicken, aber ich denke dass das Englische Publikum bereit sein wurde die selben mit interesse zu betrachten und zwar aus mehreren Ursache. Sie wissen vielleicht dass eine Königliche Commission allhier ernannt worden ist um die besten Mittel zu erforschen in Verbindung mit der Wiedererbauung der Neuen Parlaments-Gebäude.'
329. Schnorr to Eastlake, 23 February 1842 (V. & A.: 86. M. 38, fol. 13).
330. *Report of the Commissioners on the Fine Arts*, 1st report, 1842, p. 110.
331. Eastlake, *Contributions*, II, p. 149.
332. Ker to Schnorr, 6 September 1838 (Landesbibliothek, Dresden: 72. inv. 15, no. 162): 'Um uns zu zeigen dass wir nich die einzige Maler moderner Zeit sind.'
333. Ker to Schnorr, 31 July 1835 (*Ibid*, no. 191).
334. Ker to Schnorr, 6 September 1838 (*Ibid*, no. 162).
335. *Ibid*.
336. *Ibid*: 'Auch wird es Ihnen vielleicht nicht unangenehm sein zu bemerken dass es in demselben Rande mit einem Gemälde von Ihrem Freunde Eastlake eingefasst ist'.
337. See note 188.
338. A. Schahl, 'Die Geschichte der Bilderbibel von J. von Schnorr von Carelsfeld', Diss., Leipzig, 1936, p. 67.
339. Andrews, p. 66.
340. Haydon, V, p. 217.
341. British Institution, *Exhibition of Ancient Masters*, 1843, nos. 190–1.
342. *Athenaeum*, 1843, p. 612.
343. *People's Journal*, 1847, II, p. 74.
344. Haydon, V, p. 198.
345. A. M. Howitt, *An Art Student in Munich*, 1853; for Kaulbach, see especially ch. II, pp. 17–36.
346. Eastlake to Kaulbach, 14 September 1848 (Kaulbach *Nachlass*, III).
347. W. J. O'Driscoll, *A Memoir of Daniel Maclise*, 1871, pp. 149ff.
348. Raczynski to Eastlake, 15, 19, 28 August 1838 (V. & A. MS. 86.M.38).
349. Howitt to Kaulbach, 12 December 1870 (Kaulbach *Nachlass*).
350. 'Siegfried' was published in London in 1846, 'Reynard' in 1859.

351. Scott, *Gems*, pp. 91–2.
352. Kaulbach *Nachlass*, VB.
353. Andrews, pp. 124–5.
354. See pp. 174–6.

NOTES TO CHAPTER II

1. *London Magazine*, 1820, I, p. 42.
2. W. Sharp, *Progress of Art in the Century*, 1902, p. 313.
3. *London Magazine*, 1820, p. 42.
4. First published in 1554; see J. Cartwright, *Baldassare Castiglione*, 1908, I, p. 389.
5. Cicero, *De Inventione*, II. i. 1; J. J. Pollitt, *The Art of Greece*, Englewood Cliffs, New Jersey, 1965, p. 156.
6. 'Dyce Papers', XXI, p. 814.
7. J. Ruskin, *Preface to the Economist of Xenophon* (Library edn., XXXI, p. 23).
8. F. H. Lehr, *Die Blütezeit Romantischer Bildkunst*, Marburg, 1924, p. 36.
9. 'Über die deutsche Kunst-Ausstellung in Rom, im Frühjahr 1819', Kritische Friedrich Schegel Ausgabe, Paderborn, 1959, IV, pp. 237–263.
10. *Klassizismus und Romantik in Deutschland*, Nuremberg, 1966, p. 296.
11. See note 72.
12. 'The State of German Literature', *Edinburgh Review*, 1827 (Carlyle Centenary edn., XXVI, pp. 51ff).
13. *Ibid*.
14. A. G. Baumgarten, *Aesthetica*, Frankfurt an der Oder, 1750; E. Cassirer, *The Philosophy of the Enlightenment*, 1951, pp. 338ff.
15. H. Osborne, *Aesthetics and Art Theory*, 1968, p. 116.
16. *Kritik der Urteilskraft*, 1790; all references in this book are to J. C. Meredith's translation, *The Critique of Judgement*, Oxford, 1928 (1964 reprint). Quotations will therefore be in English.
17. *Kritik der reinen Vernunft*, 1781; references in this book are to F. Max Muller's translation, *The Critique of Pure Reason*, New York, 1961.
18. *Ibid*, p. 28.
19. *Ibid*, pp. 41–2.
20. Osborne, p. 130.
21. Kant, *Judgement*, p. 6.
22. *Ibid*, p. 225.
23. *Ibid*, p. 227.
24. G. P. Gooch, *Germany and the French Revolution*, 1920, pp. 215–17.
25. F. Schiller (trans. Wilkinson and Willoughby), *On the Aesthetic Education of Man*, 1795, Oxford, 1967, pp. xvff.
26. *Ibid*, p. 9.
27. *Ibid*, p. 141.
28. *Ibid*, p. xxviii.
29. *Ibid*, pp. 54–7.
30. K. E. Gilbert and H. Kuhn, *A History of Aesthetics*, 1956 edn., p. 373.
31. L. Eitner, *Neoclassicism and Romanticism*, Englewood Cliffs, New Jersey, 1970, II, p. 47.
32. P. Klee (trans. Findlay), *On Modern Art*, 1966, p. 13.
33. A. W. Schlegel, *Vorlesungen über Schöne Literatur und Kunst*, Stuttgart, 1884, I, p. 19.
34. Plagemann, pp. 31, 365.
35. Diderot's *Salons*, for example, formed the point of departure in the debate in A. W. Schlegel's 'Gemälde' (Athenaeum, 1799, II, p. 52).
36. Fragment 116; see H. Eichner, *F. Schlegel*, New York, 1970, p. 56.
37. W. H. Wackenroder, *Werke und Briefe*, Heidelberg, 1967, p. 131.
38. Eichner, p. 35.
39. A. W. Schlegel (trans. J. Black), *A course of Lectures on Dramatic Art and Literature*, 1815, p. 2.
40. Athenaeum, 1799, II, pp. 203ff.
41. Not published until 1884; see note 33.
42. P. Frankl, *The Gothic*, Princeton, 1960, p. 452.
43. *Ibid*, p. 451.
44. *Ibid*, p. 453.
45. Kritische Friedrich Schlegel Ausgabe, 1959, IV, pp. 7ff.
46. *Ibid*, p. 14: 'Keine verworrene Haufen von Menschen, sondern wenige und einzelne Figuren, aber mit dem Fleiss vollendet, der dem Gefühl von der Würde und Heiligkeit der Höchsten aller Hieroglyphen, des menschlichen Leibes, natürlich ist; strenge, ja magre Formen in scharfen Umrissen, die bestimmt heraustreten, keine Malerei aus Helldunkel und Schwarz in Nacht und Schlagschatten, sondern reine Verhältnisse und Massen von Farben, wie in deutlichen Akkorden; Gewänder und Costume, die mit zu dem Menschen gehören scheinen, so schlicht und naiv als diese; in den Gesichtern (der Stelle, wo das Licht des göttlichen Malergeistes am Hellsten durchscheint) aber, bei aller Mannichfaltigkeit des Ausdrucks oder Individualität der Züge durchaus und Überall jene kindliche gutmütige Einfalt und Beschränktheit, die ich geneigt bin, für den ursprünglichen Charakter der Menschen zu halten.'
47. *Ibid*, p. 151: '*Hieroglyphen*, wahrhaft Sinnbilder, aber mehr aus Naturgefühlen und Natur ansichten oder Ahndungen willkürlich zusammengesetzt, als sich anschliessend an die alter Weise der Vorwelt ... ist gewiss der gefährlichere, und der Erfolg lässt sich ungefähr voraussehen, Wenn er vielleicht gar von mehreren, die nicht alle gleich gewachsen dazu wären, versucht werden sollte; ... Sicherer aber bliebe es ganz und gar den alten Malerei zu folgen, besonders den ältesten, und das einzig Rechte and Naive so lange

treulich nach zu bildern, bis es dem Auge und Geiste zur andern Natur geworden wäre.'

48. *Ibid*, pp. 247–8: 'Wer ubrigens aus jenen ersten Gestirnen des anbrechenden Lichtes in der abendländischen Kunst, die Zeichnung, die Perspective, die Kenntnis des Menschlichen Körpers, oder was sonst wissenschaftlich zur Begründung der Kunst gehört, lernen, ja selbst die vollkommeneren Vorbilder eigentlich nachahmen, d.h. nachäffen wollte; den Muss man seiner eignen Torheit überlassen'; 'Jene Vorbilder möchten wohl ganz gewählt sein, und der rechte Weg zum Ziele allerdings nicht eben rückwärts zu ihnen führen wohl aber ganz erfüllt und durchdrungen von ihnen *vorwärts* zu einer neuen, aus den Tiefen des Altertums wiederhergestellten, aber dennoch frisch lebendig auf blühenden, und wahrhaft neuen Kunst für neue Zeit.'

49. E. H. Gombrich, *In Search of Cultural History*, 1974, p. 6.

50. Originally delivered as lectures *c*. 1820; see G. H. F. Hegel (trans. Osmaston), *Philosophy of Fine Art*, 1920; J. Kaminsky, *Hegel on Art*, New York, 1962.

51. The connection between Schlegel and Hegel is emphasized in Frankl, p. 452.

52. Hegel, p. 295.

53. C. F. von Rumohr, *Italienische Forschungen*, Berlin and Stettin, 1827–31.

54. *Ibid*, II, p. 44; see C. von Klenze, 'The Growth of Interest in the Early Italian Masters', *Modern Philology*, 1906, IV, p. 44.

55. R. Lehmann, p. 32.

56. C. Gould, *Trophy of Conquest*, pp. 26ff.

57. See p. 94; for a listing of translations of German works, see B. Q. Morgan, *A Critical Bibliography of German Literature in English Translation, 1481–1927*, New York and London, 1965 (reprint of 1938 edn.).

58. *Lectures on Dramatic Art and Literature*, 2nd edn., 1840 (intro. R. H. Horne), p. iv.

59. *Quarterly Review*, April 1861, CIX, p. 465.

60. Roget, I, pp. 385–6.

61. *Ibid*, p. 388.

62. H. Richter, *Daylight: A Recent Discovery in the Art of Painting*, 1817, p. 60.

63. Roget, I, p. 376; Richter did once, however, depict 'Philosophy' as a conventional allegorical figure, with Kantian categories encircling her head (engr. E. J. Roberts; example in V. & A. MS. J.5.M).

64. *Ibid*, p. 388.

65. Sumowski, p. 5.

66. 'William Blake als Künstler, Dichter und religiöser Schwärmer', *Vaterländisches Museum*, 1811, II, p. 107.

67. H. Fuseli, *Lecture on Painting*, 1833, p.3.

68. Herder's *Ideen zur Geschichte der Philosophie der Menschheit* was published in London in 1800 under the title of *Outlines of a Philosophy of History* (trans. T. O.

Churchill). There was a second edition in 1803.

69. R. F. Egan, 'The Genesis of the Theory of "Art for Art's sake" in Germany and England', *Smith College Studies in Modern Languages*, 1921, II, no. 4, pp. 11–12.

70. S. T. Coleridge, *Biographia Literaria* (Everyman Library edn., 1967, p. 86); for a literal account of Coleridges borrowings from Kant and Schellin, see N. Fruman, *Coleridge, the Damaged Archangel*, 1972, pp. 180ff.

71. Coleridge, p. 1.

72. Fruman, p. 201.

73. *Ibid*, pp. 141–64.

74. See note 12.

75. *Miscellaneous Essays*, 1899, p. 10.

76. *The Penny Cyclopaedia of the Society for the Diffusion of Useful Knowledge*, 1833, I, p. 156.

77. *British and Foreign Review*, 1836, no. 3, p. 151n.

78. J. Ruskin, *Modern Painters*, II (Library edn., IV, p. 35).

79. R. Rosenblum, *Transformations in Late Eighteenth-Century Art*, Princeton, 1967, pp. 52ff.

80. J. Flaxman, *Lectures on Sculpture*, 1829; for the defence of British mediaeval sculpture, see especially pp. 13–28.

81. *Kunstblatt*, 1827, p. 118.

82. Margaret Howitt, II, p. 62.

83. *Kunstblatt*, 1827, p. 118.

84. M. Whinney, *Sculpture in Britain, 1530–1830*, 1964, pp. 190–5.

85. Frankl, p. 453.

86. Robinson Diary, MS. 12 August 1812.

87. Robinson, *Diary*, 1869 edn., II, pp. 258–9.

88. Robinson Diary, MS., 17 January 1811.

89. *Ibid*, 27 January 1811.

90. Robinson, *Diary*, 1869, II, pp. 258–9.

91. *Ibid*, I, pp. 374–5.

92. 2nd edn., 1840, Introduction by R. H. Horne (J. Templeman); 1845, ed. J. Morrison (Bohn) (Morgan: 8254, 8255).

93. R. B. Beckett, *John Constable and the Fishers*, 1952, p. 261.

94. Eastlake, *Contributions to the Literature of the Fine Arts*, 1st series, 1848, no. XIII, pp. 351–96.

95. This translation was offered to John Murray when Eastlake returned to England, but it was never published (letter from Eastlake to Murray, June 1820; coll. John Murray).

96. See V, pp. 180ff.

97. Gage, *Colour*, pp. 173–88.

98. F. Kugler, *A Handbook of the History of Painting*, pt I, 1842.

99. Eastlake, *Contributions*, 2nd series, pp. 70ff.

100. *Ibid*, p. 169.

101. *Ibid*, pp. 191–2.

102. Eastlake, *Materials*, I, p. iii.

103. Bell, *Schools*, pp. 75, 85ff.
104. Eastlake, *Contributions*, 1st series, pp. 53–62.
105. J. W. von Goethe (trans. Eastlake), *Theory of Colours*, 1840, p. xxix.
106. Eastlake, *Contributions*, 1st series, p. 394.
107. *Ibid*, p. 358.
108. *Ibid*, pp. 368ff.
109. *Ibid*, p. 386.
110. Kugler, *Handbook*, p. xiv.
111. *Ibid*, p. 173.
112. *Ibid*, pp. 45–6n.
113. *Ibid*.
114. *Ibid*, p. 393. R. Cooper has drawn attention to the fact that, in the second English edition of the Handbook (*Schools of Painting in Italy*, 1851, (M: 5500)) Kugler modified his position. He states that he had been too deeply involved in that romantic period initiated by Wackenroder. Now he aspired to achieve a greater objectivity, paying less attention to the emotive expression of the primitives (Cooper, p. 111).
115. Eastlake may have been influenced by Kestner's *Über die Nachahmung*, which was strongly opposed to German primitive art.
116. Mary Howitt, p. 205.
117. Eastlake, *Contributions*, 1st series, p. 6.
118. *Ibid*, pp. 329–54.
119. *Ibid*, p. 338.
120. P. Stanton, 'The Sources of Pugin's *Contrasts*' in *Concerning Architecture* (ed. Summerson), 1968, pp. 130ff.
121. A. W. N. Pugin, *Contrasts*, 2nd edn., 1841, p. iii.
122. *Ibid*, p. 18.
123. A. W. N. Pugin, *An Apology for the Revival of Christian Architecture in England*, 1843, p. 44.
124. *Builder*, 2 August 1845, p. 367.
125. Wiseman, pp. vii, 24, 44.
126. M. C. Bowe, *François Rio, son place dans le renouveau catholique en Europe*, Paris, 1938, pp. 52, 63.
127. *Epilogue à l'art chrétienne*, Paris, 1870, I, p. 120.
128. A. P. de L'Isle (ed.), *The Chronicle of the Life of St Elizabeth of Hungary*, 1839; the work was issued with illustrations by E. Hauser.
129. See C. F. Montalembert, *A Letter Addressed to a Reverend Member of the Camden Society*, Liverpool, 1844, p. 3.
130. C. F. Montalembert, *De la peinture en Italie, a l'occasion du livre de M. Rio*, Paris, 1837 (Universite Catholique, 20e Livraison, *Oeuvres*, IV, p. 143).
131. Bowe, pp. 110–14.
132. *Ibid*, p. 134.
133. M. Sadleir, *Bulwer: A Panorama, Edward and Rosina*, 1931, p. 260.
134. M. Shelley, *Rambles in Germany and Italy in 1840, 1842 and 1843*, 1844, II, pp. 140–1.
135. 'Dyce Papers', VII, pp. 245ff.

136. *Ibid*, I, p. 4.
137. *Ibid*, XXIX.
138. *Ibid*, III, pp. 134ff.
139. *Ibid*, IX, p. 323.
140. Eastlake, *Contributions*, 2nd series, p. 150.
141. W. Dyce, *Theory of the Fine Arts*, 1844, p. 5.
142. *Ibid*, p. 13.
143. *Ibid*, pp. 15–16.
144. *Ibid*, p. 36.
145. Novalis (trans. Revd J. Earlton), *Christianity or Europe*, 1844.
146. F. Schiller (trans. J. Weiss), *The Philosophical and Aesthetic Letters and Essays*, 1845.
147. F. W. J. Schelling (trans. A. Johnson), *The Philosophy of Art; An Oration on the Relationship between the Plastic Arts and Nature*, 1845.
148. F. von Schlegel (trans. E. J. Millington), *The Aesthetic and Miscellaneous Works*, 1849.
149. Darley became inspired by Rio, in the late 1830s, to see the 'spiritual' element in the primitives which lay beneath their awkward exteriors. He frequently called, in his reviews in the *Athenaeum*, for a greater attention to design in British art. Nevertheless, he was highly critical of the modern Germans, who he felt copied the form, rather than the spirit of the primitives (see *Athenaeum*, 1846, p. 327). For a discussion of Darley's attitude to the primitive, see Abbott, pp. 162ff; Cooper, pp. 132ff.
150. Ruskin, *Modern Painters*, I (Library edn., III, p. 84). Ruskin's aversion to German art and theory cannot have been lessened when John Murray rejected the first volume of *Modern Painters* and suggested he write instead 'on the German School, which the public was calling for works on' (letter from John Ruskin, senior, to W. H. Harrison, 31 March 1847 (Library edn., III, p. xxxii).
151. Ruskin, *Modern Painters*, III (Library edn., V, p. 330).
152. K. Lotter, *Carlyle und die deutsche Romantik*, Nuremberg, 1931, pp. 12–14.
153. Ruskin, *Modern Painters*, III (Library edn., V, pp. 205ff).
154. Gilbert & Kuhn, p. 373.
155. G. Eliot, 'A Word for the Germans', *Pall Mall Gazette*, 7 March 1865, I, p. 201.
156. Ruskin, *Modern Painters*, II (Library edn., IV, p. 33).
157. *Ibid*.
158. *Ibid*.
159. *Ibid*.
160. J. Steegman, 'Lord Lindsay's *History of Christian Art*', *Journal of the Warburg and Courtauld Institutes*, 1947, X, p. 125.
161. Ruskin, *Modern Painters*, III (Library edn., V, p. 424).

162. Ruskin, *Modern Painters*, I (Library edn., III, p. 582.

163. *The Times*, 13 May 1851 (Ruskin, Library edn., XII, p. 319).

164. See note 48.

164. See note 148.

166. J. D. Rosenberg, *The Darkening Glass*, New York, 1961, p. 6.

167. *Athenaeum*, 1849, p. 295.

NOTES TO CHAPTER III

1. The basis of the general comments on the depiction of German subjects by British artists is the list in Appendix I of my thesis 'The German Manner in English Art, 1815–55' (University of London, 1977). Here only the section of the appendix that lists depictions of historical and literary subjects is given (see p. 257)—since this relates most closely to the main topic of this book.

2. Morgan, p. 8.

3. Ratios of themes varied considerably between exhibiting societies. While the number of German views exhibited at the Royal Academy never approached more than half of the French or Italian views, those at the Old Water-Colour Society were in excess during the middle decades of the century. The figures for selected years are as follows:

	France	Italy	Germany
1820	18	11	0
1830	16	9	6
1840	11	17	22
1850	8	19	10
1860	1	23	10
1870	15	40	9

4. W. Howitt, p. 2.

5. The other citations of *Childe Harold* were:
 1845—G. Arbuthnot, *Drachenfels* (BI: 85)—Canto III. lv.1.
 1845—E. W. Cooke, *Coblenz and Ehrenbreitstein* (RA: 365)—Canto III. lviii.
 1855—R. H. Nibbs, *Drachenfels* (BI: 499)—Canto III. lv.1.

6. 1841—C. Deane *Castles of Liebenstein and Sternfels* (RA 499)—Lytton, *Pilgrims of the Rhine*.
 1856—S. G. Tovey, *In the church of Sainted Sebald* (BI: 168) and *In the church of Sainted Lawrence* (BI: 181)—Longfellow's *Nuremberg*.
 1859—S. Read, *In the Church of Sainted Lawrence* (SPW: 41)—Longfellow's *Nuremberg*.

7. *Childe Harold*, Canto III. xlvi.

8. M. Hardie, *Water-Colour Painting in Britain*, 1967, II, p. 195.

9. M. Butlin and E. Joll, *The Paintings of J. M. W. Turner*, New Haven and London, 1977, no. 138, p. 93.

10. Butlin and Joll, no. 232, pp. 127–8.

11. *Childe Harold*, Canto III. lviii.

12. B. M.: CCCLXIV—285, 319, 328, 346.

13. *Art Union*, 15 May 1841; quoted in Butlin and Joll, p. 220.

14. Finberg, pp. 395–6.

15. (SBA: 84).

16. J. Ballantine, *The Life of David Roberts, R. A.*, Edinburgh, 1864, p. 35.

17. J. Dafforne, *Pictures by Sir A. W. Callcott*, 1875, p. 53.

18. In all he exhibited 119 German subjects. The nearest rival to this number is G. Howse with 75 German subjects.

19. J. Ruskin, *Notes on Prout and Hunt*, 1880, p. 26.

20. Hardie, III, p. 25.

21. *Ibid*, p. 17.

22. See *View of Waterloo Bridge* in Museum of London (cat. no. 33).

23. S. Redgrave, *A Dictionary of Artists of the English School*, 1874, p. 302.

24. Now at Osborne House, Isle of Wight.

25. 1834 (BI: 288, 500).

26. S. Redgrave, p. 471.

27. There is an engraving after a scene from Guy Mannering in the Witt library, Courtauld Institute of Art, London.

28. G. R. Lewis, *A Series of Groups, Illustrating the Physiognomy, Manner and Character of the People of France and Germany*, 1823.

29. Morgan, pp. 15–17.

30. c.f. C. Gordon, 'The Uses of Material from Sir Walter Scott in Nineteenth-Century English Painting', M.A. Report, London, 1970.

31. First published in English translation in 1797 (Morgan: 2251).

32. (Morgan: 2281).

33. (RA: 53).

34. S. Gessner (trans. J. Goodwin), *Death of Abel*, 1813, p. 212.

35. M. Butlin, *William Blake* (Tate Gallery cat.), 2nd edn., 1971, p. 62.

36. Stokoe, pp. 15ff.

37. G. Schiff, *Johann Heinrich Füssli*, Zurich, 1973, I, p. 315.

38. (Morgan: 10157).

39. Schiff, *Füssli*, I, p. 372.

40. 23 November 1804 (B.M. Add. MS. 39780, Flaxman Papers, LXXXVI).

41. Stokoe, p. 48.

42. Gottfried August Bürger (ed. Reinhard), *Sämmtliche Schriften*, Göttingen, 1796–7, I–III. The translations published in 1796 were by the following: Walter Scott (Morgan: 846), H. J. Pye (Morgan: 887), W. R. Spencer (Morgan: 891), J. T. Stanley (Morgan: 896) and William Taylore of Norwich (Morgan: 898).

43. British Museum, Dept of Prints and Drawings. See M. Butlin, *William Blake* (Tate Gallery exh. cat., 1978, no. 254, p. 124.

44. *European Magazine*, 1821, p. 362.

45. Morgan, p. 15.

46. *Leonora*, 1847 (Morgan: 865).

47. Despite the fact that the poem was set in the eighteenth century, Maclise clothed his figures in mediaeval dress.

48. Morgan, pp. 15, 17.

49. *Ibid*, p. 14.

50. See pp. 130ff.

51. In the exhibition catalogue Turner described the subject as 'an idea suggested by the German invocation upon casting the bell' (see Butlin and Joll, p. 245). This might be related to the theme of the 'Song of the Bell', in which the bell is being cast and provides a refrain which accompanies the progress of human life around it. Schiller's poem existed in several English translations in the 1840s. The most popular was that by Bulwer Lytton, published in 1844 (Morgan: 7914).

52. Schiff, 'von Holst', pp. 23ff.

53. W. M. Rossetti (ed.), *Dante Gabriel Rossetti: His Family Letters*, 1895, I, p. 58.

54. 1849 (RA: 601).

55. S. Redgrave, p. 268.

56. Gage, *Colour*, pp. 185–8.

57. *Undine, A Romance* (trans. G. Soane), 1818 (Morgan: 1748).

58. Robinson, *Diary*, II, p. 371.

59. Schiff, *Füssli*, pp. 379–80.

60. It appeared in the sale of his works at Christie's on 28 May 1827, no. 39; Schiff, *Füssli*, p. 603.

61. Both were obtainable from J. H. Bohte.

62. J. Curling, *Janus Weathercock*, 1938, pp. 9–12.

63. Cutting preserved in Catalogue of Exhibitions, Royal Academy.

64. It should also be remembered, however, that the success of Weber's *Oberon* and Mendelssohn's incidental music to *A Mid-Summer Night's Dream* affected the British interpretation of fairy subjects.

65. *The Times*, 7 May 1844, p. 6.

66. Burne-Jones, I, p. 141.

67. W. Schirmer, *Der Einfluss der deutschen Literatur auf die Englische im 19. ten. Jahrundert*, Halle, 1947, p. 86.

68. *Ibid*.

69. J. Ruskin, *The Elements of Drawing* (Works, XV, p. 222).

70. See p. 136.

71. See pp. 23ff.

72. See especially P. Muir, *Victorian Illustrated Books*,

73. *The Autobiography of Martin Luther* (trans. J. P. Lawson, after M. Michelet's arrangement), 1836 (Morgan: 5989).

74. The earliest was E. B. Morris, *Luther Burning the Pope's Bull*, exhibited 1852 (BI: 504).

75. Ormond and Turpin, *Daniel Maclise* (National Portrait Gallery exh. cat.), 1972, p. 95.

76. *Ibid*.

77. Ames, p. 134.

78. *Art Journal*, 1851, pp. 20ff.

79. *Goethe's Correspondence with a Child* (trans. Bettina von Arnim and Mrs Austin), 1837 (Morgan: 87).

NOTES TO CHAPTER IV

1. The most complete list of Retzsch's engravings can be found in L. Hirschberg, *Moritz Retzsch, Chronologisches Verzeichniss seiner graphischen Werke*, Berlin, 1925. It does not, however, contain details of English editions.

2. See pp. 157ff.

3. Notably in J. H. W. Tischbein, *Collection of Engravings from Ancient Vases ... discovered in the Kingdom of the Two Sicilies ... now in the Possession of Sir William Hamilton*, Naples, 1791–5, I–III.

4. J. Flaxman (engr. Piroli), *La Divina Commedia di Dante Alighieri*, Rome, 1793.

5. *Athenaeum*, II, Berlin, pp. 204ff: 'Ihre Zeichen werden fast wie Hieroglyphen, wie die des Dichters. Die Phantasie wird aufgefordert zu ergänzen und nach der empfangenen Anregung selbständig fortzubildern, statt dass das ausgeführte Gemälde sie durch entgegenkommende Befriedigung gefangen nimmt. So wie die Wörte des Dichters eigentlich Beschwörungsformeln für Leben und Schönheit sind, wenn man auch ihren Bestandteilen ihre geheime Gewalt nicht anmerkt, so kommt es einem bei dem gelungenen Umrisse wie eine wahre Zauberei vor, dass in wenigen zarten Strichen so viel Seele wohnen kann.'

6. For the influence of Flaxman, see Rosenblum, pp. 169ff.

7. W. H. Smith, *Essays in Design ... illustrative of the Poem of Thalaba the Destroyer by Robert Southey Esq., Poet Laureate*, Birmingham, 1818.

8. *Ibid*, p. 4.

9. Robinson Diary, MS., 5 January 1817.

10. *Ibid*.

11. Ruskin, *Notes on Modern Art* (Library edn., XIV, p. 360).

12. *Foreign Quarterly Review*, 1837, XVIII, p. 63.

13. Thieme-Becker, XIV, p. 538.

14. For an account of Retzsch's life see S. E. Odenkirchen, 'Moritz Retzsch, Illustrator', M.A. Thesis, Chicago, 1948.

15. Jameson, *Visits*, III, p. 124.

16. R. Benz, *Goethe und die romantische Kunst*, Munich, 1940, pp. 170ff.

17. *Ibid*, p. 175.

18. *Ibid*, p. 170: 'Dieses Gedicht hat man oft

darzustellen gesucht. Ich halte aber dafür, dass es wenig für die bildende Kunst geeignet, weil es zu poetisch ist. Retzsch hat mehr das wirklich Darstellende ergriffen.'

19. *Ibid*, pp. 110ff.
20. F. A. M. Retzsch, *Umrisse zu Goethe's Faust in 26 Blättern*, Tübingen, 1816, plates 3, 4; 8, 9; 22, 23.
21. Benz, *Romantische Kunst*, P. 170–1.
22. It seems that Retzsch knew in particular C. P. J. Normand's engravings for C. P. Landon's *Annales du Musée et de l'Ecole Moderne des Beaux-Arts,* Paris, 1800–22. Apart from stylistic affinities there appear to be some compositional borrowings. *Gretchen am Spinnrad* (*Faust*, pl. 18), for example, has distinct similarities to the engraving after Fleury Richard's *Valentin de Milan* (IV, 1803, p. 13).
23. C. F. Schultze, *14 Umrisse zu Undine, von de la Motte Fouqué*, Nuremberg, 1817; L. Schnorr von Carolsfeld, *Umrisse zu Undine von de la Motte Fouqué*, Leipzig, 1816.
24. H. Ebert, *Bonaventura Genelli: Leben und Werke*, Weimar, 1971, pp. 86ff.
25. F. A. M. Retzsch, *Fancies* (intro. Mrs Jameson), London, 1834.
26. *Die Schachspieler, Leipzig, 1836* (subscription list in Landesbibliothek, Dresden).
27. Benz, *Romantische Kunst*, p. 176.
28. See pp. 24ff.
29. Odenkirchen, ch. III.
30. *Faustus ... Embellished with Retsch's series of 27 Outlines engraved by H. Moses.*
31. Robinson Diary, MS., 3 January 1817.
32. *Ibid*, 5 January 1817.
33. Dibdin, III, p. 120.
34. See p. 25.
35. *London Magazine*, 1821, IV, p. 104.
36. *Monthly Review*, 1810, LXII, p. 491.
37. W. F. Hauhart, *The Reception of Goethe's Faust in England in the First Half of the Nineteenth Century*, New York, 1909, pp. 26ff.
38. *Ibid*, pp. 63ff.
39. Dibdin, III, p. 129.
40. *London Magazine*, 1820, I, p. 136.
41. *Ibid*.
42. *Ibid*.
43. *Kunstblatt*, 1827, p. 118.
44. Hauhart, pp. 32ff.
45. B. Disraeli, *Vivian Grey*, 1826–7, p. 48.
46. *Edinburgh Review*, 1822, pp. 316ff.
47. Letter to John Gisborne, 10 April 1822; see *The Letters of Percy Bysshe Shelley* (ed. Ingpen), 1912, II, p. 954.
48. F. A. M. Retzsch, *Acht Umrisse zu Schiller's Fridolin, oder der Gang nach dem Eisenhammer* (add. text C.A. Boetticher), Stuttgart and Tübingen, 1823.

49. 6 February 1823 (Boetticher *Nachlass*, 45b, Landesbibliothek Dresden): 'In dem Kunstblatt no. 1 von 1823, finden Sie von unser trefflich Maler Retzsch 8 Umrisse zu Schillers *Fridolin* in Cotta Verlag angesagt. Kommen Sie nur, wie wir alle wunsche, zu Messe Nach Leipzig und nach Dresden, so können Sie vielleicht, da Retzschs Faust England beifall fand, mit dem Fridolin eine kleine Speculation.'
50. *London Magazine*, 1821, IV, p. 104.
51. For Janus Weathercock's comment on this, see *London Magazine*, 1820, II, p. 301.
52. *Artistisches Notizenblatt*, 1825, X, p. 40: 'Man hatte in England, wo alle seine Arbeiten von Moses nachgestochen worden sind, angefangen, Skizzen in Retzsch's Manier zu Shakespeare an's licht zu bringen, die aber wenig Beifall fanden. Nun wird er für England selbst dergleichen unternehmen und mit Hamlet anfangen.'
53. Ackermann to Boettiger, 9 April 1828 (Boettiger *Nachlass*, II, 66).
54. Howard's series, entitled *The Spirit of the Plays of Shakespeare*, appeared between 1827 and 1833. His Shakespeare illustrations were last published in 1895. L. S. Ruhl's Shakespeare Outlines were published between 1832 and 1838.
55. *Foreign Quarterly Review*, 1828, p. 697.
56. *Ibid*.
57. The full list of Retzsch's Shakespearean subjects is as follows: *Hamlet*, 1828; *Macbeth*, 1833; *Romeo and Juliet*, 1836; *King Lear*, 1838; *The Tempest*, 1841; *Othello*, 1842; *The Merry Wives of Windsor*, 1844; *Henry IV* (Parts 1 and 2), 1846. All were published by Fleischer.
58. e.g. H. Howard, *Ariel released by Prospero* (1822 RA: 72)) D. Maclise, *Puck disenchanting Bottom* (1832 (RA: 464)). Maclise was later to turn to more tragic Shakespearian subjects, some of which were based on Retzsch's designs (see p. 147).
59. *Wretch's Illustration of Shakespeare*, Edinburgh, 1829.
60. A. Crowquill (pseud. A. H. Forrester), *Faust: A Serio-Comic Poem*, 1835.
61. *Punch*, 1846, p. 202.
62. 31 June 1839 (Retzsch *Nachlass*, 37; Landesbibliothek, Dresden): 'Ihre Werke werden verstanden und hoch geschätzt. Ich bin gewiss es wurde ihnen einen angenehemen Anblick gewahren einen englischen Familien Kreis zu sehen nicht wenig bekannt mit der Literatur ihres eigen wie fremder Länder, wie sie sich des Abends niedersetzen um Retzsch's Umrisse zu studieren vielleicht zum tausendmal ... wie sie jeder linie jeder einzelnen Reiz, irgend einen Beweis bisher unbemerkt von idealistischen Schönheit, entdecken.'
63. Jameson, *Visits*, II, p. 128.
64. *Ibid*.

65. Retzsch, *Fancies*, Pp. ix–x.

66. Mrs S. C. Hall, 'A Morning with Moritz Retzsch', *Art Journal*, 1851, p. 20; Mary Howitt, I, pp. 315–18.

67. *People's Journal*, 1847, III, p. 101.

68. See note 66.

69. Hirschberg, nos. 292–4, 315–25; *Faust* (trans. J. Birch, eng. J. Brain after M. Retzsch), 1839–43: *Outlines to Goethe's Faust* (M. Retzsch, Sampson, Law etc.), 1875: *Faust* (trans. Ann Swanwick, ill. after M. Retzsch), 1879; rev. edn., 1893.

70. W. H. Hunt, I, p. 130.

71. *Art Journal*, 1857, p. 252.

72. *Chambers' Encyclopaedia*, 1908, VIII, p. 672.

73. Perhaps the earliest was V. R. Grüner's to Goethe's *Pandora* in 1810; see Rosenblum, p. 175.

74. Robinson Diary, MS., 17 January 1811.

75. *Compositions from Shakespeare's Tempest*, Edinburgh, 1845.

76. Severn to his father, 10 April 1821 (Keats House, Hampstead).

77. *Ibid*, 21 November 1825.

78. *Compositions from the Tragedies of Aeschylus* (des. J. Flaxman, eng. T. Piroli and F. Howard), 1879.

79. *Kunstblatt*, 1827, p. 416.

80. *The Howard Shakespeare*, with illustrations by F. Howard.

81. S. T. Coleridge, *The Rime of the Ancient Mariner* (des. and etch. David Scott), Edinburgh, 1837.

82. W. B. Scott, *Memoir of David Scott*, 1850, p. 240.

83. H. C. Selous, *Outlines to Shakespeare's Tempest*, 1836.

84. *Ibid*, p. i.

85. This was the first of a series of Outline competitions held annually by the London Art Union; see Rossiter, pp. 25–6.

86. H. C. Selous, *Scenes from the Life of Moses* (eng. C. Rolls), 1850.

87. W. B. Scott (ed. W. Minto), *Autobiographical Notes*, I, p. 162.

88. See note 85.

89. These were published, together with Outlines to *The Tempest*, in Edinburgh in 1845, by W. P. Nimmo; see note 75.

90. *Punch*, 1846, p. 32.

91. *Punch*, 1846, p. 145.

92. H. Hubbard, *Some Victorian Draughtsmen*, 1944, p. 124.

93. *Edinburgh Review*, 1846, p. 343.

94. See Appendix I.

95. G. Schiff, 'Die Faust–Illustrationen des Malers Theodore Matthias von Holst (1810–1844)', *Jahrbuch des Wiener Goethe–Vereins*, 1962, LXVI, pp. 74–88.

96. G. Schiff, 'Theodore von Holst', pp. 23ff.

97. For a description of Holst's work, see *People's Journal*, 1847, III, p. 128, where the influence of Retzsch is denied.

98. Schiff, 'Theodore von Holst', p. 25.

99. R. Dadd, 'Walpurgis Night: A Lay of the Hartz Mountains and other Tales', MS. in V. & A. Library (Box I.36M), n.d.; see P. Allderidge, *The Late Richard Dadd* (Tate Gallery exh. cat.), 1974, p. 66, no. 71.

100. See note 47.

101. The connection with Retzsch was remarked in the *Athenaeum*, 1842, pp. 409–10. A copy of Retzsch's Shakespeare Outlines was in the artist's sale (lot 117).

102. See p. 213.

103. Ormond and Turpin, pp. 71–2.

104. Some discussion of Brown's dependence on Retzsch's Outlines in his early Shakespearian subjects can be found in Helen O. Borowitz '"King Lear" in the Art of Ford Madox Brown', *Victorian Studies*, 1978, XXI, no.3, pp. 309–34.

105. C. Gurlitt, *Sir Edward Burne-Jones*, Munich, 1895, p. 35.

106. Rossetti, *Family Letters*, I, p. 58.

107. *Foreign Quarterly Review*, 1833, XII, p. 445.

108. Rossetti, *Family Letters*, I, p. 59.

109. V. Surtees, *Paintings and Drawings of Dante Gabriel Rossetti: A Catalogue*, Oxford, 1971, no. 18.

110. L. A. Willoughby, *Dante Gabriel Rossetti and German Literature*, 1912, pp. 28–9.

111. Rossetti, *Family Letters*, I, p. 98.

112. Royal Academy exh. cat., 1849, no. 601.

113. Rossetti, *Family Letters*, II, p. 44.

114. W. H. Hunt, I, pp. 125ff.

115. *Ibid*, p. 130.

116. *J. E. Millais* (Royal Academy exh. cat.), 1967, nos. 210–13, p. 70.

117. *Ibid*, no. 211, p. 70.

118. Hunt, in the *Contemporary Review*, 1886, p. 482.

119. Noted by Stephen Calloway in 'Attitudes to the Mediaeval in English Book Illustration, c. 1800–57', M.A. Report, Courtauld Institute of Art, 1975, pp. 33, 70.

NOTES TO CHAPTER V

1. *Athenaeum*, 1799, p. 204.

2. For example in John of Genoa's *Catholicon*; see M. Baxandall, *Painting and Experience in Fifteenth-Century Italy*, Oxford, 1974, p. 41.

3. J. P. Eckermann, *Gespräche mit Goethe* (Insel Verlage edn.), Leipzig, 1968, p. 165.

4. *Ecclesiologist*, 1845, V, p. 203.

5. See p. 172.

6. *Ecclesiologist*, 1845, V, p. 225.

7. R. Aldick, *The English Common Reader*, Chicago, 1957, p. 277.

8. R. McLean, *Victorian Book Design*, 1963, p. 118.

9. Twyman, pp. 3ff.

10. McLean, *Book Design*, pp. 58ff.

11. H. Beck, *Victorian Engravings*, 1973, pp. 19ff.

12. In 1855, during the Crimean War, the circulation rose to 200,000 (L. de Vries (ed.), *Panorama, 1842–1865*, 1967, pp. 10–11).

13. M. Wolff and C. Fox, 'Pictures from the Magazines' in *The Victorian City* (ed. Dyos and Wolff), II, p. 578 n. 21.

14. A. Dobson, *Thomas Bewick and his Pupils*, 1884, pp. 52–3.

15. *Ibid*, pp. 173–4.

16. *Art Union*, 1839, p. 32.

17. J. B. Molière; *Oeuvres de Molière précédées d'une notice sur sa vie et ses ouvrages par M. Saint-Beuve* (ill. Tony Johannot), Paris, 1835–6.

18. Thieme-Becker, XV, p. 184.

19. *Neureuther's Cid*, for example, was advertised as having wood engravings 'geschuitten von den besten Englischen Holzschneidem, Thompson, Orrin Smith, Williams, Gray, Wright, Folkard, etc.' (*Kunstblatt*, 1845, no. 61, p. 256).

20. Nichols engraved *Wie die Königin den Saal verbrennen Liess* for *Das Nibelungenlied*, Leipzig, 1840. He also engraved Richter's illustrations to *Der Landprediger von Wakefield*, Leipzig, 1841. Apparently Bewick's pupil John Allanson was the engraver considered most able at cutting Richter's work (Hoff, p. 405).

21. Thieme-Becker, XXXIII, p. 585.

22. K. Scheffler, *Adolph Menzel*, Leipzig, 1938, pp. 36ff.

23. *Art Union*, 1839, p. 32.

24. S. C. Hall (ed.), *The Book of British Ballads*, 1842.

25. G. E. Dalziel, *The Brothers Dalziel: A Record of Fifty Years Work*, 1901.

26. R. Benz, *Goethe's Götz von Berlichingen in Zeichnungen von Franz Pforr*, Schriften der Goethe-Gesellschaft, LII, Weimar, 1941, pp. 33–6.

27. Andrews, p. 31. The frontispiece was designed in Rome and shows an additional influence of Italian grotesque work. This was hardly incompatible with Dürer's designs, which were themselves executed under Italian influence (E. Panofsky, *The Life and Art of Albrecht Dürer*, Princeton, 1971 edn., p. 185).

28. Jameson, *Visits*, I, pp. 284–5; *Art Union*, 1847, p. 242.

29. *Art Union*, 1847, p. 241.

30. Feige, *Kleine Gesellschafter*, Berlin, 1836.

31. Reinick was later to provide the accompanying verses for Rethel's *Auch ein Totentanz* (J. Ponten, *Alfred Rethel's Briefe*, Berlin, 1912, p. 116).

32. *Art Union*, 1842, p. 211.

33. *Art Union*, 1843, p. 32.

34. *Der Nibelungen Noth*, Munich, 1843. This is the edition used by D. G. Rossetti when making his translation of the Nibelungen in 1845 (Rossetti, *Family Letters*, I, p. 104).

35. W. Franke, *Alfred Rethel's Zeichnungen*, Berlin, n.d., p. 22.

36. See p. 176.

37. Jagow, p. 73.

38. The subscription list is in a copy of the *Nibelungen* in the Kupferstichkabinett, Museum der Bildenden Künste, Leipzig.

39. Ponten, *Rethel's Briefe*, p. 143.

40. Franke, p. 31.

41. *Ibid*, p. 31.

42. Ruskin, *Addresses on Decorative Colour*, 1854 (Library edn., XII, p. 489); Baudelaire, *L'Art philosophique (Curiosites esthetique)* (Garnier edn.), Paris, 1962, pp. 506–8.

43. Schahl, pp. 56ff.

44. Andrews, p. 66.

45. McLean, *Book Dessign*, p. 9.

46. *Ibid*, pp. 46–52.

47. A. A. Clownes, *Charles Knight: A Sketch*, 1892, pp. 70–1.

48. McLean, *Book Design*, pp. 161–2.

49. Dalziel, pp. 124–6.

50. *Art Union*, 1839, p. 32.

51. *Der Cid, nach spanischen Romanzen besungen* (ill. E. Neureuther), Stuttgart, 1838.

52. J. G. Lockhart (trans.), *Ancient Spanish Ballads, Historical and Romantic* (ill. Owen Jones), 1841.

53. *Athenaeum*, 1874, p. 569.

54. McLean, *Book Design*, pp. 60ff.

55. *The Book of Common Prayer . . . illuminated and illustrated with Engravings from the Works of the Great Painters* (ill. Owen Jones), 1845.

56. J. C. Horsley provided *Holy Communion* (p. 253), *Matrimony* (p. 324), *The Burial of the Dead* (p. 350); Henry Warren provided *Public Baptism* (p. 281).

57. Hall, *Retrospect*, I, p. 327.

58. *Ibid*, p. 333.

59. G. K. Nagler, *Die Monogrammisten*, Munich, 1858, I, p. 518, no. 1208.

60. W. B. Scott, *Autobiography*, I, p. 108.

61. *Ibid*, pp. 153–6.

62. Hall, *Retrospect*, I, p. 327.

63. W. B. Scott, *Autobiography*, I, p. 162.

64. *Tableaux from Crichton* (des. and etch. J.F.), 1837.

65. W. H. Ainsworth, *Old Saint Paul's* (ill. J.F.), 1841.

66. Franklin's last recorded illustrations were for *St George and the Dragon*, 1868.

67. Gammer Gurton's Story Books, Cundall, *c.* 1845; see McLean, *Book Design*, pp. 34, 39, 40.

68. Hall, *Retrospect*, I, p. 333.

69. *Ibid*, p. 345.

70. Reid, *Illustrators of the Eighteen Sixties*, 1928, p. 27.

71. McLean, *Book Design*, p. 66; repr. pl. 8.

72. H. N. Humphreys, *Ten Centuries of Art*, 1852, pp. 61ff.

73. *Art Union*, 1845, p. 342.

74. *Athenaeum*, 1845, p. 1036.
75. *Athenaeum*, 1847, p. 49.
76. M. Bennett, *J. E. Millais* (Arts Council exh. cat.), 1967, no. 244.
77. See note 4.
78. Dalziel, p. 52.
79. *Ibid*, p. 55.
80. Ruskin, *Elements of Drawing* (Library edn., XV, p. 80).
81. Dalziel, p. 57.
82. *Art Union*, 1839, p. 32.
83. Scheffler, pp. 36ff.
84. Dalziel, p. 56.
85. Reid, p. 31.
86. W. Crane, *An Artist's Reminiscences*, 1907, p. 47.
87. W. J. Linton, *Wood Engraving: A Manual of Instruction*, 1884, p. 36.
88. Crane, p. 44.
89. G. Burne-Jones, I, pp. 254–5.
90. *Ibid*, p. 255.

NOTES TO CHAPTER VI

1. See Introduction, notes 1–4.
2. Reproduced in Bell, *Victorian Artists*, pl. 3.
3. H. Sass, *A Journey to Italy, 1817*, 1818.
4. See pp. 35ff.
5. Reynolds, Discourse III, pp. 49–50.
6. *London Magazine*, 1820, p. 42.
7. Reynolds, Discourse III, p. 50.
8. Severn to Leslie, 21 November 1821 (MS. in V. & A. Library).
9. Metz is identifiable through being described in a letter of Severn's as having achieved fame through his engraving after Michelangelo's *Last Judgement* (Sharp, *Severn*, pp. 112–13).
10. In this year he painted a *Mother and Child* for Prince Leopold of Saxe-Coburg (Sharp, *Severn*, p. 138).
11. *Kunstblatt*, 1841, p. 92.
12. 17 September 1840 (National Library of Scotland, Hope Scott Correspondence, MS. 3669, no. 58).
13. Now in the Pinacotheca di S. Paolo Fuori le Mura. The commission caused considerable bitterness amongst Catholic prelates and such Italian rivals as Cammuccini (Sharp, *Severn*, p. 297).
14. Severn to sister Maria, 21 January 1821 (MS. in Keats House, Hampstead).
15. Sharp, *Severn*, p. 203.
16. *Ibid*, p. 201.
17. Rossetti, *Family Letters*, I, p. 45.
18. In a letter to his mother, sent from Gatton Park on 24 September 1845, he described the frescos as 'in many respects the most important works I have ever done as they are the first example in England of architecture being decorated with pictures in this style', (MS. in Keats House, Hampstead).
19. Rossetti, *Family Letters*, I, p. 61.
20. Eastlake, *Contributions*, 2nd series, p. 60.
21. See p. 36.
22. *London Magazine*, 1820, p. 42.
23. *Ibid*.
24. Eastlake, *Contributions*, 2nd series, p. 99.
25. *Ibid*, p. 194.
26. *Ibid*, p. 194.
27. (RA: 289), Diploma Gallery.
28. Eastlake, *Contributions*, 1st series, pp. 351–96.
29. Letter to *The Times*, 13 July 1854, p. 7.
30. Eastlake, *Contributions*, 2nd series, p. 127.
31. See chapter I, note 326.
32. Mrs Jameson, for example, had a great respect for Schnoor as a colourist (*Visits*, I, p. 287).
33. See chapter I, note 173.
34. See p. 60.
35. Eastlake, *Contributions*, 2nd series, p. 195.
36. Overbeck made three versions of this theme in sepia. The earliest, executed in 1826, was issued by its owner Johann Velten as a lithograph in 1828 (*Die Nazarener* (Städelschen Kunstinstitut exh. cat.), 1977, p. 384).
37. Eastlake, *Contributions*, 2nd series, p. 195.
38. *Ibid*.
39. *Ibid*.
40. *Art Union*, 1843, p. 164.
41. Eastlake, *Contributions*, 2nd series, pp. 179ff.
42. *Ibid*.
43. See chapter I, note 52.
44. Schnorr's first letter to Eastlake concerning mural technique was sent on 5 July 1840. In this he made Eastlake aware of encaustic paintings: 'bin ich . . . in grossen Vorteil gesetzt, dass ich bei meiner neuen grossen Aufgabe eine Technik auswenden kann nehmlich die Technik der *enkaustischen Malerei*' (V. & A. MS. 86.M.38). Encaustic painting was not actually used at Westminster before Maclise's visit to Berlin in 1859.
45. Haydon, V, p. 217.
46. 'Dyce Papers', IX, p. 339.
47. *Ibid*, X, p. 338.
48. *Ibid*, p. 341.
49. Letter to Eastlake, 23 March 1846; 'Dyce Papers', XXII, pp. 849–50.
50. 'Dyce Papers', I, p. 16.
51. *Art Journal*, 1860, p. 294.
52. Andrews, p. 81 n. 3.
53. *London Magazine*, 1820, p. 149.
54. Dafforne, 'Dyce', p. 299.
55. *Kunstblatt*, 1828, p. 296: 'Die Zukunft wird lehren, welche Partei Recht gehabt habe, aber so viel ist gewiss, dass er ein grosses Talent für Farbe bessass.'
56. See Pointon, 'Dyce', pp. 21ff.

57. Steinle, I, p. 247.

58. A. Staley, 'William Dyce and Outdoor Naturalism', *Burlington Magazine*, 1963, p. 471.

59. W. H. Hunt, I, p. 219.

60. Dyce's exhibited religious works from his Edinburgh period were as follows:

1829	*The Daughters of Jethro,*	Institute for the Encouragement of the Fine Arts, no. 51.
	Designs for pictures of the *Annunciation, Visitation* and *Entombment,*	Institute for the Encouragement of the Fine Arts, no. 179.
1830	*Christ Crowned with Thorns,*	Royal Scottish Academy, no. 276.
1835	*The Dead Christ: An Altarpiece,*	Royal Scottish Academy, no. 228.

61. *Divina Commedia*, Inferno, pl. V.

62. Pointon, 'Work', p. 207.

63. W. Dyce and C. Wilson, *Letter to Lord Meadowbank*, Edinburgh, 1837, p. 22.

64. Dyce, p. 36.

65. *Report from the Select Committee on the Schools of Design*, 27 July 1849, Dyce's Evidence, IX, 740.

66. 'Dyce Papers', XXV, p. 1024.

67. *Ibid*, XXII, p. 867.

68. No trace of this work can now be found. It was possibly destroyed when the chapel was burned out during the 1939–45 war (*Survey of London,* 1951, XXIII, pt 1, p. 9).

69. 'Dyce Papers', XXI, p. 850.

70. *Ibid*, X, p. 338.

71. Eastlake to Schnorr, 20 August 1837 (Schnorr *Nachlass*, 197; Landesbibliothek, Dresden).

72. Andrews, p. 66.

73. 'try to get a sight of his *Bible*—a collection of designs by him from the Old Testament'; Dyce to Hope Scott, 17 September 1840 (National Library of Scotland, MS. 3669).

74. Andrews, p. 132.

75. See Mary Chamot's entry on William Dyce, *Madonna and Child* (T.618), *The Tate Gallery Report, 1963–4*, 1964, p. 22. In this the opinion of Charles Carter in favour of such a dating is cited, but not wholeheartedly accepted. Charles Carter's views can be found more extensively in his correspondence with Mary Chamot in the Tate Gallery catalogue file on T.618. From a letter to C. H. Wilson dated 30 July 1837 it is clear that Dyce was engaged in painting a Madonna at the time. It would seem more likely that Dyce would exhibit such a work at the Royal Academy in 1838 than one painted at an earlier date. On the back of T.618 is an old label that states that the work had been exhibited at the Royal Academy in 1846. This is clearly not the case, since the work

exhibited then was the Madonna commissioned by Prince Albert. However, the tradition that it *had* been exhibited at the Royal Academy cannot be altogether overlooked. An early owner of the work would have been less likely to make a mistake about this than about the actual year in which it was shown.

76. *Alte Pinakothek München, Kurzes Verzeichnis der Bilder*, Munich, 1958, p. 80 (W.A.F. 796). The picture was acquired for King Ludwig in 1829.

77. The identification of the Madonna by Dyce at Nottingham Art Gallery as the one exhibited at the Royal Academy in 1838 (Andrews, p. 131) is unconvincing. The work is clearly a study, and it is unlikely that it would have been exhibited at the Academy without some allusion to this being made.

In view of the Nottingham Madonna's unusual technique (oil on slate) it may well be the 'study in fresco' for the Osborne Madonna that was sold at Dyce's sale (5 May 1865, lot 141).

78. 12 May 1846; Jorns, p. 371: 'Nur seltsameweise sein frühere Schönheitssinn hat ihn verlassen . . . Dyce ist in neuen Papismus untergegangen, scharf, spitzig und trocken geworden.'

79. See p. 90.

80. See p. 234.

81. 'Dyce Papers', XXVII; letter dated 14 October 1852.

82. *Ibid*; transcript of letter in Royal Collection.

83. Margaret Howitt, II, pp. 61–72.

84. *Art Journal*, 1860, p. 295.

85. Staley, 'Outdoor Naturalism', pp. 470ff.

86. Mary Howitt, p. 205.

87. 'The public works now going on in the small town of Munich in the decoration of Churches, palaces, and public buildings is truly surprising, and among which there are productions of very marked excellence in the epic style.' This passage is a part of a plea for public patronage of which, Howard says 'no commercial speculation, nor art-union, can fill its place' (Lecture VI; published in H. Howard (ed. F. Howard), *A Course of Lectures on Painting*, 1848, p. 291).

88. F. K. Hunt, p. 80.

89. There were:

1838	E. M. Ward: studied fresco for a few months under Cornelius on way back to England from Rome (Thieme Becker, XXXV, 1942, pp. 157–8)
1840	H. O'Neil: with Schnorr in Munich July/August (*Art Journal*, 1880. p. 171)
	A. Elmore: stayed in Munich on way to Rome (Thieme Becker, X, 1914, p. 477)
	H. J. Stanley: pupil of Kaulbach. Later settled in Munich (Nagler, *Künstlerlexikon*, 1847, XVII, p. 218)
1842	W. Cave Thomas: worked under Heinrich

Maria Hess on frescos in Bonifaziusba-silika (Thieme-Becker, LIII, p. 68)

T. Sibson: studied under Kaulbach (W. B. Scott, *Autobiography*, I, p. 206)

J. C. Horsley: (*D.N.B.*, 2nd suppl., 1912, p. 304ff)

1845 J. Tenniel: (*D.N.B.*, XX, pp. 1412–21)

C. W. Cope: studied under Hess (*Art Journal*, 1890, p. 320).

90. These were reprinted in the first series of *Contributions*.

91. See Eastlake Corr., V. & A.:
Schnorr to Eastlake. 24 April 1842 (86. M.38, fol. 4)
Schnorr to Eastlake, 18 April 1843 (86.M.38, fol. 6).

92. The democratic procedure of the first exhibition— in which the names of the contestants were withheld from the judges—was not repeated in the subsequent contests. Of the artists who won premiums in the first competition only three—Watts, Cope and Horsley— were finally commissioned to execute frescoes in the Palace of Westminster. The most important commissions went to Dyce and Maclise, who only entered the second Westminster Hall competition after being invited to do so.

93. Eastlake, *Contributions*, 1st series, p. 21.

94. F. K. Hunt, p. 79.

95. Boase, 'New Palace', p. 327.

96. W. B. Scott, *Autobiography*, I, p. 206.

97. Letter dated 5 November 1843 (Kaulbach *Nachlass*, IV).

98. The catalogues are reprinted with numerous illustrations in F. K. Hunt's *Book of Art*, 1846, chs. IX, X, and XII. Lithographs of the prize-winning designs of 1843 were published in J. J. & W. Linnell, *The Prize Cartoons*, 1843.

99. No. 44 (Linnell, pl. 1).

100. Boase, 'New Palace', p. 328.

101. Linnell, pl. 9.

102. No. 105 (Linnell, pl. 3).

103. No. 70 (Linnell, pl. 8).

104. No. 128 (Linnell, pl. 6).

105. Boase, 'New Palace', pp. 328–9.

106. No. 92 (F. K. Hunt, p. 103).

107. No. 54 (*Ibid*, p. 124). In *A Critical Examination* H. G. Clarke took exception to the gilded background in this work: 'the old Catholic practice . . . transplanted from Italy to Munich is now imported to England, but we trust it will continue to be an exotic among us'. Presumably Thomas was following the practice of Hess in the Bonifazius-Basilika.

108. Nos. 6 & 63 (F. K. Hunt, p. 126).

109. No. 51 (*Ibid*, p. 123).

110. No. 53 (*Ibid*).

111. No. 74 (*Ibid*, p. 131).

112. Reproduced in *Ibid*, p. 127. There is a study for the composition in the Department of Prints and Drawing, V. & A. (E. 1797–1910).

113. 3 July 1845; see T. Taylor, *The Life of B. R. Haydon*, 1853, III, p. 309.

114. Details of the commissions and execution can be found in R. J. B. Walker, *A. Catalogue of Paintings and Drawings in the Palace of Westminster*, 1962, IV (typescript-copies in Courtauld and V. & A. Libraries).

115. See Pointon, 'Work', pp. 153–4.

116. See p. 146.

117. Neureuther's illustrations to *Der Cid* may have been especially influential. These were already known in England by 1839, when they were reviewed in the *Art Union* (p. 32).

118. This is first evident in Maclise's contributions to Dickens' second Christmas book, *The Chimes*, 1844. More striking examples are his illustrations to Thomas Moore's *Irish Melodies*, 1845, and Bürger's *Lenore*, 1847 (see pp. 171ff).

119. C. H. Cope, *Reminiscences of Charles West Cope, R.A.*, 1891, pp. 152–4.

120. J. C. Horsley, *Recollections of a Royal Academician*, 1903, pp. 151ff.

121. Cope, pp. 152ff.

122. Walker, IV, p. 9.

123. J. C. Horsley, p. 206.

124. Walker, IV, pp. 60, 66–70.

125. 'Dyce Papers', XXI, p. 850.

126. O'Driscoll, p. 93; Maclise's Paris journal is at the Royal Academy.

127 *Athenaeum*, 1847, p. 496.

128. O'Driscoll, pp. 149, 241–64.

129. *The Times*, 30 June 1845, p. 5.

130. Tenniel was frequently to satirize the style of the Palace of Westminster frescoes, as for example in his frontispiece of the Great Exhibition for *Punch* (1851, XX, frontispiece).

131. F. K. Hunt, frontispiece and p. 173.

132. W. H. Hunt, I, p. 125; Brown himself admitted that his 'profoundest admiration' for Overbeck and Cornelius was 'a belief in which I differed essentially from the young Pre-Raphaelites' (letter to Cornelius Gurlitt, 9 December 1891, published in Gurlitt, *Burne-Jones*, p. 35). My attention was drawn to this letter by Dr Stefan Muthesius.

133. 'Before going to Rome in 1845 I had already received some considerable impulse from the German engravings in the Parisian shop windows. I and my friends, French or Belgium, often discussed them; we did not require to go Rome for this' (Gurlitt, *Burne-Jones*, p. 35).

134. The cartoon is in the South London Art Gallery.

135. F. K. Hunt, p. 80.

136. *Ibid*.

137. *The Times*, 30 June 1845, p. 5.
138. Hueffer, p. 38.
139. In the 1845 exhibition, Brown's specimen was in fresco.
140. F. K. Hunt, pp. 175–6.
141. Hueffer, pp. 43–4. In his letter to Gurlitt (see note 130) Brown stated: 'When I was in Rome, except the two great Germans just above mentioned [Overbeck and Cornelius] I saw no one but the Doctor: My poor wife was dying at the time' (Gurlitt, *Burne-Jones*, p. 35).
142. Hueffer, p. 82.
143. See chapter IV, note 116.
144. This last remark is purely conjectural, since there is no evidence that Combe ever possessed the work. It would presumably have been stocked by the Oxford dealer James Ryman, who owned a set of Overbeck drawings of the life of Christ, and published a translation of Overbeck's explanation of *Triumph der Religion* in 1850 (Margaret Howitt, II, p. 419).
145. In City Museums and Art Gallery, Birmingham.
146. W. H. Hunt, I, p. 208.
147. Noted by Allen Staley in *Romantic Art in Britain: Paintings and Drawings, 1760–1860*, Philadelphia, 1968, p. 273.
148. J. Ruskin, *Modern Painters*, III, Appendix III (Library edn., V, p. 429).
149. J. B. Atkinson 'The Schools of Modern Art in Germany, VII', *Portfolio*, 1878, p. 154; M. Bennett, *Walker Art Gallery, Liverpool, Bulletin*, XIII, 1968–70, pp. 27ff.
150. See note 148.

NOTES TO CHAPTER VII

1. Law, p. 164.
2. *Ibid.*
3. *Athenaeum*, 1846, p. 72; *Illustrated London News*, 1846, p. 337.
4. *Fine Arts Journal*, 1847, p. 450.
5. Pugin, *Apology*, p. 44.
6. *Ecclesiologist*, 1845, p. 203.
7. Law, p. 142.
8. *Builder*, 1845, p. 367.
9. *Ecclesiologist*, 1850, p. 398.
10. P. Stanton, 'Pugin', Ph.D., London, 1951, p. 108.
11. P. Thompson, *William Butterfield*, 1971, p. 84.
12. See *Ecclesiologist*, 1852, p. 241. For the Wantage project, see A. E. Street, *Memoirs of G. E. Street*, 1888, p. 13. Street's chancel paintings caused some local discomfort, but the matter was decided in his favour by the Bishop of Exeter (*Ecclesiologist*, 1852, pp. 16–17).
13. 'Dyce Papers', I, p. 5.
14. *Ibid.*, p. 4.

15. *On the Garments of Jewish Priests*, 1830 (*Ibid*, between pp. 84 and 85); *The Jesuits*, 1833 (*Ibid*, II, pp. 90ff). The latter was discussed extensively in correspondence with Nicholas Wiseman.
16. 'Dyce Papers', XIII, p. 529.
17. See Pointon, 'Work', p. 248.
18. Letter from Sir J. T. Coleridge to Dyce, 21 February 1848 ('Dyce Papers', XXIV, p. 1006).
19. *Ibid*, XIII, p. 412.
20. *Ibid*, I, p. 17.
21. Steinle, I, p. 247.
22. *Ibid.*
23. 'Dyce Papers', XVI, pp. 808ff.
24. 9 January 1834 (*Ibid*, II, p. 103).
25. *Ibid*, IX, p. 353.
26. *Kunstblatt*, 1828, p. 296.
27. 1 September 1834 ('Dyce Papers', II, p. 105).
28. 29 June 1838 (*Ibid*, V, p. 179).
29. P. Stanton, *Pugin*, 1970, p. 57.
30. Stanton, 'Pugin', p. 193.
31. 1840 (RA: 287).
32. 1842 (RA:11).
33. 1844 (RA: 364).
34. Dr Wheedel, Exh. 1841 (RA: 441); Wiseman, Exh. 1842 (RA: 530).
35. See chapter VI, note 73.
36. On 18 May 1843, Gladstone sent a letter to Dyce agreeing to pay 30 gns for the picture ('Dyce Papers', X).
37. *Ibid*, I, p. 18.
38. P. Magnus, *Gladstone*, 1963 edn., p. 52.
39. 'On Ecclesiastical Architecture—A Defence of Anglican Usage' ('Dyce Papers', Ch. XIII, p. 411).
40. M. Pointon, 'W. E. Gladstone as an Art Patron and Collector', *Victorian Studies*, 1975, XIX, no. I, p. 88.
41. *Ibid.*
42. See letter from Gladstone to Acland, 19 November 1839 ('Dyce Papers'). The production of cheap religious illustrations was a widespread concern of the 1840s. It occasioned the enthusiastic reception of the reissue of Dürer's *Small Passion* by the *Ecclesiologist* in 1845 (p. 113). It was not until F. R. Pickersgill's *Six Compositions from the Life of Christ*, modelled on Rethel's *Auch ein Todtentanz*, was produced in 1851 by the Dalziels that this objective was felt to have been achieved. 'We have seen numerous foreign introductions, excellent in their kind, and issued at a tolerably moderate charge, but that charge has not been sufficiently low to bring them within the range of the classes whose means should more especially have been consulted—the intelligent working classes and those who belong to them. Now, Mr. F. R. Pickersgill's series is just the publication to meet their requirements; it comes within the reach of their pockets, while it is no less adapted for their mental instruction and to elevate the conception to the beauty

and sublimity of true art' (*Art Journal*, 1850, p. 392). The price was one shilling.

43. The S.P.C.K. project was superseded by Ludwig Gruner's series of engravings, *Scripture Prints from the frescos of Raphael in the Vatican*. Sponsored by Hope Scott in 1844, it was eventually published in 1861 (R. Ormsby, *Memoirs of J. R. Hope Scott*, 1882, II, p. 38).

44. Letter from Acland to Dyce, 19 November 1839 ('Dyce Papers', V, p. 206).

45. *Ibid*, VII, p. 256.

46. *Ibid*.

47. *Ibid*.

48. Dyce to Gladstone, 7 July 1841 (*Ibid*, p. 251).

49. Wiseman, p. vii; in the introduction Wiseman says that the drawing 'kindly drawn for him by the illustrious Overbeck ... has found an engraver worthy of it, in Ludwig Grüner Esq., whose work will descend to posterity in close connexion with those of the ancient Roman school which he has so well followed both in spirit and execution.'

50. Dyce in fact offered to do the drawing free if Gruner were employed to engrave it (Dyce to Brechin, 7 December 1851 ('Dyce Papers', XXIX)).

51. *Athenaeum*, 1846, p. 71.

52. *Ecclesiologist*, 1846, p. 73.

53. *Ibid*, 1845, p. 225.

54. 'Dyce Papers', V, p. 208.

55. *Ibid*, VII, pp. 256ff.

56. J. Ruutz Rees, *Horace Vernet*, 1880, pp. 22ff.

57. W. B. Scott, *David Scott*, p. 111.

58. Ruutz Rees, p. 22.

59. Wiseman, p. 8.

60. *Kunstblatt*, 1844, p. 293: 'Ich weiss nicht, ob der Künstler des Verlusts von religiosem und poetischen Gehalt nicht irre wird gegen den Gewinn einer sogenannten wahren Geschichte, die in ihrer Kahlheit entweder—wie bie Rebecca nuchtern—oder bei der Judith entsetzlich—erschien.'

61. *Art Union*, 1844, p. 158.

62. 12 June 1844 (National Library of Scotland, Edinburgh, MS. 3669).

63. *Ibid*.

64. J. Cave-Brown, *Lambeth Palace and its Associations*, 1882, pp. 266–7.

65. Dyce to Eastlake, 15 August 1848 ('Dyce Papers', XXVII).

66. Andrews, p. 131.

67. Cope, p. 171.

68. Staley, 'Outdoor Naturalism', p. 474.

69. W. H. Hunt, I, pp. 35–6.

70. *Ibid*, p. 207.

71. *Illustrated London News*, 1846, p. 337.

72. *Ibid*.

73. *Art Journal*, 1851, p. 30.

74. *Ibid*, 1850, p. 175; 1851, p. 285.

75. *Ibid*, 1851, p. 285.

76. *Illustrated London News*, 1846, p. 337.

77. *Art Journal*, 1851, p. 286; see also *The Times*, 9 May 1850, p. 8: 'Mr Millais and his imitators, who are attempting to graft themselves on the wildest and most uncouth productions of the early German school'. For the actual influence of the 'Early German school' on the Pre-Raphaelites, see J. G. Christian, 'Early German Sources for Pre Raphaelite Designs', *Art Quarterly*, 1973, XXXVI, 1–2, pp. 68ff.

78. *Ecclesiologist*, 1850, p. 45.

79. *Ibid*, p. 45.

80. *Illustrated London News*, 1846, p. 337.

81. Jameson, *Sacred and Legendary Art*, Introduction: II. 'Of the Distinction to be Drawn between Devotional and Historical Subjects' (1896 edn., p. 11).

82. *Ibid*, p. 11.

83. *Ibid*, p. 14.

84. *Ibid*.

85. Cope, p. 167.

86. 'Dyce Papers', XVII.

87. L. Errington, 'Social and Religious Themes in English Art, 1840–60', Ph.D., London, 1973, p. 177.

88. 'On Ecclesiastical Architecture' ('Dyce Papers', XIII, p. 515).

89. *Ibid*, XXV, p. 1021.

90. *Ibid*, XXV, p. 1025.

91. 2 February 1846 (*Ibid*, XXI, p. 813).

92. A. J. Beresford Hope, *The English Cathedrals of the Nineteenth Century*, 1861, p. 250.

93. 'On Glass Painting', *Ecclesiologist*, 1852, pp. 237–47.

94. See note 12.

95. *Memoir of G. E. Street*, 1888, p. 38.

96. C. L. Eastlake, *A History of the Gothic Revival*, 1872, p. 260.

97. Law, p. 177 n.1.

98. 'Chapters on Painted Glass: I. The Munich School', *Ecclesiologist*, 1847, p. 127.

99. *Ibid*, p. 123.

100. Dyce to Pusey, 9 October 1848 ('Dyce Papers', Ch. XXVIII).

101. *Ibid*, XXVI, p. 1068.

102. *Ibid*, XIV, p. 536.

103. It was noticed as being in situ in the *Builder* in 1856; see Pointon, 'Work', p. 268.

104. Dyce quarreled with Wilson over this; see Pointon, 'Work', p. 255.

105. Dyce to John Webster, 25 March 1857 ('Dyce Papers', XXXVI).

106. Dyce to Webster, 4 July 1857 (*Ibid*).

107. *Ibid*.

108. J. Ballantine, *A Treatise on Stained Glass*, London and Edinburgh, 1845, p. 21.

109. *Ecclesiologist*, 1852, p. 241.

110. Street, pp. 16ff.

111. Preedy may well have known the cartoon of this

subject which was bought by M. J. Rhodes of Leeds in 1851, or the replica that was bought by Henry Woods of Wigan in 1857. However, the subject was also known through the engraving by X. Steifensand (Margaret Howitt, II, p. 416). References to other borrowings from modern German designs by Preedy and other Victorian stained-glass designers will occur in Martin Harrison's forthcoming book on Victorian stained glass.

112. *Burne-Jones* (Hayward Gallery exh. cat.) 1975, p. 33, no. 55.

113. 'Report on the 21st Anniversary of the Ecclesiological Society', *Ecclesiologist*, 1860, p. 250.

114. John Cornforth, 'Gambier Parry', *Country Life*, 1967, CXLI, pp. 512–13.

115. *Ecclesiologist*, 1860, p. 250.

116. *Ibid.*

117. *Ibid.*

NOTES TO THE EPILOGUE

1. Rossetti, *Reminiscences*, I, p. 138.

2. *Gems of Modern German Art*, 1873.

3. Vaughan, Appendix II, pp. 362–3.

4. e.g. 'eine (nicht näher genannte) Zeichnung wurde von dem Künstler im Januar 1862 an einen englischen Edelmann für 200 scudi verkauft. Ebenso eine Zeichnung an den Rev. M. Powell 1863 für 10 Pfd. Sterling' (Margaret Howitt, II, p. 431).

5. In Dorchester Abbey, there are two side windows in the south choir by Mayer dated 1899 (Pevsner, *Oxfordshire*, p. 583). In St Mary Magdalene, Melchbourne, Bedfordshire, there is an east window by Mayer 'as late as 1902 or later' (Pevsner, *Bedfordshire, Huntingdon and Peterborough*, 1968, p. 124).

6. Andrews, p. 64.

7. See Vaughan, Appendix II.

8. *Die Nazarener* (exh. cat.), Frankfurt, 1977, pp. 365ff.

9. See chapter I, note 7.

10. *Art Journal*, 1861, p. 200; *Athenaeum*, 1861, pp. 23–4.

11. See Cassel's *Illustrated Exhibitor*, 1862.

12. *Art Journal*, 1862, p. 183.

13. *The Times*, 26 August 1862, p. 5.

14. *Portfolio*, 1878, p. 147.

15. 'Eisenwalzwerk', 1875, Nationalgalerie, East Berlin.

16. R. and L. Ormond, *Lord Leighton*, New Haven and London, 1975.

17. Ruskin, *Modern Painters*, II (Library edn., IV, p. 33).

18. R. F. Egan, 'The Genesis of the Theory of "Art for Art's Sake" in Germany and England', *Smith College Studies in Modern Languages*, 1921, II, no. 4, pp. 11–12.

19. F. Haskell, *Rediscoveries in Art*, 1976, p. 112.

20. Ormond, p. 33.

21. J. Ruskin (ed. Evans & Whitehouse), *Diaries*, Oxford, 1958, II, p. 540.

22. Sharp, *Progress*, p. 318.

23. Christian, p. 68.

24. See Sharp, *Progress*, p. 319.

25. Morgan, pp. 80–2.

26. G. S. Layard, *The Life of C. S. Keene*, 1893, p. 56.

27. Sharp, *Progress*, p. 323.

28. W. Singer, *The Drawings of Adolf Menzel*, 1906.

29. See *The Times*, 26 August 1862, p. 5 (review of German section of International Exhibition); 'Exposition d'Adolphe Menzel a Paris', *Gazette des Beaux-Arts*, 1885, XXXI, p. 519.

30. J. Rewald, *The History of Impressionism*, New York, 1961, p. 498; A study for the 'Eisenwalzwerk' owned by Degas was reproduced in the *Gazette des Beaux-Arts*, 1881, XXII, p. 107. This drawing is now in the David Daniels collection; see *Loan Exhibition; Selections from the Drawing Collection of David Daniels*, Fogg Art Museum, Harvard, 1968, no. 41 (repr.).

31. *Burlington Magazine*, 1906, IX, p. 52.

32. W. B. Scott, *Gems*, p. 38.

33. Sharp, *Progress*, p. 313.

34. E. Panofsky, *The Life and Art of Albrecht Dürer*, Princeton, 1971 (paperback edn.) p. 3.

35. *Ibid.*

BIBLIOGRAPHY

ARCHIVAL SOURCES

Aberdeen, City Art Gallery—'Dyce Papers' Typescript biography of William Dyce by his son Stirling Dyce.

Berlin (West), Staatsbibliothek der Stiftung Preussischer Kulturbesitz—Pereira-Arnstein *Nachlass* Letters of Salomon Bartholdi.

Cambridge, Fitzwilliam Museum—Flaxman Letters.

Cologne, Stadtarchiv—Diary of Sulpiz Boisserée.

Dresden, Landesbibliothek—Correspondence of G. A. Boettiger, M. Retzsch and J. Schnorr.

Edinburgh, National Library of Scotland—Hope Scott Correspondence.

Hanover, Kestnermuseum—Kestner's *Tagebuch*.

London, British Museum—Flaxman Letters.

——, Keats House—Letters of Joseph Severn.

——, John Murray—Letters of C. L. Eastlake.

——, Victoria and Albert Museum —Diary of Henry Cole—Letters to C. L. Eastlake—R. Dadd, 'Walpurgis Night: A Lay of the Hartz Mountains and other Tales'.

——, Dr Williams' Library—Correspondence and unpublished portions of Diary of Henry Crabb Robinson.

Munich, Landesarchiv—Kaulbach *Nachlass*.

Oxford, Bodleian Library—Letters of J. R. Herbert.

Rome, Deutsches Institut—F. Flohr's *Taschenbuch*.

——, Keats-Shelley Memorial—Correspondence of J. Severn.

——, Stato D'Anime—Parish Register for S. Trinita dei Monti.

CONTEMPORARY PERIODICALS

In cases where a periodical has been consulted for a single reference, the date of this is given in parentheses. Otherwise dates indicate the years of publication of the periodical.

Almanach as Rom für Künstler und Freunde der Bildende Kunst, Leipzig, 1810.

Annals of the Fine Arts, 1817–20.

The Art-Union: A Monthly Journal of the Fine Arts, 1844–8; continued as *The Art Journal*, 1849–1912–.

Artistisches Notizenblatt, Dresden, 1822–35; supplement to *Abendzeitung*.

The Athenaeum, London Literary and Critical Journal, 1828–1921.

Bentley's Miscellany, 1837–68.

Berliner Kunstblatt (1828).

Blackwood's Edinburgh Magazine, 1817–.

The British and Foreign Review, or *European Quarterly Journal*, 1835–44.

The Builder, 1843.

The Ecclesiologist, 1842–68.

The Edinburgh Review, 1803–1929.

The European Magazine, 1782–1825; N.S. 1825–6.

The Foreign Quarterly Review, 1827–46.

Foreign Review and Continental Miscellany, 1828–30.

Fraser's Magazine for Town and Country, 1830–69.

The Gentleman's Magazine, 1731–1833.

BIBLIOGRAPHY

The Germ, Nos. 1 & 2; continued as *Art and Poetry*, Nos. 3 & 4. 1850.
The German Magazine, 1800–1.
Giornale Arcadico di Scienze, Lettere ed Arte, Rome, 1819–56.
The Hampshire Chronicle (1842).
Hannoverische Kunstblätter (1836).
Howitt's Journal of Literature and Popular Progress, 1847.
The Illustrated London News, 1842–.
Jahrbücher der Königlichen Akademie der Künste (1846).
Kunstblatt, Tübingen, 1817–56; supplement to *Morgenblatt für gebildete Stände*.
The Keepsake, 1826–57.
Leipziger Kunstblatt (1817).
The London Magazine, 1820–9.
The Magazine of the Fine Arts, 1821.
The Monthly Magazine, 1796–1843.
The New Monthly Magazine, 1814–71.
The Oxford and Cambridge Magazine, 1856.
The People's Journal, 1846–8.
The Quarterly Review, 1809–.
The Repository of Arts, Literature, Commerce, Manufactures, Fashion and Politics, 1809–29.
Vaterlandisches Museum, Hamburg, 1810–11.

OTHER SOURCES

Where place of publication is not cited, it is London.

Abbott, C. C. *The Life and Letters of George Darley*, 1928.
Adrian, J. V. *Bilder aus England*, Frankfurt, 1827, 8.
——. *Neuestes Gemälde von London und seinen Umgebung*, Frankfurt, 1829.
——. *Skizzen aus England*, Frankfurt, 1830.
Ainsworth, W. H. *Old Saint Paul's* (ill. J.F.), 1841.
Alberti, C. (pseud.). *Bettina von Arnim, 1785–1851. Ein Erinnerungsblatt. Zu ihrem hundersten Geburtstage*, Leipzig, 1885.
Album Deutscher Kunstler in original Radierungen, Leipzig, 1839.
Aldick, R. *The English Common Reader*, Chicago, 1957.
Allderidge, P. *The Late Richard Dadd* (Tate Gallery exh. cat.), 1974.
Allston, W. *Lectures on Art, and Poems*, New York, 1850.
——. *Outlines and Sketches* (plates), Boston, 1850.
Ames, W. *Prince Albert and Victorian Taste*, 1967.
Andrews, K. *The Nazarenes: A Brotherhood of German Painters in Rome*, Oxford, 1964.
Antal, F. *Fuseli Studies*, 1956.
Atkinson, J. B. 'The Schools of Modern Art in Germany', *Portfolio*, 1878.
——. *The Schools of Modern Art in Germany*, 1880.
Ballantine, J. *The Life of David Roberts, R. A.*, Edinburgh, 1866.
——. *A Treatise on Stained Glass, shewing its applicability to every style of architecture*, London and Edinburgh, 1845.
Bang, I. *Die Entwicklung der deutschen Märchen Illustration*, Munich, 1944.
Barrington, E. I. *The Life, Letters and Work of Frederick Leighton*, 1906.
Baudelaire, C. (ed. Pichois). *Critique d'Art*, Paris, 1965.
Baudissen, K. W. S. *George Augustus Wallis, Maler aus Schottland*, Heidelberg, 1924.
Bauer, J. *The London Magazine, 1820–29*, 1953.
Baumgarten, A. G. *Aesthetica*, Frankfurt an der Oder, 1750.

BIBLIOGRAPHY

Baxandall, M. *Painting and Experience in Fifteenth-Century Italy*, Oxford, 1974.

——. *South German Sculpture, 1480–1530*, Victoria and Albert Museum, 1974.

Beattie, W. *The Danube, its History, Scenery, and Topography, splendidly illustrated, from sketches taken on the spot by Abresch, and drawn by W. H. Bartlett*, 1844.

——. *Journal of a Residence in Germany*, 1831.

Beck, H. *Victorian Engravings*, 1973.

Beckett, R. B. *John Constable and the Fishers*, 1952.

Beeley, H. *Disraeli*, 1936.

Beenken, H. *Das neunzehnten Jahrhundert in der deutschen Kunst*, Munich, 1944.

Bell, Q. *The Schools of Design*, 1963.

——. *Victorian Artists*, 1967.

Bennett, M. *J. E. Millais* (Arts Council exh. cat.), 1967.

Bentley, G. E. *Blake Records*, Oxford, 1969.

Bentley, G. E. and Nurmi, M. K. *A Blake Bibliography*, Minneapolis, 1964.

Benz, R. *Goethe und die romantische Kunst*, Munich, 1940.

——. *Goethes Götz von Berlichingen in Zeichnungen von Franz Pforr*, Schriften der Goethe-Gesellschaft, LII, Weimar, 1941.

Benz, R. and Schneider, A. V. *Die Kunst der deutschen Romantik*, Munich, 1939.

Berefeld, G. *Philipp Otto Runge zwischen Aufbruch und Opposition*, Stockholm, 1961.

Beresford Hope, A. J. *English Cathedrals of the Nineteenth Century*, 1861.

Bewick, T. *A Memoir of Thomas Bewick written by himself*, Newcastle, 1862.

Blunt, A. F. *The Art of William Blake*, Oxford, 1959.

Boase, T. S. R. *English Art 1800–70*, The Oxford History of English Art, X, Oxford, 1959.

——. 'The Decoration of the New Palace of Westminster 1841–1863', *Journal of the Warburg and Courtauld Institutes*, XVII, No. 3–4, pp. 319–58, 1954.

Boetticher, F. von. *Malerwerke des neunzehnten Jahrhunderts*. Beitrag zur Kunstgeschichte, 4 vols., Leipzig, 1941, 2.

Bohte, J. H. *Catalogue of Books on Sale. . . by J. H. Bohte*, 1816; appendix, 1816.

——. *A Catalogue of Books now selling by J. H. Bohte and Co.*, 1819; supplement, 1820.

——. *Extracts of the most useful and valuable works contained in the Frankfurt and Leipzig Fair-Catalogue, just imported by Bohte, Wilson and Glover*, 1818.

——. *Handbibliothek der deutschen Litteratur*, 1825.

——. *Supplement to a Catalogue of Books*, 1824.

——. *Verzeichniss deutscher Bücher*, 1814.

Boner, C. *Charles Boner's Book* (ill. Count Pocci), 1848.

——. *Chamois hunting in the Mountains of Bavaria* (ill. Theodore Horscheldt), 1853.

—— (ed. R. M. Kettle). *Memoirs and Letters of C. Boner*, 2 vols., 1871.

Boosey, T. *Catalogues of Foreign Books on Sale by T. Boosey*, 1807–16.

Boosey & Sons. *Catalogues of Foreign Engravings & Woodcuts*, 1820.

Börsch-Supan, E. 'Das Mädchen aus der Fremde' in *Kunstgeschichtliche Aufsätze . . . Heinz Ladendorf zum 29 Juni 1969 gewidmet*, Cologne, 1969.

Bowe, M. C. *François Rio, son place dans le renouveau catholique en Europe*, Paris, 1938.

Bray, Mrs. *Life of Thomas Stothard*, 1851.

Brockedon, W. *Illustrations of the Passes of the Alps*, 1828–9.

Bruford, W. H. *Germany in the Eighteenth Century*, Cambridge, 1935.

Bülau, E. 'Der Englische Einfluss auf die deutsche Landschaftsmalerei des frügen 19. Jahrhunderts', Diss., Freiburg, 1955.

Bunsen, F. von. *A Memoir of Baron Bunsen*, 1868.

Bürger, G. A. (ed. Reinhard). *Sammtliche Schriften*, 3 vols., Göttingen, 1796–7.

—— (trans. J. T. Stanley). *Leonora: A tale* (ill. W. Blake), new edn., 1796.

—— (trans. W. R. Spencer). *Leonora* (ill. the Right Honourable Lady Diana Beauclerc), 1796.

—— (trans. J. M. Cameron). *Leonora* (ill. D. Maclise), 1847.

BIBLIOGRAPHY

Burke, W. J. *Rudolph Ackermann, Promoter of the Arts and Sciences*, New York, 1935.

Burne-Jones, G. *Memorials of Edward Burne-Jones*, 2 vols., 1906.

Butler, E. M. *The Fortunes of Faust*, Cambridge, 1952.

Butlin, M. *William Blake* (Tate Gallery exh. cat.), 1978.

Butlin, M. and Joll, E. *The Paintings of J. M. W. Turner*, 2 vols., New Haven and London, 1977.

Carlyle, T. 'The State of German Literature', *Edinburgh Review*, 1827 (Carlyle Centenary edn., XXVI, pp. 51ff).

Carrie, R. A. *A Diplomatic History of Europe since the Congress of Vienna*, New York, 1958.

Cartwright, J. *Baldassare Castiglione*, 1908.

Carus, C. G. *England und Schottland im Jahre 1844*, Berlin, 1845.

——. *Lebenserinnerungen und Denkwürdigkeiten*, Leipzig, 1865–6.

Cave-Brown, J. *Lambeth Palace and its Associations*, 1882.

Cassirer, E. *Die Philosophie der Aufklärung*, Tübingen, 1932.

Chamisso de Boncourt, L. C. A. *Peter Schlemihl* (ill. George Cruikshank), 1824.

—— (trans. W. Howitt). *Peter Schlemihl's wundersame Geschichte*, 1843.

Chapman, R. *The Laurel and the Thorn*, 1945.

Chatto, W. A. *A Treatise on Wood Engraving, Historical and Practical*, 1839; 2nd edn. (with new chapter by Henry G. Bone), 1861.

Christian, J. G. 'Early German Sources for Pre-Raphaelite Designs', *Art Quarterly*, 1973, XXXVI, 1–2, pp. 68ff.

Christoffel, U. *Bonaventura Genelli Aus dem Leben eines Kunstlers*, Berlin, 1922.

Clark, K. M. *The Gothic Revival*, 1923.

Clarke, H. G. *The Art Union Exhibition, for 1843*, 1843.

——. *A Hand-Book Guide to the Cartoons now exhibiting in Westminster Hall*, 1843.

——. *A Hand-Book Guide to the Cartoons, Frescos, and Sculptures . . . exhibiting in Westminster Hall*, 1844.

——. *A Critical Examination of the Cartoons, Frescos and Sculptures exhibited in Westminster Hall. To which is added the history and practice of fresco painting*, 1844.

——. *A Critical Catalogue of the Cartoons, Frescos and Sculpture, and exhibiting in Westminster Hall*, 1845.

——. *A Critical Examination and Complete Catalogue of the Works of Art now exhibiting in Westminster Hall*, 1847.

Clownes, A. A. *Charles Knight: A Sketch*, 1892.

Cockerell, C. R. (ed. S. P. Cockerell). *Travels in Southern Europe and the Levant, 1810–1817*, 1903.

Coleridge, S. T. *Biographia Literaria* (Everyman Library edn.), 1967.

Collins, W. W. *Memoirs of the Life of William Collins, Esq., R.A.*, 2 vols., 1848.

Cooper, R. 'British Attitudes towards the Italian Primitives', D.Phil., Sussex, 1976.

Cope, C. H. *Reminiscences of Charles West Cope, R.A.*, 1891.

Copenhagen, Thorwaldsens Museum. *Catalogue*, Copenhagen, 1961.

Cornelius, P. von. *Zwölf Bilder zu Goethe's Faust* (engr. F. Ruscheweyh), Frankfurt, 1816.

——. *Darstellungen aus dem Liede der Nibelungen*, Frankfurt, 1817.

——. *Umrisse zu Dante's Paradies*, Leipzig, 1830.

——. *Sechs Entwürfe zu Darstellungen aus Tasso's befreitem Jerusalem*, Berlin, 1843.

——. *Entwürfe zu dem Fresken in der Friedhofshalle zu Berlin*, Leipzig, 1848.

——. *Entwürfe zu dem Kunstgeschichtlichen Fresken in den Loggien der Königlichen Pinakothek zu München*, Leipzig, 1875.

Council of Europe. *The Romantic Movement* (exh. cat.), 1959.

Crane, W. *An Artist's Reminiscences*, 1907.

Crossland, R. *Wainwright in Tasmania*, Melbourne, 1954.

Crowquill, A. (pseud. A. H. Forrester). *Faust: A Serio-Comic Poem*, 1835.

Cruikshank, G. *The Bottle*, 1847.

Cundall, J. *On Ornamental Art, applied to Ancient and Modern Bookbinding*, 1848.

Cunningham, A. *The Life of Sir David Wilkie*, 2 vols., 1843.

Curling, J. *Janus Weathercock*, 1938.

Dafforne, J. 'William Dyce', *Art Journal*, 1860, pp. 293–6.

——. *Pictures by Clarkson Stanfield, R.A.*, 1873.

——. *Pictures by Sir A. W. Callcott*, 1875.

BIBLIOGRAPHY

Dalziel, G. E. *The Brothers Dalziel: A Record of Fifty Years Work*, 1901.

Delaroche, P. *Exposition des oeuvres, Palais des Beaux-Arts* (cat. by J. Goddé), Paris, 1857.

——. *L'Hemicycle du Palais des Beaux-Arts* (eng. Hariquel Dupont), Paris, 1857.

Deneke, O. *Die Brüder Riepenhausen*, Göttingen, 1936.

Dibden, T. F. *A Bibliographical, Antiquarian and Picturesque Tour in France and Germany*, 3 vols., 1821.

Dickens, C. *The Chimes*, 1844.

Disraeli, B. *Vivian Grey*, 1826–7.

Dobson, A. *Thomas Bewick and his Pupils*, 1884.

Dürer, A. *Albert Dürer's Designs of the Prayer Book*, 1817.

Dussler, L. *Die Incunabeln der deutschen Lithographie, 1796–1821*, Berlin, 1925.

Dyce, W. *Theory of the Fine Arts*, 1844.

Dyce, W. and Wilson, C. *Letter to Lord Meadowbank . . . on The Best means of ameliorating the Arts and Manufactures of Scotland in Point of Taste*, Edinburgh, 1837.

Eastlake, Sir C. L. *Contributions to the Literature of the Fine Arts*, 1st series, 1848; 2nd series, 1870.

——. *Discourse delivered to the Students of the Royal Academy on the distribution of the prizes, December, 1851/1853/1855/1857/1859/1863*. 1852, 4, 6, 8, 9, 64.

——. *Materials for a History of Oil Painting*, 2 vols., 1847.

Eastlake, C. L. *A History of the Gothic Revival*, 1872.

Eastlake, E. (ed. C. E. Smith). *Journals and Correspondence of Lady Eastlake*, 2 vols., 1895.

Eaton, C. *Rome in the Nineteenth Century*, Rome, 1820.

Eberlein, K. K. 'Goethe und die Bildende Kunst der Romantik', *Jahrbuch der Goethe-Gesellschaft*, 1928, XIV, pp. 6ff.

Eberlein, K. K. and Heise, C. G. *Die Malerei der deutschen Romantiker und Nazarener*, Munich, 1928.

Ebert, H. *Bonaventura Genelli: Leben und Werk*, Weimar, 1971.

Eckermann, J. P. *Gespräche mit Goethe*, Leipzig, 1968.

Edinburgh, Royal Scottish Academy. *Catalogues*, 1830–8.

Edwards, E. *The Fine Arts in England*, 1840.

Eichner, H. *F. Schlegel*, New York, 1970.

Einem, H. von. 'Peter Cornelius', *Wallraff-Richartz Jahrbuch*, XVI, 1954.

Eitner, L. *Neoclassicism and Romanticism*, 2 vols., Englewood Cliffs, New Jersey, 1970.

Egan, R. 'The Genesis of the Theory of "Art for Art's Sake" in Germany and England', *Smith College Studies in Modern Languages*, 1921, II, no. 4.

Eliot, G. *Middlemarch: A Study of Provincial Life*, Edinburgh, 1871–2.

—— (ed. A. T. Kitchel). *Quarry for Middlemarch*, Berkeley, 1950.

——. 'A Word for the Germans', *Pall Mall Gazette*, 1865, I, p. 201.

Elmes, J. *The Arts and Artists*, 1825.

——. *A General and Bibliographical Dictionary of the Fine Arts*, 1826.

Engelmann, W. *Daniel Chodowiecki's sämmtliche Kupferstiche*, Leipzig, 1857.

Errington, L. 'Social and Religious themes in English Art, 1840–60', Ph.D., London, 1973.

Erskine, B. C. *Lady Diana Beauclerc: Her Life and Work*, 1903.

Escher, H. *A Catalogue of German Books and Prints now on Sale*, 1807.

Fahne, A. *Die Düsseldorfer Maler-Schule in den Jahren 1834, 1835 & 1836*, Düsseldorf, 1837.

Farington, J. (ed. J. Greig). *Diary, 1793–1821*, 8 vols., 1922–8; (ed. K. Garlick and A. Macintyre). *The Diary of Joseph Farington*, New Haven and London, 1978–.

Feige, *Kleine Gesellschafter*, Berlin, 1836.

Fernow, C. L. *Carstens, Leben und Werke . . . herausgegeben und ergänzt von H. Riegel*, Hanover, 1867.

Fernow, I. *Carl Ludwig Fernow als Asthetiker*, Würzburg, 1938.

Ferrey, B. *Recollections of A. N. W. Pugin*, 1861.

Finberg, A. J. *The Life of J. M. W. Turner*, 2nd edn., 1961.

Flagg, J. B. *The Life and Letters of Washington Allston*, New York, 1892.

Flaxman, J. *Lectures on Sculpture*, 1829; 2nd edn. (enlarged), 1838.

BIBLIOGRAPHY

Foerster, E. *Vermischte Schriften*, I, Munich, 1862.

——. *Peter von Cornelius: Ein Gedenkbuch aus seinem Leben und Wirken*, 2 vols., Berlin, 1874.

Fortoul, H. *De l'Art en Allemagne*, 2 vols., Paris, 1841–2.

Fothergill, B. *Nicholas Wiseman*, 1963.

Franke, W. *Alfred Rethel's Zeichnungen*, Berlin, n.d.

Frankfurt, Städelsches Kunstinstitut. *Die Nazarener* (exh. cat.), Frankfurt, 1977.

Frankl, P. *The Gothic*, Princeton, 1960.

Franklin, J. (ill.). *The Ballad of Chevy Chase*, 1836.

—— (ill.). *Tableaux from Crichton*, 1837.

—— (ill.). *Wertheim's Bible Cartoons*, 1848.

Fredeman, W. E. *Pre-Raphaelitism: A Bibliocritical Study*, Cambridge, Mass., 1965.

Fresko-Gemälde aus der Geschichte der Bayern . . . in den Arcaden des Hofgartens zu München, Munich, 1829.

Freyberg, E. *Erinnerungen an England. Aus der Januar-Reize 1842*, Berlin, 1842.

Frith, W. P. *My Autobiography and Reminiscences*, 3 vols., 1887–8.

Fruman, N. *Coleridge, the Damaged Archangel*, 1972.

Fuehrich, J. von. *Umrisse zu Goethes Hermann und Dorothea*, Prague, 1827.

——. *Das Vater-unser in 9 Blättem*, Prague, 1826.

Fuehrich, L. von. *J. von Führich's Briefe aus Italien an seine Eltern*, Freiburg in Breisgau, 1883.

Fuseli, J. H. *Lectures on Painting* (1–12), Bohn's Scientific Library, 1848.

Gage, J. *Colour in Turner*, 1969.

——. 'Turner's Academic Friendships: C. L. Eastlake', *Burlington Magazine*, 1968, CX, pp. 677–85.

Geller, H. *Die Bildnisse der deutschen Künstler in Rom, 1800–1830*, Berlin, 1952.

Gerdts, W. H. 'Washington Allston and the German Romantic Classicists in Rome', *Art Quarterly*, 1969, XXXII, p. 177.

Gerstenberg, K. and Rave, P. O. *Die Wandgemälde der deutschen Romantiker im Casino Massimo in Rom*, Berlin, 1943.

Gessner, S. *The Letters of Gessner and his Family*, 1804.

Gilbert, K. E. and Kuhn, H. *A History of Aesthetics*, 1939.

Gilchrist, A. *Life of William Blake*, 2 vols., 1863.

Goerres, G. *Das Narrenhaus von W. Kaulbach*, Coblenz, 1840.

——. *Der hürnen Siegfried und sein Kamf mit dem Drachen* (ill. W. Kaulbach), Schaffhausen, 1843.

Goethe, J. W. von. *Goethes Werke: Hamburger Ausgabe*, XII, Schriften zur Kunst (annot. H. von Einem), Munich, 1973.

—— (trans. Eastlake). *Theory of Colours*, 1840.

Goldsmith, O. *The Vicar of Wakefield* (ill. Mulready), 1841.

Gombrich, E. H. *In Search of Cultural History*, 1974.

Gotch, R. B. *Maria, Lady Callcott*, 1937.

Gooch, G. P. *Germany and the French Revolution*, 1920.

Graevenitz, G. F. W. G. von. *Deutsche in Rom*, Leipzig, 1902.

Graves, A. *The Royal Academy of Arts*, 8 vols., 1905–6.

——. *The British Institution, 1806–1867*, 1908.

——. *A Century of Loan Exhibitions (1813–1912)*, 5 vols., 1913–15.

Grigson, G. *Samuel Palmer: the Visionary Years*, 1947.

Grimm, J. L. K. and W. K. *Kinder und Hausmärchen*, Berlin 1812–22.

—— (trans. E. Taylor). *German Popular Stories*, 1823.

—— (trans. E. Taylor). *Gammer Grethel*, 1849.

Grobe, P. *Die Entfestung München*, Munich, 1970.

Grobe, H. *Memoir of the Life of Ary Scheffer*, 1860.

Grote, L. *Die Brüder Olivier und die deutsche Romantik*, Berlin, 1938.

Gruner, L. *The Decorations of the Garden Pavilion in the Grounds of Buckingham Palace*, 1846.

Gurlitt, C. *Sir Edward Burne-Jones*, Munich, 1895.

——. *Die deutsche Kunst des Neunzehnten Jahrhunderts*, Berlin, 1899.

BIBLIOGRAPHY

Gwynn, D. *Lord Shrewsbury, Pugin and the Catholic Revival*, 1946.

Habicht, V. C. *Niedersachsische Kunst in England*, Hanover, 1930.

Hagen, E. A. *Die Deutsche Kunst in unserem Jahrhundert*, 2 vols., Berlin, 1857.

Hall, S. C. (ed.). *The Book of British Ballads*, 1842.

———. *Retrospect of a Long Life*, 2 vols., 1883.

Hamburg, Kunsthalle. *Katalogue der Meister des 19 Jahrhunderts*, Hamburg, 1969.

Hardie, M. *Water-Colour Painting in Britain*, II, 1967; III, 1968.

Harnack, O. *Deutsches Kunstleben in Rom im Zeitalter der Klasik*, Weimar, 1896.

Haskell, F. *Rediscoveries in Art*, 1976.

Hauhart, W. F. *The Reception of Goethe's Faust in England in the First Half of the Nineteenth Century*, New York, 1909.

Hausermann, H. W. 'Danby at Geneva', *Burlington Magazine*, 1949, pp. 227ff.

Haydon, B. R. (ed. W. B. Pope). *The Diary of Benjamin Robert Haydon*, 5 vols., Cambridge, Mass., 1963.

Hegel, G. H. F. (trans. Osmaston). *Philosophy of Fine Art*, 1920.

Heine, H. *Die Romantische Schule* (Reclam edn.), Leipzig, 1955.

Heinemann, W. *Bibliographical List of the English translation and annotated editions of Goethe's Faust*, 1882.

———. *Goethe's Faust in England und Amerika: Bibliographisches zusammenstellung*, Berlin, 1886.

Henderson, P. *William Morris: His Life, Work and Friends*, 1967.

Hennings, C. R. *Deutsche in England*, Stuttgart, 1923.

Hensel, W. *Die lebenden Bilder und pantomimischen Darstellungen bei dem Festspiel Lalla Rukh aufgeführt auf dem Königlichen schlosse in Berlin der 27ten Januar 1821*, Berlin, 1823.

Herder, J. G. von. *Der Cid, nach spanischen Romanzen besungen . . . Mit Randzeichnungen von E. Neureuther*, Stuttgart, 1838.

———. (trans. T. O. Churchill). *Outlines of a Philosophy of History*, 1800.

Hering, G. E. *Sketches on the Danube in Hungary and Transylvania*, 1838.

Herrmann, F. 'Who was Solly?', *Connoisseur*, 1967, CLXIV, pp. 229ff, CLXV, pp. 13–15, CLXVI, pp. 10–18.

Hirschberg, L. *Moritz Retzsch: Chronologisches Verzerchniss seiner graphischen Werke*, Berlin, 1925.

Hoare, P. *Epochs of Art*, 1813.

Hoecker, W. *Der Gesandte Bunsen als Vermittler zwischen Deutschland und England*, Göttingen, 1951.

Hoff, J. A. *L. Richter*, 2nd edn., Freiburg, 1922.

Hoff, U. *The Melbourne Dante Illustrations by William Blake*, Melbourne, 1961.

Holborne, H. *A History of Modern Germany*, 1965.

Horsley, F. A. *Mendelssohn and his friends in Kensington*, 1934.

Horsley, J. C. *Recollections of a Royal Academician*, 1903.

Howard, F. *The Spirit of the Plays of Shakespeare exhibited in a series of Outline Plates*, 5 vols., 1827–33.

Howard, H. (ed. F. Howard). *A Course of Lectures on Painting*, 1848.

Howitt, Mary (ed. Margaret Howitt). *An Autobiography*, 1891.

Howitt, Margaret. *Friedrich Overbeck, sein Leben und Schaffen*, 2 vols., Freiburg im Breisgau, 1886.

Howitt, Mary (ed. Margaret Howitt) *An Autobiography*, 1891.

Howitt, W. *The Rural and Domestic Life of Germany*, 1842.

Hubbard, H. *Some Victorian Draughtsmen*, 1944.

Hueffer, F. M. *Ford Madox Brown: A Record of his Life and Work*, 1896.

Humphreys, H. N. *Ten Centuries of Art*, 1852.

Hunt, F. K. *The Book of Art*, 1846.

Hunt, W. H. *Pre-Raphaelitism and the Pre-Raphaelite Brotherhood*, 2 vols., 1905.

Hütt, W. *Die Düsseldorfer Malerschule*, Leipzig, 1964.

Iannatoni, L. *Roma e gli Inglese*, Rome, 1945.

Ironside, R. and Gere, J. *Pre-Raphaelite Painters*, 1948.

Irwin, D. *English Neo-Classical Art*, 1966.

Jaffé, E. *Joseph Anton Koch: Sein Leben und sein Schaffen*, Innsbruck, 1905.

Jagow, K. *Letters of the Prince Consort*, 1938.

Jahresbericht des Sächsischen Kunstvereine, Leipzig, 1845–6.

BIBLIOGRAPHY

James, J. T. *The Flemish, Dutch and German Schools of Painting*, 1822.

——. *Journal of a Tour in Germany*, 1816.

James, P. B. *Childrens Books of Yesterday*, 1953.

Jameson, A. B. *A Lady's Diary*, 1826.

——. *Visits and Sketches at Home and Abroad*, 3 vols., 1834.

——. *Sacred and Legendary Art*, 2 vols., 1848.

—— (ed. G. H. Needler). *Letters of Anna Jameson to Ottilie von Goethe*, 1939.

Jensen, C. 'I Nazareni, Das Wort, Das Stil' in *Klassizismus und Romantik*, Nuremberg, 1966, p. 49.

Joll, J. 'Prussia and the German Problem' in *The Zenith of European Power*, The New Cambridge Modern History, X, Cambridge, 1960.

Jorns, *August Kestner und seine Zeit, 1777–1853*, Hanover, 1964.

Joseph, M. K. *Charles Aders: A Biographical Note*, Auckland, 1953.

Jügel, C. *Catalogue of Valuable Prints, Engravings etc. etc. by the most distinguished artists of Germany which are now offered for sale (for the first time in London) at the original German publishing prices* [c. 1836].

Justi, C. *Das Augusteische Dresden*, Dresden, 1955.

Kaminsky, J. *Hegel on Art*, New York, 1962.

Kant, E. (trans. F. Max Muller). *The Critique of Pure Reason*, 1781, New York, 1961.

—— (trans. Meredith). *The Critique of Judgement*, 1790, Oxford, 1928 (1964 reprint).

Kauffmann, C. M. *Catalogue of Foreign Paintings, Victoria and Albert Museum, London*, II, 1973.

Kestner, A. *Römische Studien*, Berlin, 1850.

Kestner-Köchlin, H. *Briefwechsel zwischen August Kestner und seiner Schwester Charlotte*, Strassbourg, 1904.

Klassizismus und Romantik in Deutschland, Nuremberg, 1966.

Klee, P. (trans. Findlay). *On Modern Art*, 1966.

Klenze, C. von. 'The Growth of Interest in the Early Italian Masters', *Modern Philology*, 1906, IV, pp. 44ff.

Knowles, J. *The Life and Writings of Henry Fuseli*, 2 vols., 1831.

Kosewitz, W. F. (pseud.). *Eccentric Tales from the German of W. F. von K.*, 1827.

Kugler, F. *Geschichte Friedrichs des Grossen*, Berlin, 1840.

——. *A Handbook of the History of Painting*, pt I, 1842.

Kuhn, A. *Peter Cornelius und die geistigen strömungen seiner Zeit*, Berlin, 1911.

Lanckoronska, A. M. I. and Oehler, R. *Die Buchillustration des XVIII Jahrunderts in Deutschland, Osterreich und der Schweiz*, 1932.

Landon, C. P. *Vies et oeuvres des peintures les plus celebres*, Paris, 1803–17.

Lasinio, C. *Pitture e fresco del Campo Santo di Pisa*, Florence, 1812.

Law, H. W. and I. *Book of the Beresford Hopes*, 1928.

Layard, G. S. *The Life and Letters of C. S. Keene*, 1893.

——. *Sir Thomas Lawrence's Letter Bag*, 1906.

Lehmann, E. H. *Die Anfänge der Kunstzeitschrift in Deutschland*, Leipzig, 1932.

Lehmann, R. *An Artist's Reminiscences*, 1894.

Lehr, F. H. *Die Blütezeit Romantischer Bildkunst, Franz Pforr der Meister des Lukasbundes*, Marburg, 1924.

Levey, M. 'Dürer and England', *Anzeiger des Germanisches Nationalmuseum*, 1971–2, pp. 157–64.

Lichtwark, A. *Hamburger Aufsätze*, Hamburg, 1917.

——. *Hamburgische Kunst*, Hamburg, 1898.

——. *Hermann Kauffmann und die Kunst in Hamburg von 1800 bis 1850*, Hamburg, 1895.

Lindsay, Lord. *History of Christian Art*, 3 vols., 1847.

Linnell, J. J. and W. *The Prize Cartoons*, 1843.

Linton, W. J. *Wood Engraving: A Manual of Instruction*, 1884.

Liptzin, S. *The English Legend of Heinrich Heine*, New York, 1954.

L'Isle, A. P. de (ed.). *The Chronicle of the Life of St Elizabeth of Hungary*, 1839.

Lockhart, J. C. (trans.). *Ancient Spanish Ballads, Historical and Romantic*, 1841.

Lohmeyer, K. *Heidelbergen Maler der Romantik*, Heidelberg, 1935.

London, Arts Council of Great Britain. *Burne-Jones* (exh. cat.), 1975.

BIBLIOGRAPHY

London, Arts Council of Great Britain. *London: The Romantic Movement* (exh. cat.), 1959.

London, Art Union. *Catalogue of the Pictures etc., selected by the prize holders in the Art Union of London*, 1844, 5.

London, British Institution for Promotion of the Fine Arts. *Catalogues*, 1806–67.

——. *Exhibition of Ancient Masters*, 1843.

London, Royal Academy of Arts. *Catalogues*, 1769–1861.

London. *Survey of London*, XXIII, 1951; XXX, 1960.

Lotter, K. *Carlyle und die deutsche Romantik*, Nuremberg, 1931.

Lutterotti, O. R. *Joseph Anton Koch*, Berlin, 1940.

MacColl, D. S. *Nineteenth-Century Art*, Glasgow, 1902.

McLean, R. *George Cruikshank*, 1948.

——. *Victorian Book Design*, 1963.

Marquardt, H. *Henry Crabb Robinson und seine deutschen Freunde*, 2 vols., Göttingen, 1964–7.

Martin, T. *The Life of the Prince Consort*, 5 vols., 1875–80.

Marx, C. F. H. *Erinnerungen an England, 1841*, Braunschwerg, 1842.

Mason, E. C. *Deutsche und Englische Romantik: Eine Gegenüberstellung*, Göttingen, 1959.

Matthews, T. *The Biography of John Gibson*, 1911.

Maurer, E. 'Turner's Laufenberger Zeichnungen' in *Festgabe für Otto Mittler*, 1960, pp. 217–26.

Millar, O. *The Later Georgian Pictures in the Collection of H.M. The Queen*, 1969.

Millais, J. G. *The Life and Letters of Sir John Everett Millais*, 2 vols., 1899.

Montalembert, C. F. *De la peinture en Italie a l'occasion du livre de M. Rio*, Paris, 1837.

——. *A Letter Addressed to a Reverend Member of the Camden Society*, Liverpool, 1844.

Moore, T. *Irish Melodies* (ill. Maclise), 1845.

Morgan, B. Q. *A Critical Bibliography of German Literature in English Translation, 1481–1927*, New York and London, 1965 (reprint of 1938 edn.).

Morley, E. J. *The Life and Times of Henry Crabb Robinson*, 1935.

Moses, H. *Faustus . . . Embellished with Retzsch's series of twenty-seven outlines . . . engraved by H. Moses*, 1820.

Müller von Koenigswinter, H. *Münchener Skizzenbuch*, Munich, 1856.

Muir, P. *Victorian Illustrated Books*, 1971.

Murray, J. *A Handbook for Travellers in Southern Germany*, 1837.

Murray, Sir J. *John Murray III, 1808–1892: A Brief Memoir*, 1919.

Nagler, G. K. *Die Monogrammisten*, Munich, 1858.

Neigebauer, J. D. F. *Handbuch für Reisende in England*, Leipzig, 1829.

Neubert, F. *Vom Doktor Faustus zu Goethe's Faust*, Leipzig, 1932.

Neureuther, E. *Randzeichnungen zu Goethe's Balladen und Romanzen*, 5 vols., Stuttgart, 1829–39.

Das Nibelungenlied (ill. E. Bendemann and J. Hubner), Leipzig, 1840.

Der Nibelungen Noth (ill. J. Schnorr and E. Neureuther), Munich, 1843.

Noack, F. *Das Deutschtum in Rom*, Berlin and Leipzig, 1927.

Novalis. *Die Christenheit oder Europa*, Leipzig, n.d.

—— (trans. Earlton). *Christianity or Europe*, 1844.

Odenkirchen, S. E. 'Moritz Retzsch, Illustrator', M.A. Thesis, Chicago, 1948.

O'Driscoll, W. J. *A Memoir of Daniel Maclise*, 1871.

Ormond, R. and L. *Lord Leighton*, New Haven and London, 1975.

Ormond, R. and Turpin, J. *Daniel Maclise* (National Portrait Gallery exh. cat.), 1972.

Ormsby, R. *Memoirs of J. R. Hope Scott*, 2 vols., 1884.

Osborne. *Catalogue of the Paintings, Sculptures and other Works of Art at Osborne*, 1876.

Osborne. *Catalogue of the Principal Items on View at Osborne House*, 1966.

Osborne, H. *Aesthetics and Art Theory*, 1968.

Ottley, W. Y. *An Inquiry into the Origins and Early History of Engraving upon Copper and Wood*, 1816.

Palmer, A. H. *The Life and Letters of Samuel Palmer*, 1892.

Panofsky, E. *The Life and Art of Albercht Dürer*, Princeton, 1971 edn.

Passant, E. J. *A Short History of Germany, 1815–1945*, Cambridge, 1962.

BIBLIOGRAPHY

Passavant, J. D. *Kunstreise durch England und Belgien*, Frankfurt, 1833.

Paton, Sir J. N. *Compositions from Shelley's 'Prometheus Unbound'*, 1844.

——. *Compositions from Shakespeare's 'Tempest'*, 1845.

Pecht, F. *Geschichte der Münchener Kunst im neunzehnten Jahrhundert*, Munich, 1888.

Penny Cyclopaedia of the Society for the Diffusion of Useful Knowledge, I, 1833.

Perthes, C. T. *Friedrich Perthes Leben. Nach dessen schriftlichen und mündlichen Mittheilungen aufgezeichnet von C. T. Perthes*, 3 vols., Hamburg and Gotha, 1848–55.

Pevsner, Sir N. *Academies of Art, Past and Present*, Cambridge, 1940.

——. *The Buildings of England*, 1951–75 (especially Cornwall, Cambridgeshire, Leicestershire, Northumberland, Oxfordshire and Suffolk).

Pichtos, N. M. *Die Aesthetik A. W. Schlegels in ihrer geschichtlichen Entwicklung*, Berlin, 1894.

Pickersgill, F. R. *Six Compositions from the Life of Christ*, 1851.

Pickert, L. C. 'Die Brüder Riepenhausen, Darstellung ihres Lebens bis zum Jahr 1820', Ph.D., Leipzig, 1950.

Pilkington M. (ed. Fuseli). *A Dictionary of Painters*, 1805.

Plagemann, V. *Das deutsche Kunstmuseum, 1790–1870*, Munich, 1967.

Pointon, M. 'The Work of William Dyce, R.A., 1806–64'. Ph.D., Manchester, 1974.

——. 'W. E. Gladstone as an Art Patron and Collector', *Victorian Studies*, 1975, XIX, no. I, pp. 73–98.

Poelnitz, W. *Münchener Kunst und Münchener Kunstkämpfe, 1799–1831*, Munich, 1936.

Pollitt, J. J. *The Art of Greece*, Englewood Cliffs, New Jersey, 1965.

Ponten, J. (ed.). *Alfred Rethel: Des Meisters Werke*, Stuttgart, 1911.

——. *Alfred Rethel's Briefe*, Berlin, 1912.

Prause, M. *Carl Gustav Carus: Leben und Werk*, Berlin, 1968.

Price, E. *Norway: Views of Wild Scenery; and Journal*, 1834.

Pückler-Muskau, H. L. H. *Tour in England, Ireland and France in the years 1826, 1827, 1828, & 1829*, Zurich, 1840.

Pugin, A. W. N. *Contrasts*, 1836; 2nd edn., 1841.

——. *The True Principles of Pointed or Christian Architecture*, 1841.

——. *An Apology for the Revival of Christian Architecture in England*, 1843.

Pye, J. *Patronage of British Art*, 1845.

Raczynski, A. *Histoire de l'art moderne en Allemagne*, 3 vols., Paris, 1836–41.

Raimbach, A. (ed. M. T. S. Raimback). *Memoirs and Recollections of the late Abraham Raimbach Esq.*, 1843.

Raumer, F. von. *England in Jahre 1835*, Leipzig, 1836–42.

Rave, P. O. 'Das Rheinansichten in den Reisewerken zur Zeit der Romantik', *Wallraff-Richartz Jahrbuch*, 1924, pp. 123ff.

——. *Die Malerei des XIX Jahrhunderts*, Berlin, 1945.

Redgrave, R. (ed. F. M. Redgrave). *Richard Redgrave: A Memoir*, 1891.

Redgrave, S. *A Dictionary of Artists of the English School*, 1847.

Redgrave, R. and S. *A Century of Painters of the English School*, 2 vols., 1865.

Redman, A. *The House of Hanover*, 1960.

Reed, B. *The Influence of Solomon Gessner upon English Literature*, 1905.

Rehberg, F. (engr. Piroli). *Lady Hamilton's Attitudes*, Rome, 1794.

Reid, F. *Illustrators of the Eighteen Sixties*, 1928.

Reitlinger, G. *The Economics of Taste: The Rise and Fall of Picture Prices, 1760–1960*, 1961.

Reports of the Commissioners on the Fine Arts, presented to both Houses of Parliament by command of Her Majesty

Report		Parliamentary Papers	
1st	1842	XXV	pp. 105ff
2nd	1843	XXIX	pp. 197ff
3rd	1844	XXXI	pp. 189ff
4th	1845	XXVII	pp. 151ff
5th	1846	XXIV	pp. 253ff
6th	1846	XXIV	pp. 276ff
7th	1847	XXXIII	pp. 267ff
8th	1849	XXII	pp. 349ff
9th	1850	XXIII	pp. 329ff

BIBLIOGRAPHY

Rethel, A. *Auch ein Todtentanz*, Leipzig, 1850.

Retzsch, F. A. M. *Umrisse zu Goethe's Faust in 26 Blättern*, Tübingen, 1816.

——. *Acht Umrisse zu Schiller's Fridolin*, Stuttgart and Tübingen, 1823.

——. *Sechszehn umrisse zu Schiller's Kampf mit dem Drachen*, Stuttgart and Tübingen, 1824.

——. *Umrisse zu Hamlet*, Leipzig, 1828.

——. *Umrisse zu Macbeth*, Leipzig, 1833.

——. *Umrisse zu Romeo & Juliet*, Leipzig, 1836.

——. *Umrisse zu der Sturm*, Leipzig, 1841.

——. *Umrisse zu Othello*, Leipzig, 1842.

——. *Umrisse zu die Lustige Weibern von Windsor*, Leipzig, 1844.

——. *Umrisse zu Henry IV, Part 1 & 2*, Leipzig, 1846.

——. *Fancies: A Series of Subjects in Outline* (intro. Mrs Jameson), 1834.

Reynolds, J. (ed. R. Wark). *Discourses on Art*, San Marino, 1959.

Richartz, E. F. *Die Brüder Boisserée*, Jena, 1916.

Richter, A. L. (ill.). *The Black Aunt*, 1848.

—— (ill.). *Nutcracker and Sugar Dolly*, 1849.

—— *Lebenserinnerungen eines deutschen Malers*, Frankfurt-am-Main, 1885.

Richter, H. *Daylight: A Recent Discovery in the Art of Painting*, 1817.

Riedelbach, H. *König Ludwig I von Bayern und seine Kunstschöpfungen*, Munich, 1888.

Riegel, H. *Geschichte der Wandmalerei in Belgien seit 1856*, Berlin, 1882.

Riepenhausen, F. and J. *Geschichte der Mahlerei in Italien nach ihrer Entwicklung, Ausbildung und Vollendung*, Tübingen, 1810.

Ritchie, L. *Travelling Sketches in the North of Italy, the Tyrol . . . on the Rhine* (eng. from drawings by C. Stanfield), 3 vols., 1832–4.

Robinson, H. C. 'William Blake, Künstler, Dichter und Religioser Schwärmer', *Vaterlandisches Museum*, 1811, II, p. 107.

—— (ed. Sadler). *Diary, Reminiscences and Correspondence*, 3rd edn., 1872.

Roget, J. L. *History of the Old Water-Colour Society*, 2 vols., 1891.

Rosenberg, A. *Die Berliner Malerschule, 1819–70*, Berlin, 1871.

Rosenblum, R. *Transformations in Late Eighteenth-Century Art*, Princeton, 1967.

Rossetti, W. M. *Pre-Raphaelite Diaries and Letters*, 1900.

——. *Some Reminiscences*, 2 vols., New York, 1906.

—— (ed.). *Dante Gabriel Rossetti: His Family Letters*, 1895.

Rossiter, P. 'The First Years of the Art Union', M.A. Report, Courtauld Institute of Art, 1975.

Ruhl, L. *Ruhl's Outlines to Shakespeare*, 5 vols., 1832–40.

Rumohr, C. F. von. *Italienische Forschungen*, 3 vols., Berlin and Stettin, 1827–31.

Rümann, A. *Die illustrierten deutschen Bücher des 19. Jahrhunderts*, Stuttgart, 1926.

——. 'Der Einfluss der Randzeichnungen Albrecht Durer's zum Gebetbuch König Maximilians auf die Romantische Graphik in Deutschland', *Zeitschrift des deutschen Vereins für Kunstwissenschaft*, 1936.

Runge, P. O. *Hinterlassene Schriften*, 2 vols., Hamburg, 1840.

Ruskin, J. (ed. E. T. Cooke and A. Wedderburn). *The Complete Works of John Ruskin* (Library edn.), 39 vols., 1903–12.

Russell, J. *A Tour in Germany, and some of the Southern Provinces of the Austrian Empire*, 2 vols., 1824.

Ruutz Rees, V. *Horace Vernet*, 1880.

Sadleir, M. *Bulwer: A Panorama, Edward and Rosina*, 1931.

Sartain, J. *Reminiscences of a Very Old Man*, New York, 1899.

Sass, H. *A Journey to Italy, 1817*, 1818.

Schaden, J. N. A. von. *Artistisches München im Jahre 1835*, Munich, 1836.

Schahl, A. 'Die Geschichte der Bilderbibel von J. Schnorr von Carolsfeld', Diss., Leipzig, 1936.

Scheffler, K. *Adolph Menzel*, Leipzig, 1938.

Schefold, M. 'William Turner in Heidelberg und am Neckar', *Jahrbuch der Staatlichen Kunstsammlungen in Baden-Wurtemburg*, 1968, V, pp. 131–50.

BIBLIOGRAPHY

Scheidig, W. *Goethes Preisaufgaben für bildenden Künstler, 1799–1805*, Schriften der Goethe-Gesellschaft, LVII, Weimar, 1958.

Schelling, F. W. J. (trans. Johnson). *The Philosophy of Art: An Oration on the Relationship between the Plastic Arts and Nature*, 1845.

Schiff, G. 'Theodore von Holst', *Burlington Magazine*, 1963, pp. 23–32.

——. *Johann Heinrich Füssli*, Zurich, 1973.

Schiller, F. (trans. Weiss). *The Philosophical and Aesthetic Letters and Essays*, 1845.

—— (trans. Wilkinson and Willoughby). *On the Aesthetic Education of Man*, 1795, Oxford, 1967.

Schirmer, W. *Der Einfluss der deutschen Literatur auf die Englische im 19. ten. Jahrhundert*, Halle, 1947.

Schlegel, A. W. 'Die Gemälde', *Athenaeum*, 1799, II, pp. 52ff.

——. *Vorlesungen über Schöre Literatur und Kunst*, Stuttgart, 1884.

Schlegel, F. 'Uber die deutsche Kunst Austellung in Rom, im Frühjahr 1819', *Kritische Friedrich Schlegel Ausgabe Paderborn*, 1959, IV, pp. 237–63.

——. *F. Schlegel's sämtliche Werke: Ansichten und Ideen von der christlichen Kunst*, VI, Vienna, 1823.

—— (trans. Millington). *The Aesthetic and Miscellaneous Works*, 1849.

Schleier, L. (pseud.). *Das Merkantilische Hamburg*, Hamburg, 1838.

Schmidt, P. F. *Biedermeier Malerei*, Munich 1922.

Schnorr von Carolsfeld, J. *Die Bibel in Bildern*, Leipzig, 1852–60.

——. *Briefe aus Italien*, Gotha, 1886.

——. *Umrisse zu Undine von de la Motte Fouqué*, Leipzig, 1816.

Schopenhauer, J. *Youthful Life and Pictures of Travel*, 2 vols., 1847.

Schubring, P. (ed.). *Dantes Göttliche Komödie in Zeichnungen deutscher Romantiker*, Leipzig, 1921.

Schultze, C. F. *14 Umrisse zu Undine, von de la Motte Fouqué*, Nuremberg, 1817.

Schultze, H. W. *Friedrich von Rumohr: sein Leben und seine Schriften*, Leipzig, 1844.

Schwind, M. von (ed. Stoessl). *Briefe*, Leipzig, 1924.

Scott, D. *Scenes from Coleridge's Ancient Mariner*, Edinburgh, 1837.

——. *British, French and German Painting*, Edinburgh, 1841.

Scott, W. B. *Memoir of David Scott*, Edinburgh, 1850.

——. *Albrecht Dürer: His Life and Works*, 1869.

——. *Gems of Modern German Art*, 1873.

——. *Illustrations to the King's Quair*, Edinburgh, 1887.

——. (ed. W. Minto). *Autobiographical Notes*, 2 vols., 1892.

Selous, H. C. *Outlines to Shakespeare's Tempest*, 1836.

——. *Scenes from the Life of Moses*, 1850.

Shackford, M. H. *Wordsworth's Interest in Painters and Pictures*, Wellesley, 1945.

Sharp, W. *The Life of Joseph Severn*, 1892.

——. *Progress of Art in the Century*, 1902.

Shee, M. A. *Life of Sir Martin Arthur Shee*, 2 vols., 1860.

Shelley, M. *History of a Six Weeks Tour through a part of France, Switzerland, Germany and Holland*, 1817.

——. *Rambles in Germany and Italy in 1840, 1842, and 1843*, 2 vols., 1844.

Shelley, P. B. (ed. Ingpen). *The Letters of Percy Bysshe Shelley*, 2 vols., 1912.

Scherer, J. M. *Notes and Reflections during a Ramble in Germany*, 1826.

Sieveking, H. *Karl Sieveking, 1787–1847. Lebensbild eines Hamburgischen Diplomaten aus dem Zeitalterder Romantik*, 3 vols., Hamburg, 1923–8.

Simon, K. *Gottlieb Schick*, Leipzig, 1914.

Singer, H. W. *Julius Schnorr von Carolsfeld*, Bielefeld, 1911.

Smith, W. H. *Essays in Design . . . illustrative of the Poem of Thalaba the Destroyer by Robert Southey Esq., Poet Laureate*, Birmingham, 1818.

Solly, N. N. *Memoir of the Life of David Cox*, 1873.

——. *Memoir of W. J. Müller*, 1875.

The Spanish Lady's Love (ill. Lady Dalmeny), 1846.

Speckter, E. *Briefe eines deutschen Künstlers aus Italien*, 2 vols., Hamburg, 1846.

BIBLIOGRAPHY

Speckter, I. M. *Verzeichniss der Kupferstich Sammlung*, Hamburg, 1822.

Speckter, O. (trans. M. Howitt). *The Child's Picture and Verse Book* (commonly called O. Speckter's Fable Book), 1844.

—— (ill.). *Puss in Boots*, 1844.

—— (ill.). *The Charmed Roe*, 1847.

Stael, G. de. *De L'Allemagne*, 1813.

Staley, A. *The Pre-Raphaelite Landscape*, 1973.

——. *Romantic Art in Britain: Paintings and Drawings, 1760–1860*, Philadelphia, 1968.

——. 'William Dyce and Outdoor Naturalism', *Burlington Magazine*, 1963, pp. 470ff.

Stanton, P. 'The Sources of Pugin's *Contrasts*' in *Concerning Architecture* (ed. Summerson), 1968.

——. *Pugin*, 1970.

Starke, M. *Travels on the Continent*, 1820.

——. *Travels in Europe*, 1833.

Statuto della Societa e de' Cultori delle Belle Arti, Rome, 1829.

Steegman, J. *Consort of Taste, 1830–1870*, 1950.

Stein, W. *Die Erneuerung der heroischen Landschaft nach 1800*, Strassbourg, 1937.

Steinle, A. M. (ed.). *E. von Steinle's Briefwechsel*, 2 vols., Freiburg im Breisgau, 1897.

Stephens, F. G. *Memorials of William Mulready*, 1867.

Stockmar, C. F. *Memoirs of Baron Stockmar*, 2 vols., 1872.

Stokes, H. 'J. F. Lewis', *Walker's Quarterly*, 1929, no. 28.

Stokoe, F. W. *German Influence in the English Romantic Period*, 1926.

Stolterfoth, A. von. *The Rhenish Minstrel* (ill. A. Rethel), 1935.

Story, A. T. *The Life of John Linnell*, 2 vols., 1892.

Strang, J. *Germany in 1831*, 2 vols., 1836.

Street, A. E. *Memoirs of G. E. Street*, 1888.

Strixner, J. N. *Die Sammlung Alt-Nieder-und Ober-Deutscher Gemälde der Brüder Boisserée und Betram lithographert von J. N. S.*, Munich, 1822–34.

Stuttmann, F. *J. H. Ramberg*, Munich, 1929.

Sulger-Gebing, E. *Die Brüder A. W. und F. Schlegel un ihrem Verhältnisse zur bildenden Kunst*, Munich 1897.

Sumowski, W. *Caspar David Friedrich Studien*, Wiesbaden, 1970.

Surtees, V. *Paintings and Drawings of Dante Gabriel Rossetti: A Catalogue*, Oxford, 1971.

Syamken, G. 'Die "Tageszeiten" von Philipp Otto Runge und "The Book of Job" von William Blake', *Jahrbuch der Hamburger Kunstsammlungen*, 1975, XX, pp. 61–70.

Taylor, T. *The Life of B. R. Haydon*, 1853.

Thieme, U. and Becker, F. *Allgemeine Lexicon der bildenden Künstler*, 37 vols., Leipzig, 1907ff.

Thomas, W. C. *Mural or Monumental Decoration: Its Aims and Methods*, 1869.

Thompson, P. *William Butterfield*, 1971.

Tieck, L. *Franz Sternbalds Wanderungen*, Stuttgart, 1966.

Tirebuck, W. *Dante Gabriel Rossetti: His Work and Influence*, 1882.

Tischbein, J. H. W. *Collection of Engravings from Ancient Vases ... discovered in the Kingdom of the Two Sicilies ... now in the Possession of Sir William Hamilton*, 3 vols., Naples, 1791–5.

Toynbee, P. J. *Dante in English Literature from Chaucer to Cary* (c. 1380–1844), 1909.

Treuttel & Würtz. *Catalogues of Books published or imported by Treuttel & Würtz, 1820, 1826, 1828, 1830, 1838*.

Tymms, R. *German Romantic Literature*, 1955.

Twyman, M. *Lithography, 1800–1850*, Oxford, 1969.

Uwins, Mrs. *A Memoir of Thomas Uwins, R.A.*, 2 vols., 1858.

Vaughan, W. 'The German Manner in English Art, 1815–55', Ph.D., London, 1977.

Vidler, A. R. *The Church in an age of Revolution: 1789 to the Present Day*, 1962.

Virgilius Maro, P. *Dell' Eneide di Virgilio del Commendatore Annibal Caro* (with 102 plates after the designs of the Duchess of Devonshire, Catel, Eastlake, Canova, Sir W. Gell, etc.), Rome, 1819.

Vries, L. de (ed.). *Panorama, 1842–1865*, 1967.

Waagen, G. F. (trans. H. E. Lloyd). *Works of Art and Artists in England*, 3 vols., 1838.

BIBLIOGRAPHY

Waagen, G. F. (trans. Lady Eastlake). *Treasures of Art in Great Britain*, 4 vols., 1854–7.

——. *Supplement to Treasures of Art in Great Britain*, 1857.

Wackenroder, W. H. *Werke und Briefe*, Heidelberg, 1967.

Waddington, A. W. *The Development of British Thought from 1820 to 1890, with Special Reference to German Influence*, Toronto, 1919.

Waiblinger, W. *Blüther der Muse aus Rom*, Berlin, 1829.

Wainewright, T. G. (ed. W. C. Hazlitt). *Essays and Criticism*, 1880.

Waldmüller, F. G. *Andeutungen zur Belebung der vaterländischen bildenden Kunst*, Vienna, 1857.

Walker, R. J. B. *A Catalogue of Paintings and Drawings in the Palace of Westminster*, IV, 1962.

Wallis, G. *British Art, Pictorial, Decorative and Industrial: A Fifty Years' Retrospect*, 1882.

Waterhouse, E. K. *Painting in Britain*, 1530–1790, 3rd edn., 1969.

Wegner, W. G. *Die Faust Darstellung vom 16. Jahrhunderts bis zur Gegenwart*, 1962.

Weiglin, P. *Berliner Biedermeier: Leben, Kunst und Kultur in Alt Berlin*, Bielefeld, 1942.

Westmacott, R. *A Letter—the Second—on Government Encouragement of the Higher Classes of Art, Addressed to the . . . Marquis of Landsdowne*, 1836.

Whinney, M. *Sculpture in Britain, 1530–1830*, 1964.

Whitley, W. T. *Art in England, 1780–1820*, Cambridge, 1928.

——. *Art in England, 1821–1837*, Cambridge, 1937.

Wiegmann, R. *Die Königliche Kunstakademie Düsseldorf*, Düsseldorf, 1856.

Wieland, C. M. (trans. W. Sotheby). *Oberon: A Poem, from the German of Wieland* (ill. Fuseli), 2nd edn., 1805–6.

Wild, F. *Gemälde von F. & H. Winterhalter*, Zürich, 1894.

Wilkinson, N. *Sketch of the Life of C. Brocky, the Artist*, 1870.

Williams, D. E. *The Life and Correspondence of Sir Thomas Lawrence, Kt.*, 2 vols., 1831.

Willoughby, L. A. *Dante Gabriel Rossetti and German Literature*, 1912.

Wilson, M. *The Life of William Blake*, 1927.

Wilson, M. T. *The History of the English Church in Rome*, 1916.

Wiseman, N. *Four Lectures on the Offices and Ceremonies of Holy Week*, 1839.

Wolff, M. and Fox, C. 'Pictures from the Magazines' in *The Victorian City* (ed. Dyos & Wolff), II, pp. 359–84.

Wolzogen, A. von. *Aus Schinkels Nachlass*, 3 vols., Berlin, 1863.

Wörndle, H. von. *Josef Führichs Werke*, Vienna, 1914.

Wornum, R. *The Epochs of Painting*, 1847.

Wretch's Illustrations of Shakespeare, Edinburgh, 1829.

Young, J. C. *A Memoir of C. M. Young*, 2 vols., 1871.

Zeitler, R. *Klassizismus und Utopia* (Figure 5), Stockholm, 1954.

Zeydell, E. H. *Ludwig Tieck and England*, Princeton, 1931.

Zink, F. 'William Turner in Heilbronn am Neckar', *Zeitschrift für Kunstwissenschaft*, 1954, VIII, pp. 225ff.

INDEX

INDEX

INDEX

INDEX